IMAGES IN
CLAY SCULPTURE

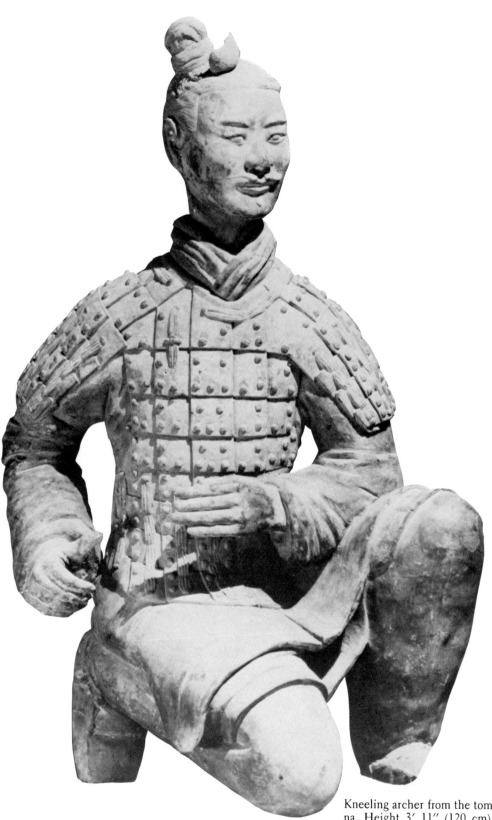

Kneeling archer from the tomb of the first emperor of China. Height 3′ 11″ (120 cm). Qin dynasty, 221–206 B.C. *Courtesy of* The Great Bronze Age of China: An Exhibition from the People's Republic of China *and the Kimball Art Museum, Fort Worth. Photo: Seth Joel.*

IMAGES IN CLAY SCULPTURE

Historical and Contemporary Techniques

CHARLOTTE F. SPEIGHT

ICON EDITIONS

HARPER & ROW, PUBLISHERS, New York

 Cambridge, Philadelphia, San Francisco

1817 London, Mexico City, São Paulo, Sydney

IMAGES IN CLAY SCULPTURE. Copyright © 1983 by Charlotte F. Speight. All rights reserved. Printed in the United States of America. No part of this book may be used or reproduced in any manner whatsoever without written permission except in the case of brief quotations embodied in critical articles and reviews. For information address Harper & Row, Publishers, Inc., 10 East 53rd Street, New York, N.Y. 10022. Published simultaneously in Canada by Fitzhenry & Whiteside Limited, Toronto.

FIRST EDITION

Designer: Charlotte Staub

Library of Congress Cataloging in Publication Data

Speight, Charlotte F., 1919–
 Images in clay sculpture.

 (Icon editions)
 Bibliography: p.
 Includes index
 1. Ceramic sculpture—Technique. 2. Modeling.
I. Title.
NK4235.S6 1983 731.4 83–47560
ISBN 0-06-438525-6 83 84 85 86 87 10 9 8 7 6 5 4 3 2 1
ISBN 0-06-430127-3 (pbk.) 83 84 85 86 87 10 9 8 7 6 5 4 3 2 1

CONTENTS

Color insert follows page 184.

PREFACE

Images in Clay Sculpture tells the story of how humans throughout history have taken one of the most common materials in the world—clay—and from it have created expressive images reflecting their hopes, their fears, their deepest feelings. It also explores how contemporary creators of clay sculpture feel about the material they use, how they work with it, what problems they face, how they solve them, and the satisfactions their work in clay gives them.

The book grew out of the ideas and information that clay sculptors around the world have generously shared with me. I felt that the material I was gathering would be both inspirational and informative to readers who are considering working in clay and to others who wish to expand their knowledge of art. Besides, it gave me an excuse to travel and to meet and talk with artists.

It also grew out of my own life-long love for clay, my own involvement with sculpture, and my interest in the way that sculpture in clay so vividly mirrors the personal and communal emotions and the daily lives of people throughout history.

As I searched out clay sculpture in museums, in churches, or on buildings, and researched its origins and its development, I became increasingly aware of the importance of clay as a sculptural medium.

In addition, while I was studying sculpture in San Francisco in the 1960s, a considerable number of California artists were beginning to create polychrome sculpture, and many of them turned to clay and the ceramic process in order to be able to combine surface color with sculptural form. I realized then that not only had clay been an important sculptural medium in the past, but that contemporary artists were now finding it an ideal material with which to express ideas and images that were very much of the moment.

In this book I have gathered together ideas from many artists, as well as information on their techniques. I hope this photographic and written material will help the reader to see today's clay sculpture as part of a long tradition, and to recognize the importance of clay as an art medium.

I was able to write this book only because so

many people—artists and museum directors, personal friends and personnel in government bureaus, librarians and authors—have helped me in my search.

I cannot imagine a more generous, welcoming group of people than those who make clay sculpture. While I was gathering material, artists everywhere took time to talk with me, to show me their work, to answer questions, and to stimulate my thinking. To all of you who appear in the photographs or in the text and to others whom I was unable to include, a hearty "thank you."

It would be impossible to acknowledge everyone who had a part in the making of the book by name, but as examples of the type of help so kindly offered me, I will mention some names, emphasizing that these are but a few of those who gave of their time and energy. For example: Professor Yoshiaki Inui and Mr. Masahito Shibatsuji, who gave me invaluable help and guidance, and gathered photographs for me of work by Japanese sculptors as well; Molly Little of the World Craft Council who took time to put me in touch with sculptors; Colette Save of *L'Atelier des métiers d'art* in Paris, Françoise Le Borne in Brussels, and Helly Oestreicher in Amsterdam, who were among others who gave generously of their time, often driving me around so that I could see scattered works of art more easily.

No book of this type can come to life without the help of an editor who first of all understands what the writer wants to do, who feels it is worthwhile, and who helps develop the manuscript into a form that will communicate the author's concept to the reader. Cass Canfield, Jr., of Harper & Row is such an editor. His confidence in me and in the project made it possible for me to write the book, and his perceptive and helpful suggestions have been incorporated into its pages. Among those of whom a reader is often unaware are the editorial, design, and production staff whose hours of thought, skill, and creativity are an integral part of the process of building a book. They include Robert Leuze, copyeditor; Lydia Link, design director; Charlotte Staub, designer; and Bitite Vinklers, production editor.

Curt Philips did a great job of deciphering my cut-and-pasted collage of a manuscript in order to prepare the final typescript, Judith Litvich carried a heavy box of photographs to New York when I feared to trust them to public transport, and my daughter Martha gave me the continuing supportiveness that helped me to keep plugging away at the typewriter.

So, although the final product bears my name, it is in reality the joint effort of many dedicated and talented people. I take responsibility for any omissions or errors that may appear in the book, but wish to give credit for its strengths to all those who helped me.

1-1 Louise McGinley, U.S.A., working on *The Norns*. As the artist worked on this sculpture, her hands repeated the pinching and smoothing gestures with which sculptors have built images for thousands of years.

METHODS
AND TECHNIQUES

How Artists, Past and Present, Have
Formed, Fired, and Finished
Clay Sculpture

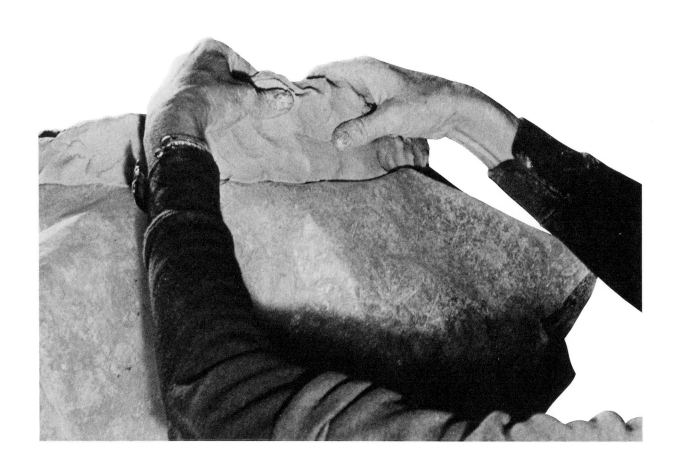

The Earth:
An Introduction to the Medium

Clay is a sometime thing; to be overconfident is to court disaster. The materials and the process respond to the way in which they are handled and when the work succeeds you must realize that you have only partici-pated in the event.... —*Margaret Ford, U.S.A.* *

I don't oppose the material; rather I adapt to it, trying to understand it, merging it with my fantasies.... Instead of forcing and distorting the clay unnecessarily, I try to draw from it, as perceptively as possible, the natural invisible forms that hide in it, that breathe, that want to come to the surface, "to be." —*Carlo Zauli, Italy*

It is not surprising that clay sculptors everywhere express similar attitudes toward their material or that the swelling forms of hills, the jagged shapes of mountains and rocks, and the cracks and folds of the earth's surface appear frequently in their sculp-ture, for a deep love of the earth, and an under-standing of the geological forces that lift, fold, and erode its surface animates those who work with clay (1–1 through 1–13).

Inspired by the natural world around them, hu-mans have shaped this common, malleable mate-rial into sculpture since the Ice Age, modeling it into images of the bison they hunted (1–1), pinch-ing a chunk of clay into a hand-sized female image (1–14), or creating sculpture whose forms remind us of the fragility of our planet Earth (1–12).

Two sculptors—miles apart—speak in both words and clay of their feeling for the earth. Ken Vavrek, U.S.A., came to understand his connec-tion to the earth through travel: *A trip through Utah and the West helped me to see my ideas in a landscape form. The quality of the raw land ex-*

*Quoted in *Overglaze Imagery* (Visual Arts Center, California State University, Fullerton).

presses directly the forces of time. Man's presence is barely recorded.... I sense that the earth-as-spaceship frame of reference has affected me (3–22). Gideon Kari, of Israel, on the other hand, lives close to the land at all times, and says that the earth *is a direct medium for a spectrum of experiences, forms and colors accumulated since my childhood in the landscapes of Israel.... Today I'm anchored in this earth, as a farmer and as an artist. I'm not digging into—I'm producing from it!* (1–11).

Like many of those who work in clay, California sculptor Stephen De Staebler (1–3, Colorplate 6) feels that, since the arrival of the modern techno-logical period, we have lost touch with the natural rhythms of the world and have glorified our imag-ined independence from them. Remembering his childhood, when he played in the woods, damming streams, exploring the sandstone bluffs of the Indi-ana countryside, he feels fortunate to have had a close relationship with nature for, he says: *Having all that is the same thing for an artist as having the raw materials handy, having an environment which is unformed enough so that the creative urge to form things is possible.*

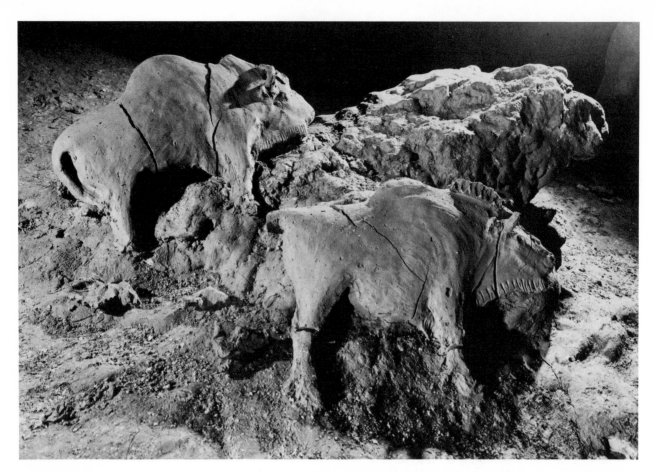

1-2 An Ice Age artist crawled about seven hundred yards into a cave to model these lifelike bison. Created between twelve thousand to thirty-seven thousand years ago, they still show the marks of the sculptor's tool and are as fresh in their surface detail as if they had been modeled yesterday. 25 × 24″ (64 × 61 cm). Upper Paleolithic period, Cave of Tuc D'Audoubert, France. *Photo: Jean Vertut, Begouen collection.*

1-3 Right: Stephen De Staebler, U.S.A., *Seated Woman with Mimbres Womb,* detail. De Staebler speaks of the influence of his childhood in Indiana, where he climbed on rock bluffs and explored caves; from this background he developed a *feeling about nature as it is. It is a reverence for what is.* Low-fire clay, stoneware, and porcelain, fired at cone 6; colored with oxides and stains.

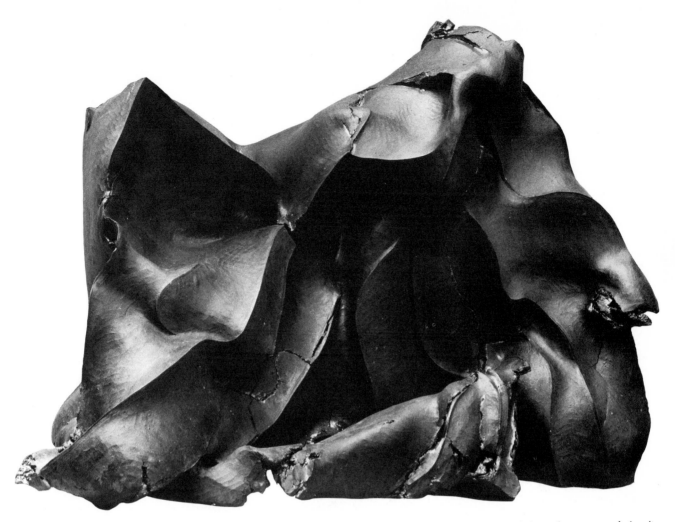

1-4 Carlo Zauli, Italy, *Soft Sculpture*. Zauli says, *I feel I am above all a man who loves a lump of clay, who wants to bring it to life, giving it form, bringing out and recording its rhythms and the mysterious tensions that are hidden in it.* 1982. Stoneware colored black with manganese and touches of black glaze, 47 × 35″ (120 × 89 cm). *Courtesy of the artist.*

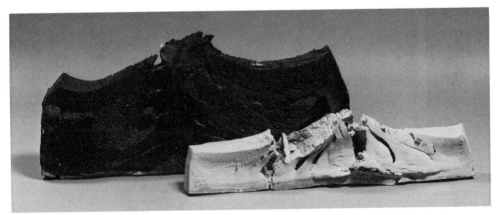

1-5 Rita Pagony, Hungary, *Earth + Heat I* and *II*. 1981. Porcelain and stoneware, 29 × 7″ and 33 × 10″ (74 × 18 and 84 × 25 cm). *Courtesy of Concorso Internazionale della Ceramica d'Arte Faenza. Photo: Villani.*

1-6 Above: Detail of terracotta relief, in a theatre in Vàc, by Imre Schrammel, Hungary. The hand of an Ice Age hunter modeling an animal image or that of a contemporary sculptor pressed in the clay leave visual reminders of the vulnerability of clay to human energy. Schrammel comments, *Man and earth/clay are constantly affecting each other. To fix the traces of this struggle, the traces of this molding, mutual fight ... that is what I try to do during my work.* 9 × 66′ (2.85 × 20 m). *Courtesy of the artist. Photo: Lelkes László.*

1-7 Tony Hepburn, U.S.A., *Plateau.* Part of a series, *Plateaus and Sites,* which reflects Hepburn's interest in prehistory, myths, and communal structures. 1981. *Courtesy of the artist.*

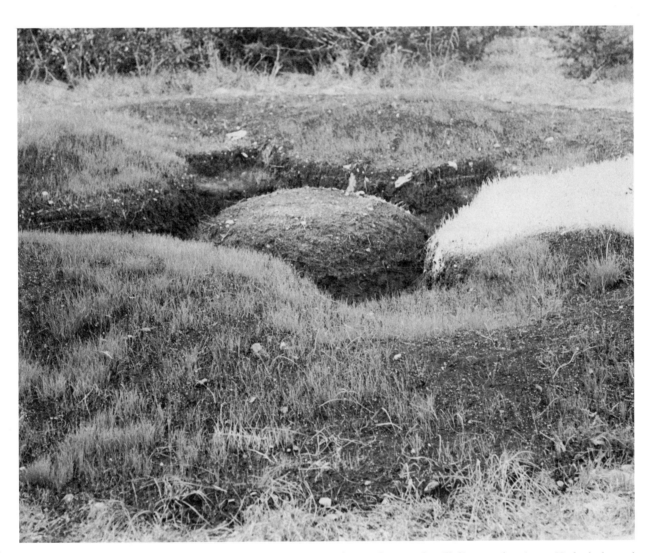

1-8 William Maxwell, U.S.A., *Excavated Sphere.* Influenced by ruins he saw in Mexico and Arizona, Maxwell created a series of excavation pieces that he left for the elements to transform. The sphere had already sprouted grass when the photo was taken. Maxwell plans to document this interaction over a prolonged period, and also hopes that people will discover the pieces. He had planned to coat the sphere with slip, burnish it, and dung fire it. But, he says, *I like the quality of the earth with the roots sticking out of the sphere so decided against it with this particular piece.* 1981. *Courtesy of the artist.* Photo: Richard Dreher.

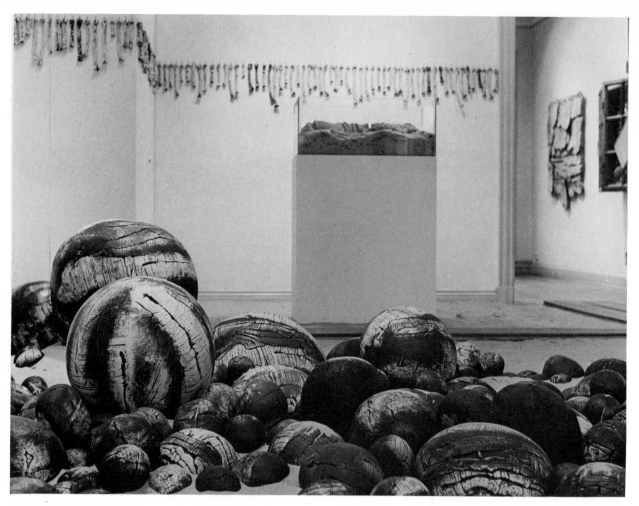

1-9 Ulla Viotti, Sweden, *Traces of Life: Sand Room.* Viotti explains that the installation has sand on the floor, a horizon line of modeled bones, and on the floor a ceramic landscape in some of whose stones one can see traces of the human cranium. *In the Plexiglas sarcophagus you can see newly modeled figures of wet clay. I poured water over the figures, and now the people are symbolically going back to nature—a ceramic drama that shows the life cycle.* Exhibition installation, 1981, Kristianstad Museum. *Courtesy of the artist.*

1-10 Above: With earthenware clay, slips, and flash salt firing, David Crane, U.S.A., created a vessel that reflects the qualities of the earth from which it was formed. 1981. 11 × 18″ (28 × 46 cm). *Courtesy of Hill's Gallery, Santa Fe.*

1-11 Right: Gideon Kari, Israel, *Ancient Plow,* detail. Kari, who divides his time between work on his farm and in his ceramics studio, says, *My leitmotiv is the desert— parched soil almost dehydrated by the heat of the sun— with its bare, wild forms.* 24 × 12″ (60 × 30 cm). *Courtesy of the artist.*

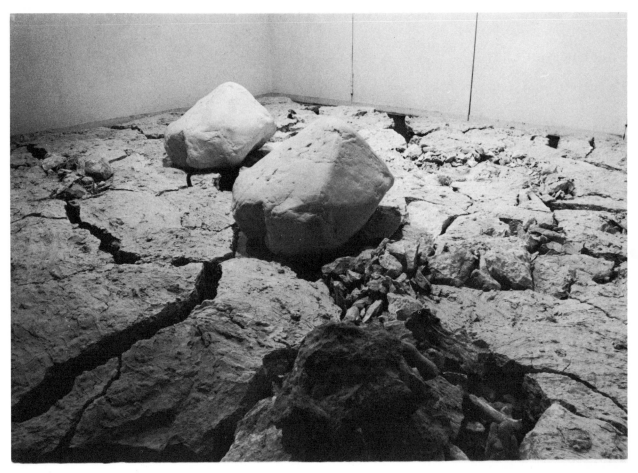

1-12 Kimpei Nakamura, Japan, *Vanity of Vanities.* Cracking and crumbling, the clay forms could be the mantle of the earth as it responds to the movements of its tectonic plates. 1976. Earthenware, 15 × 15′ (4.5 × 4.5 m). Installation, Art Core Gallery, Kyoto. *Photo: K. Nakamura.*

1-13 Erik Gronborg, U.S.A., *Figure Environment,* detail. Gronborg partially buried sections of figurative clay sculpture in sand on the beach. Life-sized. *Courtesy of the artist.*

Uniqueness of Clay

The material earth, wellspring of all mineral and organic forms.
—Carmen Dionyse, Belgium

One of the most common materials on our earth, clay is a remarkable substance. It is like no other artistic medium in the wide range of possibilities for creative expression it offers. Easily formed, it holds its shape as it dries, becomes permanently hard when subjected to heat, and even if a fired clay sculpture is broken, its fragments can be reassembled into their original form. Clay can be modeled and carved, and it can also be diluted to a semiliquid state and poured into a mold to take on a positive image from the mold's negative. It is this versatility of clay—its plasticity and its ability to hold the impression of the artist's hands and tools—that has led humans to use it as a sculptural material for so many centuries.

We would better understand the why of clay's plasticity if we were to look at it under a microscope and see its thin, flat particles that, when dampened and surrounded by water, are able to slide freely against each other while at the same time adhering to each other. It is this action, similar to that of two sheets of wet glass that both cling and slide, that gives clay its plastic quality.

That this plasticity was recognized by very early cultures we know from their many myths and legends telling how gods or goddesses molded the first humans or animals from clay. For instance, an ancient Babylonian myth, the *Poem of Creation,* tells how a god was sacrificed so that humanity might be brought to life from clay, while in Egypt, the potter-god Khum was entrusted with modeling bodies in clay and breathing life into them.

Creation myths vary in detail, but many of them depict clay as the primeval material from which we humans were formed, and these poetic interpretations of creation may well be remarkably near the truth. Recent investigations into the beginnings of life on earth have shown that clay was actually a factor in the transformation of the inanimate substances on earth into living ones. Clay particles apparently served as catalysts and templates for the amino acids that were essential to the formation of the protein molecules that produced the first life on earth.

For millennia, clay lay inert and passive in beds where it was deposited eons ago by the action of water, its particles weathered from feldspathic rocks and carried to new resting places by the action of streams and rivers. After being subjected to geological forces, after being pressed by its own weight into solid beds, clay was subjected to a new force—the one that concerns us in this book—human creativity. We humans have strong needs to touch, to explore, to transform what we find around us, and putting our physical and creative forces to work on this plastic material, we formed images and objects from clay wherever we found it—in the dim recesses of a cave, in the brilliant sunshine of a river delta, in the damp northern woods.

Images from the Earth

The earth, with its swelling forms, its deep crevices, its fecundity, has been identified since time immemorial with the female figure, with fertility. In Sumerian myths it was the goddess Nammu, the mother of all the gods, who gave birth to heaven and earth. In Africa, the Bambara peoples of the upper Niger believe that the god Pemba molded the first woman out of earth and she gave birth to plants and animals. This link between the female image and the earth's fertility has been almost universal, and many of the world's earliest clay images were of the feminine form. Modeled from chunks of damp clay, these little figures were pinched and poked into exaggeratedly feminine symbols of the procreative power of the earth. They were formed solid, the earliest without decoration, the later ones with rolls and pellets of applied clay and scratched lines defining their features or clothing (1–14, 1–15, 1–16). Unfired, simply set out in the hot sun to dry, over the centuries thousands of these images must have crumbled back into the earth from which they came.

Early Fired Images
Some female figurines, however, are among the earliest known fired clay sculptures. In 1925, what

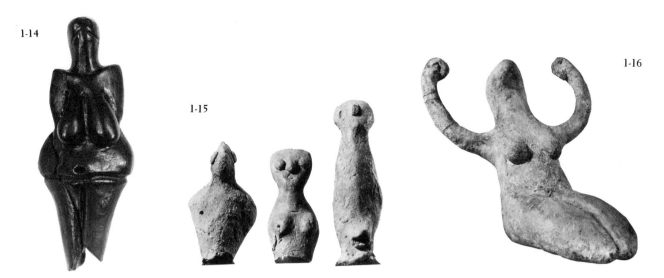

1-14 *Venus of Dolní Věstonice.* Found in an Ice Age site in South Moravia, this is one of the earliest known fired sculptures. Excavated along with fired animal images and a vaulted clay structure believed to be a kiln, it proves that the firing of clay started much earlier than the Neolithic period. Height 4½″ (11 cm). Upper Paleolithic period, Pavlovian culture, c. 26,000 B.C. *Courtesy of the Moravian Museum, Anthropos Institute, Brno.*

1-15 Tiny unfired figurines from the Horvat Minha excavations in Israel were formed by pinching and poking solid clay into simple images, which probably were connected with fertility rites. Dating from four thousand to six thousand years ago, these were all sun-dried rather than fired. The tallest is almost 2″ (4.5 cm). *Courtesy of the Israel Department of Antiquities and Museums, The Israel Museum, Jerusalem.*

1-16 In the days before Egypt was ruled by the pharaohs, inhabitants of the farming communities along the Nile scooped up handfuls of mud to form female images. Fired at a very low temperature, the earthenware clay did not mature, so the color is gray rather than the usual iron-red. Pre-dynastic, Badarian civilization, c. 4000 B.C. *Courtesy of The Trustees of the British Museum, London.*

was apparently a sculptor's workshop was found during the excavation of an Ice Age living site in Moravia. In it was the so-called Venus of Dolní Věstonice (1–14). She was found along with fired images of animals—bears, mammoths, and rhinos—and broken fragments of legs and heads, while a primitive kiln was found nearby. This startling discovery showed that humans learned to fire clay about twenty-five thousand years ago, much earlier than was once believed.

The technology needed to fire images like those found at Dolní Věstonice did not develop suddenly, or only in one place. In other areas it was much later, about six thousand years ago, that solidly formed figures were no longer sun-dried but were baked in open fires or in simple kilns (1–15).

The early sculptors of these images had little choice in the type of clay they could use, or in the temperatures to which they could fire it. They had to use whatever clay was available locally, and since their knowledge of firing techniques was limited, they were restricted to firing at low temperatures. This meant that they used earthenware clay.

This common clay, which exists in most parts of the world, matures at a low temperature because of its iron content; the iron serves as a flux, causing the more heat-resistant materials to meld and mature at lower temperatures. The same iron gives this clay its reddish color when it is fired to maturity, but when under-fired, like the Nile River mud of the kneeling goddess (1–16), it comes from the fire a muddy gray.

Once the image makers in early periods had learned to fire their small solid sculptures, they must also have tried to build larger pieces solid and discovered that it was difficult to fire them. Thick-walled or solid clay sculpture *can* be fired if it is dried extremely slowly and fired carefully. For example, the legs of the soldiers and horses of the Emperor Qin's clay army were fired solid (2–1), and there are sculptors working today who succeed in drying their solid clay pieces for days, then firing them in a long, slow firing, bringing them out of the heat of the kiln safely. Generally, however, clay sculpture is made with relatively thin walls, leaving the interior open. One way to do this is to form the sculpture solid, then, before it dries completely, hollow it out until the walls are thin enough to fire successfully. This method was used at times in Mesoamerica and sometimes is used by sculptors today. Usually, though, sculptors build up their work hollow, using a variety of techniques

11

that vary from pinching wads or coils of clay up to form walls (2–5), using the potter's wheel to throw cylindrical forms that can be combined or altered (7–23), forming the sculpture hollow with slabs of clay joined with slip (3–12), or pouring liquid slip into molds (5–25).

These methods have been used throughout history, and despite new technology in the ceramics field, all of them are still in use today. Many con-

Creativity and Technique

The aim of the chapters that follow is to present a wide range of clay sculpture—the finished product of human creativity—and to explore how its creators feel about the material they use, how they work with it, what problems they face, how they solve them, and the satisfactions that material gives them. Clay sculpture is an exacting art, for in addition to keeping the concept of the work alive and dealing with the development of three-dimensional forms in relation to each other, the clay sculptor faces the technical problems of how to make the material stand up, stay together, dry safely without cracking, fire well, and possibly receive color.

However, no matter how important such technique remains, without that intangible, but essential ingredient—creativity—the damp lump of clay would never be transformed into a piece of sculpture. It is primarily the artist's ability to conceive of the forms that allows him to create a work of art that exists in real space, with its own physical properties of mass, texture, and color. Technique is a tool that can be acquired.

Unfortunately, there is no written material left by the earliest sculptors to tell us of their trials and triumphs, their successes and frustrations. It would be fascinating to talk with the Ice Age artist who sculpted the bison in the cave, to discuss building and firing methods with the Etruscan who created one of the world's most moving funerary monuments (2–4), or to visit the studio of Niccolò dell' Arca in Bologna when he was taking his dramatic figures from his kiln (8–11). Would these earlier artists express the same feelings that sculptors express today about the material? The chances are good that they would, and that the relationship between artist and material would have been very similar—whether in Etruscan Italy, ancient China, or pre-Columbian America.

Contemporary sculptors, unlike their artistic an-

temporary sculptors find that working with these ancient techniques gives them an important sense of continuity with the past. Indeed, in no other material is the mark of the sculptor preserved with such clarity as in clay, where we can see fingerprints that date from the earliest times. In fact, anthropologists use the finger marks left in fired clay as source material for their researches into the physical characteristics of ancient peoples.

cestors, have an almost bewildering choice of clays from which to choose—from rough, porous earthenware, through dense, vitrified stoneware, to fine white porcelain that may be cast so thin it becomes translucent. In addition, firing nowadays can make use of recent technology. We will see in later chapters how sculptors utilize the wide range of possibilities that the ceramic process offers, for their own creative purposes. Sharply defined forms, smoothly glazed surfaces, overglazes, lusters, and photoprocessed images are as much a part of the contemporary scene as are the more "earthy" textures and surfaces. However, it is the earth that remains the basis of it all, making its own demands on the people using it.

These demands can be almost overwhelming at times, and most clay sculptors have a love-hate relationship with their material, sometimes waxing lyrical about its almost mystical character, then suddenly bursting out in exasperation at its perversity. Nikolaas Van Os, of Holland, for example, expressed the ambivalent feeling so common among those who work in clay, first saying: *I use clay because it suits me. Clay can grow like a plant, or as a building is constructed.* Soon after, however, he referred to it as *this terrible material that never does what I want.* Italian sculptor Carlo Zauli once spoke of the almost godlike power he felt working with clay, but on another occasion, when he discovered a large crack in one of his sculptures as he took it from the kiln, he was more humble, groaning: *You have to be crazy to want to work in clay. In my next life I'll work in another material!*

Despite, or perhaps partly because of, the material's perversity and the challenges it offers, sculptors have been able to externalize their inner visions with great vitality in clay. Using their inventiveness, ingenuity, perseverance, and the strength of their bodies, they have created work

that reflects their individual philosophies and their cultural milieus. Today, like thousands before them, contemporary sculptors leave their physical and creative imprint on this plastic material that can do so many things. English sculptor Percy Peacock expresses the seemingly endless possibilities of the medium: . . . *soft, hard, wet, dry, permanent, transient, detailed, rough, smooth, monolithic, small, fine, translucent, stony, shiny, glass, precise, strong, fragile, bright, matt, mechanical, organic, mud, solid, hollow, practical, functional, disguise, imitate, fragment, break, mold, press, tear, extrude, distort, twist, mark.* . . . His list just about covers every aspect of the clay sculpture illustrated in the following chapters.

As you read and look at these examples, however, remember that when sculptors explain their methods of working, they are describing processes that they have developed to suit *their* needs, and none of them would suggest that any one method is the "right" one. The technical expertise of many artists is presented here to show the wide range of ways one can work with clay, but the reader must, of course, choose, experiment, and come up with his or her own solutions in the age-old struggle to develop a personal way of working in clay. Technique is important, but without creativity any amount of technique is useless. It is also important to realize that although many sculptors welcome the new technological aids that have appeared in recent years, there are others who feel, with Richard Lipscher, U.S.A. (8–26), that *too many people are given the impression that ceramics can only be done at a large facility with massive quantities of expensive machinery. My space is small, my equipment the barest minimum, but I have yet to come up with an idea that could not be constructed in the desired size, shape, or color.*

Pinching, Coiling, and Firing the Clay

Anyone who has worked with clay knows that the bigger you get the more overwhelming the structural problems become. That's the point at which a person who doesn't have a sort of suicidal love affair with the material gives it up and goes on to other materials.
—Stephen De Staebler, U.S.A.

In its natural state, clay lay flat in beds and banks, its platelets aligned horizontally, each particle responding to gravitational pull, moved from its prone state only by the forces of geology. Then humans appeared, dug it out, and, valuing its plasticity, used it to express their feelings about the world, to create portraits of gods, goddesses, and heroes, to honor the dead, to decorate buildings (Colorplate 1). As long as they respected the clay's response to gravity, modeling only small figures, humans could easily exploit the clay's qualities, for clay is the most direct sculptural material, most responsive to hand and tool. It is also very difficult to

work with, because it always wants to return to a prone position.

But since we humans are upright beings, with a vertical outlook, we have constantly tried to overcome clay's horizontality so that we can reflect our own perspective. One could almost say that the story of clay sculpture is the story of that struggle. That is, of course, an oversimplification, but certainly in our relationship with clay there is a constant conflict between our respect for its innate structure and characteristics and our human desire to transform it into images that express our own viewpoint, our human emotions and fantasies.

Building Large Sculpture

At different times in history, in various parts of the world, sculptors have developed techniques that enabled them to build and fire large clay sculptures, solving the problem of gravity in a variety of ways. Some of the larger sculptures made of clay that have come down to us range in type from the

terracotta figures that once decorated the roofs of temples (7–4) to life-sized horses that were built and fired on site in outdoor sanctuaries in India (2–29). The technical problems of building, drying, and firing such large pieces were solved by adding tempering materials to open the pores of the clay—

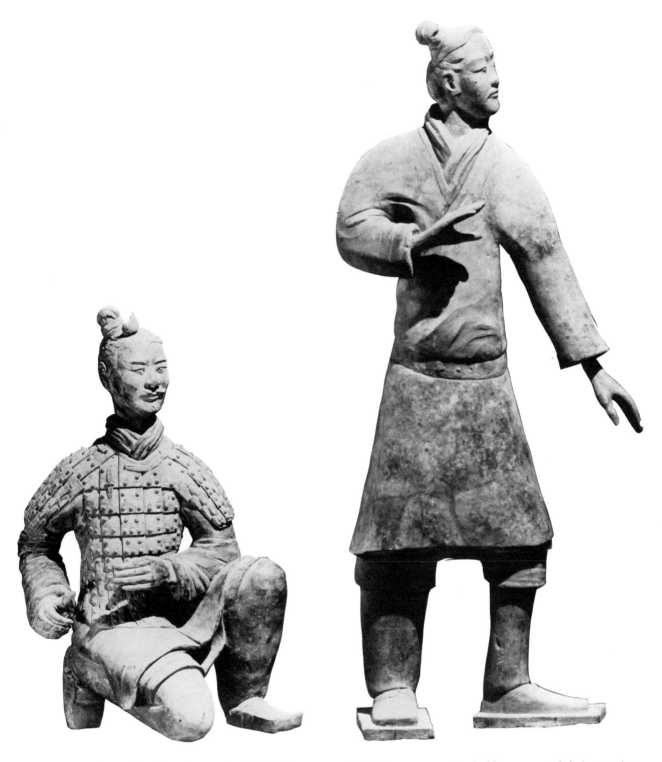

2-1 Left: Kneeling archer from the tomb of the first em-
peror of China. It was part of a terracotta army buried
about 210 B.C.; so far, about seven thousand life-sized terra-
cotta figures have been found along with clay horses and
chariots. The lower part of the figure was built solid, while
the upper was coil-built hollow, and the heads, attached
with long cylindrical necks, were probably formed in
molds, then individualized. Originally painted with bril-
liant colors, the army was lined up in ranks to guard the
emperor in death. Height 3′ 11″ (120 cm). Qin dynasty,
221–206 B.C. Right: This warrior's gestures suggest the
Chinese art of shadow boxing, which may have been used

by the troops as a method of harassment of their enemies.
Details of armor and clothing were applied while the clay
was still damp, and the surface of the figure was finished
with fine slip, then was painted. The simple but realistic
faces must have been modeled and carved by master sculp-
tors, suggesting a long tradition of clay sculpture, unsus-
pected before the recent discovery. Height 5′ 10″ (1.8 m).
Qin dynasty, 221–206 B.C. *Courtesy of* The Great Bronze
Age of China: An Exhibition from the People's Republic
of China and the Kimball Art Museum, Fort Worth. *Pho-
to: Seth Joel.*

sand, straw, or crushed once-fired clay—as well as by building the pieces in sections and reassembling them after firing (7–17).

Japan and China

In Japan, sculptors built the *haniwa*—cylindrical images of people and animals that were placed around graves—by coiling long ropes of clay to build up the walls, adding the details of clothing or armor later (2–17). Chinese sculptors, on the other hand, in a somewhat earlier period, used several different techniques to create the thousands of clay soldiers and horses buried in the Emperor Qin's tomb. Probably working with an assembly-line technique, with crews of workers specializing in each phase, they built and fired the legs solid, used coils to form hollow torsos, then press-molded the faces. These were later individualized through modeling and carving while the

clay was still damp (2–1). Another method used in China to create large sculpture was that of building it up on wooden frameworks, with straw or other fiber helping to attach the clay to the armature (4–2). These wood-supported figures were left unfired, but the stoneware figures of northern China represent a high degree of firing technology (2–8). Since these lohans were seated on hollow, arch-strengthened bases, the artists avoided the problem of building a standing figure, but the figures' size and the thickness of their walls must have presented problems in the high firing necessary to mature the glazes.

Africa

In northern Nigeria, tin-mining operations uncovered fragments of large terracotta sculpture (2–2, 2–3). Now known as Nok for the town near which it was found, this culture produced stylized figures, impressive and expressive, modeled and carved from rough clay that contains substantial grains of sand and pebbles. Whether this tempering materi-

2-2

2-3

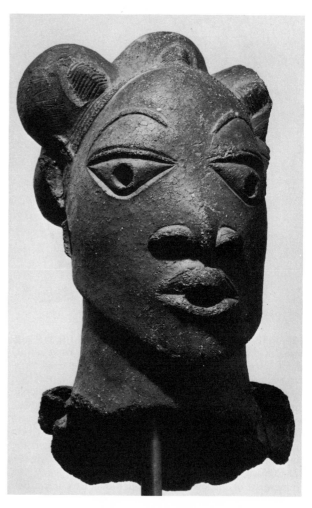

2-2 Terracotta leg fragment from the Nok culture. Tin miners in northern Nigeria uncovered fragments of large earthenware figures that had been built up hollow with clay that contained considerable rough tempering material. *Jos Museum, Nigeria. Courtesy of National Museum of African Art, Eliot Elisofon Archives, Smithsonian Institution. Photo: Eliot Elisofon.*

2-3 Nok head, Nigeria. The expressive figures from which fragments such as this one come are evidence of a sophisticated firing technology that probably developed along with ironworking activities. Since there is no evidence that they were fired in kilns, open firing—a method that requires careful attention to keep the heat even—must have been used. Height of head, 14″ (36 cm). *Jos Museum. Courtesy of National Museum of African Art, Eliot Elisofon Archives, Smithsonian Institution. Photo: Eliot Elisofon.*

al was deliberately added or not is uncertain, but since the figures, from the size of their fragments, are believed to have been at least four feet tall, it seems likely that the sculptors had already learned the value of adding such material to make the clay less likely to shrink in drying and firing. The faces of these large figures have apparently been carved into the still-damp clay, leading one writer to suggest that they followed an earlier wood carving tradition. Whether that is true or not, these fragments are the oldest sculpture yet found in Africa (outside Egypt), dating from about 400 B.C.

Etruria

The Etruscans, who lived in central and northern Italy before the Romans became all-powerful, were said to have learned their clay-building techniques from the Greeks (Colorplate 1). However they learned their skills, the Etruscans were masters in the use of clay, covering their wooden temples with terracotta panels that also served to protect them from the weather, animating the roofs of these places of worship with tall standing figures of gods and goddesses, as well as with horses and riders or chariots. These ambitiously conceived groupings usually recreated dramatic mythological incidents, such as the struggle between the god Apollo and Hercules. While making the figures of Apollo (7–4), the Etruscan sculptor, possibly the famous Vulca who made the sculpture for the terracotta-covered temple on the Capitoline Hill, Rome, solved the problem of making him stand alone by incorporating a support into the composition.

The reclining figures that the Etruscans placed on their funerary urns and sarcophagi presented less of a problem, but they were nevertheless often built in sections, to facilitate firing, with the divisions carefully following the lines of the draperies and the form of the body (2–4).

The tradition of modeling sculpture in clay continued into the Roman period, when the sculptors were usually Greek slaves. The Roman writer Pliny the Elder (A.D. 23–78) speaks of how even in his day terracotta was still the preferred material for sculpture on temples in Italy.

Renaissance Italy

Using Italy's abundant low-fire clay, Renaissance artists continued the tradition of clay sculpture, creating almost lifesize religious groups for churches in

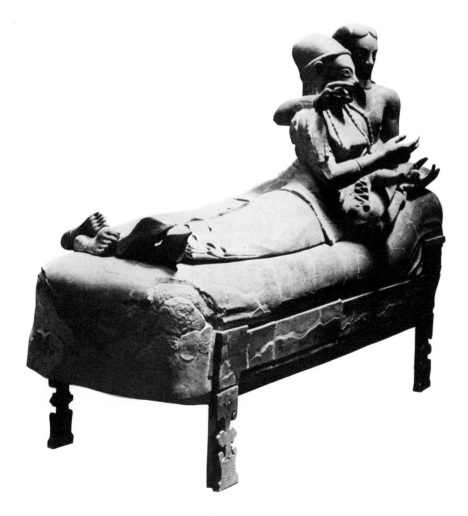

2-4 This masterpiece of Etruscan art, built of wads and chunks of clay, exhibits the vitality and enjoyment of life typical of that culture. The husband and wife probably held ritual objects in their hands—perhaps eggs. The figures and the couch under them were formed and fired in two parts. Found in hundreds of pieces, the sarcophagus has been reassembled with the missing pieces restored. Terracotta. Height 56″ (140 cm). From Cerveteri, c. 520 B.C. *Photo: permission of Museo Nazionale di Villa Giulia, Rome.*

what had once been Etruscan towns. Many of these consist of kneeling figures, but Niccolò dell' Arca modeled his agonized mourners in standing poses, using dramatic gestures, body stance, and facial expression to intensify the emotional impact of his *Pietà* (8–11, 8–12). Sometimes the faces of these figures were made from life casts, and often the arms and hands were cast from living limbs—a fact that probably accounts for their slightly smaller-than-life size. To be sure that a sculpture comes through the drying and firing process in life scale, it must be built larger than life to allow for shrinkage, so if the whole sculpture was formed to the scale of limbs that had been cast from life, the finished piece would be smaller. Whatever technique or combination of techniques these sculptors utilized, it is clear that they, too, had to contend with the problem of making the clay stand up. Today, when different motivations, concepts, and images concern the sculptor, this still remains a major factor that must be faced by anyone who works in clay.

One contemporary sculptor who has tried to defy the gravity that constantly pulls damp clay back down to earth is Stephen De Staebler, who has worked in a variety of sculptural materials but always comes back to clay (1–3, 8–17).

Aware of the body's vulnerability to the forces of time, he is equally conscious of the vulnerability of the clay to the forces that can be exerted on it by the artist's body. Comparing clay to other materials, he points out that in working with steel one would have to use hydraulic forces to approach the capability of even a frail person to change the clay through use of human muscles.

This response to clay, to its tactile qualities, to its vulnerability to the force exerted on it by human energy, is typical of the response of many artists working in the material today—artists who still use the same basic hand-forming methods once used by the earliest clay sculptors. The technique of pinching wads and coils of clay together to build large pieces with hollow walls is one of the simplest of methods, but with it many contemporary artists create large and complex works.

Tempering Materials
One difficulty with large sculpture is that uneven shrinkage of the walls will cause cracks and warping. Early sculptors found, probably by accident, that clay containing a considerable amount of sand, pebbles, or straw stood the stresses of drying and

firing more easily, so sculptors have usually added some form of temper to their clay. This addition helps to control shrinkage as the clay dries, keeping the pores of the clay open as the water evaporates and the clay particles move closer together. Nowadays the usual additive is grog, a material consisting of crushed particles of already fired ceramic material, but sand, sawdust, nylon fibers, fiber glass, or pearlite are also used to open the clay, to strengthen it, or to lighten it in its final fired form. Organic additives, like sawdust, burn out in the firing, leaving the clay less dense and heavy, and fiber glass will melt into the clay, becoming vitreous in the heat.

NIKOLAAS VAN OS, the Netherlands
Nikolaas Van Os, whose large stoneware figures enliven both private gardens and the park of a provincial government building, constantly faces the problems of how to build, dry, and fire his intricate creatures safely at high temperatures. His work exemplifies the difficulties that sculptors may encounter when drying and firing large sculpture. Asked if he had a particular aesthetic concept, he replied: *Theory! What is it compared to the physical presence of my creatures?*

Certainly the beings that peer out through masses of pink columbines and purple iris in Nikolaas Van Os's garden have a commanding presence, transcending aesthetic theories, living a life of their own (2–9). They seem far removed from the atmosphere of the Dutch village where their creator lives and works in a garden-surrounded brick barn that has been converted into a combined living and studio space.

Pinching and Paddling
Surrounded by his drying, about-to-be-fired and completed work, Van Os pinches, pokes, and paddles the clay into intricate forms that become creatures, boats, chairs, or animals.
Jokingly referring to the wads and coils as his secret method, he says he uses clay because *the process of building up, of constructing a ceramic object as I do it has become a part of my fantasy. The way I construct is my language. There are no aesthetic concepts to imprison in a formula, because art is not a fixed thing. Art grows and decays with the one who creates it. I use clay as a plant growing, so my criteria are subject to my moods, to the stages of my very growing or decaying process.*

Temper

Working in French stoneware clay, Van Os adds about twenty percent large-grained grog and ten percent fine. Grog, or other tempers, can be added at the time the clay body is mixed, or when the clay is wedged before use. The wedging, or kneading, process also helps to drive out any air bubbles that may be trapped in the clay and explode in the kiln, damaging the sculpture.

In order to lighten the weight of his sculpture, and to facilitate the drying and firing of his work, Van Os has developed a system of arched and curved supports that he builds into his sculpture, engineering it to support the weight as well as incorporating it as an element in the visual composition. Developing this system through experiment, he was unaware that a Chinese sculptor centuries ago had devised a similar system to support a seated figure (2–8).

Drying

Once built, Van Os's creatures stand around his studio in various stages of drying, waiting to be fired. This drying period is critical for them, and they must be watched carefully to make sure that they dry slowly. *Usually,* says Van Os, *the atmosphere in Holland is rather moist, but if it gets really hot, I put pans of water around the room.* After they have dried thoroughly, Van Os fires them, only, he says, because he can't cast them in bronze. *It would be too complicated casting all those weird, hollow complex forms into molds. But I hate firing a kiln and all the tensions due to it.*

Even Van Os's careful construction and drying are not proof against problems developing in the firing. For example, the sculpture of a horned creature that appears to watch the sculptor at work (2–5) fared badly in the kiln. Van Os reported: *The underpart of the structure is rather damaged with cracks because the pressure was too great from the weight to allow it to shrink evenly.*

Such episodes are part of a clay sculptor's life, and the sculptor must be prepared to find that a piece that has taken weeks of work may emerge from the kiln with considerable damage. The time in the kiln may produce a magical transformation, but the fire can also be cruel, destroying in a few hours what took so long to create.

Changes in the Clay in Firing

If a large sculpture like one of Van Os's figures survives the critical drying period without mishap,

2-5 Working on a large fantasy chair, 1981, Nikolaas Van Os, the Netherlands, builds with what he jokingly calls his secret method—wads and coils. The lower portion of the chair is wrapped in plastic to keep it from drying too quickly, and moist plastic is placed between the lower portion and the new clay to keep it from adhering.

its next trial comes as the temperature of the kiln is raised in the first, the bisque, firing. As the temperature goes up, at first the last of the physical water is driven from the clay, evaporating as vapor. Later, when the kiln reaches a higher temperature, the molecular water (the water that eons ago combined chemically with the alumina and silica in the rock particles) leaves the clay. At this point the clay is actually altered chemically, and can never be returned to its original state. In the second firing—the firing that causes high-fire clays like stoneware and porcelain clay to mature and the glazes to fuse—sculpture is subjected to temperatures that may cause warping. (In fact, if the kiln were left to rise to a very high temperature, the clay would eventually sag and droop as the heat-resistant materials melted into glass.) Thus, the sculpture goes through its "sojourn in Hell" while the sculptor lives through his own Hell, waiting to see what the fire has done to his creation. For this reason, a kiln opening is a dramatic moment, and if successful, is a cause for satisfaction.

It is clear that anyone who decides to work in clay must learn just what the clay can and can't do, trying to push it to its limits and expand its possibilities, but ultimately respecting its unique structure and inherent characteristics.

2-6

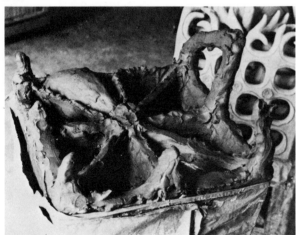

2-6 Van Os pokes and pulls the clay into a domed form to support the cushion. *Like the tensions in architecture, you have to distribute the weight. I'm making it almost the way they make it in a church, with arches so that it will be strong. This will be the cushion—an elegant Queen Anne cushion.*

2-7 Glazed and fired, the chair has outlived its "sojourn in Hell" and has emerged colorful in blue, green, and brown tones. An iron pin set in the lower section fits into a socket in the upper part, making the chair demountable.

An artist like Van Os confronts these limits every day, and they control his existence as he works in his garden-studio to the sound of humming bees, clucking chickens, and the musical notes of the village church bells. A romantic life? Perhaps, but it is debatable whether a daily struggle with the realities of earth, water, and fire is not more "real" than, say, a daily confrontation with a computer.

LOUISE McGINLEY, U.S.A.

Using many of the same basic building techniques as Van Os, Louise McGinley creates fantasy scenes that tell deceptively amusing fables, often

2-7

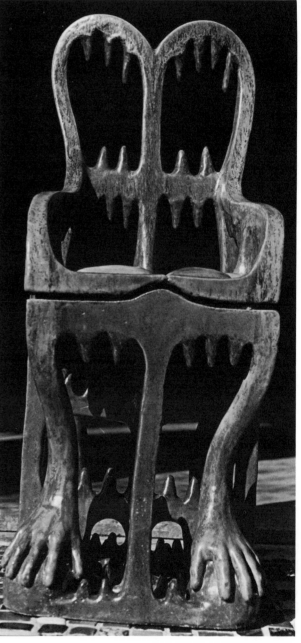

concealing biting comments on society and on our human foibles.

McGinley works in a basement studio in her hillside San Francisco home. Outside her studio, in a grove of redwood and laurel trees, groups of her Breughel-like sculptured figures roister, cavort, burst into song, or peer gloomily through the leaves. Inside, where she works, opera tapes play, a tea kettle heats on the gas fire, and on the walls photos of medieval castles provide inspiration for many of her sculptures. McGinley says: *The main urge in my work is to express a state of mind, a sensation, an emotion which I believe all of us are subject to.*

Visually inspired by the illustrations in old folk-

tale and fairy tale books she read as a child, her work deals with emotions that are often ominous, reflected in titles like *Paranoia, Brooding,* or *Premonition* (2–10). One effect of her miniature sculpted scenes is to make us look more carefully around and within ourselves, fearful that we may discover some danger lurking in the shadows. McGinley says: *I am very much drawn to the theater, especially opera. I try, too, to open my mind to the mysterious and strange sensations one feels in the mountains and dark forests.*

Referring to her medieval and exotic settings

2-9

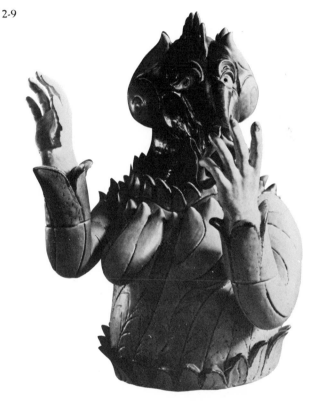

2-8

2-8 Above: Lohan. China. One of a set said to have come from the I-chou caves in Hopei Province. Note the construction of the base where a series of arches supports the flat slab on which the Lohan sits. Stoneware. Height 50″ (1.27 m). Liao dynasty, A.D. 907–1125. *Courtesy of the Trustees of the British Museum, London.* Below: The base of one of Van Os's stoneware sculptures shows the same type of support system. Van Os, all of whose sculptures are built with supports integrated into the composition, was unaware that a Chinese sculptor almost a thousand years ago had devised a similar system. As Van Os says, *Well, the clay dictates the solution.* 1981.

2-9 *Sarah.* 1982. Van Os's creatures are built of stoneware, bisque fired, then glazed and fired again at high temperature. In order to help them take the strain of the kiln, he mixes considerable grog into the clay—20 percent rough and 10 percent fine.

and the half-human, half-animal figures that inhabit them, McGinley says she finds it is best to keep them nonspecific because: *In that way I can avoid the look of a particular person or place. It is easier to say what I want with animal-like figures.* Although many of McGinley's pieces are small, they have a sense of space, bringing into their stage settings echoes of the world outside. Even when McGinley works on a large piece of sculpture, she

generally makes it first in small scale, working out her concept and figuring out how to divide the sculpture into sections to facilitate firing. Recently she chose a mythological subject, *The Norns,* then built a nine-foot sculpture using only the simplest pinch method (2–11). *I chose the three Norns, or Fates, who spin the thread of life and look into the future, because I think that it is an ability we all wish for at times—to see how things will turn out,*

2-10

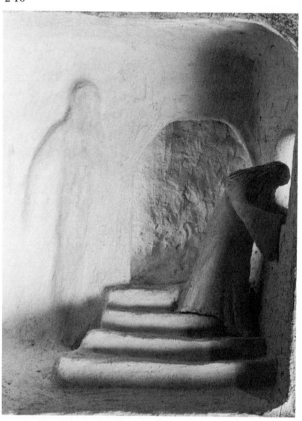

2-11

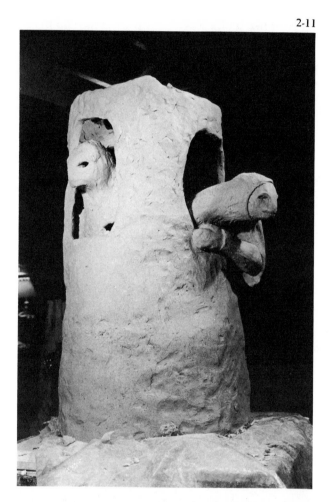

2-10 Louise McGinley, U.S.A., *Premonition.* One of McGinley's miniature stage settings. Here, an apparition appears through a wall as the robed figure gazes out the window unaware of the menace behind it. In this work, McGinley wished to express *that sensation we feel when we know something dire is about to happen but we don't know from which direction it will come.* 1981. 15½ × 15 × 12½″ (40 × 38 × 32 cm). Low-fire sculpture mix; acrylic stain, lights.

2-11 Above, right: Louise McGinley, *The Norns.* 1981. Top section. Right: Building a large piece of sculpture like *The Norns* is really very easy, McGinley says: *I simply start at the bottom and pinch up the walls, then as I go along I thin them. The base of a large piece has to be sturdy, so I build it thicker, scraping the walls down to about one-half inch in thickness.* She added new sections of *The Norns* when the lower clay was hard enough to support them, separating them with plastic and resting each new part on a flange. She built a network of walls inside the top section to support the figures.

to have a worldwide view of what is happening to mankind.

Using only the simplest pinch method, and working with predampened, low-fire sculpture clay directly from the bag without wedging, she slowly built up the craggy tower from which the Norns survey the world (2–11). This premixed clay works well for McGinley, and like her pinch methods, she has no wish to change it, for she says she is more interested in what she has to say than in experimenting with techniques.

Pinched Sculptural Vessels

The same ancient pinch method has also been used for thousands of years to create vessels, many of which incorporated sculptural forms either as decoration or as part of the basic shape of the vessel (2–13, 11–1).

In the 1930s, Cameroon artist Naa Jato built her vessels up with wads and lumps of clay, which she attached to a sculptural base, adding the walls layer by layer. She modeled the lively scenes of village life separately, and attached them, along with the handles and spouts, when the pot was finished. A day or so later, when the clay was at just the right consistency, she burnished the area between the figures with a smooth stone. Sun-dried, then lightly fired to strengthen them enough for transport, these vessels were not for ordinary use; rather they were used by village chiefs for storage of palm wine or oil. Before being put to this use they were fired a second time (2–12).

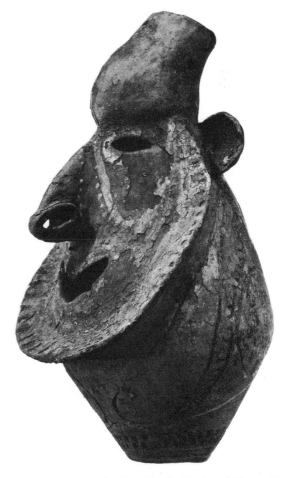

2-12 Palm wine jug by Naa Jato, built of wads and lumps of clay attached to a sculptured base. Fired once lightly for transport, then fired again before use, the artist's vessels were bought by chieftains for storage of wine or oil. Applied figures showed scenes of daily life or local customs. 1936. Terracotta, height 16½″ (42 cm). Cameroon, Northern/Mfunte, Lus group. *The Portland Art Museum, The Paul and Clara Gebauer Collection of Cameroon Art. Photo: Bill Grand.*

2-13 A potter in the East Sepik district of Papua New Guinea modeled this vessel, which shows a pierced nose, laughing mouth, and ears that make fine handles. The colored slip coating is now flaking off, but enough remains to show the red and beige coloring that animated the surface. Earthenware, paint. Height 15½″ (40 cm). *The Metropolitan Museum of Art. The Michael C. Rockefeller Memorial Collection, Gift of Nelson A. Rockefeller, 1969. All rights reserved, The Metropolitan Museum of Art.*

Modeling and Carving

After a sculptor has developed the built-up pinched forms to a certain point, using only the fingers, he or she may want to refine and finish the work with tools. In early cultures, a sculptor's tools were made from wood, bone, stone, sea shells, nutshells, or other natural materials. Then, when metallurgy developed sufficiently, clay workers undoubtedly took advantage of the new material and adapted metal tools to their needs. Clay tools have changed little over the centuries, and the tools used today are not that different from ancient ones. Most sculptors have favorite tools that they have made for themselves from scrap materials or objects they have found and adapted to their particular needs. Carving, easily done when the clay is leather hard, produces clean edges that bring a crispness to the more rounded modeling that is achieved with the hands or a modeling tool. The faces of the Nok figures, with their deeply cut mouths and eyes, the sharp edges of their eyelids, and their incised eyebrows (2–3), show evidence of carving, as do the faces of the terracotta army of the Emperor Qin (2–1).

2-14 Dzintars Mezulis, Canada, builds his small figures solid, cuts them in half at the waist to hollow them, then reassembles them and attaches the limbs with slip. Painting slip on the scored clay, Mezulis prepares to reattach them. *Photo: D. Mezulis.*

Hollowing Out Solid Sculptures

As we saw in Chapter 1, the earliest clay sculptures were modeled solid. This can cause problems in firing, so most sculptors build their work hollow as they form it. Some, however, prefer to build the sculpture of solid clay, then hollow it out when it becomes stiff. This necessitates slicing the piece open, then digging out the excess clay. Once the walls are thinned down, the whole sculpture must be reassembled. To do this, the edges of any areas to be joined are scored, then painted with liquid clay—slip—and firmly pushed together. The clay itself cannot be too dry at this point, or the joint will not hold. Dzintars Mezulis, Canada, uses this method to build most of his small fantasy figures (2–14), although on occasion he builds a figure hollow, using slabs. Margaret Keelan, U.S.A., who also works figuratively, uses a combination of methods. She forms the legs hollow of rolled slabs, then builds up the body, adding sometimes as much as two inches of clay in certain areas. Then, before firing, she cuts the figure into segments and thins all the walls down to one-half inch, then reassembles it. She also often cuts off limbs—whatever she feels does not add to the expressiveness of the composition (8–18).

A Terracotta Army

More sophisticated in technique than the Nok sculptures, the enormous army of terracotta soldiers, archers, horses, and chariots placed near the grave of the Emperor Qin Shihuangdi of China about 210 B.C. show skillful modeling and carving in their individualized features. Working with technical skill and a knowledge of portraiture, the unknown sculptors modeled and carved the eyes, the mouths, and the details of the hair with clean-cut planes, forming sharp shadows that animate the simple, stylized forms of the head, turning them into lifelike representations of the emperor's officers and soldiers—no two of the several thousand found so far are alike (2–1).

These impressive figures of warriors and horses were buried with the Emperor Qin when he died, probably as a substitute for a living army. The horde of soldiers must have required another army of clay workers, hundreds of kilns, and whole forests of trees to fire them. Now they are being restored, and eventually the army will stand again as it once stood, guarding its emperor in death.

Coiling, Past and Present

Another ancient method of building hollow sculpture that is still in use today is coiling. Parts of the army figures were built with coils—rolls of clay coiled around in a cylinder to produce a hollow form. When potters and sculptors work with coils to build up the walls of vessel or figure, they generally smooth the clay together with their fingers or with a scraper so that the wall becomes solid and homogeneous. In this way, the coils are melded so that no cracks will develop along the joints as the clay dries. Often they will paddle the walls as well, tightening the clay by driving the particles closer together and strengthening the walls. Because the clay is finally smoothed and melded, it is often difficult to tell exactly which method—coil or pinch or a combination of both—was used in a particular historical example. Both methods were used in Africa and China, and we know that the haniwa—the clay cylinders that were placed around the graves of royalty in Japan—were built up of long coils of clay.

Haniwa Figures

Archaeology tells us that the lively figures of warriors, musicians, farmers, dancers, horses, and male and female shamans developed from the simple clay cylinders that had earlier ringed the tomb mounds, perhaps to hold back the earth. As time went on, their creators began to add faces, arms, clothing, or armor to the basic cylinders, always respecting their columnar form (2–17, 10–1) but turning them into expressive records of the men and women who lived during the three centuries of this culture. On the other hand, legend tells us that it once was the custom when a member of the royal family died, to line up his or her servants and warriors in a circle around the grave, burying them to their necks and leaving them to die of starvation or thirst. But, the story goes, a compassionate emperor was troubled by the cries of the victims buried at his brother's grave, and remarked that it was a very painful thing to force those one has loved in life to follow one in death. So when his empress

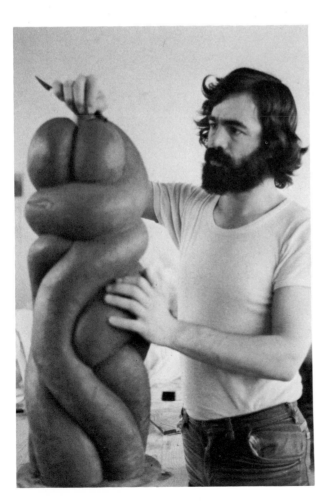

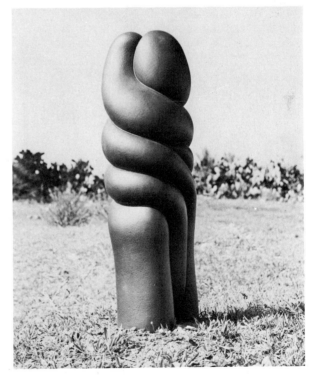

2-15 Left: Eduardo Andaluz, Canary Islands, uses a modification of the ancient coil method, pounding out strips of clay with a mallet. Above: Attaching them to each other, he builds up his organic forms. *Always,* he says, *before building a sculpture, I make numerous drawings and a model which I use for reference.* 1981. Stoneware; black glaze, reduction firing. *Courtesy of the artist.*

2-16 Built with thick, pinched walls, this supplicant figure was probably used as a libation receptacle. Its former owner claimed it was used by his forebears long ago. Collector Paul Gebauer, unable to discover the reasons for the protruberances on the body, suggested they might represent scarification—a popular art form in Cameroon. Height 8″ (20 cm). *The Portland Art Museum. The Paul and Clara Gebauer Collection of Cameroon Art. Photo: Bill Grand.*

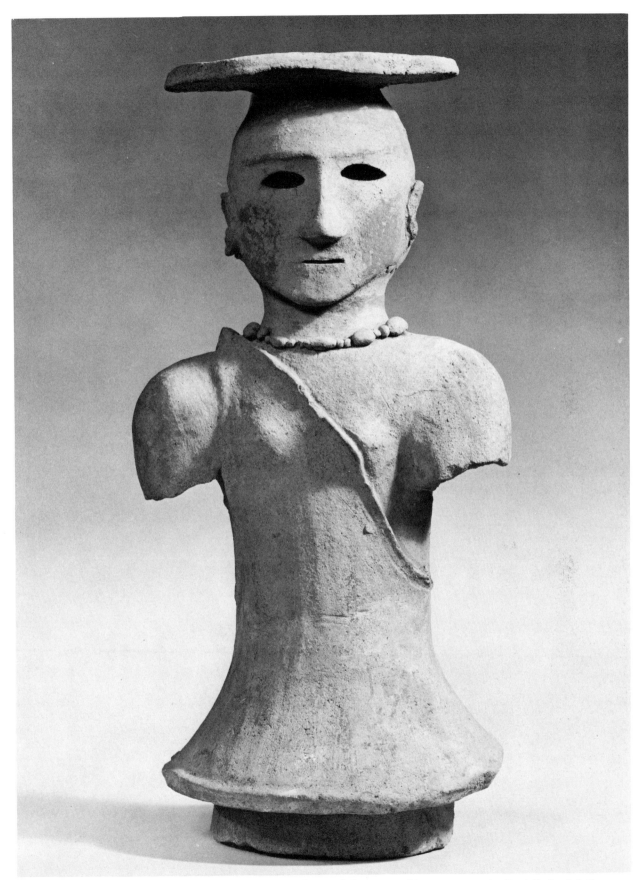

2-17 Haniwa figures like this female shaman were placed around the graves of important people. Partially buried, they may have replaced living victims. Made of long ropes of clay coiled into cylinders, their expressive faces and clothing details were added when the clay had partially stiffened. Old Tomb period, fifth to sixth centuries A.D. *Brooklyn Museum. Gift of Mr. and Mrs. Stanley Marcus.*

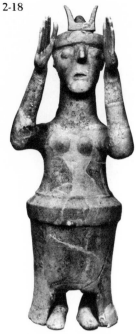

2-18

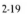

2-19

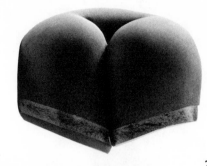

2-20

2-19 Yasuo Hayashi, Japan, *Pose.* The arcs and straight lines of patterns on ancient artifacts fascinate Hayashi, who uses them as inspiration for many of his sculptures. 1972. Red clay, ash glaze. 14½ × 12″ (37 × 30 cm). *Photo: Koyoshi Hamada.*

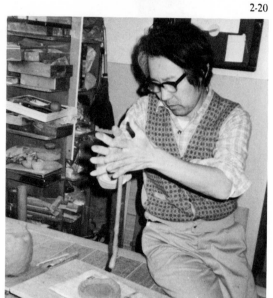

2-18 Cylindrical goddess figures from Crete may represent the nature goddess whose image appeared in Mediterranean cultures in many guises. This particular image was probably built up with coils, 1400–1100 B.C. *The Archeological Museum, Heraklion.*

2-20 Yasuo Hayashi works with a simple, ancient method, rolling a coil to add to the base. Carefully melding the new clay onto the old, he then builds up the walls. 1982. *Courtesy of the artist.*

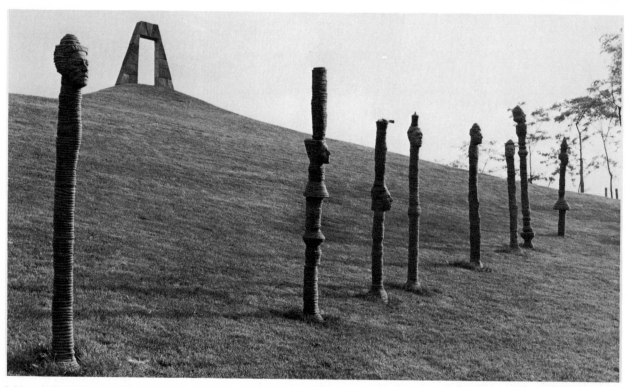

2-21 Sally Michener, Canada. An installation consisting of 60 coil-built columns and two arches. The columns range from 5′ to 6′ 8″ (1.5 to 2.0 m), each with a portrait face. Terracotta. 1981. Granville Island installation, British Columbia. *Courtesy of the artist. Photo: D. Radmore.*

died, he sent for one hundred men of the clay workers guild to form clay into images that henceforth would be placed at the tombs instead of the living. There is no direct evidence that the early Japanese practiced burial of retainers and servants, but this story, and others about a clay horse that came alive, seem to indicate a tradition of living burials at the graves. At any rate, these haniwa figures are sculpted with great vitality—they almost appear to be rejoicing at saving their human counterparts from a horrible death.

Intrigued by the ancient clay traditions of his native Japan, Yasuo Hayashi, a contemporary potter-sculptor, learned to work with clay from his potter father in Kyoto and uses the same coil method his predecessors used so long ago (2–19). He says of clay: *Clay and human beings have been in relation to each other since old times. I'm charmed with the characteristics of clay because of the variety of natural, pleasing ideas that are born from the fusion of clay, fire, and man.*

Along with using the ancient coil technique, Hayashi has also been studying the *chokkomon*—a type of interlaced pattern that was used as decoration on the surface of the stone graves and on the bronze mirrors of the Old Tomb period. He sees these linear patterns as having similarities to Cubism, and he has been turning to their two-dimensional geometric and organic patterns as an inspiration for the three-dimensional forms of his sculpture.

When a figure must be built up slowly, or when a particular piece of sculpture calls for large, simple, cylindrical forms, sculptors today still frequently use modifications of the coil technique. Ernst Häusermann in Switzerland, for example, who creates both sculpture and vessels using a variety of building methods—wheel, coil, and pinch—recently used a variation of the coil technique to build a monument for a cemetery (2–27).

ERNST HÄUSERMANN, Switzerland

Sculptor, musician, potter, and teacher, Häusermann works in a small, low-ceilinged studio attached to the old farmhouse he shares with his wife, his children, two dogs, and a cat. While some of his nature-inspired clay sculptures are only inches long, his one-of-a-kind vessels may be three feet high, and some of the factory-fabricated metal commissions that he designs reach thirty feet in height. Because his studio is small, when he has a large clay piece to build he works outside in a roofed-over area next to the house.

When he won a competition to create a monument for a crematorium, after much thought and many discarded ideas, he decided on clay formed into a rounded arch with an organic bronze form in the center, because, he says: *I think the arch is an*

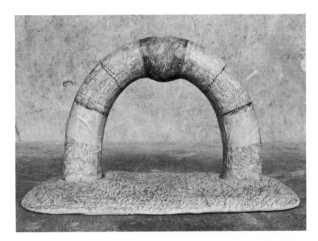

2-22 Left: Ernst Häusermann's sketches for a coil-built monument for a crematorium in Switzerland show its dimensions, the materials to be used, and the proposed grading of the site. Above: The small clay model helps the clients visualize the final sculpture and the sculptor to work out the form of the central bronze form. 1981.

archaic form with a biological aspect that links it to what is common to all humans. The arch represents the continuity of life. It grows up from the earth, and if you wish to think of it that way, you can imagine the arch completing a circle under the ground.

Häusermann says he sees one side of the arch springing from the ground as youth, while the area at the top represents middle age—the age of responsibility for both children and for older family members. This is symbolized by the bronze form that holds the arch together, while the other side of the arch represents old age. Häusermann also picked the arch form for another reason: *Since this is for a community crematorium, I didn't want to use the symbol of any one religion, but the arch is a universal symbol to me, and this one is based on human dimensions.*

The site in the crematorium garden where the monument is placed is a grassy area where those who do not want to have individual graves may be buried. The clay arch rises up from the earth, and within its span the ground is graded into a softly swelling form.

Drawing and Sculpture

Drawing is an important skill for any artist, whether working in clay or in any other medium. Not only does a sculptor use drawing to train hand and eye, or to gather sketches as source material for later work, but it is also a convenient way to work out some of the technical problems before tackling the clay. The finished drawings and models can also serve for presentation to clients, and once the concept and the technical scheme are decided on, it may be necessary to make a full-sized cartoon as a guide while working on the sculpture (2–25).

Models of Projected Work

Before tackling the construction, and in order to work out his ideas, Ernst Häusermann did many drawings and built a small clay model of his proposed monument (2–22), using both to present his ideas to the competition jury. Since it was an invitational competition and his work was already known, his drawings could be freer than they would need to be for a more formal contest.

A sculptor's small clay model may be a free sketch, like Bernini's angel (8–13), or it may be a

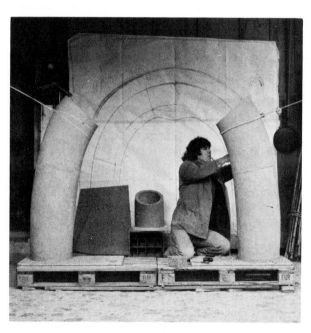

2-23 Using heavily-grogged stoneware, Häusermann built the coil-formed arch up from both sides, adding new strips of damp clay as the lower part became stiff enough to support the weight. Melding each strip with his fingers, he then smoothed the joints. Building each section taller than necessary, he cut it to the exact size to get sharp edges at the joints and to control the curve of the arch. As he built it, he checked it with wooden templates as well as by eye against the full-scale drawing behind it.

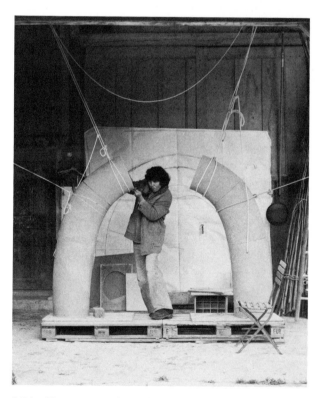

2-24 Häusermann devised a system of ropes to hold the damp pieces in place so that he could fit on the next one. After checking that all joints were correct, he disassembled the piece for glazing and firing.

miniature version of the final sculpture, complete down to every detail. Häusermann had to calculate the clay forms for the arch very carefully because the fitting of the bronze section at the key point of the arch was critical. For this, a model was a help, and the full-sized cartoon was a necessity.

To insure their proper fit, Häusermann had to work out how best to build the clay sections, where to cut them, how to attach them after firing, how to reinforce the arch. He also had to plan how to protect the surface against alternate freezing and thawing, and the best way to attach the whole piece to the concrete footings.

Since neither the stoneware forms nor the bronze keystone could be changed once completed, and since the bronze was to be cast separately in a foundry, Häusermann had to make allowances for the clay shrinking in the drying and firing, and hope that everything would fit.

Building the Cylinder

Beginning with a simple cylinder, Häusermann began to build up the clay with strips, using a variation of the ancient coil method. He used a wooden template to be sure that he kept the cylinder the same size all the way up. *The cylinder is slightly oval, and although I also used other templates to keep the curve of the arch right as I built it up, I still had to use my eye.*

When all the parts were built, dried very carefully, and checked for fit (2–25), Häusermann fired them section by section in his electric kiln. Only then could he reassemble the piece to work out the exact size of the bronze. He first formed this key piece out of wire and plaster, allowing for a slight change of size, then turned it over to the foundry for casting.

Finally, Häusermann had to oversee the assembling of the sculpture at the site, where it was rein-

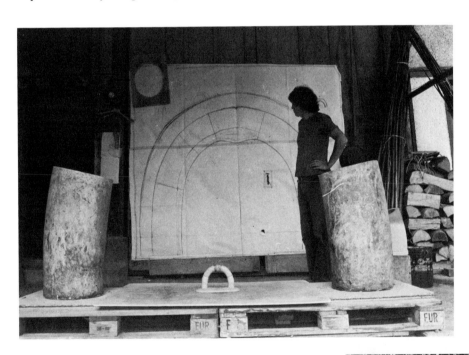

2-25 Two fired sections of the arch checked against the original drawing. Häusermann applied a thin ash glaze to the stoneware, then wiped the excess off. The glaze will protect the sculpture from water that might enter its pores and cause damage through alternate freezing and thawing. 1981-82. *Photos: Courtesy of the artist.*

2-26 When it came to installation, Häusermann said, *I wasn't sure till the end if it was really possible. When we tried it first, it fitted perfectly together, but when it was filled with concrete, everything seemed to go wrong (and we had chosen a concrete that hardens quickly).* The arch, with its bronze central section, is supported until the cement sets. Häusermann said he and his helpers *banged like mad at the forms with large pieces of wood, prepared to see the whole thing break, or that there would be a gap between two pieces. It was like a miracle when we made it fit at last.* 1982.

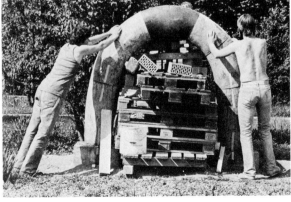

forced with rods and concrete and placed on the concrete footings (2–26).

Häusermann suggested that trees be planted behind the arch so that they will be seen through it, heightening the symbol's relationship with the living forms that spring from the earth (2–27).

Most of Häusermann's work, whether vessel or sculpture, has a strong relationship to nature, to animal, human, or plant forms. He uses stoneware and porcelain, often gathering local clay and gravel in the woods near his house and paddling it into the surfaces. When he uses glazes on his sculpture, they are usually ash glazes, made with the ashes from the large tiled stove that keeps his home warm in winter. Like many clay sculptors who also have worked as potters, Häusermann rarely makes domestic ware now, but still enjoys creating one-of-a-kind vessels that may range in size from three inches to three feet. Sometimes he uses the wheel, and at other times he builds by hand.

Wheel-Formed Sculpture

Starting out as a flat stone rotated on top of another stone, the potter's wheel was first a turntable rotated by hand to aid in forming hand-built pottery. Eventually it became the mechanism of today whose rotation speed helps the walls rise as the potter's hands press the clay.

The potter's wheel has had a place in the development of contemporary clay sculpture. In the 1950s when artists like Peter Voulkos (3–1) came to sculpture from pottery, much of that first burst of new ceramic sculpture was based on pottery forms that were altered, slashed, deformed, crushed, and otherwise changed radically. At the same time, the expertise developed through pottery production and firing could be applied to many aspects of sculpture.

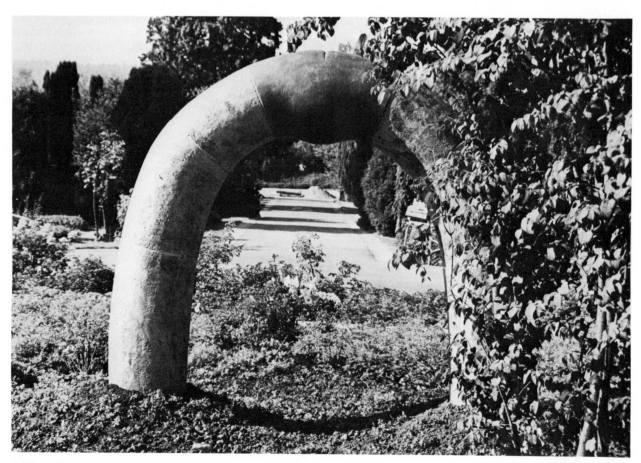

2-27 After months of work and uncertainty, the arch is finally in place in the crematorium garden. Häusermann would have preferred grass under the sculpture, but the clients decided on ground cover. 1981–82. Height 10′ (3.0 m). *Courtesy of the artist.*

The Fire

Once a sculpture is formed through pinching, coiling, or any other method, it is generally fired in order to harden the clay and make it permanent. Although we don't know when humans first used fire to harden clay, we do know that this knowledge, in one part of the world at least, goes back to the Ice Age (1–14). Myths and legends from around the world tell of how humans first used fire both for working metal and firing clay, and usually these new technologies were believed to have been the gifts of gods or goddesses. The Egyptians depicted the god Khum as a potter, the Greeks credited the goddess Athena with inventing pottery, while a Chinese legend tells how a potter was so distressed at the failure of a firing that he jumped into the fire and was transformed into the god of the kiln. To this day, artists and craftspeople often set an image of a god or goddess on the top of their kilns, and speak of the fire in almost mystical terms. Indeed, the action of the fire on clay does seem mysterious and awesome, and it is an area of a sculptor's work over which he does not have complete control. Although, after a time, the sculptor will get to know his or her kiln, to know where its hot spots are, to know its quirks and to make allowances for them, it is always a tense moment when the kiln doors are opened and the artist anxiously examines the work, hoping it has survived the fire.

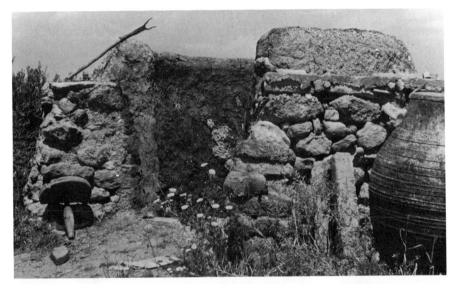

2-28 A modern-day descendant of the Mediterranean type of kiln in which Greek and Etruscan sculptures would have been fired. This contemporary kiln on the island of Crete is basically the same as the ancient kilns, although now sheet metal is used to cover the stacked ware instead of pottery shards. The heat rises up into the kiln from the firebox, through perforations in its floor. 1979.

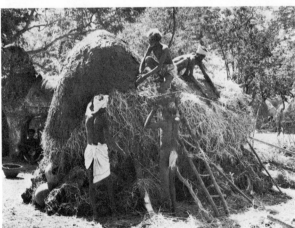

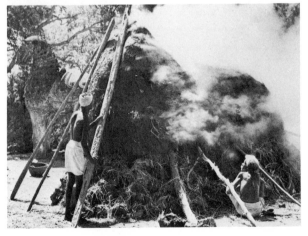

2-29 Left: To fire a massive votive horse in India, the potters built up a wall of damp earth around it, setting cracked, discarded vessels into the walls of the temporary kiln. They laid a layer of straw, then one of dung, inside the firing chamber, then packed wood and dung around the horse. Right: Finally, they covered it with rice straw and plastered it with a layer of slurry to seal it. After lighting the kiln from the bottom, they waited for the fire to do its work. *Photos: Ron duBois.*

Kilns

The type of kiln used for firing can vary from the simple updraft kilns still in use throughout the Mediterranean (2-28), to those used by potters in India, who simply pile the fuel around a massive horse figure (2–29), from the most sophisticated kiln in a production workshop to an outdoor raku kiln (2–34). The technology of firing and the different types of kilns and their design are all well covered in numerous books and magazines, some of which are listed under Further Reading.

Bisque Firing

In general, but by no means always, the procedure of firing a piece of sculpture consists of two firings. It starts with the first firing, when the kiln is brought up slowly to a temperature of around 890° C to 1030° C. This is the bisque firing. When this has been completed, the clay object will be hard enough to handle without damage, and all the molecular water will have been driven from the clay. As we have seen, clay bodies mature at different temperatures—low for iron-rich earthenware, considerably higher for stoneware, and the highest for porcelains. Most low-firing clays mature at around 950° C to 1100° C, so for clays in the low-firing ranges, frequently only a single firing is used to bring it to maturity. Stoneware and porcelain can also be fired in a single firing, and often sculptors who use color integrated into the clay body or applied as oxides will use this method. In addition,

many sculptors today who paint the bisque-fired clay with acrylics or other paints will skip the second firing.

Glaze Firing

However, if the sculptor chooses to use glazes, usually these are applied to the bisqued object. If that is the case, the work will have to be fired again to mature the glaze, and even after a glaze firing, additional surface treatments in the form of overglazes and lusters can be applied and refired. There is nothing to keep an artist from refiring several times—each time at a lower temperature.

One obvious question is how the sculptor knows when a work is properly fired and when to let the kiln cool down. There are those who have been firing for so long and who know their kilns so well that they can judge when the clay or glaze has reached maturity simply by looking through a peephole to see the color of the interior of the kiln—red, orange, or pale yellow. However, in gas kilns pyrometric cones may be used, or pyrometers that tell the temperature, while electric kilns usually have an attachment that can be set with a pyrometric cone that will trip a switch when it melts and turn off the current.

Pyrometric Cones

Throughout the book you will see references to work being fired to cone 05, cone 9, or other numbers. This means that the kiln has been heated the length of time and to the heat necessary to melt a cone of a particular number. These small cones of

2-30 Antoine de Vinck, Belgium, has two kilns in his studio. He uses the electric kiln on the left for bisque firings as well as for glaze firings. The wood kiln on the right he reserves for glaze and salt firings. 1981.

heat-resistant clay can be used in any type of kiln as an accurate guide to the effect of the fire on the objects in the kiln. Since both heat and time affect the melting point of the cones, they are better indications of the maturity of the clay or glaze than a temperature guide alone. Made of clay bodies that are formulated to fuse and bend over at certain points in the firing, the cones are placed in the kiln so that they can be watched through a peephole. Generally they are placed in a series of three; when the first cone bends, it warns the sculptor that the clay is nearing maturity. The middle cone bends as the clay matures, and if the third one slumps, the clay is past maturity. A low-fire sculpture clay might mature at cone 04, while a stoneware clay may require firing to cone 10.

Firing an unglazed sculpture to a high enough temperature to make it reasonably strong is not as complicated as glaze firing, but any sculpture firing is always a bit uncertain. Cracks, warpage, or even explosions can occur in the kiln. Furthermore, since the color of the clay or glaze depends upon the kiln atmosphere, that adds another variable to the process. A kiln, depending on the amount of oxygen circulating in it, will burn in either an oxidation or a reduction atmosphere.

Oxidation and Reduction

In an oxidation atmosphere, plenty of oxygen remains in the kiln feeding the fire so that it burns cleanly. In a reduction atmosphere, there is not enough oxygen for the fuel to burn properly, and both smoke and carbon monoxide will be present. When this happens, the carbons in the kiln atmosphere act on the oxides in the clay, changing their chemical makeup and—depending on the oxides— changing their color. The subtle colors that can be produced by reduction appeal to some artists, who deliberately induce reduction in order to obtain them.

Reduction can be accomplished in a gas kiln by closing the dampers, and in a wood firing, while there is generally some reduction going on at all times, a greater reduction can be induced by dampering. To produce reduction in an electric kiln, however, the sculpture must either be fired inside some form of container along with a reducing material like straw or wood chips, or if that is not possible, the reducing material must be introduced into the kiln itself. This is hard on the electric heating elements, but in places where wood or gas kilns are forbidden or impractical, it may be worth it to the artist.

Depending on the clay body used, a wide range of glaze effects is available to the sculptor through the use of either low-fire or high-fire glazes, and the choice of either oxidation or reduction firings. In addition, overglazes, china paints, and luster of various sorts offer almost unlimited possibilities of surface effects (see Chapter 6).

2-31 Petra Weiss, Switzerland, fires her large murals in sections. She estimated that it took about ten bisque firings and twenty glaze firings to fire a recent large mural commission. 1980. *Courtesy of the artist.*

Fuels

Traditionally, fuels like grass, wood, straw, peat, dung—anything that would burn—were used to fire sculpture, either in open fires or in simple kilns (2–29). Since the industrial revolution, Western potters and sculptors have generally fired first with coal, then with gas, oil, and electricity, and these are still the most popular fuels in industrialized countries. Now, however, with the costs of gas and electricity soaring and with the increasing interest in early clay techniques, many sculptors have returned to wood firing. Others are experimenting with alternative fuels—used car oil or solar heat, for example—while space age materials are used to insulate kilns in order to conserve heat.

Firing Large Sculpture

In order to fire a large piece of sculpture, the sculptor may be lucky enough to have a big kiln like the one in which Weylande Gregory fired his *Mother and Child* in one piece (8–4), may build up a kiln around a sculpture (2–32), or may lower a sectional kiln around it (2–33). On the other hand, firing a large sculpture can also be accomplished by building the work in sections, or by cutting it into pieces before the clay hardens (7–16). Loading a large sculpture into the kiln can be a lengthy, tricky, and tiring procedure unless one has a demountable kiln, a sectional kiln, or access to a kiln with runways to slide the piece in. A hoist can help move the sculpture near to the kiln, but many artists feel that the best way to do the last careful fitting into the kiln is to use muscle power.

Whatever type of kiln is available, whatever the size of the piece, whatever final effect is desired, every sculptor has to work out his or her own method of loading and firing the kiln, and by experience learn how to control the process of firing.

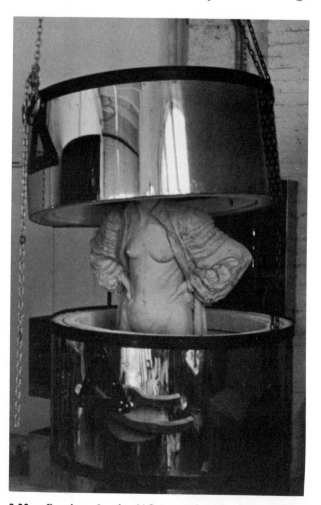

2-32 Jerry Caplan, U.S.A., executes his large sculpture in place, then builds the bricks of the kiln up around it. Pipes and gas ports are already in place. *Courtesy of the artist.*

2-33 Penelope Jencks, U.S.A., used to fire her standing figures in sections, but with her sectional kiln, she can now build the piece on the kiln base, then lower the electric kiln around it. *Courtesy of the artist.*

Most sculptors have somewhat ambivalent feelings about the fire, and there are those who have decided not to fire their large work at all (11–5), while more than one has expressed the opinion that if someone invented a chemical to mix in the clay that would make unfired clay truly permanent, he'd gladly dispense with the fire entirely.

2-34

2-35

2-34 Left: John Balossi, Puerto Rico, gives his sculpture a post-firing smoking to produce surface patterning. He plunges the hot piece into a can of excelsior, which bursts into flame and smokes the sculpture. *Courtesy of the artist. Photo: El Nuevo Dia.*

2-35 Keljko Kujundzic, U.S.A., has experimented with several designs of solar kilns. Kujundzic says, *The fact must be recognized that the high intensity of the temperature, which can be so easily achieved with solar, is not enough, since the amount of this energy is limited. Therefore, the sensible thing to do is to concentrate this small volume of heat generated on firing one's ware and not dispersing it on heating the kiln.* In one version of the kiln, the lens was filled with wine as refraction fluid, and with it the kiln has reached 1425°C (2600°F) in under eight minutes. *Courtesy of the artist.*

3

Building with Slabs and Extruder

*I felt freed by working in clay. I responded particularly to its malleability and the way it invites the use of hands. I sliced, folded, tore, rolled, curled, pounded, broke and shattered it.** —*William Noland, U.S.A.*

The technique of building sculpture with slabs offers the artist a choice of geometric or organic forms as well as innumerable surface treatments to suit his or her individual style of working.

Slabs became especially popular when clay sculpture was influenced by twentieth-century art movements like Cubism and Constructivism that broke images into planes, abstracted them, and assembled them by building rather than by modeling, casting, or carving. Slab construction also seemed particularly well adapted to the geometric sculpture which reflected the urban environment of the twentieth century. However, despite their obvious adaptability to hard-edge or nonobjective sculpture, slabs have a much wider range than that. As well as being used effectively to create smooth, tightly controlled constructions (3–18), they can also be successful in work that calls for organic

forms, for jagged edges, or for textured or mutilated surfaces that carry the mark of the sculptor's hand or tool (3–1, 3–10).

The use of slablike forms made of clay is not, of course, new. For centuries slabs have been used to make tiles as well as to form the press-molded reliefs that were incorporated into the architecture of temples, palaces, and homes. But it is only comparatively recently that slabs have been used with greater freedom.

In the 1950s and 1960s a group of young American ceramists, among them Peter Voulkos and John Mason, responded to new energies in the art world, moving from throwing functional pots on the wheel to building nonfunctional clay constructions, often combining wheel-thrown forms with slabs. Imposing in size, rich with dribbled and splashed color, their forms smashed and ruptured, these sculptural experiments in clay introduced new concepts to the ceramic process.(See also Chapter 6.)

* As quoted in *New Works in Clay III* (Everson Museum of Art, Syracuse, N.Y.), 1981.

Making Slabs

Slabs can be made by a variety of techniques that include pressing and pounding the clay by hand (3–7), rolling out the clay by hand (3–8), cutting a slab off a chunk of clay with a wire, slapping it on a flat surface, pouring slip onto a plaster bat, or putting the clay through a slab-rolling machine (3–9).

For slabs that are to be pressed or rolled out by hand, it is best if the clay is wedged before the slabs are formed, in order to avoid the bubbles of air that may become trapped in the clay and explode in the kiln, causing damage to the sculpture. Unless a pitted surface is desired, any small bubbles that appear on the surface should be pricked and rolled smooth. Slabs can be textured at this point by rolling the clay over or under cloth, crumpled paper, or plastic (3–9); onto natural objects that will burn out in the kiln; or onto colored clays or oxides that will meld and fire into the surface (6–14, 6–20). If a ridged surface is desired, the clay can be pressed or poured over textured plaster forms, and slabs can also be given three-dimensional form by being draped or pressed over or into a mold. (See Chapter 5.)

Slabs can be made in any type of clay, and, obviously, the type of clay chosen depends upon the work to be created. John Mason would hardly have chosen delicate porcelain to build his rugged *Cross Form* (3–10) any more than Joanne Burstein would have chosen heavily grogged stoneware to construct her delicate *Waterfall Vessels* (3–24).

Joanne Burstein, U.S.A., arrived at the light envelope form she uses for her sculptural vessels after many experiments with thrown forms and sheet-like slabs. *This form,* she says, *allowed me to ma-*

nipulate thin sheets of porcelain, yet, because their only support was along the two seams, it gave them flexibility at each stage. . . . Since they have to be constructed on the horizontal plane, there is a shift that occurs when the piece is set vertical at the wet leather stage.

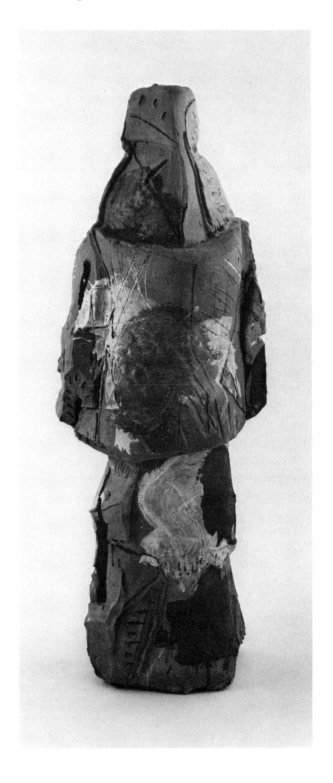

3-1 Peter Voulkos, U.S.A., *Red River.* In the 1950s and 1960s Peter Voulkos began to assemble thrown and slab forms. Impressed with Picasso's use of color on three-dimensional clay, and influenced by Abstract Expressionist painting, he brushed and splashed color onto his constructions. c. 1960. Glazed stoneware, 37 × 12½ × 14½" (94 × 32 × 37 cm). *Photo: The Whitney Museum of American Art, New York City. Gift of the Howard and Jean Lipman Foundation, Inc. Photo: Jerry L. Thompson.*

Joining Slabs

Slabs can be joined when the clay is still plastic enough to work, leaving the mark of fingers and tools at the joint, and unless the artist's concept calls for clean sharp edges, he or she will take advantage of the spontaneity of joining at this stage to bring a freshness to the sculpture (3–10). For example, Stephen De Staebler (7–16) joins his slabs when the clay is at this point, in order to take advantage of the events which occur in the clay—in the forms and on the surface. He makes his slabs by pounding them out with his hands, arms, or whole body, joining them to create tall figures, massive thrones, or large architectural works. Usually working with thick slabs, about 2 to 3½ inches, he does not care for slab rollers, feeling that a mechanical method does not permit the idiosyncrasies and uniqueness of clay to develop. In order to keep the spirit he is searching for in his work, he says: *I just wedge out as big a hunk as is comfortable and then I flatten it out. If I want a bigger slab, I get another piece of clay, wedge it out and then knit them together. Working like this you can make them as big as you want.*

Describing an experience he had in his early days of working with clay, De Staebler tells how he had a slab ready to put on a large piece of sculpture, with a strong mental image of just how the slab was going to wrap around the column. But when he put it on and stepped back to view it, at first he felt it was all wrong. *It didn't do what I wanted to do. But almost instantly I looked at it with fresh eyes, and I saw it was more beautiful than anything I ever could have dreamed of. That was when I finally discovered this reverence for the clay. . . . Fortunately I had the eye to see it. It was a great revelation to me. . . . I realized that it was there not by my asking for it but because it happened.* (See also Chapter 7.)

However, forms and textures like De Staebler's or John Mason's may not suit an artist's concept, and if instead of folding, cracking, or undulating clay surfaces a clean edge and controlled form is desired, the clay can be left to dry until leather hard, then cut into slabs that will stand upright without slumping and that can be joined together with a "gluing" technique. The usual method for joining leather-hard slabs is to attach them with slip made from the same type of clay as that used in the slabs (3–12). The two pieces to be joined will stick together if both of the slabs are scored with a sharp tool along the edges, painted with slip, and pressed together. To meld them together even more firmly, it may help to slide them back and forth slightly while aligning them. Some sculptors paint the scored areas with vinegar; others do not use slip at all, but merely wet the scored sides before sticking them together; while yet others always add a reinforcement by pressing a roll or strip of clay into the joint on the inside of the piece. If the slabs are not adequately joined, if the edges of the slabs are too dry when the joint is made, or if the piece is dried too quickly after joining, cracking or breakage may occur along the joint. But if it is handled properly, such a joint may be just as strong as any other part of the sculpture.

MARY FRANK, U.S.A.

*There is a fine line between giving in to the medium so that clay is nothing but clay and letting the medium have its own life. I want to articulate sculptural form, but art that denies nature seems very arrogant to me.**
　　　　　　　　　　　　　—Mary Frank, U.S.A.

Using slabs to create her figurative sculpture, Mary Frank has developed a highly individual way of working with them that is well adapted to her creative needs (3–2, Colorplate 10). A sculptor who has worked three-dimensionally with wax, wood, and plaster as well as clay, Frank is also known for her two-dimensional work—her prints, collages, and drawings. Her images and techniques in one medium are often echoed in the other. For example, she sometimes handles her clay slabs almost like paper, folding them to make them stand up, or spreading them out like pages of a sketch book on which she draws with a sharp tool. She sometimes also stamps or stencils them in a printing technique. Speaking of this, Frank says: *I often feel as if I'm doing sculpture when I'm drawing or making prints. It feels three-dimensional even though it's flat.**

The fluidity with which Frank uses slabs of damp clay gives her figures their characteristic sense of movement—a quality they maintain even

* All quotations by Mary Frank are taken from Hayden Herrera, *Mary Frank, Sculpture/Drawings/Prints,* Neuberger Museum (State University of New York, Purchase, N.Y.), 1978.

when reclining (3–2). Frank constructs her figures in sections, molding the slabs over realistic clay forms, joining the slabs in some areas, leaving them unjoined in others. The torn edges, the fluting that reflects the draping of the slabs, the cracked surfaces, and the finger marks at the joints all give her work a freshness and spontaneity that is achieved only through long experience with the medium. Her figures both open themselves to the surrounding space and enclose space, while the slab walls that she uses to support them act both structurally and as part of the formal composition.

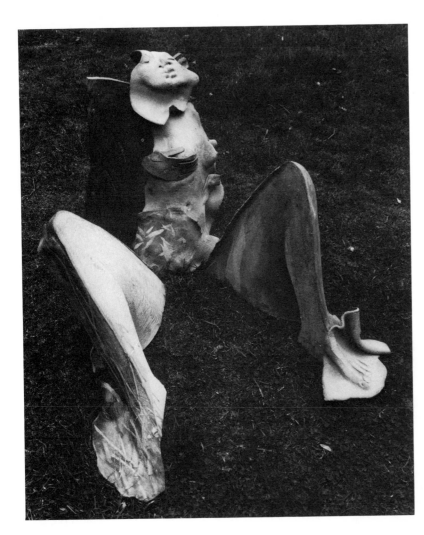

3-2 Mary Frank, U.S.A., *Lover.* Mary Frank enriched the surface of this image with imprints of leaves and grasses by pressing the natural material into the clay, then coloring around it with oxides. Strongly nature-oriented, Frank's sculpture expresses a sense of oneness with the earth and growing things. *Once I lay on the grass in the fall when all the leaves were dropping. I remember feeling that this would be as good a time to die as any. . . . It was a kind of acceptance, a peace, a feeling of being part of nature.* 1977. Sectional figure in five parts, 23 × 44 × 25″ (58 × 112 × 64 cm). *Courtesy of the Zabriskie Gallery, New York City. Photo: J. Ferrari.*

WILLIAM WYMAN, U.S.A. (1922–1980)

Wyman began to work with slabs in the early 1960s, first creating large vessels that he constructed from sheets of clay he rolled out on the floor. He waited for the slabs to become leather hard, then joined them with precision. Next he formed the slabs into temples, building them into rectangular and pyramidal constructions (3–3), piercing them with tall doorways and tiny windows. As he built his sculptures, he found that they gave him an opportunity to work on a large, rectangular area, using slips, glazes, and wax-resist and sgraffito techniques to enrich the surface. He also drew, painted, and wrote on their flat sides.

Although actually quite small, the buildings appear monumental in scale. Commenting on his sculpture, Wyman said: *If one becomes absorbed in passing through the tiny openings, entering the pieces and exploring the dark interiors, one can be*

3-3 William Wyman, U.S.A. (d. 1980), *Temple No. 30.* Wyman explored the theme of pyramids in a series of temples whose openings defy entrance yet draw one's eye to the interior. Constructed of slabs, the temples reflect Wyman's interest in formal relationships as well as in meditation. 1979. 16½ × 19 × 5¾″ (42 × 48 × 15 cm). *Courtesy of Impressions Gallery, Boston.*

3-4 Tony Hepburn, U.S.A., *Dome.* Hepburn used textured slabs to form the walls of a hut, reflecting his interest in prehistory and early structures. The glass panel allows us to peer into the interior, but like the passing of time, it separates us physically and psychologically from the life that may have been lived inside. Height 26″, diameter 24″ (66 × 61 cm). *Collection Yorkshire Sculpture Park, England. Photo: Maurice Elstub.*

3-5 A towering slab construction by Dennis Gallagher preserves the spontaneous texture imparted to the clay from whatever surface Gallagher chooses on which to pound out his slabs by hand. The edges are sometimes torn, while the joints retain the artist's fingerprints. 1981. White clay, height approximately 7′ (2.1 m). *Courtesy of the Quay Gallery, San Francisco. Photo: Roger Gass.*

3-6 William Noland, U.S.A., *C.L. 3.* Noland normally works in metal, but after building slab constructions in clay, he said, *It was so natural to play with clay that I returned to my work in steel and was determined to find ways to translate that sense of playing with the material into my other sculpture.* (As quoted in *New Works in Clay III,* Everson Museum of Art, 1981.) 1979. Stoneware, unglazed; 13 × 33 × 20″ (33 × 84 × 51 cm). *Courtesy of the artist.*

*caught up in a limitless trip in time and space, a sort of confrontation, if you will, with infinity.**

A master technician, Wyman saw his precise craftsmanship as incidental to his expression. Of

*All quotations by William Wyman are from Wyman's notes on his work, as quoted in an article by Marilyn Pappas in *American Craft*, March 1980.

the temples he said: *The sculptures are not about clay work, crafts, techniques, function or decoration. I also made some "temples" in wood and they are different, as they should be, in that the form changes slightly but the idea is the same. I am interested in the process as a means to manifest ideas and form.*

3-8 Ruenell Temps, U.S.A., uses a mechanical roller, but then rerolls her slabs by hand to firm the clay and prick out any bubbles. With this technique, she says she can bend and form the slabs before they become leather hard.

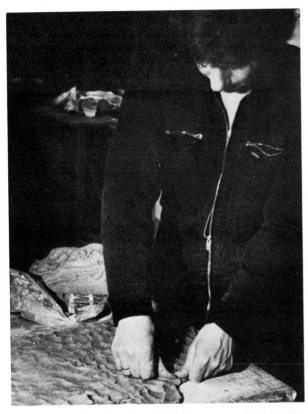

3-7 Helly Oestreicher, Netherlands. Above: She forms a slab by simply pressing clay on a bat with her thumbs, pounding the clay to meld it. Below: Cutting a layer off the surface with a wire, she rolls off a layer to uncover a textured slab. Later she applies oxides to emphasize the surface. Since both her studio and kiln are small, Oestreicher constructs her wall reliefs and her large freestanding sculptures from these small slab components. 1981.

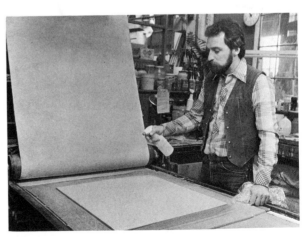

3-9 John La Francesca, U.S.A., uses a slab roller, placing denim fabric under the clay to give it a slight texture. After rolling the slab he sprays it with water, covers it with plastic, and leaves it overnight so that the clay can settle into its new configuration. 1981. *Courtesy of the artist.*

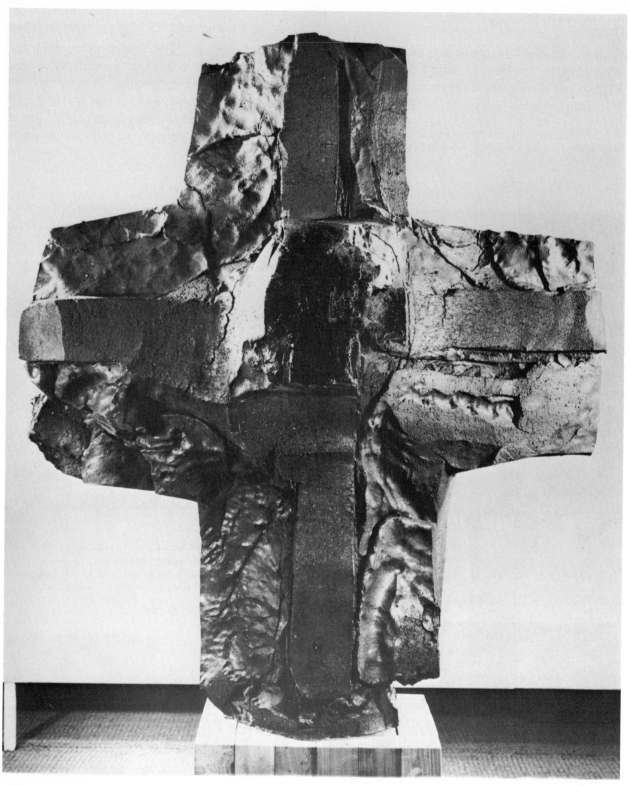

3-10 John Mason, U.S.A., *Cross Form.* Mason was also one of the group of clay artists in California in the 1950s and 1960s who extended the physical possibilities of the medium, always pushing it further. His large constructions were built with extremely thick slabs that required long drying and slow firing. 1963. Glazed stoneware, height 7½' (2.3 m). *Courtesy of the Art Institute of Chicago. Gift of the Ford Foundation.*

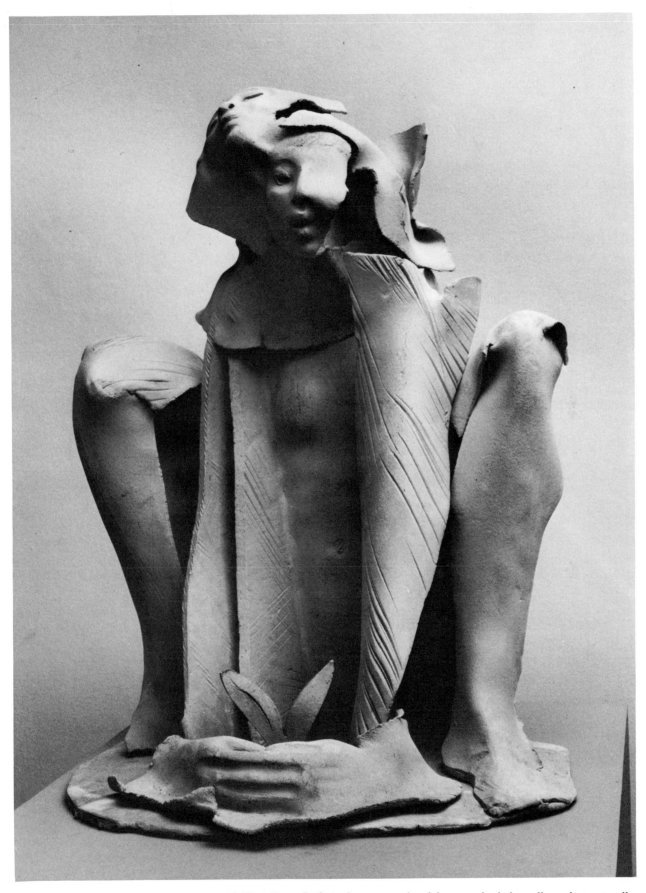

3-11 Mary Frank, *Crouching Woman with Two Faces.* Built in four parts, the slabs serve both formally and structurally. 1981. 29 × 24 × 16″ (74 × 61 × 41 cm). Collection Ekstreet. *Courtesy of the Zabriskie Gallery, New York City.*

3-12 Jens Morrison, U.S.A., usually forms slabs with a rolling pin. *I try not to use a lot of expensive machinery.... Most of the places I have been in the world I am always delighted and amazed at the beautiful things made by people who have basic, traditional tools.* Working on one of his *Tea Temples*, he attaches the wall to the base, painting slip on the scored edges. 1982. *Photo: Fritzi Huber Morrison.* (See also 6-16 through 6-19.)

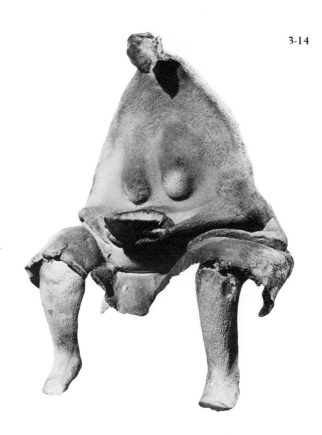

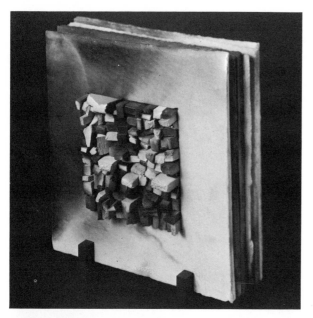

3-13 Dale Zheutlin, U.S.A., *Kita/North #2, Fort Point Window Series.* Inspired by an abandoned fort near the Golden Gate, Zheutlin assembled slabs into a series of small constructions suggesting crumbling walls and boarded-up windows. The color comes from sawdust firing. 1981. 8 × 8 × 2½″ (20 × 20 × 6 cm). *Courtesy of the artist and The Elements Gallery, New York City. Photo: Stephan Merken.*

3-14 Lorraine de Castro, *Doña Dita.* De Castro's slab-formed ladies seem to speak of fatigue and resignation, an effect heightened by her forming methods, which take advantage of clay's natural propensity to slump. 1980. Sculpture mix; iron, cobalt, and copper oxides. Height 34″ (86 cm). *Courtesy of the artist.*

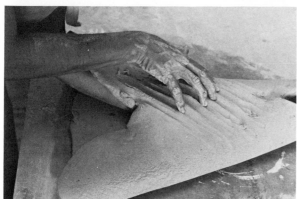

3-15 Lorraine de Castro, Puerto Rico, says, *I roll my slabs by hand because doing so gives me a new and more spontaneous form each time. I almost never have a preconceived idea as to what it will look like, for I have learned to respect the clay's wishes.* Left: Pulling and scraping, she melds the edges together while the clay is still damp.

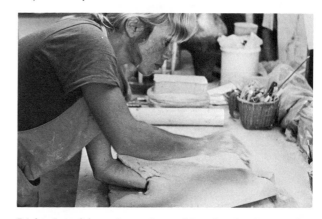

Right: *I model my figures by pushing the clay from underneath with one hand while holding it from above with the other hand. In this way, there is a push and pull action which causes some interesting cracking on the clay surface.* 1981. *Courtesy of the artist. Process photos: Jaime Suarez.*

46

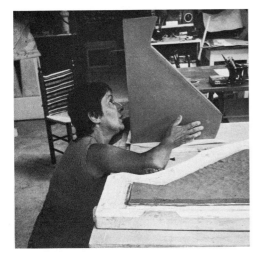

3-16 Nedda Guidi, Italy, *Diagonal, Elements in Red-Green.* Guidi constructs her slab structures by forming them in press molds. She uses colored clays in gradations that are based on careful testing. 1980–81. 80 × 10 × 1¼″ (200 × 25 × 3 cm). *Courtesy of the artist.*

3-17 Barbara Grygutis, U.S.A., *Mustang Mountain Odyssey.* Grygutis joined leather-hard slabs to form a series of arches that suggest the bowlegged stance of a cowboy—our imagination supplies the horse and hat. 1981. Earthenware; slips and oxides, 4′ × 3′ × 9″ (122 × 91 × 23 cm). *Photo: Guy Mancusco/TWF.*

3-18 Lee Babel, Germany, *Untitled.* The artist builds clean-edged slabs and tiles into architectural settings that seem waiting for miniature figures to stroll through them. 26 × 52″ (65 × 130 cm). 1981. Porcelain and stoneware; white, ocher, light blue glaze. *Courtesy of the artist.*

3-19 Nilsgunnar Zander, Sweden, *Mask with a Red Mouth.* Zander shaped a damp slab into a mask, emphasizing its starkness with a red mouth. The forms underneath swell through the slab, cracking it in places, breaking up the dead white expanse of skin. 1980. Porcelain. 8 × 6″ (20 × 15 cm). *Courtesy of the artist. Photo: Håkan Johansson.*

3-20 John Nelson, U.S.A., *W.B. #14.* Nelson says of his slab constructions, *I'm dealing with warping space and illusion, with the relationship of this form on the wall with the viewer. I want the viewer to be conscious of the room they are standing in, and of the relationship that these pieces have to that particular space.* Nelson makes very thin slabs by pouring slip onto a plaster bat. He supports them with an interior gridwork. 1981. Low-fire clay, slip, underglaze, 19½ × 14″ (50 × 36 cm). *Courtesy of Anna Gardner Gallery, Stinson Beach, California. Photo: Harry Rosenbloom.*

3-21 Margaret Ford, U.S.A., *Gown of Thorns.* Ford rolls out her slabs by hand to three-eighths-inch thickness, cuts them with paper patterns, then drapes them to shape them. Often her pieces have interior detail that is added before firing, while exterior detail, like the rose thorns on this gown, are added after firing. Low-fire clay, underglaze. 12 × 14 × 8″ (30 × 36 × 20 cm). *Courtesy of Foster/White Gallery, Seattle, and The Elements Gallery, New York City. Photo: Colleen Chartier.*

In addition to the slab-built works illustrated here, variations of the technique appear throughout the book in works that differ in both concept and expression. From the strong but supple planes of Mary Frank's *Lover* (3–2), to the smooth cast slabs of a wall piece (3–20), from thick, rough slabs (3–6) to slumping slabs (3–14), the technique is adapted and transformed by each artist's vision and imagination. As with every technique, it is not the method the artist uses to achieve expression that counts, but what he or she does with that method. Technique is only one of an artist's tools, not an end in itself, and as in so many clay techniques, it is basically through experience and experiment that

3-22 Kenneth Vavrek, U.S.A., *Rough and Ready.* Vavrek builds slabs into a three-dimensional wall piece in which muted tones in the foreground overlie brightly colored areas, creating an unusual spatial interplay. 1982. Stoneware; high- and low-fire glazes. 66 × 56 × 2½″ (168 × 142 × 6cm). *Courtesy of the artist.*

3-23 Above, left: Patricia Beglin, U.S.A., *Untitled.* Beglin rolls out paper-thin slabs to make her miniature constructions, cuts them with scissors, then shapes them with sandpaper and wood planes. After flash-firing them to achieve the desired color, she assembles them with pegs and pins and binds them with black linen thread. Beglin says, *The scale in my work is important. I want the works to convey a strong but intimate statement.* Low-fire porcelain, sawdust-fired. Average height 6″ (15 cm). *Courtesy of The Elements Gallery, New York, and California Crafts Museum, Palo Alto. Photo: Richard Kampas.*

3-24 Left: Slab-formed vessel by Joanne Burstein, U.S.A., is part of a series of *Waterfall Vessels.* Burstein says, *The strength and flexibility of the clay allows me to shape these delicate sheets of clay into folded forms which retain the lightness and translucency of classical porcelain.* Built horizontal, the forms shift when set vertical at the wet-leather stage, then change even more when exposed to the heat of the kiln. Burstein says, *I view these works as a collaboration between myself, clay, gravity, and fire, in order to evoke the grace of chance given to us by the mountain range and the waterfall.* Porcelain, with ash celadon glaze. 18 × 16 × 7″ (46 × 41 × 18 cm). *Courtesy of the artist. Photo: Gary Burstein.*

individuals develop a slab method that works best for them. No one can say about *any* method "This is the only way to do it." Each person must explore, experiment, test, and often suffer failure before finding out what works best for him. Differing concepts, varying tastes, and diverse personal attitudes will naturally influence the way a sculptor works in any particular technique.

In sculpture, the interplay between technique and idea, concept and material is constant, and one often influences the other. This is perhaps particularly true in the field of ceramics where so many different methods are available. Offered a new technique or tool, an artist may adapt it to his or her way of working, but may in turn also be influenced by the technique or tool itself.

3-25 Far left: Extruder at Brockway Clay Pipe Company making eight-inch pipe. Left: Responding to the hollowness of pipe, Jerry Caplan, U.S.A., created with it a *Container* series in which empty clothing evokes the character of invisible inhabitants. *I found that the pipe would take an amazing amount of pounding and reshaping and realized I could defy the admonition that extruded clay would crack if bent or warped.* 1973. Terracotta. Height 2′ (61 cm). *Courtesy of the artist. Photo: Jack Weinhold.*

3-25

3-26 Oldrich Asenbryl, England, *Extended Movement.* Asenbryl alters and combines extruded forms into assemblages. *They are about movement, rhythm, action and aggression. Color plays a very important part as it emphasizes the content of the form.* Porcelain, base glaze; air-brushed green, yellow, and orange china paint. 36 × 36″ (90 × 90 cm). *Courtesy of the artist and Oxford Gallery, Oxford, England.*

3-27 Petra Weiss, Switzerland, may use hundreds of extruded forms in one of her large murals, attaching the extrusions to slabs. Here she forms the extrusions using a simple mechanism. 1980.

Extruded Forms

The extruder is an example of how a sculptor may work with certain types of images or ideas that he might not have developed if that particular tool had not been available.

Originally developed to fabricate solid bricks and hollow drain pipes, an extruder pushes the plastic clay through a die that forms it to the desired shape (3–25, 3–27). Smaller extruders than those used in industry are manufactured for studio use, but more than one sculptor has gone back to the factory to use large industrial extruders, while others have developed their own modifications (3–28). Extruders offer the sculptor many possibilities, depending on their size and on the die used to shape the clay. The extruded forms can be angular, rounded like Oldrich Asenbryl's (3–26), sticklike such as William Abright's in his vessels (11–33), or multiple like those Alessio Tasca achieves with a special die (3–28). The many forms the extruder can produce and the ways in which those forms can be used is limited, it seems, only by the imagination of the user.

Both these constructive methods—building with slabs and extruded forms—have been widely explored in recent years and have been incorporated into the long list of methods available to the clay sculptor. In combination with pinching and coiling, they extend the range of possibilities open to the artist, and used with the press-molding and casting techniques that will be illustrated in Chapter 5, they offer just one more proof of clay's versatility as a sculptural medium.

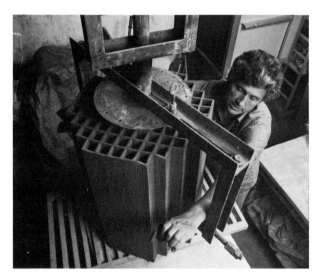

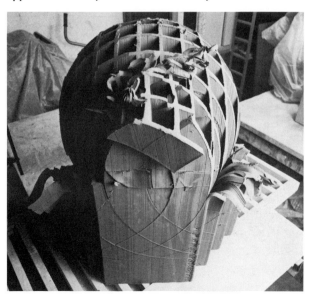

3-28 Alessio Tasca, Italy, developed an extruder that creates large hollow cylinders with a network of inner walls. Above: Once the extruded form is leather hard, Tasca places it on a cutting machine he invented. With eight cuts of a wire, he can produce a sphere. Below: Sphere appears as cut clay is removed. *Courtesy of the artist.*

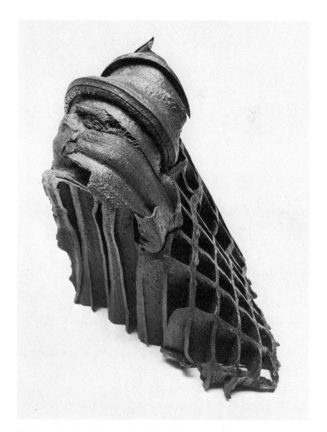

3-29 Alessio Tasca, *Untitled.* Tasca sometimes uses several clays of varying heat resistance which change, fuse, or deform in the single firing at 676° C. (1250° F). Length 32″ (81 cm). *Courtesy of the artist.*

4

Supporting the Clay As It Is Built

The tracks and trails of process are the record of movement through
time and space with a sense of dance and the nature of a frozen moment.
—Joan Marmarellis, U.S.A.

The sculpture we have seen so far has demonstrated how artists have pinched, coiled, slab-formed, or constructed images and objects to externalize their ideas in clay. Sometimes, however, the clay will not do what the sculptor wants, using only those methods. Then some sort of support may become necessary to keep the clay from collapsing. These can be burnable supports like paper or cardboard that will fire out in the kiln, or they can be man-made materials that can be incorporated into the sculpture—fabric, fiber glass, or Styrofoam, for example, will either burn out or melt into the surrounding clay on firing. And on occasion, sculptors have satisfactorily fired sculpture with wooden and metal supports built into it (4-9).

Building Sculpture on Armatures

Wood is a natural support material, often used in the past to construct frameworks (armatures) on which sculptors built up the clay, creating sculpture that was left unfired. For example, a Chinese sculptor of the T'ang dynasty (A.D. 618–906), who worked in the western area of China where good stone for carving did not exist, produced a large figure of a Bodhisattva in this way, building the clay up on a wooden frame, and using natural fibers to help hold the clay to the armature (4-2). Remarkably well preserved for unfired clay, only on one spot has the dried clay of this sculpture broken away from the armature, revealing the wood and fiber of its construction. Since works like these were unfired, few of them have survived to our time. It is likely, though, that unfired images were created in other areas of the world as well. In India, where village sculptors still know how to build and fire large images over wooden supports (10-7), the tradition may have developed from unfired images built of mud and straw and supported by wooden frames.

Clay Originals for Bronze Casting

Bronze casting developed in widely separated cultures—China, Greece, and Africa—and in each the influence of clay can be seen. According to a Greek tradition, two sculptors from the island of Samos were said to have been the inventors of bronze casting in the seventh century B.C., and to have been the first to have used clay to form sculpture for casting in bronze. Although the tradition is probably not historically accurate—bronze casting must have taken many years to develop—the linking of the presumed inventors of metal casting with clay does show the importance given to clay in the process. The bronze Charioteer of Delphi and the Poseidon in the National Museum in Athens are examples of classic Greek bronzes that would first have been built up of clay over an armature. An interesting record of the method exists in a painting on a Greek vase dating from about 470 B.C. It depicts the goddess Athena sculpting a horse with

clay, and the carpenter's tools that hang on the wall suggest that she first made a wooden armature to support the clay. The break in one of its hind legs leaves us in doubt whether there is a framework under the clay or not, but it is hard to believe even a goddess could get a clay horse to stand up on three thin legs without an armature (4-1).

In Rome, the writer Pliny the Elder stated that modeling in clay was the parent art of sculpture and that no figure or statue was made without a

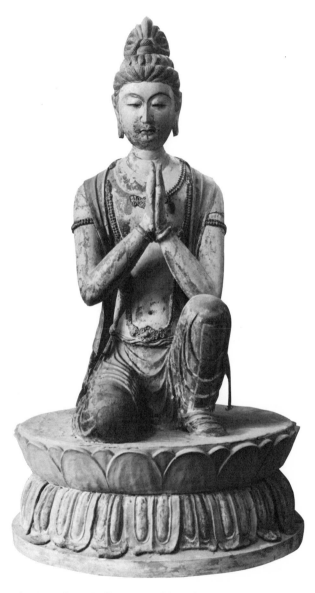

4-1 The Greek goddess, Athena, who was credited with inventing the earthenware pot, is shown in her studio, her cloak wrapped around her like an apron. The horse she is sculpting is presumably built over an armature, but the broken hind leg is puzzling—where is the support for this part of the sculpture? Painted on a Greek vase. c. 470 B.C. *Courtesy of Antikenmuseen Staatliche Museen Preussischer Kulturbesitz, West Berlin. Photo: Ingrid Geske.*

4-2 *Kneeling Bodhisattva.* Although unfired, this figure from the T'ang dynasty is remarkably well preserved. Its interior support is exposed at one place on the side, where the clay has broken off, revealing the wooden armature and fibers. Once dried, the figure was covered with slip, then painted in bright colors, some of which remain. A.D. 618–907. Height 48″ (1.2 m). *Courtesy Fogg Art Museum, Harvard University, Cambridge, Massachusetts.*

clay model. We also know that the Romans built up large pieces of sculpture with clay on wooden frameworks that were called "stipes."

By the Middle Ages, clay was less popular for sculpture since almost all statuary was made as part of the architectural decoration of churches and was therefore usually made of stone instead of bronze or clay. In some areas, however, such as parts of northern Italy where good stone was scarce, many religious statues were still made of clay (8-11). During the Renaissance, the taste for large-scale bronze sculptures was revived, and these were commonly cast from clay originals built on armatures. In fact, Renaissance sculptors like Donatello (1386–1466) and Andrea del Verrocchio (1453–1488) (Colorplate 3) were equally skilled in modeling clay for fired works or in creating originals for bronze.

In the Western world, from the Renaissance on,

the technique of building clay on armatures for casting was one of the most common sculptural methods in use until the development of Constructive sculpture in the twentieth century, so learning to make an armature was an essential part of the training of a sculptor. Auguste Rodin (1840–1917), for instance, was trained in working with clay—in fact, he was employed for several years at the Sèvres porcelain factory in France. Some of his clay

4-3 *Man on Horseback*, possibly King George II. The salt-glazed figure of the rider was built with a clay armature, then thin slabs were draped over it to shape the clothed rider. Staffordshire, salt-glazed stoneware; c. 1740. Height 9″ (23 cm). *Courtesy of the Victoria and Albert Museum, London. Crown copyright.*

4-4 Above: Audrey Blackman, England, continues the Staffordshire tradition. Using clay as an armature, she builds a skeleton, then applies thin slabs that become both clothing and body. Below: *Onto the Wing,* a tiny figurine whose pose is emphasized by the drape and line of its clothing. 1981. Porcelain.

works were fired (8-29), and his bronzes carry the free, sure marks that his clay tools made on the original model. Another nineteenth-century artist, the painter Edgar Degas (1834–1917), was equally masterful in his modeling of clay, although he was not very adept at handling armatures. His armatures were weak, and he let the clay dry too rapidly, so that it cracked and fell off. Degas' bronzes are well known, but in fact none of his sculptures were actually cast in bronze until after his death, and of the more than one hundred clay originals found in his studio, only about a third of them were in good shape. Apparently he used clay as a study material for the dancers and horses that appear in his paintings, with no intention of casting the pieces in bronze.

Since the development of Constructive, Nonob-jective sculpture, fewer sculptors build their work with the idea of casting it in bronze, although in Italy, Giacomo Manzù, well known for his bronzes, uses both wax and clay (8-15). The panels he created for the doors of St. Peter's in Rome use clay freely and expressively, and he has also done some fired clay sculpture. Some clay sculptors in the United States—Peter Voulkos (3-1), Stephen De Staebler, and Robert Arneson (8-32)—now also cast some of their clay sculptures in bronze, but these are built directly with clay rather than on armatures.

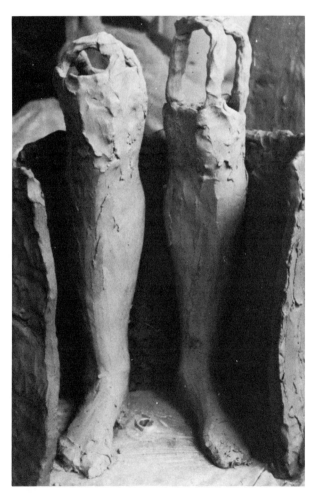

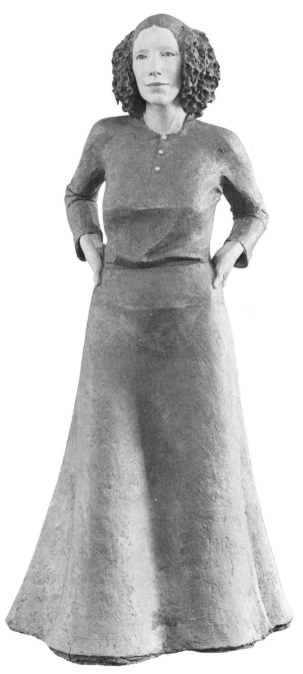

4-5 Left: Penelope Jencks, U.S.A., constructs an armature of clay to build up the knees of a standing figure, using the skirt partially surrounding the legs to help support it as it grows. Right: Long skirts or cloaks are a great help to the clay sculptor in getting a figure to stand up. (See also 8-22.) Terracotta. *Courtesy of the artist.*

The traditional use of clay on armatures to create originals for cast metal sculpture serves to remind us how important clay has always been in sculpture, whether fired or not. A knowledge of armatures can also be helpful to the sculptor who wants to build large pieces in clay, because sometimes some type of support becomes necessary in order to make the clay follow the sculptor's wishes.

Supporting the Clay with Clay

A variety of supports can be used, one of which is the clay itself. Penelope Jencks, U.S.A., uses clay and wood supports to help build her life-sized figures. She first forms the rough shapes of knees, heads, or other parts of the body with a framework made of rolls of clay, then adds more clay to the slightly hardened supports to fill out the form (4-5). She also sometimes incorporates removable wooden supports to help her as she builds up the soft clay. Mary Frank has also worked out a system of clay supports for her figures (3-2, Colorplate 10). Sometimes she folds part of the figure to form the support, sometimes she incorporates the supporting

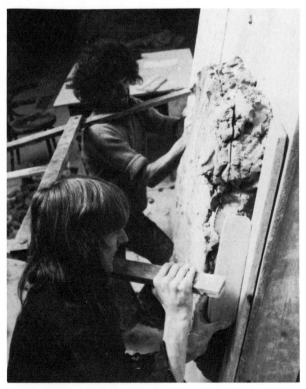

4-6 Struktuur 68, Netherlands, will construct, fire, and glaze large sculptures and wall panels for artists. Staff members start a wall relief by throwing clay against a supporting panel. They then cut and carve the clay, divide it into sections, and hollow out the thick pieces before firing. *Courtesy of Henck Trumpie, Struktuur 68.*

slabs into the sculpture so that they become almost as important a part of the composition as the figure itself.

Using rolled clay supports on a much smaller scale than Penelope Jencks, eighteenth-century English modelers at the ceramics factories in Staffordshire handbuilt small figurines with clay armatures. Rolling the clay into thin coils, they bent them to form sticklike figures, then laid thin sheets of clay over the supports to form clothed figures (4–3). In the 1930s, William Ruscoe revived the method, and today Audrey Blackman continues to use the Staffordshire technique to create small figurines whose own clay skeletons serve as armatures (4-4).

Supports for Wall Reliefs

It is helpful for a sculptor to be able to model a wall relief vertically so that while it is in progress it can be seen in the position it will have when installed. To do this, the artist may attach a wooden frame made of laths, or a panel of plywood to the wall, sometimes adding bits of wood and metal called "butterflies" to help hold the clay in place. Next the clay is flung at or pressed onto the wall with sufficient force to make it stick. Obviously, the clay must not be too soft, or it will slide down off the wall. Once the desired thickness is built up on the support and the clay has firmed up, it can be modeled or carved, and eventually cut into sections for removal from the supporting panel (4–6). This is one of the methods used at Struktuur 68, a workshop in The Hague, Netherlands, whose facilities and expertise are available to artists who may want to create large works for which they may not have the equipment or technical experience. (See also Chapter 7.)

JERRY ROTHMAN, U.S.A.

Anxious to use clay as a medium for large sculpture, Jerry Rothman experimented in the 1960s with different supporting materials and a variety of clays, always trying to push the limits of clay further and further (4–7, 4–8, 4–9).

When Rothman started building his large sculpture, few people were using clay on such a large scale. He first used a low-shrinkage clay body, then went on to develop a zero-shrinkage clay, using chemicals to alter the structure of the clay so that the water would evaporate without changing the space between the clay particles. With these addi-

tives he was able to make a clay body that could be used in combination with stainless steel armatures that are capable of resisting heat up to 2,000°F. Since the sculpture was fired at a slightly lower temperature than that, the steel supports could be left in the clay and fired with it. Unfortunately, these chemicals are rather dangerous to use.

Fabric Supports and Slip

A totally different way of working with supported clay is to use fabric as the support. In this method, the fabric is dipped into slip—that is, clay dissolved in water and mixed to a creamy consistency. To make slip that is liquid enough to dip, it must contain a large amount of water, and this can cause the clay to shrink excessively on drying. Also, it is hard

4-7 Jerry Rothman, U.S.A., built *On the Outside Only #3* on a wooden armature. The sculpture was also reinforced with steel and cement on installation. 1970. Stoneware, cone 3-5; exterior: black gun metal; interior: shiny yellow and brown glaze. Height 15′ (4.6 m). *Courtesy of the artist.*

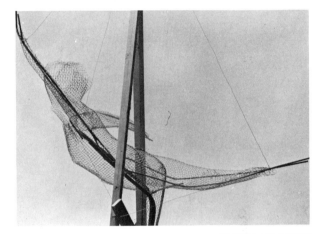

4-8 Extruder pushing tubes of clay through a wooden die to form the components from which Rothman built his tall sculpture.

4-9 Jerry Rothman, U.S.A., *Opel Flies Again.* Above: The metal armature over which the six-foot horse was shaped. Below: When the horse was completed, the wooden supports were removed, but the heat-resistant metal armature was left in during firing. 1974–76. Zero-shrinkage stoneware. Length 6′ (1.8 m). *Courtesy of the artist.*

to keep the clay particles suspended in the water, as they tend to move together and sink to the bottom of the container. For these reasons, a deflocculant such as soda ash or sodium silicate is added to the slip. This changes the electrical charges in the clay particles so that they will separate and disperse through the water rather than stick together in clots. When a slip is properly compounded for dipping, the fabric will absorb the slip and become saturated with the mixture. On drying, the water

evaporates and the clay adheres to the strands of the fabric. During the firing, the fibers burn out, leaving the texture of the fabric intact in the sculpture. This method was used in the eighteenth century when factories like Sèvres or Royal Copenhagen fabricated delicate porcelain figurines to grace the boudoirs and salons of the European aristocracy. Their lacy collars and ruffled cuffs were often made by dipping real lace into slip and firing it.

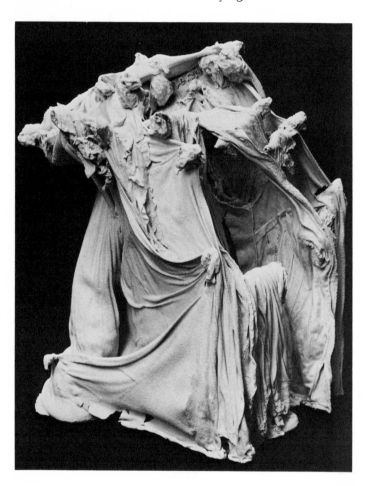

4-10 Nicole Giroud, France, *Pour ne pas oublier 1*. Fabric draped and knotted over string captures the beauty of damp, clinging garments, freezing the fabric into a ghostlike memory. Porcelain. *Courtesy of the artist. Photo: Pierre Hujsa.*

4-11 Joan Marmarellis, U.S.A., says of her working methods in clay and fiberglass, *I sew the pieces with all their edges turned in to keep them from fraying in the slip. Then I soak the fabric in white-firing clay slip. As I string the pieces on the line, I smooth slip of the right consistency over the surface with a brush. Too thick a coating will cause cracking. When it is fired, the silica from the fiber glass fuses into the clay, leaving a matrix of clay and glass.*

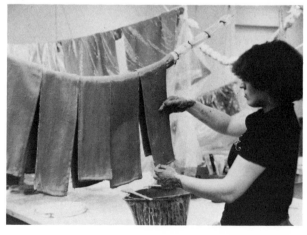

4-12 *Clay Dance*, by Joan Marmarellis, was created in a gallery space at the University of Florida, where, the artist says, *The slip was wheeled into the gallery in large barrels. Once the forming process was completed, the pieces were removed, and I fired them in groups of three over a six-month period. To fire them, I draped them on special alloy stainless steel rods that were threaded through the kiln, and gave them added support with Kaowool throughout the firing—a necessary precaution because of the extension of the flap forms. 1981. Photos: Courtesy of the artist.*

4-13 *Clay Dance*, by Joan Marmarellis. After firing, Marmarellis returned the pieces to the gallery where she hung them on stainless steel lines, leaving evidence of the missing rope—an important part of the image. 1981. Low-fire clay slip, fiber-glass. 10 × 20 × 24′ (3 × 6.1 × 7.3 m). *Courtesy of the artist.*

4-14 Guido Mariani, Italy, *Panni di Tutti.* Mariani built the folds into the garments, then dried the clay forms over a rod. Later he hung the clothes on a wooden rack that became an essential part of the image. 1981. Heavily grogged clay, painted with oxides. 1060° C (1940° F). 55 × 79 × 15″ (140 × 200 x 38 cm). *Courtesy of the artist.*

Nicole Giroud, of France, uses a similar technique, draping and folding fabric in order to create sculptures that seem suspended in space and time—rather like ghosts of our daily lives captured permanently in clay (4–10). To form them, Giroud dips cotton, linen, terry cloth—almost any fabric— in porcelain slip, then hangs it to dry on strings laced across a wooden framework.

Similarly, the dip-formed sculptures of American sculptor Joan Marmarellis are also draped on strung supports. Hers, however, are formed with fiberglass cloth, which melts into the surrounding clay in the heat of the firing. Marmarellis built her *Clay*

Dance to fill a large room, and incorporated the supports into the final piece (4–11 through 4–13).

Guido Mariani of Italy, on the other hand, worked directly with slabs of clay, rather than with dipped fabric, to fashion the empty clothing that appears to be flung to dry over a rod (4–14). Later he incorporated the wooden support into the sculpture as a visual element of the work.

In another variation, American sculptor Marilyn Levine rolls out slabs of clay onto plastic to make drawstring purses of clay. After rolling the slab very thin, she gathers the plastic together to support the clay until it sets.

Drape and Hump Molds

In some early cultures, potters formed the base of a pot with damp clay laid over a rounded stone or draped over the bottom of an old pot. Allowed to stiffen, the clay was removed and turned upright, and the walls of the pot were then built up on this base. A logical extension of this method is to form clay over some sort of support to shape slabs for sculpture. These are called hump molds or drape molds.

One disadvantage of forming over hump molds is that since clay shrinks as it dries and a hump mold will not allow the clay to contract, the clay is bound to crack if it dries too long on the hump. However, for making not-too-complex forms, a hump or drape mold is a quick and easy way to shape the clay, and the damp clay form can be altered after it is removed.

Artists use this method in different ways. Ann Mortimer, for example, drapes strips of clay over a carved Styrofoam model of a face, while Jod Lourie uses "willing victims" as her hump molds (8–24). She drapes a slab over a section of her living model, then dries it slightly with a hair dryer so that it is stiff enough to hold its shape when she removes it, yet soft enough to work into. Mary Frank also uses hump molds in the form of modeled clay torsos, over which she drapes the slabs in order to create her sectional figures (3–2). In a further variation of the method, John La Francesca has carved wood to create a mold over which he could drape damp clay to form elements for a construction (4–15).

It is also possible to use rolled or crumpled newspapers as hump molds to support damp clay, and although these do not provide any detail, they are useful for making simple forms because the newspaper will contract as the clay dries. Thus it can be left underneath the clay until it is totally dry, or it can be left in, to burn out during firing.

Styrofoam also can be carved and shaped to form a support for clay, and if it is padded with paper or cellulose sponge, it will let the clay contract as it dries so that it does not crack. The Styrofoam can be melted out with solvent, or left to fire out in the kiln, but care must be taken to exhaust the toxic fumes it releases as it melts.

It is clear, then, that various materials can be used as supports for clay—wood, metal, paper, plastic materials, strings, ropes, living people, and finally the clay itself. The technique of using drape and hump molds leads us into the next chapter, which explains how clay can be pressed and poured into molds rather than laid over them.

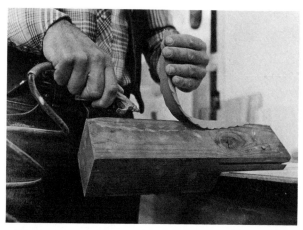

4-15 John La Francesca, U.S.A., cut and draped a slab over a shaped wooden form to create leaves for one of his assemblages. Draping it over the form he removes it with the help of air pressure, then paints the scored edges with slip before joining them. *Courtesy of the artist.*

Pressing and Pouring the Clay into Molds

*For they (the image makers) use a mold; and whatsoever clay they put
into it comes out in shape like the mold.*
　　　　　　　　—Dio Chrysostom, Greece (A.D. c. 40-115)

The use of molds to create clay sculpture has a long history. From the earliest days, when clay-forming techniques developed concurrently with metalworking, to the present day, when molds are used to create sculptural works ranging from miniature components of assemblages (5–11) to life-sized figures (5–27), molds have provided sculptors with a comparatively easy way to make an exact copy of any original. One of the advantages to using molds is that the clay can be pressed or poured into them to form smoother, thinner walls of more consistent thickness than it is often possible to achieve with modeling or constructive methods.

Early Terracotta Molds

The use of molds to form clay images was known in widely separated areas of the world at an early date. Although pressing clay into a mold may seem an obvious procedure to us, the discovery was quite a technological step forward at the time, and it must have taken considerable experimentation to learn to make the molds that produced votive images (5–1) or created portrait vessels (6–7).

In order to make a mold, the object or the image to be cast had first to be created by hand, and the skill and sensitivity of the artist who formed the original was what made the difference between truly expressive castings and mass-produced work. As with all clay techniques, it is what is made with the technique that counts, for the technique itself is nothing without the ideas and the creativity of the artist.

Before the development of plaster for making molds, the molds themselves were made of damp clay, then fired. The earliest molds were made in one part, formed by being stamped with the original positive, or by pressing a sheet of clay onto the original and letting it dry enough to hold the impression when removed, but not so much that it would crack. In both cases, the molds were fired to produce porous terracotta negatives that would reproduce the original image (5–1). In some cultures, instead of impressing the mold from an original, a convex image was carved into stiff clay, then fired. This stamp would be pressed down onto a slab of

clay and from it would appear a raised relief. The theory was the same, but the application of the negative was performed in a different manner.

Made of porous terracotta, these early molds took advantage of two unique qualities of clay— the same that make press or slip casting in plaster possible today. Casting in clay is based on the fact that when damp clay is pressed, or liquid clay is poured, into a dry, porous material, the water that surrounds the clay particles moves from the clay into the pores of this dry material. As this happens, the clay particles move closer together, the clay shrinks, and as it shrinks, it releases itself from the surface of the mold. In addition, clay's ability to hold and maintain any impression made on it means that as the positive dries, it retains the image of the mold.

Press Molds

The development of mold making generally appeared in any society where organized religion or burial traditions required large numbers of votive images or objects, to be buried with the dead. Earlier such images were made individually by hand modeling, perhaps by the woman of a family or clan, perhaps by a shaman (1–15, 1–16). But as religion became more formalized, the home-based image maker no longer would have been able to fill the increasing demand for votive objects. At that point the craft became specialized, and new methods were devised to speed production and to insure consistent output. This is the point at which molds and stamps generally came into use.

Press Molds in Greece

In Greece, one area from which we have a rather complete record of changes and developments in ceramic techniques, at first many of the small figurines used as votive offerings were made with stylized bodies, fashioned from a flat slab of clay, but with stamped or molded heads (5–2). Later, the

5-2

5-3

5-1 A half-round, freestanding figure of a Bodhisattva was produced in this porous terracotta press mold. India. Kula Dheri. Late third to fifth century A.D. *Courtesy of the Victoria and Albert Museum, London. Crown copyright.*

5-2 Terracotta statuette of a Greek goddess. Formed with a combination of techniques, its body is a simple slab thickened at the bottom for support, while the head was made by stamping, or by pressing the clay into a mold. Painted red and black, c. 555 B.C., 10″ (25 cm). Made in Boetia, from Tanagra. *Courtesy of The Trustees of the British Museum, London.*

5-3 Mass-produced images like this terracotta Eros were given variety by changing the gestures of the arms, the objects carried, or by retouching the faces. Made in multiple press molds, the various parts were assembled when leather hard. Hellenistic, Greek, from Erehia, 4½″ (11 cm). *Courtesy of the Museum of Fine Arts, Boston. Catharine Page Perkins Fund. 97.300.*

whole image was formed half-round, modeled only on one side in relief, with the back left unfinished, flat, or slightly hollowed.

Next, the two-part mold was developed so that both the front and the back could be molded separately, then joined with slip to create a full-round image. This was a great step forward, but even so, there were limitations to what could be cast. For instance, undercuts were not possible, for if a mold was undercut the clay could not be removed intact. This meant that the pose of the body had to be rather rigid, and the arms had to stay close to the body.

Finally, the multi-part press mold was developed, making it possible to cast a figure in any pose with any gesture—that is, provided enough molds were used. Now the small terracotta figurines were made from several molds, and their arms, wings, and other details were cast separately and assembled with slip when the clay was leather hard (5–3). Named Tanagra for the town in Greece where so many were made, figurines of this type were actually produced in many other areas as well. In fact, Tanagra exported molds throughout the Mediterranean, so that a craftsman far from the art center of mainland Greece could use the imported mold to produce the latest novelty from Tanagra—perhaps a figure of a dancer or flute player, or the fantasy figure of a man riding a goose (10–10). These figurines were painted in bright colors, and were tremendously popular throughout Greece, her colonies, and Rome, and the molds from which the best were made commanded high prices.

The artist who modeled the originals for these figures was called a *koroplast*. The truly creative koroplast would make his own originals, make, or at least oversee, the shaping of his molds, and alter, combine, and recombine the molded parts to create a repertoire of expressive figures. But the less skilled worker would buy ready-made molds, turning out large numbers of the figures cheaply. Sometimes he combined them in an awkward manner, on occasion even attaching a head that was too large for the body.

Press molds made of clay also were used in the northern and southern continents of America, where the technology of fired pottery molds was highly developed. They were used to form sculptural vessels (6–7) and parts of sculpture (5–4), or to make decorative motifs that were appliquéd to form complex assemblages (5–5).

In Peru, the figurative vessels that reflected the ritual of the Moche culture were partially hand-formed and partly made in molds pulled from hand-formed models. Some sections of the vessels were press-molded, and according to some authorities, parts of them were slip-cast. The different parts were assembled before firing, then the whole was so carefully finished that it takes careful examination to discover which forming method was used.

Press Molds in Europe

Press molds continued in use throughout the Western world long after the last Greek koroplast's shop was shut. The Romans learned from the Greeks, the Roman legions took the knowledge of brick forming in molds to England, and for centuries in Europe, hand-forming in press molds was used to produce decorative architectural details such as the foliage and other designs that decorated the terracotta facades of buildings.

In Europe, terracotta press molds were also used to cast the small figurines that were so popular in aristocratic salons, until the development of plaster molds simplified the process of mold making and casting.

5-4 *Warrior.* Mayan figures from the island of Jaina were often made by a combination of techniques: partly hand-modeled, partly appliquéd, with other sections, like the shield, press molded. A.D. 600–900. Painted terracotta, 12½″ (32 cm). *Courtesy of the William Rockhill Nelson Gallery of Art, Atkins Museum of Fine Arts, Kansas City. Nelson Fund.*

Plaster Molds

Once plaster was discovered to be an ideal mold material, the mold no longer had to be made laboriously from clay, then fired. It was far easier to make a mold by painting or pouring plaster over the original than by pressing clay over it, and as an added advantage, dry plaster was much more absorbent than terracotta. That meant that the damp clay shrank away from the mold more rapidly, speeding production. This porosity also meant that even liquid clay would lose enough water in the mold to form firm walls. So with plaster came slip casting, and press molding for sculpture lost favor until quite recently, when interest in its use revived.

Contemporary Use of Press Molds

With the new interest in clay sculpture, sculptors once again are using press molds. A Greek koro-

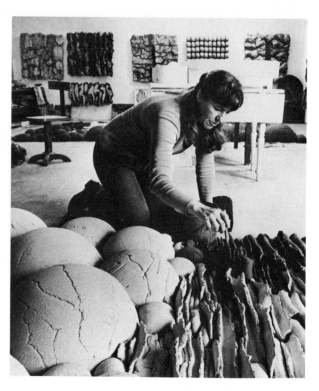

5-6 Ulla Viotti, *Stone, Stone, Stone.* Viotti, working in her studio in southern Sweden, applies oxides to a stoneware wall piece, part of which was made in press molds. This relief, Viotti says, is symbolic of the people who once lived in poverty in this part of Sweden; now all that can be seen to remind one of those who emigrated to the United States about one hundred years ago are the stone walls. 1981. Stoneware, 79' square (24 m square). In the Sparbanken Kronan, Vaxjo. *Photo: Fotograferna Mälmo.*

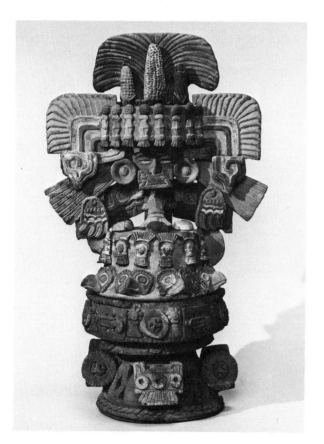

5-5 Above: Many of the components of this elaborate incense burner and its lid were press molded, then appliquéd to the assembled vessel. The figure on the lid is Quetzalcoatl, identified by the wings, four quetzal heads, feathers in the headdress, and the spiral badges applied to the figure. A.D. 800. Terracotta. Base 7½ × 10 × 8½" (19 × 25 × 22 cm). Teotihuacán; from Azcapotzalco, Valley of Mexico. *Courtesy of the Denver Art Museum.*

5-7 Antoine de Vinck, Belgium, draws guidelines in a plaster mold before pressing coils of clay into it. He then places the coils in the mold and covers them with a slab; as he presses the slab into place, the coils are flattened and held together. 1981.

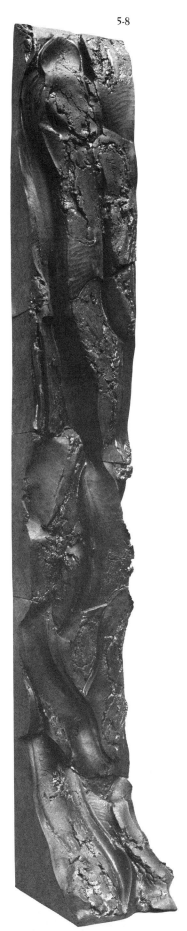

5-8 Carlo Zauli, Italy, *Column*. Many of Zauli's sculptures reflect his fascination with clay's natural tendency to collapse (1-4), but in this towering column he has created a vertical form that rises to an imposing height. Shaped in a wooden mold, it retains the inherent quality of the clay while at the same time bearing the imprint of the artist's fantasies and fulfilling Zauli's wish: *I want always to do work that is strong, but at the same time refined.* Stoneware body, colored black with manganese; touches of black glaze. Height 9'4" (280 cm). *Courtesy of the artist.*

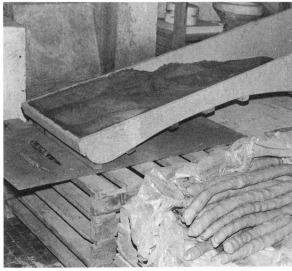

5-9 One of Zauli's wooden molds. Next to it are rolls of clay that are ready to be pressed into it. 1981.

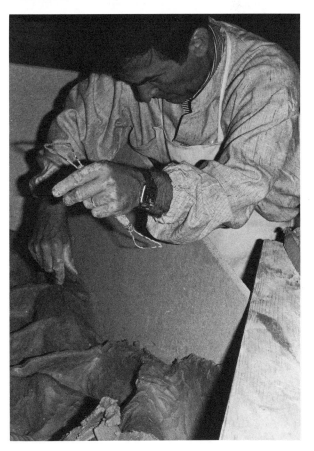

5-10 Keeping the important supporting framework intact, Zauli presses in new clay, somewhat altering the forms as he builds the clay up against the mold. As the mold is slowly filled, the earlier parts are kept damp under plastic. When the mold is removed, the piece will be sectioned while still damp, then dried, and fired. 1981.

65

plast would be startled if he could see the variety of sculpture that now comes out of press molds.

For example, Ulla Viotti, in Sweden, shaped the rounded sections from which she assembled a mural by using a plaster press mold, while Antoine de Vinck, in Belgium, presses coils and slabs of clay into plaster molds to create the patterns on the surfaces of his stele (5–7). Carlo Zauli, on the other hand, presses clay into large wooden box forms to build towering columns (5–8 through 5–10). Nicholas Wood, U.S.A., cuts and carves press-molded components that may come from as many as ten molds (11–19), and Jugo de Vegetales makes press molds from living models (9–16).

Clay Bodies for Use in Press Molds

Once the mold is made, the type of clay chosen for use in the mold depends upon various factors—the effect desired, firing temperature, finish and coloring intended, etc. Some clay bodies are easier to use in press molds than others, and a sculptor may test several before finding one that suits his or her particular needs. John La Francesca (5–11 through 5–13), for instance, tried unsuccessfully for months to develop a porcelain that would work in his particular mold, before switching to a low-fire sculpture clay, and Nicholas Wood gives great importance to the formulation of his clay bodies: *I have mixed and designed my own clay bodies for years, always feeling that it is an important preliminary step in the mental and physical preparation I need for each sculpture, or series of sculptures. Since each clay body is designed to best suit a particular series of work, it also offers a sense of control and personality to that work.*

CARLO ZAULI, Italy

Many sculptors today use press molds in such individual ways that they have widened the range of work that can be created with this ancient technique. Among these is Carlo Zauli of Italy, who builds some of his large sculptures in wooden press molds.

At the age of three or four, Zauli says, he became conscious of ceramics, because all around him in his native Faenza people were busy working at wheels, glazing clay, and firing kilns. At that time, he says, all you needed to do to find ancient discarded pottery was to dig a house foundation, or even just scratch away some soil. Displayed in Zauli's home is a fire-deformed majolica vessel, its

walls collapsed into a twisted heap, its colorful glazes running and melting together, victim of a wood-burning kiln whose temperature rose too high. Although this antique kiln-damaged pot was given to Zauli after he had already started to smash his own pots, he keeps it as a reminder of the crumpled pots and pot shards he saw as a boy and whose influence is reflected in many of his titles: *Repose of a Vase, Erupting Vase.*

It was natural, Zauli says, that *my studies led me above all to ceramics, an ancient material that is, I think, particularly adapted to my creative needs I am an artist who tries the best he can to know his trade, his techniques, his craft, even in its most humble aspects, because I think that without awareness, knowledge, and control of the material, there is no art.* After working as a potter for several years, Zauli began to explore new ways of handling clay, altering, tearing apart, and crushing his vessels until his wheel-thrown pots began to resemble clumps of the fertile soil of his native Emilia. In doing this he became part of a widespread and growing movement that was expanding the uses of clay for sculpture. In Italy at this time, Leoncillo's and Lucio Fontana's work with clay (6–12) had the same liberating influence as Peter Voulkos's had in the United States (3–1).

As Zauli continued to develop his clay forms, they expanded into sculptures that reflected the rhythms of rolling hills or undulating ocean waves (1–4). He finally concentrated all his energies on sculpture, and he now creates large freestanding pieces as well as architectural commissions.

Appropriately, Zauli works in a studio that once housed an ancient ceramics workshop. High above the modern kilns that fire his work, the beams of the studio are blackened with soot from the wood kilns that for centuries produced low-fire majolica pottery decorated with brilliant color. The clay he now fires here is usually stoneware, and the glazes are ash, like Zauli's favorite "white" glaze that actually shades from white through gray to red. Lately, however, he has been building many of his sculptures with an oxide-colored black clay body, on which he uses only touches of black glaze (5–8).

In addition to using hand-building and direct-modeling methods, Zauli has for some time been using plaster press molds, with freedom and creativity, and recently he has been working with large wooden molds. Into these he presses rolls and slabs of clay, combining it with sections that have

been preformed in plaster molds (5–8, 5–9, 5–10). Once the clay has stiffened in the wooden mold, the sculpture is released, and Zauli then works over the surface, allowing the spontaneous effects of the pressing to remain as they come from the mold in some areas, and in others reworking the forms.

The tall columns of black clay that appear from Zauli's press molds may have little visual relationship to the tiny image of a Bodhisattva made from a terracotta mold (5–1), but Zauli is extremely conscious of the long tradition of clay that stretches behind him. *To stay true to this material—at once so antique, yet so modern—gives me great satisfaction.*

JOHN LA FRANCESCA, U.S.A.

Using press molds in a quite different way, John La Francesca, on the other hand, press-molds the wall plates in which he assembles miniature objects to create a dreamlike world of his own (5–11).

Working in a waterfront studio in what was a ship-repair plant in Gold Rush days, La Francesca uses press molds to create fantasy images in shallow square plates. In them, the illusionary space is exaggerated by the receding roads that he paints onto them.

To make his plates, he uses a slab roller, giving the slabs a slight texture by rolling them over denim (5–12). *I generally let a slab sit for a couple of days after I roll it. It seems to help it mature and get used to that shape before I drop it into the mold.* Using both press molds and slip molds he forms the components which he later assembles and glues to the plates. La Francesca's wall pieces are made with three different clays; he uses a sculpture mix for the plate body, a porcelain sculpting body for some of the objects, and a porcelain slip for those parts that call for greater delicacy (5–13). Before switching to the sculpture clay, he says he *spent about six months trying to develop a porcelain that would take the stress of a flat slab being pressed into a shape like this, but there was no way it would do it.*

Once he has pressed the clay into the mold, La Francesca fills the plate with Styrofoam beads and waits for it to shrink from the mold—ideally this takes a couple of hours, but it depends on weather conditions. The plate then serves as the basis for an assemblage in which La Francesca combines objects that he may make from commercial molds or from molds he makes from any object that happens to appeal to him. Frequently he alters, bends, or breaks the molded parts to fit his concept, just as the makers of the Tanagra figures in ancient Greece recombined or altered the details of their molded figurines.

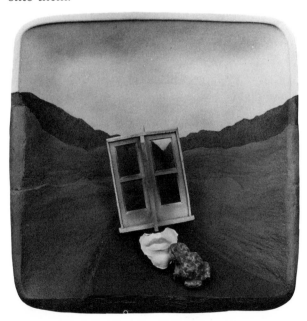

5-11 John La Francesca, U.S.A., *You Have to Kiss a Lot of Toads Before You Kiss a Prince.* The background plate is press molded, the revolving door is hand built, while the lips and toad are slip cast and all are assembled with epoxy. 1980. Low-fire clay, heavily grogged. Porcelain slip; underglaze colors, acrylic paint; cone 05. 19″ × 19″ (48 × 48 cm). *Courtesy of Anna Gardner Gallery, Stinson Beach, Calif. Photo: Dennis De Silva.*

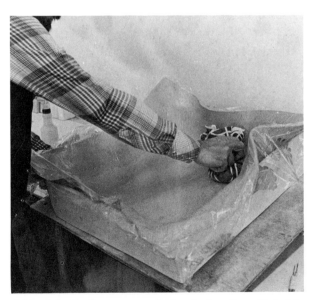

5-12 John La Francesca peels the denim off a rolled slab, drops a plastic-coated slab into the mold, then pounds the slab into place using a bag of slip covered with fabric. 1981. *Courtesy of the artist.*

La Francesca next fires the parts separately but all at the same temperature, and after firing, assembles them with epoxy. Although he tries to keep the gluing to a minimum, he says he is not a purist about the ceramic process and will use a variety of materials to get the effect he wants.

The Development of Slip Casting

Slip casting as we know it was developed in the eighteenth century, probably in England. Although some authorities say that the ability to cast objects in molds with liquid clay was developed earlier in the Moche culture in what is now Peru, it is from the European tradition that we trace our own uses of the technique. Very soon after plaster of Paris molds were first introduced into England, around 1745, they became popular for all types of ceramic casting there, especially slip casting. Slip casting is based on the fact that a dry plaster mold filled with liquid clay will very quickly absorb enough water to allow firm clay walls to form. Using slip casting technique, one thus can produce in-the-round reproductions rapidly instead of being compelled to make two halves, then join them, as one must do with press-molded pieces. Another advantage of slip casting in plaster is that the smooth surface of the plaster allows much greater detail than the porous terracotta that had been used before plaster molds were developed.

By the time slip casting became common, there had already been a long European tradition of press-molding small figurines. Originally made of faience, then of porcelain and bone china, mold-formed figures were often used as table decorations, reflecting the changing artistic taste of the aristocracy and wealthy merchant classes. Usually decorative and, to our eyes at least, rarely expressive, the originals for these were created by hand modeling. The best modelers were sculptors such as J. J. Kändler (1706–1775), who had already become known as the creator of large-scale sculpture in other media and who was in charge of all modeling at the Meissen factory in Germany for many years (6–6). Sometimes artists from other media, like the French painter François Boucher, were also called in to design the figures for the royal porcelain factories.

With the introduction of slip casting, figurines could be produced cheaply, so that now almost every home could afford some sort of decorative group on the mantelpiece—groups that reflected the life of the times. Political figures, heroes, comic figures: their aesthetic level depended not on the process of slip casting itself but rather on the fact that they reflected the popular taste of the period.

Slip casting thus became linked with mass-produced figurines, many of which had little artistic merit, and it was not until comparatively recently that serious sculptors began to use the technique to create one-of-a-kind or limited edition sculpture.

5-13 Above: La Francesca brushes porcelain slip into a mold to form the lips and, as it dries, uses compressed air to release the edges. Right: Success! A perfect cast. 1981. *Courtesy of the artist.*

Techniques of Slip Casting

In order to make a successful cast, the mold, which may be two-part or multiple, must be carefully constructed and registered so that each section fits tightly against the next, making a watertight seal (5–25). Anyone who has experienced the frustration of having an ill-fitting mold leak liquid clay all over the workbench can testify to the importance of this. The thickness of the plaster is also important, for on it depends the speed with which the moisture is absorbed, and the evenness of the clay walls depends on the evenness of the plaster walls.

Formulating Slip for Casting

The slip to be used for casting can be made from both low-fire and high-fire clay bodies, but in general, bodies that are less plastic and that contain a higher percentage of flint or feldspar, along with the purer clays like kaolin or ball clay, make the most successful casting slips.

Deflocculants

Making a slip, however, is not just a matter of pouring some dry clay into a bucket of water. If water alone were mixed with the clay to make it liquid, so much water would be required to form an easy-pouring mix that the mold would become too wet to absorb it. In addition, the cast itself would shrink enormously when the water left the clay, so the mold would have to be much larger than the desired size of the cast. Such a large amount of shrinkage would also cause warping. Also, with a simple clay and water mixture there can be a problem with the particles of clay clotting together in the water rather than remaining separated and suspended throughout the whole mixture.

In order to avoid these difficulties, a deflocculant such as soda ash or sodium silicate must be added to the water. When such a deflocculant is added, the amount of water needed to make an easy-to-pour slip whose particles stay suspended is greatly reduced. There are other deflocculants, but these two, either used singly or together and properly dissolved in the water before the dry clay is added, are generally adequate to produce the desired mixture. Not all clays, however, will make satisfactory slip, even with added deflocculant, and the chemistry of local water can also affect the way a slip acts. After the slip has been mixed, it is poured through a wire-meshed sieve, the size of the mesh depending on the type of slip. Once it is mixed, the slip should

be tested to see how it acts in a mold. It is also a good idea to dry some test pieces cast in the slip to see how strong the dried sculpture will be. Some of these steps can be avoided using commercially prepared slips, but even a commercial slip may not work well in a particular type of mold, may not give the effect desired, or may be too expensive if large quantities are needed.

Casting

The mold must be thoroughly dry before casting, and since plaster absorbs water from the atmosphere, it must be kept in a dry place before use. With the mold assembled and tightly bound with elastic (5–25) or with plaster-soaked fabric (5–29), the liquid clay is poured in and left to settle, then topped off as the mold starts to absorb the water. As the plaster absorbs the liquid, the slip at the outer edge begins to firm up, creating a wall. How long this takes depends upon several factors—including humidity of the workroom and type of clay. When the walls have built up to the desired thickness, the excess slip is poured out (5–26) and the mold is left until the walls shrink away from the sides. Then as the mold is carefully removed, the clay should release easily, and a perfect cast should appear (5–13, 5–26). However, like everything else in ceramics, things may not work according to the book, and the sculptor may have to start all over again, or formulate a new body that will work better in that particular situation.

Molds must be carefully cared for if multiple casts are to be made, and there is a limit to how many casts can be made from any one mold, for the plaster surface is rather fragile and the deflocculant in the slip may cause the plaster to break down.

Since each sculptor's needs are different, each artist develops his or her own method of casting to suit those needs. The illustrations in this chapter show what a wide range of work is possible using the technique, and some sculptors who cast their work describe some of their methods and thoughts about their use of the methods. Their work ranges in size from a few inches to life-sized. Richard Shaw makes molds from everyday objects, then combines them into figurative images (5–14, Colorplate 11), David Vaughan uses both slip and press molds (5–16), as does Jugo de Vegetales (5–18).

And Glenys Barton casts several pieces from a mold, but changes the appearance of the casts with varying finishes (5–22). Lukman Glasgow, U.S.A., may make up to six or eight different molds, cast the forms in slip, then cut, alter, and construct them into a single piece.

RICHARD SHAW, U.S.A.

Like a good many others who started using clay for polychrome sculpture in the 1960s, Richard Shaw came to ceramics from painting, and several as-

5-15 A figure in the process of assembly in Richard Shaw's studio, 1982.

5-14 Richard Shaw, U.S.A., *Bag Lady.* To create this porcelain lady, Shaw made molds of sticks, tin cans, a bag, and a brush, then slip cast them. He also took a mold from textured plywood, pressed slabs of clay into it, then assembled the slabs to recreate a piece of plywood for the lower left leg. Porcelain with decal overglaze. 1981. 43 × 10 × 20″ (109 × 25 × 51 cm). *Courtesy of Braunstein Gallery, San Francisco. Photo: Schopplein Studio.*

5-16 David Vaughan, England, *As Seen from Other Angles.* One of a series of cast pieces with saw images. Vaughan has explored the use of casting as a method of repeating the same form with differing surface and constructional treatments using both press molds and slip casting. *This combination, often in the same piece, allows some very strongly contrasting surfaces to form during the firing and glazing, as well as the making.* Clay and wood. Diameter 14″ (36 cm). *Courtesy of the artist.*

pects of his painter's background—a solid foundation in drawing, an understanding of color, and a knowledge of the human figure—contributed to the success of his work in clay.

When he first started making sculpture in clay, Shaw worked with low-fire clay and glazes, but in 1971 when he and Robert Hudson worked together for a time, he switched to porcelain. He has been working exclusively with that clay body ever since. At the same time, he moved from hand building to casting, usually with slip, but sometimes with press molds. He also builds objects from slabs when that technique is appropriate. It was in his early ceramic constructions that he started to use underglazes, glazes, and decals to give verisimilitude to works that were at times rather like nineteenth-century still life paintings transferred from the two dimensions of canvas to the "reality" of three dimensions. That reality was, in itself, of course, a translation through negative molds of the actual objects into a clay object.

Since 1978, Shaw has been concerned largely with figurative sculpture, creating figures that he constructs from cast objects and parts of objects that, he says, are largely just cut up and stuck together after they come out of the mold. Other parts are fired separately, then glued together with epoxy after firing.

Shaw frequently makes his molds from actual objects—a funnel, a twig, a buffalo horn, a basket—but he also may first construct a mock-up in wood, masonite, or cardboard and make the mold from that. Often he combines these constructed objects with real ones, as he did to make the six-part mold of a pile of envelopes. He made most of the pile from mat board, placing a real envelope only on the top. Thus his sculpture is derived from a handcrafted replica from which he first makes a mold, then another replica—a double trompe l'oeil. It is this interplay between "real" and "unreal" objects that is central to all of his work.

The surface of Shaw's work is always colorful, and his painterly skill is apparent in the subtle color relationships and the transitions between colors. When he wishes to depict surface patterns like those on labels or playing cards, he makes his own decals, silk-screening them onto the transfer paper with a photographic process using low-fire glaze materials (Colorplate 11). But not all of his surfaces come from painting with glaze or underglaze or from decals. For instance, he sometimes marbleizes the clay to achieve marbleized paper on the books, and, in order to produce the texture on a slab-built section of a figure, he first may make a mold from sandblasted plywood, then roll the slabs onto it to get the woodgrain texture.

5-17 Far left: Charles Fager, U.S.A., *Reflections on a Firing.* Taking advantage of the ability of molds to produce repeat images, Fager used slip casting to create a series of self-portraits in porcelain, in which lighted interiors show different aspects of the artist's life and interests. Here Fager's head becomes a glowing kiln. 1978. 12 × 11 × 8″ (30 × 28 × 20 cm). *Courtesy of the artist.* Left: Herman Fogelin, Sweden, *Gesture I.* Interested in body language, Fogelin uses simple multiples from molds, varying the gestures to express everyday actions or moods. *Courtesy of the artist.*

GLENYS BARTON, England

Creating sculpture with techniques that are taken from the pottery industry, Barton slip-casts her work in a newly remodeled studio, where her white sculptures and the white molds from which they are made reflect back the light from skylights

5-18

and freshly painted white walls. Desperate for studio space in crowded London, she came upon a row of crumbling sheds that had once housed delivery wagons. She bought them and feels very lucky, for here, she says, *I can build this little world of my own in which to work.*

The surroundings in which people work have an effect on their work, and Barton is no exception. Invited to work at the Wedgwood china factory for a year, she had access to highly developed ceramic technology and expertise, and during that year she used the facilities to cast and fire white, cool, formalized figures in bone china. On leaving Wedgwood, she began to realize how difficult it would be to reach that perfection of technique in a studio situation.

Lent a large studio by a friend, she tried to continue doing the same type of work, but although having that much space to work in made her sculpture freer, she found she was working under adverse conditions in terms of cleanliness and keep-

5-18 Jugo de Vegetales, U.S.A., *Nimbus.* The artist models the original of his animal heads in solid clay, then makes a plaster piece mold of them. Once the multi-part mold is assembled, he casts the sculpture in low-fire clay. 1980. Life-sized. *Collection of J. M. Kohler Arts Center.* (See also 9-15).

5-19 Patti Warashina, U.S.A., *Domestic Breakthrough.* Warashina uses both handbuilding and slipcasting to create her glazed figures. Their color and size are somewhat reminiscent of the white slip-cast Parian figurines popular in the nineteenth century, but there all resemblance ends as this exuberant lady sends a knife crashing through her glass prison. 1980. Low-fire clay, glaze, underglaze; Plexiglas. 18 × 16 × 13½″ (46 × 41 × 34 cm) (including case). *Courtesy of the artist. Photo: Roger Schreiber.*

5-20 Right: Kurt Spurey, Austria, uses porcelain for his *Touch* series because, he says, *It's not touchy. There is always a distance between the viewer and the sculptor.* Spurey casts his porcelain forms, which he then alters with hand gestures. Below: Spurey uses a quick chop to crush a pristine slip-cast block. *This way I can make a fixation of my own marks. Firing hardens them to permanence.* Porcelain. *Courtesy of the artist. Photos: Christian Springer.*

5-21 Anna Malika-Zamorska, Poland, constructs most of her large works with small components. *I am interested in monumental forms, but I achieve it by quantity. . . . I try in the hardest ceramic materials—china and porcelain—to reproduce the softness of trees, grass, and clouds.* The construction on the left is made with cast elements. 1981. *Courtesy of the artist. Photo: Czezlaw Chwiszacuk.*

5-22 Glenys Barton, England, *Ozymandias, King of Kings.* Barton has cast several heads using this mold, each fired or finished in a different way. She sawdust-fired this one in an old oil drum in a gas kiln so she could cool it slowly, because she felt it would not have survived an outdoor sawdust firing. Of the series of heads cast from this mold, Barton says, *You couldn't really call them an edition—they all look so different.* 1979. Semi-porcelain, sawdust-fired. Height 17″ (43 cm). *Courtesy of the artist. Photo: Karen Norquay.*

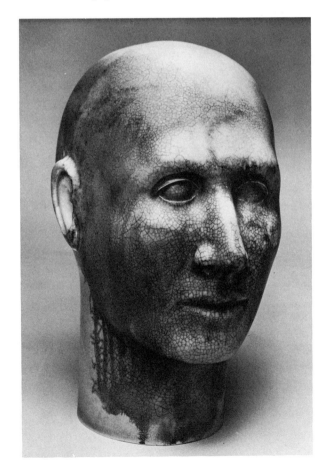

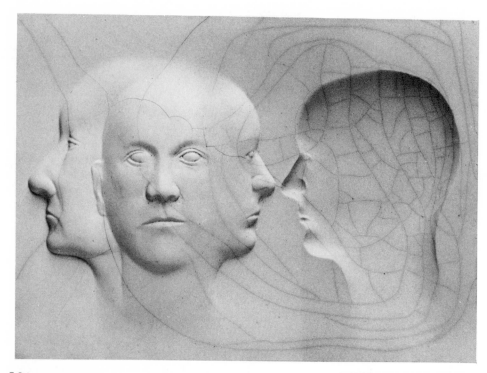

5-23 *Self-Portrait* by Glenys Barton. This relief was glazed, fired, then sawdust smoked to emphasize the crackle. Because sharp-edged forms like this are subject to thermal shock, Barton lost many in the firing and smoking; later, instead of smoking them, she dyed the crazing to emphasize the lines. *I can really draw with it. . . . The further I go with it, the more control I've got. But it's how you use it, how you develop it in relation to the human head that counts.* 1981.

5-24

5-25

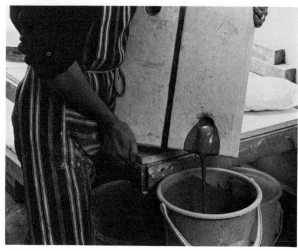

5-26

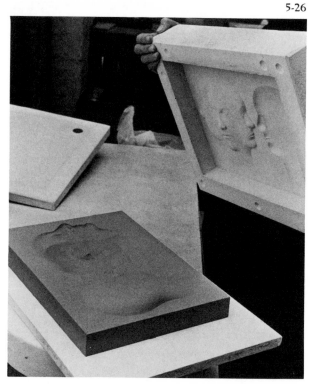

5-24 Barton pours the creamy slip into a plaster mold.

5-25 Pouring out the excess slip after the walls have reached the desired thickness. Once she is sure that all the slip has been drained, Barton trims off the collar which has formed around the pouring holes. 1981.

5-26 As Barton lifts the mold off, a perfect cast appears. 1981.

ing the purity of the work. *The roof was sooty, so if you left something overnight, the next morning it was absolutely covered with black smut. It came to the question of whether or not I should continue working in ceramics.* Barton decided that with her experience and understanding of the material she should continue with clay, but that she should expand her use of the various techniques available. *I thought, I'm only using one tiny corner of ceramics—why not use more glazes, more techniques, why not actually branch out in terms of ceramics, but still in terms of what I want to do?*

So that large, dusty studio not only had the effect of encouraging Barton to work larger, but it had another effect on her work: *You ask, why did I start smoking my sculpture? Funny little reasons . . . I looked at all this white ware hanging about in that borrowed studio, getting smutty and dusty, and I thought, "To hell with this, you've got to go with this instead of fighting against it." So I decided to get things gray.* This led her to abandon the high firing she had been doing, and to smoke her work. Because of the fragility of her sculpture, Barton says she does not use traditional raku firing, as she does not want to put her work through *the ultimate shock of taking them from a hot kiln and dumping them in buckets of water, then flinging them into pits of sawdust. I don't do much of that any more because the big things don't survive it.* Speaking of the large cast head (5–22), for example, Barton says she lost at least three casts and now has just eight pieces that have survived from that particular mold. So now, instead of using raku, she smokes her work.

Barton uses a variety of techniques to create the originals for her slip-cast sculptures. Sometimes she carves them out of blocks of plaster; sometimes she models them in clay, or uses a combination of these techniques. Although she has taken her techniques from the pottery industry, she says, *the way I make the originals, they could go on to be cast in bronze or any other material. . . . A lot of my work comes from a sort of bastard technique.* For example, she first modeled the large head in clay, but then she became irritated by the fact that the clay moved and changed as she worked on it. So she made a mold and translated the whole thing into cast plaster. She then proceeded to finish it in the plaster before making yet another mold to cast it back into clay. *So, it is neither modeled nor carved. It's more modeled than carved, but the finish on the modeling is of a hard nature.*

Looking at the changes in her work since her time at Wedgwood, Barton says: *As you change, the work changes; as you develop, the work develops. Things that have happened in my life have totally changed my life, my attitude towards myself, and my work. . . . And I think that what I'm doing now is moving a little closer to the human being.* More concerned with these inner changes and changes of attitude than in technique, she points out that *a more serious issue is what the piece is actually about.*

JUGO DE VEGETALES, U.S.A.

Influenced by the surrealists, De Vegetales says of his work: *The total image is usually a mystery to me. The parts are easy to identify; they are the building blocks of mythic figures. Earth, water, and plant forms, which usually form the base, are the sources of life. The animals lend superhuman identity by virtue of their historical as well as present-day associations.* To create the elements with which he builds his mythic figures (5–18, 9–16), De Vegetales uses several techniques that involve molds. For the animal heads, he generally models the original in solid clay, then makes a plaster piece mold, and from this he casts the sculpture in low-fire slip. For his figures he makes body casts from living models. To do this he covers the parts of the body to be cast with plaster gauze and makes *crude two-piece molds which are backed up with more plaster. Then I press-mold clay into them, rework the positive, smooth it out and shim it up and recast it in straight plaster to make a slip mold. . . . Sometimes I use press molds if I don't want to use the mold often, but the plaster gauze comes apart too easily and chunks of plaster get in the clay as the plaster wears down.* Once all the separate pieces of his works are cast and assembled, he finishes them as smoothly as possible with a sponge and a rib before firing them.

PIP WARWICK, England

Pip Warwick first had traditional training as a sculptor. He then happened to see someone doing ceramic sculpture, thought he'd like to try it, and so started his years of work in clay: *It has taken me a gradual buildup of fifteen years to arrive at a point where at last I know enough about clay to use it on a monumental scale.*

Even now, when Warwick has his methods per-

fected down to the last detail and has the help of graduate students in the studio, it is quite an undertaking to slip-cast a life-sized figure (5–29).

First, Warwick builds up the figure, working on an armature, applying damp clay to the armature as any nineteenth-century sculptor might have done it. This solid clay original will establish the pose and the overall concept of the piece, but he keeps it general, and as soon as it reaches a satisfactory point he makes a plaster mold from it. This mold may have some twenty interlocking parts, and he uses it as a press mold into which he pushes damp stoneware clay. He prefers stoneware at this point as he feels it gives him flexibility, allowing him to move forms around and to join them as he wants.

Once the clay in the mold is sufficiently dry to support its own weight, yet damp enough to be worked on, he separates the mold from the clay, and starts to work on the figure again (5–30). He may smash three or four of these press-molded casts before he arrives at what he wants. When this prototype is finished to his satisfaction, he makes a slip mold from it. When the plaster mold has set up, the clay is cleaned from the mold and the mold is left to dry completely. Once dry, the parts are fitted together, and the mold is bound tightly with scrim soaked in plaster. Now it is ready to fill with slip. Sometimes Warwick casts the entire figure in one mold, but usually he casts it in separate parts, attaching the head and arms when the clay is leather hard. In this way he can vary the gestures and positions of the head and arms.

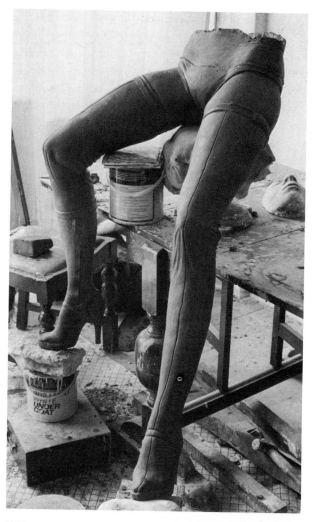

5-27 Pip Warwick, England, early version of *Brigitte Bardot as Guerillina*. Warwick usually makes several prototypes of a piece before he is satisfied. In the case of Brigitte, he broke one up because he felt the pose was too stiff. *I had to take it several frames along so there was more action, more movement.* Asked if he ever goes back to the original to rework a piece from scratch, Warwick answered, *Oh, no. I'm mad, but not that mad.*

5-28 Press-molded legs and torso of a new version of *Brigitte*. At this point, Warwick works in stoneware because he likes the way it handles and finds it easy to make changes. Once this prototype is completed and hand finished, it will be the basis for the slip mold. 1981. *Courtesy of the artist.*

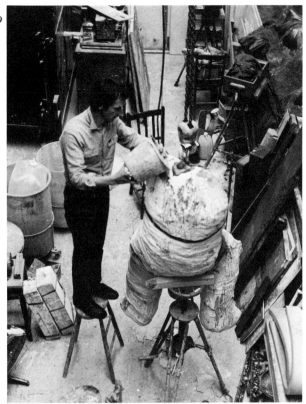

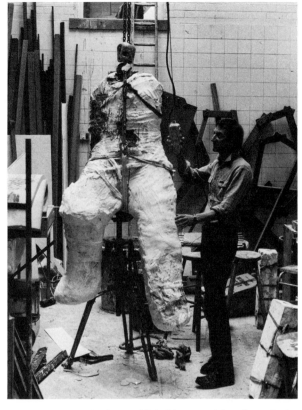

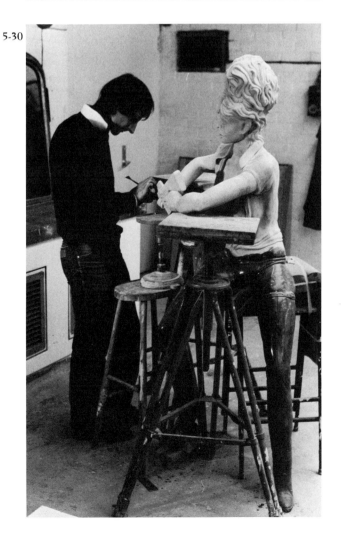

5-29 Left: With the mold held in position by a hoist, Warwick starts to fill it with slip. This mold comprised about sixty interlocking parts and took about thirty gallons of slip to fill. Right: Lifting the mold with a hoist in preparation for drilling a hole in the foot to drain out the slip. 1981. *Courtesy of the artist.*

5-30 Pip Warwick working on the final slip cast with the new head attached. Arms in place, he is attaching the gun in a new position. The plastic coating on her legs will burn off in the kiln. *I love clay,* says Warwick, *and find it impossible to turn my back on a medium that is both live and satisfying. Its sensual and sensitive qualities demand to be started and finished in. . . . As a builder, as opposed to a carver or constructionist, I find—though so difficult to master—clay suits my every purpose. 1981. Courtesy of the artist.*

Warwick mixes his own casting slip, varying the formula according to how much deflocculant he needs, or to what clay he is using. After the slip is poured in, it usually takes about twelve hours for the walls to build up to the desired thickness in the mold. Then comes the draining. Even with a mechanical lift, it would be difficult to upend a mold of this size, so he drills a hole in the foot, and the slip runs out with a great rush. If care is not taken at this point, a vacuum may form and cause the walls to collapse. This cast figure must dry very carefully before being subjected to the stress of firing. Warwick takes every precaution possible in firing, but, he sighs, *Even so, there are accidents, and one never knows until the kiln doors are open whether you have a successful firing. It does make one rather philosophical if after months of work one is confronted with a pile of rubble.*

Warwick's main concern in his work is to reflect the contemporary phenomena of image projection and the interaction of the media, the legend, and the myth in mass society. He feels that since he was brought up, was socialized, and became an artist in a fast-moving, technocratic society, *its images are the only subject matter with which I can truthfully deal. I insist that artists should deal only with what fascinates them. If the elevation of trivia— pop culture—with all its gaudy pretensions is not serious art, then I'm afraid the argument ends here.*

From these contemporary examples of press molding and casting with slip, we can see that the simple ancient method of making sculpture in molds has now developed into a sophisticated technique that allows clay artists the freedom to create almost any type of sculpture. Depending on the artist's concept, on the type of clay used, on the finishing methods, sculptures made from molds may vary from rough earthy forms to glossy finishes that reflect every light source around them.

Indeed the surfaces used on them may totally change the appearance of several casts taken from the same mold. Glenys Barton cast about eight pieces that survived from the mold of the large head (5–22) and finished them differently. She says, *It is very interesting to see. Although you get the identical thing coming out of the mold, if you put a white glaze on it as opposed to this dark brooding finish, or you change the surface, it is amazing how it appears to change the forms.*

In the next chapter we will look at the ways in which the surface of clay can be manipulated, colored, glazed, or otherwise changed, and what opportunities for expression those processes offer the artist.

Altering the Surface of Clay: Color and Texture

The rule of "doing" as well as "thinking" is in accordance with the rhythm of life. It means to weigh, to measure, to add, to subtract, to write down the relations, to manipulate, to take care, to wait for the last test, for the color-matter that is born from the fire.
—Nedda Guidi, Italy

Clay, always a seductive material, is perhaps at its most alluring when one begins to enrich its surface with texture and color. Since there is hardly a texture that cannot be simulated on clay, or a color that cannot be achieved, the possibilities for treating its surface are almost endless: For instance, the clay can be left in its natural state, allowing the forms themselves to create the visual interest and the pleasing texture of the clay to create the tactile interest. Or, taking advantage of clay's plasticity, the mark of hand or tool can be impressed on its surface. On the other hand, clay lends itself especially well to a variety of color effects, and the ceramic process offers many possible methods of

achieving that color. To do this, coloring materials can be mixed into the clay body itself, or color can be applied to fired clay in the form of underglaze, glaze, overglaze, luster, decals, or nonceramic paint, transforming the surface completely. In fact, with the help of these techniques, fired clay objects can be made into facsimiles of almost any material, natural or man-made. It is up to the artist to make the choice that best expresses his or her inner vision, and while the very richness of choice can offer exciting freedom to those whose concepts and ideas are strong and sure, alternatively, the same multiplicity of choice can be seductive to a dangerous point.

Surface Treatments in the Past

When ceramic technology was still undeveloped, clay sculptors were not confronted with such a wealth of possibilities—the cave artist, for example, had no choice but to leave the unfired clay showing the marks of his hands and tool (1–2), while

those who formed the sun-dried images of fertility goddesses could only poke, pinch, scratch, or smooth the surface of the clay (1–15).

After potters learned to fire clay, the first step toward changing the surface color was to paint di-

rectly on the fired clay surface with earth colors or organic pigments. However, an untreated clay surface is not an ideal painting ground, and the color flakes off it easily. As clay technology developed, various methods were devised to coat the clay so that the reddish terracotta could be covered with a beige or white tone, and provide a better ground for paint application. At first, this coating was just a wash of unfired color, but eventually a slip or engobe was applied and fired to the clay. This gave the sculptor a smoother, more permanent, light-colored surface on which to paint. Since early sculptures were generally images of gods and goddesses or objects of everyday life to be placed in a shrine or in a grave, realistic renderings were important to their creators and their purchasers (6–1). Thus color became an integral part of clay sculpture and continued to be an important aspect of the image in many cultures (2–1, 6–2, 6–4, 6–7).

The Greeks and Etruscans, for example, loved color and covered their terracotta sculpture—both large and small—with paint that became more real-istic as their knowledge of the material became more sophisticated. Most of the color that these artists used on their terracotta images was applied after firing, and has long since weathered so that only traces remain, as on the figures of Zeus and Ganymede (Colorplate 1), but on the figurine of a man riding a goose (10–10), enough of the color still clings to it to show us how brilliant these sculptures must have appeared as they came freshly painted from the workshop.

We also know that the early Greek temples were sheathed with decorative, painted panels of terracotta that protected the wood from the weather. The red, cream, and black-purple designs on these panels and on the sculptures in the pediments must have made the buildings an awesome sight to the worshippers who gazed up at the sacred images glowing in the Mediterranean sun. The Etruscans also used color lavishly on their architectural sculpture—on the antefixes that masked the ends of roof tiles as well as on the life-sized figures that stood along the roof tree of the

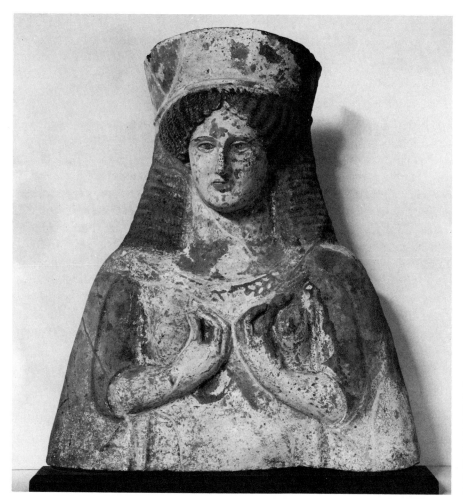

6-1 Demeter, the goddess of agriculture, fifth century B.C. Like all Greek terracotta sculpture, this bust was painted after firing, and the paint has largely flaked off with time. *Courtesy of the Museum of Fine Arts, Boston. Catharine Page Perkins Fund. 97.353.*

temples (7–3, 7–4). The Etruscans also painted their funerary sculpture. The earliest funerary images (8–3) were only painted with muted earth colors, but the later urns and sarcophagi that held portraits of the dead were painted with bright blue, white, yellow, and green pigments. Although the battle scenes on the bases of the sarcophagi were often standardized through the use of molds, the face of the figure of the dead person was individualized, and color was used to make the figure look as lifelike as possible.

Early clay sculpture in the Orient was also usual-ly painted—the small figurines placed in graves in the Han dynasty (202 B.C.–A.D. 220) depict brightly costumed acrobats, ladies in court dress, or colorfully dressed musicians, while the large T'ang dynasty religious sculptures (4–2) and the guardians of temples and graves still retain enough of their color for us to be able to visualize their original appearance. Color was the rule on the American continents as well, where colossal urns and small burial or ritual figures were usually painted, or were at least touched with color, after being covered with slip (6–2).

Early Glazes on Sculpture

Eventually, the early image makers and potters experimented with more satisfactory and permanent ways of coloring and weatherproofing clay, and were able to develop glazes that covered the clay with a reasonably durable coating of color. Among the earliest glazes used on clay sculpture were the blue-green alkaline glazes on small figures in Egypt and the multi-colored lead and tin glazes that coated the sculptured bricks decorating architecture in Babylonia (7–2). In China, during the T'ang dynasty (A.D. 618–906), the many small terracotta sculptures that depicted horses or camels with their grooms were colored with runny lead glazes in yellow, brown, and green, but later, during the Liao dynasty (A.D. 907–1125), the glazes on the larger sculpture like the stoneware *Lohan* (2–8) were better controlled, and by this time the sculptor or glaze painter was able to decorate the green underrobe and the ochre cloak with bands of skillfully executed flowers. Finally, as the knowledge of glazes became even more sophisticated, the color range widened, and by the time Chinese porcelain was introduced to Europe in the seventeenth century, the Chinese were masters of glazes, and their expertise was to have a long-lasting influence on European ceramics.

Color and Surface in Europe

In the meantime, while these developments in glaze technology were taking place in the Orient, in Europe the burst of religious building in stone during the Gothic period and the resulting subordination of sculpture to architecture led to a diminished use of clay sculpture. In parts of Italy, however, where good low-fire clay was plentiful, sculptors continued to use terracotta to create figures that, like the Etruscan sculpture that came before them, were realistically painted after firing (8–11).

This realism was partly an outgrowth of attitudes created by the revived interest in classical art, and when artists like Antonio Rossellino (8–2) or Verrocchio (Colorplate 3) created terracotta sculpture (as most Renaissance sculptors did on occasion), it expressed the new humanism and interest in the individual. Now, instead of symbolic representations, the figures of saints or madonnas were

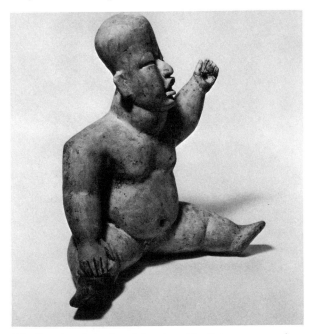

6-2 Pouting, baby-faced figurines like this one were characteristic of the Olmec culture in prehistoric Mexico and were usually light cream in color, with reddish brown or dark brown painted details. c. 1200–900 B.C. Height 16″ (41 cm). *Courtesy of the Munson-Williams-Proctor Institute, Utica.*

quite clearly individualized, based on living persons, and the colors that were painted on the red terracotta were lifelike in every detail (6-3). However, there was one artist who did not use paint. This was Luca della Robbia (1399–1482) who, instead of painting his terracotta sculpture, improved the popular majolica glazes to create blue, white, yellow, and green glazes with which he coated his madonnas and bambini (6-4). The Della Robbia family guarded the secrets of these glazes so that other artists, including Verrocchio, came to their workshop to have their sculpture fired and glazed.

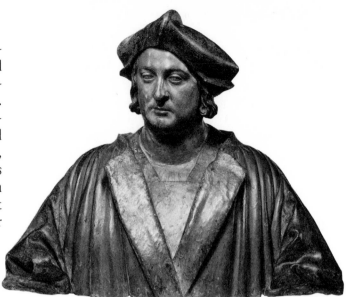

6-3 Portrait of England's King Henry VIII by one of the Italian artists who came to work in England in the late fifteenth century—probably Pietro Torrigiano, of Florence (1472–1538). Best known for his tomb sculpture, he also modeled busts of terracotta, painting them in the Italian manner with lifelike colors. Early sixteenth century. *Courtesy of The Metropolitan Museum of Art, New York City. Fletcher Fund, 1944. All rights reserved, The Metropolitan Museum of Art.*

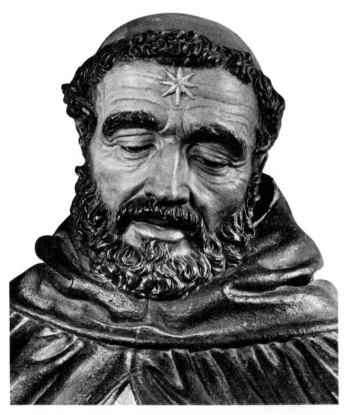

6-4 Glazed with blue and white tin glazes, this *Madonna and Child* is typical of the reliefs that Luca della Robbia, of fifteenth 15th-century Florence, created in terracotta. Based on the majolica glazes popular in Spain and Italy at that time, his colors were rich and creamy, with a freshness that his contemporaries envied. Height 3′ 7¾″ (111 cm). *Courtesy of The Cleveland Museum of Art. Bequest of John L. Severance.*

6-5 Restored and repainted, with reddish brown hair and beard, gray cloak, red book, and gilded star, this bust of Saint Dominic by Niccolò dell'Arca shows the naturalistic color that was typical of fifteenth-century Italian terracotta sculpture. Life-sized. *Photo: Villani, Bologna.*

As the Renaissance merged into the Baroque, the princes and pontiffs who were art patrons felt that bronze and marble were more luxurious materials for their images, so the production of painted clay sculpture declined. Nevertheless, some royal patrons still commissioned portraits in polychrome terracotta, perhaps as studies for bronze or marble sculpture (6–3).

In general, however, in Renaissance and post-Renaissance Europe, as bronze and marble became popular, clay lost favor and was only used to execute quick sketches (8–13), or to create the originals from which the bronzes were cast. At the same time, the once-bright colors that had livened clay in the past faded into the monochrome tones of marble and bronze. Color, in the form of glazes or paint, was generally used only on small figurines (6–6).

By the seventeenth century, wealthy art lovers in Europe, influenced by the arrival of Chinese ceramics, demanded glazed porcelain both for utilitarian and decorative items, and the ceramic factories of Western Europe began to color their output with glaze techniques they had learned from the Oriental imports. Now color was used both realistically and decoratively to depict the brocaded flowers on a lady's crinoline or the gilded embroidery on a gentleman's coat, while the figure often became merely an excuse to show off the laces and furbelows of court dress.

In England, in the eighteenth and nineteenth centuries, and in the U.S.A. in the nineteenth century, the animal and human figurines that decorated mantelpieces were more robust in image, and less effete in color than the Rococo court figures. Their glazes were hearty, befitting sculptured Toby jugs or figures of popular heroes, but they

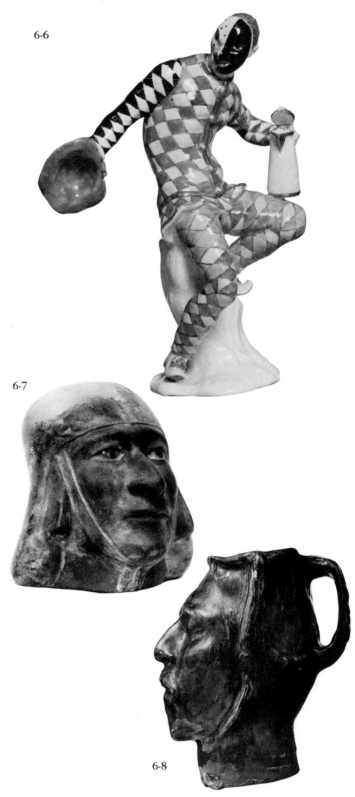

6-7

6-8

6-6 Harlequins were a favorite subject of Johann Joachim Kändler, who was *modellmeister* at the Royal Meissen Porcelain Factory in Germany in the mid-1700s. Bright colors and glossy finishes were typical of all the porcelain figurines of this period, but Kändler's colors were richer than most. Height 6″ (15cm). *Courtesy of the Victoria and Albert Museum, London. Crown copyright.*

6-7 Jar representing a human head from the Mochica culture of Peru. Generally mold-formed, these sculptured jars appear to have been individualized as portraits, after removal from the mold. Handles and spouts were added when the parts were leather hard. A.D. 400–900, Peru. *Courtesy of The Museum of the American Indian, Heye Foundation, New York City. Photo: Carmelo Guardagno.*

6-8 Paul Gauguin, *Self-Portrait*. Gauguin (1848–1903), who considered himself to be half-Indian, was greatly influenced by Peruvian pottery, but since he created his sculptural vessels at the studio of Ernest Chaplet who used Chinese glazes, he glazed rather than burnished his work. It was typical of Gauguin that he transformed influences from many cultures to create his own expressive images. c. 1899. Stoneware; gray-green feldspathic glaze, touches of flambé red. 7.5 × 7″ (19.3 × 18 cm). *Courtesy of The Museum of Decorative Art, Copenhagen. Photo: Ole Woldbye.*

were mass-produced and only occasionally reached the level of expressive sculpture.

However, even during this time when clay sculpture was generally out of favor, there were two artists in France who used clay creatively, with an appreciation of surface treatment and color. Interestingly, neither of them were artists whom we usually think of as sculptors.

HONORÉ DAUMIER (1808–1879)

Daumier, primarily a painter and a printmaker especially noted for his satirical lithographs, apparently created his clay busts (8–31) to study poses and expressions of his subjects before creating the prints for which he was famous. In 1932 Charles Philipon, who published the antigovernment *La Caricature* for which Daumier drew, announced that he would publish a gallery of portraits of the men who surrounded the monarch, Louis Phillippe. In the announcement, he said that these drawings were to be made from maquettes modeled in clay. On these busts, Daumier's treatment of the clay surface was fresh and spontaneous, and although he never fired the busts, he kept them, and painted them with realistic colors—it was only after his death that molds were made from them in order to make terracotta reproductions and to cast them in bronze.

PAUL GAUGUIN (1848–1903)

Unlike Daumier, Gauguin had experience as a sculptor, and he always considered his work in clay to be an important part of his artistic output. Gauguin, who wrote poetically about the flaming colors of glazed clay, created his ceramics at the studio of potter Ernest Chapelet near Paris. Chapelet's glazes were based on classic Chinese ceramics, and with his expertise to draw on, Gauguin used glazes on his sculpture in a manner that represented a total departure from any sculptural ceramic work that had been produced before him in Europe (6–8). He used glazes in a painterly manner, and the colors of ceramics had an influence on his two-dimensional work, an influence to which he referred in a letter describing one of his paintings: *The color is far removed from nature—picture to yourself a vague resemblance to pottery tortured by the high fire.* Gauguin also sometimes depicted his own ceramic sculpture in his paintings.

Gauguin always referred to his work in ceramics as sculpture whether it was in vessel form or figura-

tive, and believed that he would give new impetus to ceramic art through his creations. This estimation proved to be partially correct, for his artistic genius, his intense love of the exotic, and his color sense combined to create sculptural ceramics that were far ahead of his time. That the work failed to exert a strong influence at the time was due to a lack of receptiveness on the part of the public; Gauguin's approach to clay was so unusual for the time that one of his stoneware sculptures, *Oviri*, created a sensation when it was first exhibited, and was removed from the exhibition. It was the artist's favorite work, and he asked that it be placed on his grave—a request that was never carried out. (The sculpture is now in a private collection and not available for photographs; for an illustration see *Gauguin's Ceramics* by Merete Bodelsen.)

AUGUSTE RODIN (1840–1917)

When another nineteenth-century artist, Auguste Rodin, modeled many of his large sculptures in clay before casting them in bronze, his impressionistic approach to the surface was also startling to his contemporaries. Rodin knew clay well. In addition to the usual sculptural training of the day which included building with clay on an armature, he had, for a few years (1879–1882), worked at the State Porcelain Manufactory at Sèvres, and had also created fired terracotta busts that showed his characteristic surface treatment. These busts and sketches retained the impression of the artist's hands in clay—impressions that were preserved when they were cast in bronze—and it was partly due to this rough "unfinished" clay surface that Rodin's work was shocking to his contemporaries, who were used to carefully smoothed surfaces. Rodin was often involved in controversy over his sculpture, and the monument to Balzac, for which he did many sketches, was one of the most controversial (8–29).

After the upheaval of World War I, when the art world burst with new creative energy, sculptors, like other artists, rejected the academic attitude toward material and surface that Rodin also had challenged, and the freedom engendered by the multiplicity of new art movements—Dada, Surrealism, Constructivism, Cubism—led to changed approaches to sculpture that still influence us today. Most sculpture was now constructed and assembled rather than modeled and cast in bronze, and since artists began to use everyday objects in their

assemblages, color started to creep back into sculpture. In the 1930s to the 1950s, when some artists in other media, like Pablo Picasso and Joan Miró, were drawn to ceramics, it was the idea of being able to paint on three-dimensional forms that especially appealed to them. Picasso created polychrome clay sculptures in which he altered and assembled wheel-thrown elements to create animal or human figures, painting them with a brush loaded with slip, creating works that recalled ancient Mediterranean uses of color on clay (6–10). Miró's constructions in clay, on the other hand, were truly three-dimensional paintings that predicted much later clay sculpture (Colorplate 5).

During the 1930s and 1940s in the United States, a few artists—among them Elie Nadelman, Weylande Gregory (8–4), and Viktor Schreckengost (7–14)—created some figure and animal sculpture that showed a new interest in the use of glazes to create texture and color. But if on the whole clay was not in the forefront of art experimentation, it was probably partly because of its identification in some artist's minds with the clay-to-plaster-to-bronze sequence associated with the academic art against which they were rebelling, as well as because of the line that had been drawn between the "fine" and "minor" arts. Viktor Schreckengost, however, was one sculptor who saw the potential of clay as a sculptural medium. Speaking of the reasons why he chose fired clay as his material, Schreckengost remarked: *The more I worked with clay with bronze in view, the more I realized how much spontaneity was lost between the two. As a sculptor I wanted a material that could be worked directly in permanent form.*

The 1950s and 1960s

In the 1950s, new influences in both ceramics and sculpture had important effects on the forms and the surfaces of clay sculpture. The new interest in Japanese ceramics traditions that were related to raku and Bizen pottery, with their rough surfaces, fire-enhanced color, and often accidentally produced surface effects, inspired sculptors to experi-

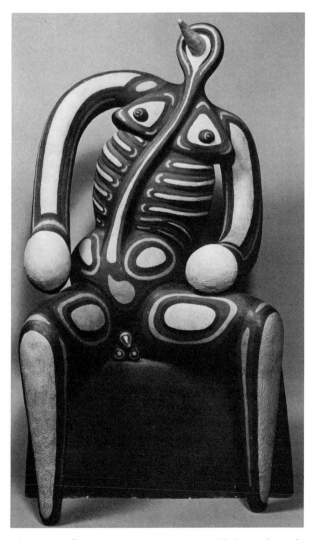

6-9 Louis Ortiz Monasterio, Mexico, *El Pensador.* Always interested in new forms and materials, Monasterio restored color to sculpture in Mexico, producing a series of polychrome terracottas that were influenced both by contemporary art movements and by pre-Columbian sculpture. 1949. *Courtesy of the Phoenix Art Museum. Gift of Mr. and Mrs. Orme Lewis.*

6-10 Pablo Picasso, Spain. *La Chouette,* 1949. In the 1950s Picasso worked in clay with Georges Ramié in Vallauris, France. *Courtesy of Documentation Photographique de la Réunion des Musées Nationaux. © SPADEM, Paris / VAGA, New York, 1983.*

ment with a less controlled use of glazes. This experimentation, linked with influences from Abstract Expressionism, Action Painting, and Color Field Painting, found a natural expression in the medium of clay—a material that responds so directly to the action of the artist's hands and tools. For example, in the United States, Peter Voulkos treated his sculptural forms as three-dimensional painting grounds, brushing on color in a nonrepresentational, nondecorative manner, changing the concept of what the surface of a clay sculpture could be (3–1). In the 1940s in Italy, Lucio Fontana (1899–1968) had worked with clay as well as paint, and after exhibiting works on paper that he called *Spatial Concepts*, in which he cut and punctured the paper, he had returned by the early 1950s to clay to create *Spatial Ceramics*, which consisted of plates and vessels whose surfaces he altered (6–12). Along with these explorations, ceramists like Robert Arneson (8–32) and James Melchert moved

from the more subdued high-fire glazes to the brilliant colors and slick surfaces obtainable with low-fire glazes. Now the stage was set for an explosion of color on sculpture that made use of every aspect of the ceramic process. Richard Shaw first painted on earthenware. Later he created cast porcelain assemblages (5–14) on which color was all-important. Ron Nagle began to spray coat after coat of china paint onto his miniature cups, and Ken Price used both glazes and paint on his colorful sculpture. Whether the artist's interest lay in funk, figure, or fantasy, at this time the artists who experimented with clay generally stayed within the ceramic tradition, depending on its techniques to create images and objects and to enhance their color and texture. This was also true in Europe where a new generation of ceramists began to expand the use of traditional processes, working in postwar conditions of scarcity of materials that are hard for us to conceive of now.

Contemporary Surface Treatments

Now that several generations of clay sculptors have followed the heady days of the 1950s and 1960s,

the interest in the ceramic process has paradoxically both heightened and become less intense. Many artists who now use clay have come to it after using other materials; they like clay, they find it the best material in which to express their ideas. In order to use it, they learn the techniques of building and firing, but when it comes to surface treatments, they are not purists about the ceramic origins of the

6-11 Joan Miró, *Courage aux oiseaux*. Miró worked in clay in the 1940s and 1950s, in collaboration with Josep Llorens Artigas. *Courtesy of Galerie Maeght, Paris.*

6-12 In the 1950s, the Italian artist Lucio Fontana (1889–1968) began to slash and puncture clay to create what he called *Spatial Ceramics,* an outgrowth of his earlier similar work on paper called *Spatial Concepts.* 1962–63. Majolica, 900° C (1650° F). Refired with metallic lusters in reduction; black with blue and gold luster. Diameter 16½″ (42 cm). *Courtesy of Carlo Zauli.*

medium in which they have chosen to work. Sometimes using the material as a painting ground, they see it primarily as a means to expression, minimizing its connection with traditional ceramic craft. At the same time, a fascination with the permanence of fired clay in contrast to the ephemeral quality of our obsolescence-oriented man-made materials has led some artists, like Paul Astbury in England, to explore clay in relation to time and to the vulnerability of other materials (9–1).

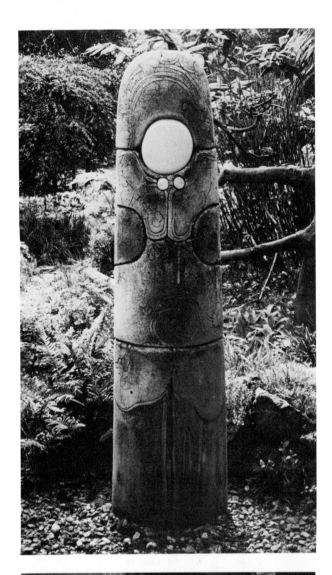

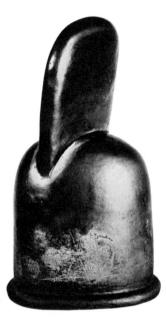

6-13 Kazuo Yagi, Japan (d. 1979), *Sprout.* Yagi usually built his sculpture of black clay, then fired it at 800°C (1470°F) after burnishing or tool-finishing the surface. On this work, incised lines and paint created an area of complexity that contrasts with the smooth burnished clay. 1977. 15½ × 7¼ × 9½" (39 × 18.5 × 24 cm). *Courtesy of the artist's son.*

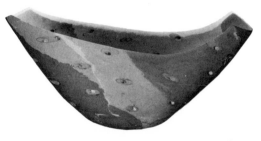

6-14 Jay Kvapil, U.S.A., achieves the color on his hump-molded vessels by rolling colored clays into the basic clay body in a "cutting and pasting" technique. The contrasting colors form surface patterns which he may emphasize by puncturing. 1980. Porcelain, cone 10. Height 16" (41 cm). *Courtesy of the artist.*

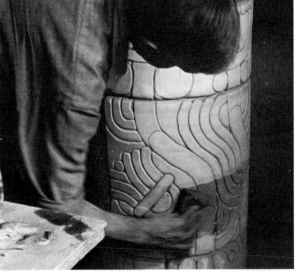

6-15 Top: Antoine de Vinck, Belgium, *Stele.* A mold-formed stele stands in the lush, almost tropical, garden that surrounds the artist's studio and home. Stoneware, fired in four parts. Height 6' (1.80 m). Below: De Vinck wipes oxide onto a bisque-fired stele. The excess will be wiped off, and the coil-formed lines will be emphasized. 1981. (See also 5-7.)

It is indicative of these new attitudes toward clay that while many sculptors turn to traditional techniques like terra sigillata or sawdust firing, they generally use them with a disregard for tradition. Clearly, clay surface and color are no longer totally dependent on the ceramic tradition. This freedom is stimulating and makes for a climate of excitement, but it can pose difficulties. Although methods of building with clay have remained pretty much the same throughout history, the artist today has access to such a bewildering array of surface treatments that it is sometimes tempting to concentrate on surface to the neglect of the idea, the image, or the forms of the sculpture.

Natural Clay Surfaces

Clay responds to manipulation in two ways. It reacts to punching, pulling, or poking, or to attempts to make it stay upright, by settling into folds, cracks, or crevices which vary according to the characteristics of the particular clay used. These spontaneous surfaces can be eliminated to a large extent by the sculptor if strict control over the surface is desired. On the other hand, as we saw in Chapter 1, many artists prefer to allow the clay to dictate its own surface and to merge their fantasies with the forms and surfaces that are created by the clay's own nature. Natural clay surfaces can also be varied by adding fine or coarse grog, or crushed brick (6–22) to the clay body, or by incorporating organic materials that will burn out and leave the surface pitted. Alternatively, burnishing the leather-hard clay with a smooth object like a pebble or the back of a spoon will create a smooth, glossy surface. If slip, engobe, or terra sigillata is painted onto the clay before burnishing, the texture will be even smoother, and the pores of the clay will be more or less sealed. Clay also responds to the deliberate action of the artist's tool, holding that impression while drying. In addition to these surface manipulations, natural clay, even with no extra coloring oxides added, offers a wide array of colors and textures that range from the reddish-brown appearance of iron-rich earthenware through the brown tones of stoneware to the white of porcelain. Specially formulated clays, whether commercially bought or mixed by the artist, extend that range even further with white earthenware or white stoneware that make it possible for the artist to use almost any color integrally in the clay, and to fire it at almost any temperature.

Coloring Oxides and Stains

Clay bodies can be colored by mixing in coloring oxides like iron, cobalt, copper, manganese, or chrome. The colors obtainable with these oxides depend upon the proportions and combinations of oxides used, and on the minerals already present in the clay body to which they are added. In addition, the mineral oxides and commercial stains which are used to color the clay react in varying ways to differing firing conditions. For example, some of them, like cobalt, are resistant to high firing temperatures, while others burn out and lose color at high temperatures. Oxides also react differently depending on the atmosphere in the kiln during firing. A kiln may develop either an oxidizing or reducing atmosphere, depending on the amount of oxygen present.

Oxidation and Reduction Firing

Firing with an oxidation atmosphere means that there is enough oxygen circulating in the kiln to burn up any carbon that might be released from organic materials or from carbonates in the clay. If insufficient air circulates and the kiln atmosphere becomes smoky and full of carbon, the carbon monoxide will draw oxygen from the oxides in order to burn, thus changing the chemical composition of the oxides and often changing their colors. Such an atmosphere is termed reduction and may be deliberately induced in order to develop certain colors in clays or glazes. To achieve reduction in a gas or wood kiln, in which a carbon-producing potential already exists in the fuel, is comparatively easy; the amount of oxygen in the kiln is merely reduced by partially closing the dampers. Reduction may also be achieved in an electric kiln, but it requires more effort, because some sort of carbon-producing material must be introduced into the kiln in order to create reduction through burning. This can be done by placing organic material in the kiln or by firing the piece inside a heat-resistant container along with some smoke-producing material, thus creating a local reduction atmosphere.

Depending on the firing and kiln atmosphere, oxides, or commercially mixed stains, can produce colors from pale salmon pink to bright cobalt blue or deep, rich black. The choice of color depends upon aesthetic considerations but may also be influenced by availability or even by economic considerations. Rinda Metz, for example, used cobalt to color one of her clay tapestries, and while work-

ing, she commented, *I'm running out of cobalt, so the drift is going to go to grays and browns. At sixty dollars a pound, the blue has got to be diluted.* Later, she used less expensive iron to color *Proliferation* (11–4).

NEDDA GUIDI, Italy

The only way to find out what coloring materials to use in the clay and what proportions to add is by testing. Working in her studio on the Via Appia Antica in Rome, Italian sculptor Nedda Guidi has given years to careful testing of coloring materials in clay bodies. Using numerous clays, she has tested and retested, varying the proportions of materials, verifying the effects of coloring oxides, and studying the relation of cause and effect on the fired material in order to observe the absorption coefficient of light (3–16). Changing the fractions of the components from equal parts—for example, $\frac{1}{3} + \frac{1}{3} + \frac{1}{3}$—to varying proportions—such as $\frac{3}{5} + \frac{1}{5} + \frac{1}{5}$ or $\frac{2}{5} + \frac{2}{5} + \frac{1}{5}$—she says she tests without any progressive planned order. *I mean that I did not start from "one" to get "ten" following a gradual continuous course. On the contrary, I chose varying quantities to test the reaction of the material.* Guidi says she thinks of

> *Color within color, red within black—*
> *Blue within gray—gray within gray—*
> * pink within white—*
> *What is a color-matter?*
> *What will happen if . . . ?*
> *Endless tension of mutations.*

In order to give the fullest attention to the extremely subtle color gradations she has developed—going from pink to red, gray to blue or even red to green—Guidi realized that her forms had to be of the very simplest, so her work of the last few years has mainly consisted of minimal slab-built forms that are displayed stretched out on the floor or on a wall; and the more complex her testing became, the simpler her forms became.

By mixing commercial stains as well as pure oxides into a white clay body, Stephen De Staebler achieves quite a palette of colors (Colorplate 6). This body can be fired to a wide range of temperatures, and he found that certain stains act as fluxes at high temperatures, causing the clay to vitrify and produce colored areas that appear glazed. By combining the colors obtained from oxides, stains, and dry pigments with the events which happen naturally on the clay, De Staebler has achieved a subtle richness on his clay sculpture without using glaze.

JENS MORRISON, U.S.A.

The surfaces of Jens Morrison's *Tea Temples* and other sculptures are also enriched with colored clays, slips, underglazes, and glazes. He says he developed his method of adding color and texture to the surface of his work by accident, as often happens. *I collected some local river clay and some other dark orange clay. . . . I took the clays back to the studio, dried them, and began to think in terms of combining these "found" earthenware clays with commercial white talc clay.* With this material he started a series of experiments that eventually led him to carve and draw incised lines into the built-up surfaces in a modification of the ancient sgraffito technique (6–19). In this technique he uses the found clays to color the surface, then draws or scrapes through the layers to expose the underlayer, finally painting on additional details with underglaze colors. Sometimes he also adds glazes.

The process he uses is, he says, basically simple. He crushes the dried found clay with a rolling pin, spreads it out on a canvas and rolls damp whiteware clay onto the dry clay. When the rolled slab becomes leather hard he covers it with colored slips he makes by running his white clay body and water through a fifty-mesh screen and adding *any number and combinations of coloring oxides—cobalt, chrome, and copper. I usually add a small amount of color to the white slip by eye and have no formula except visual feel.*

After building the sculpture, Morrison carves into the light-colored slip, exposing first the dark clay, then carving through to the white clay body underneath. After the piece is dry he bisque-fires it, then paints into the drawings with commercial underglaze colors, often adding some touches of low-fire glaze, which he fires again to cone 06. For occasional gold touches he uses lusters and refires them to cone 019. When all these firings are completed, he may rub the surface with sandpaper and steel wool to "weather" the surface.

As a result of influences from Africa and Mexico, and his fascination with mythology and ritual, Morrison created an imaginary culture called Farmounian—that is a corn-based culture of piglike creatures whose elaborate religious ritual is enacted by four-legged priests and priestesses in monumental temples. His images and his surface techniques interact with and influence each other, and Morrison considers that his works are three-dimensional drawings (6–16).

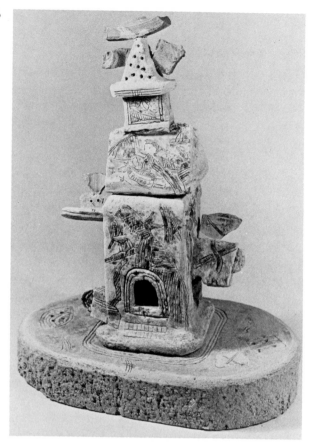

6-16 Jens Morrison, U.S.A., *Tea Temple, Earth Altar.* Morrison says of his temples: *The work is a direct reflection of my interest in magic, color, myths, surface, ritual and the Unexplained.* His surfaces are enriched with indigenous clays, as well as with incised drawings, underglazes, slips, glaze, and gold. 1981. 25 × 14 × 10" (64 × 36 × 25 cm). *All photos of Morrison: Fritzi Huber Morrison.*

6-18 Jens Morrison says that *part of the fun is to locate clay deposits, then see how they fire—what color or texture they give.* He crushes the dry clay, then presses slabs over it to produce a complex surface texture. 1981.

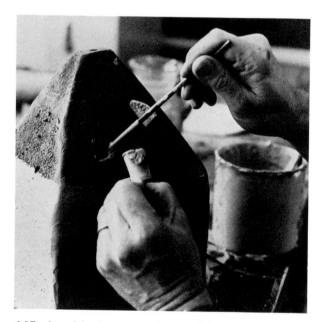

6-17 Jens Morrison coats the temple with colored slips. He then makes potsherds from thrown shapes or slabs, paints them with underglaze colors and rubs them with steel wool to bring out their textures. Finally, he inserts the slip-coated, leather-hard shard into a hole in the temple. 1981.

6-19 After the temple is assembled, Morrison leaves it to dry overnight, then starts to incise the drawings. Using a sharp tool, he cuts and carves through the slip to the colored clay and on down to the white clay underneath.

6-19

MARGIE HUGHTO, U.S.A.

Margie Hughto also incorporates color directly into the clay or into the clay slips that she uses to create her rippling reliefs (6–20). Hughto paints these slips onto a canvas-covered board, scatters crystals of glaze over the board, and rolls a slab of colored clay over them, pounding it all together. After releasing the slab, she works over the surface to refine it, lets it dry slowly, and fires the sculpture in a vertical position in an electric kiln.

As well as being used to color the clay body and slip, coloring oxides can also be painted or wiped directly onto the surface of the bisque-fired clay to enrich the color of the surface or to emphasize its texture. Antoine de Vinck, for example (6–15), makes creative use of oxide-colored surfaces, sometimes contrasting them with small areas of glaze, while Ulla Viotti uses no glazes, just oxides wiped on and then partially removed with steel wool (1–9).

Slip and Engobe

Painting the surface with a slip or an engobe is a traditional way of adding color to sculpture (6–1).

The term *engobe* comes from the French verb *engober,* which quite specifically means to cover a piece of ceramics with a material that masks the color of the clay. The word *slip* is also used for this, as well as to refer to the liquid clay used in casting.

Engobes, or slips, provide the sculptor with matt finishes and a wide range of colors that some artists feel are especially appropriate to sculptural forms, since they are actually made of clay and are nonreflective. They can be applied to leather-hard sculpture and be burnished when partially dry, or they may be brushed onto bisqued sculpture in a painterly manner. In addition, a covering coat of engobe brushed onto the sculpture may be carved through to reveal the contrasting color of the clay body underneath (6-16). The engobe or slip that is to be painted onto partially dry clay or onto bisque-fired clay must be compatible with the clay on which it is painted; otherwise it will shrink at a different rate and separate from the sculpture while it is drying, or during firing. Nevertheless, either used alone or in combination with stains and oxides, slips and engobes can add richness and contrast to the clay surface.

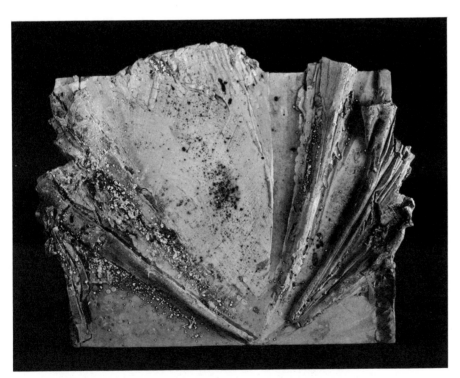

6-20 Margie Hughto, U.S.A., *Peach Bloom.* Hughto incorporates color into the clay bodies she uses for her slab-formed reliefs. To achieve surface richness, she paints slips and scatters crystals on a canvas-covered board over which she pounds and rolls wedges of clay. Later enrichment is added after the relief is released from the board. After slow drying, the reliefs are fired slowly in an electric kiln. 1981. 29 × 39″ (74 × 99 cm). *Courtesy of the artist.*

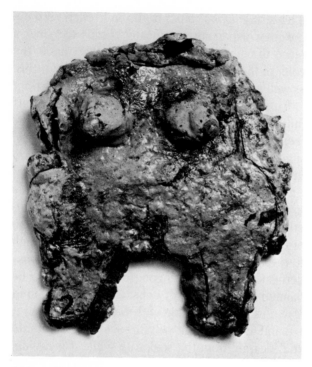

6-21 Jill Crowley, England, used slurry as the basis for her *Ladies* series. She found that when she was making her own clay, *it looked very nice on the slab as it was drying out, so I selected pieces of slurry rather than rolling out plastic clay. You have to control the slurry to a certain extent, but on the other hand there is a freshness about something in which some of the selection is done for you.* 1981. White raku body, pink glaze. *Courtesy of the artist.*

JILL CROWLEY, England

Jill Crowley uses underglazes extensively, combining them with glazes, firing them in raku, and sometimes painting on top of glazes with underglaze color. Coming to ceramics after training as a painter, she often turns to her drawings for inspiration, and also gets ideas from photographs she has taken of people at race meetings, horse sales, or in pubs.

Crowley, to whom movement and pose are all-important, has, like Daumier (8–31), a knack for capturing a characteristic gesture, a twist of the head that tells us as much about the character of the subjects as their faces. Her *Men* reveal through their poses either resignation or courage as they face the accumulated frustrations and disappointments that life has dealt them, while her *Ladies* appear to be in touch with some elemental force that keeps them lusty and strong despite their obvious age and time-worn appearance.

Like her *Men,* the *Ladies* also come from Crowley's drawings. *I have been doing a lot of life drawing,* Crowley says, *and these have to do with where the edge ends—with the edge of the piece. Some of them I've glazed just to the edge, and some are actually drawn edges, then cut....* The *Ladies* combine three-dimensional, press-molded forms with two-dimensional drawings incised into the clay with a potter's needle (6–21). The interplay that thus develops between the real, three-

6-22 Jill Crowley, *Reptile Man.* Crowley captures the characteristic twist of a head, the wrinkles and blemishes of bodies and faces that show the effects of time and hard times. Stoneware and slips. Life-sized. *Courtesy of the artist.*

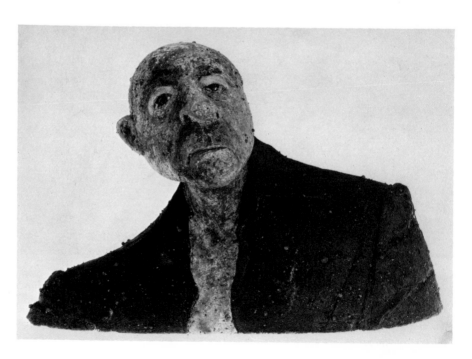

dimensional forms of the breasts and the illusionary drawn forms creates its own tension. It also develops an animation which is heightened by the glossy surface on which dots and dabs of blue, green, yellow, and red vibrate against each other.

Interested in using color expressively, Crowley mixes most of her own clays and underglazes, and finds that in general her own formulations work best for her. *I do buy some prepared raku, she says, but the bodies I make myself are not so fragile. If you fire to the right temperature, raku doesn't have to be fragile, and because I have to ship things abroad I don't want them to be crumbly. . . . Sometimes I make my own porcelain and sometimes I use David Leach porcelain, but my own is whiter. Porcelain works very well for raku—the colors are brighter.*

No matter what clay body she uses or what methods she adopts to achieve her colors and textures, Crowley works with the confidence that comes from years of experience and testing. Whether she models and paints the head of an arrogant tomcat perched like an Egyptian god on a pedestal, a racecourse tout, or the bulging torso of a lady who has seen better days, Crowley comments on her subjects with a humor that is tempered with sympathy, mocking them, but at the same time saluting them for their ability to survive.

Terra Sigillata

Terra sigillata is an ancient surface finish that is also basically an engobe or slip technique. Used by the Greeks and Romans to cover the surface of pottery with a smooth, nonglazed surface, its name has been attributed to a variety of sources. Some say the origin is from *sigillata*, meaning "sealed," referring to the filling of the pores with fine slip. It has also been suggested that it comes from the word *to sign*, since Roman potters often signed their work. Still another explanation states that in Rome the small statues placed in tombs and given as gifts at the time of a festival called Sigillaria were known as *sigilla*. Since the makers of these statues were called *figuli sigillatores* and lived and worked in Via Sigillaria, the surface they used on clay became known as *terra sigillata*. Take your pick of origins, but the method, at least, has remained basically the same.

To make terra sigillata for sculpture, dry clay is placed in water and allowed to settle. The heavier particles sink to the bottom while the finest particles remain in suspension at the top. This upper liquid clay and water mixture is siphoned off and applied to the surface of pottery or sculpture. Burnishing the surface forces the terra sigillata into the pores of the clay and creates a smooth surface popular with some sculptors because it does not have the reflective qualities of glazes. Marilyn Lysohir, for example, finishes her life-sized figures with terra sigillata because she likes the warmth of the surface it produces (6–27). Ronna Neuenschwander uses it because it gives her pieces a leatherlike surface; when making terra sigillata, she waits for the sand and the larger particles to settle until the mixture at the top is fine enough for her to spray onto her work with an airbrush. Once her sculpture is coated with terra sigillata, she burnishes its surface and sawdust-fires it to darken it; she then paints areas of the surface with acrylic paints, and finally she sawdust-fires the piece again to subdue the color (9–24).

6-23 Adding details to a face, Crowley varies her surface treatments, sometimes covering the dark clay body with a white glaze, then adding pink slip for the flesh. At other times she paints on the slip, draws through it, then paints on it again with underglaze colors she formulates herself. Her clay bodies for the *Men* and *Ladies* include crushed brick that melts in the firing into globules and bumps. She may emphasize these with touches of color. 1981.

Underglazes

As the term implies, underglaze colors are applied to the surface before the clay is coated with glaze. On pottery, which may have to contain liquids, a glaze is used over the underglaze color to produce a glossy, impermeable coating, but in sculpture where the function of containing is not an issue, sculptors may use underglaze colors without a covering glaze. Underglaze colors give a matt surface and provide a wide range of colors either as mixed by the artist or as compounded commercially. For these reasons, they are now extremely popular with artists, who use them in innovative ways that were unheard of in ceramics not so long ago. The color, water soluble, can be brushed or sprayed onto dried clay or bisque-fired clay to create transparent color areas, and if layered and built up in coat after coat, even dark colors can be achieved (6–24). Some colors, like reds and oranges, do tend to burn out at high temperatures, so in general, underglaze colors are used on low-fire clay.

Underglaze colors, alone or in combination with slips, glazes, and overglazes, have become part of the coloring technique of numerous contemporary clay sculptors.

Smoking and Raku

This technique of smoking a piece of sculpture is used by other sculptors who, like Neuenschwander, appreciate the muted quality it can give to glazed or unglazed sculpture (11–27). Smoke and flame effects can also be achieved in a wood kiln where the flames, carbon, and ash may enter the firing chamber and accidentally create changes in colors on unglazed or glazed clay. Peter Voulkos has been firing his more recent work in a wood kiln, taking advantage of all the unforeseen firing effects that occur on the surface.

Raku, still an important traditional technique in Japan, has become popular throughout the ceramics world. In the Western adaptation of raku, the fired piece is taken from the kiln and plunged into a container filled with straw, sawdust, paper, or leaves—anything that will ignite rapidly from the heat of the sculpture and create a reduction. After this, it may be plunged into cold water—a process that causes cracking of any glaze on the piece. That is, however, a thermal shock that may cause damage, so sculptors frequently skip this part of the process. At one time, Glenys Barton created the crackling on her glazes with a raku technique, but she lost so many pieces from thermal shock that she developed glazes that crackle in the kiln, and she now colors them with dye. When she was still using raku and smoking techniques she fired one of the casts of a large head in this way (5–22), and the carbon sintered onto the glaze—it took her a whole day with steel wool to remove it.

RICHARD HIRSCH, U.S.A.

Richard Hirsch has combined raku techniques he learned in Japan with his own modifications of the method to create rich, ancient-appearing colors on his ceremonial vessel-sculptures (Colorplate 8). After a memorable meeting with a descendant of the original Japanese tea master, and an exchange of ideas about traditional Eastern and expanded Western raku techniques, Hirsch continued to ex-

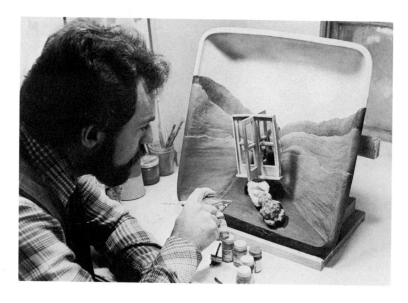

6-24 John La Francesca uses an air brush to apply the underglaze color on his wall-plate assemblages. His colors are deep and rich, requiring many coats of sprayed-on color to build up. In the photo he is faking a bit— in reality the separate components were painted before they were attached to the air-brushed landscape. The background is formed in the same mold as the plate, then attached with epoxy. 1981. *Courtesy of the artist.*

plore the rich surfaces possible with this technique. He uses metallic chlorides and sulfides (11–27) as well as some terra sigillata and lead glazes to build up a surface which is then given added richness in the fire. In smoking techniques, some areas will be oxidized, while others become reduced, producing smoky areas with soft edges. Although these techniques do not allow the artist control over the placement of the color changes, the unexpected patterning they create can add depth and variety to the surface of a piece of sculpture. Thus, the use of some form of smoking, whether in a reduction kiln, or by local smoking, has become increasingly popular with Western sculptors who want to give their work the apparent patina of age that the methods produce (11–36).

Glazes

Glazes were first applied to sculpture in Western Asia and eventually made their way to Europe in the late 1300s. Since then, sculptors have held varying attitudes toward the appropriateness of covering sculpture with glazes, and the use of glazed surfaces has varied from period to period and person to person according to art styles, popular tastes, and individual responses. Today, when almost anything goes in ceramics, the type of glazes used and the manner in which they are used

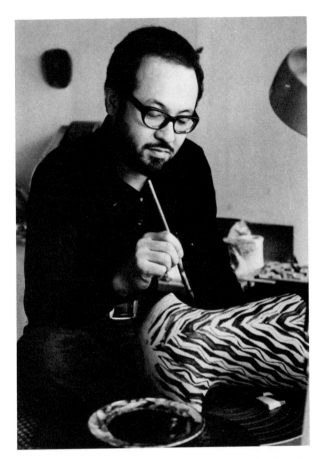

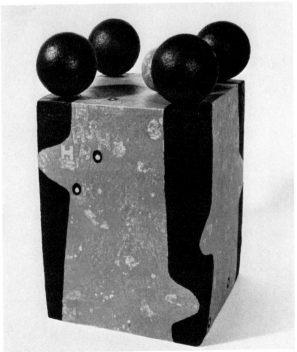

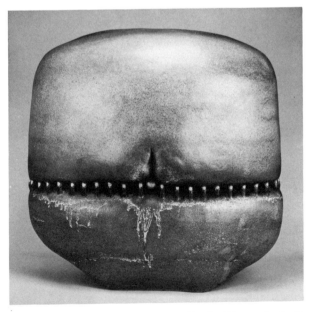

6-25 Junkichi Kumakura, Japan, *Castle*. The artist built his form with the pottery clay of Shigaraki, glazed it with the traditional *Irabo* glaze, then finished it with a gold luster fired at 850°C (1560°F). 1981. 24 × 24 × 12″ (61 × 61 × 30 cm). *Courtesy of the artist.*

6-26 Above: Hiroaki Morino, Japan, painting a sculpture in his Kyoto studio. Below: *#75-3*. The body of this piece was coated with black pigment, fired in reduction at 1230°C (2250°F) while the blue, green and vermillion areas were achieved with low-fire glazes at 750°C (1380°F). 11 × 7″ (27.5 × 18 cm). *Courtesy of the artist.*

6-27　Marilyn Lysohir, U.S.A., *The Fourth Sister.* Lysohir says she pays *particular attention to the surface detail of each piece . . . the patterns, textures and colors,* coating the sculpture with terra sigillata and burnishing it to a smooth matt finish. 1981–82. Low-fire talc body; terra sigillata. White with pink, yellow, green, and natural flesh and hair tones. Three-quarters life-sized figures. Installation, 12′ × 8′ × 5′9″ (3.7 × 2.4 × 1.7 m). *Courtesy of the artist and Foster/White Gallery, Seattle. Photo: Michael Short.*

6-28　Joe Bova, U.S.A., *In the Locks.* Bova paints with china paint directly on the unglazed whiteware body. He says, *I want the viewer to be confronted with a dual realism: for example, clay as skin, skin as clay, within the work without resorting to a trompe l'oeil reality for the whole work.* Unglazed whiteware; china paint. 9 × 8 × 16½″ (23 × 20½ × 42 cm). *Courtesy of the artist.*

depends on the concepts the sculptor brings to the work, the surface effect desired, or the type of firing. The future location of the piece may also be a factor. For example, Ernst Häusermann (2–23), Kimpei Nakamura (7–27), Stephen De Staebler (Colorplate 6), and Alain Tremblay (7–23), who on occasion create sculptures that have to withstand extremes of weather, use high-fire glazes on stoneware clay, while artists like Richard Shaw (Colorplate 11), or Jill Crowley, whose work is placed in protected environments, can use glazes that might not survive outdoors. The final appearance of a glazed piece of sculpture will be influenced by many factors: which oxides color the glaze, whether it is fired at a low or high temperature, or whether the kiln has an oxidizing or reducing atmosphere. For example, the range of possible colors in glazes is greater in low-fire glazes, because certain colors that will not withstand high temperatures can survive low firing with no color change. Thus, the decision whether to use a high- or low-fire glaze

will be influenced by the desired color or texture, the kiln available, or the ultimate location of a work; but even more importantly, the artist must discover the glaze that will best suit his or her ideas, concepts, and images.

Salt Glazing
One type of glazing that has become popular for sculpture is the technique of salt glazing, which was originally developed along the Rhine Valley for use on stoneware utility wares (11–25). It has been adapted by artists in Europe, Canada, and the United States, who like the textures and surfaces it creates (9–8). Salt glazing is achieved by introducing sodium into the kiln during firing. The salt creates vapors which combine with the silica and alumina in the clay to form a glaze on the surface of the clay. Sometimes the glaze has a rather pitted surface, while at others it is smooth and thin. It is popular for sculpture because it usually does not fill in and obscure details with glaze, and also because it is transparent so that the color of the clay shows through. The salt glaze actually becomes an integral part of the clay itself.

Overglazes
Overglazes, as their name implies, are painted on the already fired glaze. They consist of pigments that are mixed with a binder to help them cling to the surface of the glaze during firing. Refired at a low temperature—just enough to melt the colors and to make them adhere to the glaze surface—these colors were originally used to decorate table ware. Also known as china paints, they were once scorned as hobby materials, but now, combined with glazes and underglazes, they are used by many sculptors. Joe Bova (6–28) paints with them directly on unglazed clay, while Pip Warwick's image *Charlie* was finished with about forty thousand individually painted dots on a white base glaze. When this did not give the effect he wanted, a new figure was cast and glazed in black, then painted with forty thousand white dots (6–31).

6-29 Les Lawrence, U.S.A., *Black and White: Reminds Me of the Time Fern Guessed Wrong on the Radio "Secret Sound" Contest.* To create the texture on his vessel, Lawrence glazed it black, then applied white slip which he rubbed off with steel wool. Vessel was then refired. Stoneware; oxidation firing, cone 06. 42 × 9½″ (107 × 24 cm). *Courtesy of the artist. Photo: John Dixon.*

Luster

Luster is a form of overglaze which was first used in ancient Persia to create metallic effects on pottery and tiles. Actually a fine coating of metal that is transferred through firing to the clay surface, luster can be achieved in two ways. The Persian lusters were dependent on a reduction atmosphere in the kiln and were produced by cutting off the oxygen supply to create the necessary reduction atmosphere. Pip Warwick researched these ancient lusters in order to develop his own glittering metallic finishes; in order to fire them, he says, *I give it a*

6-30 The most recent version of Pip Warwick's *Death Rider* dries in the glazing booth. The base glaze is a honey glaze because, Warwick says, *the darker the glaze the better response you get from the luster.* After this glazing the work will be fired again with metallic luster in a reduction firing in his electric kiln. 1980. *Courtesy of the artist.*

tremendous reduction, in an electric kiln, using wood chips as the kiln is cooling at about 400° C. Commercial lusters, however, are manufactured with built-in reducing agents so that it is not necessary to produce a reduction atmosphere in the kiln to create lusters on clay surfaces. Thus they can be used in electric kilns. Made of precious metals, lusters are expensive. They are also highly reflective, and unless, like Warwick, a sculptor wants to have the work draw in and reflect back the environment that surrounds it, lusters generally are used on sculpture only for highlight touches, or to simulate metal. Lukman Glasgow, U.S.A., however, often uses lusters on the surface of his slip-cast sculpture, in order to give the objects a light, floating appearance. To achieve the effect he wants he may fire a metallic luster over an underglaze color, then fire an iridescent luster on top. For example, he will sometimes paint a carmine red iridescent luster

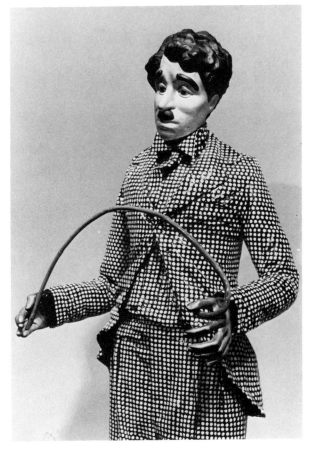

6-31 Pip Warwick says that *Charlie typifies image projection. Early Charlie and the "silver screen" had to be resolved. The finish was, therefore, of critical importance where black and white and silver must be made to reflect and to draw attention to form.* 1980. Life-sized. Slip-cast; glazed, with handpainted dots.

over a gold luster. In so doing, he loses the gold completely, but he achieves a red color that is unattainable in any other way. *Sometimes,* he acknowledges, *it can be extremely costly.*

Decals

As if all these methods of changing the surface of clay were not enough, artists have revived the method of transferring decoration to the glazed surface through the use of decals. Ceramic decals basically consist of low-fire glaze materials mixed in

6-32

a binding vehicle printed on thin paper, which can be slid off onto the clay surface. Since most artists prefer to make their own decals, like Richard Shaw they have had to master the silkscreen and photographic techniques needed to make them (6–35, Colorplate 11). Used creatively, decals offer the sculptor a method of producing trompe l'oeil effects, photographic images, or decorative details that would be difficult to draw or paint on the sculpture, while new developments in photographic techniques now make it possible to print directly on the glaze.

And as if these still do not add enough to the repertoire of surface finishes, sculpture has now gone full circle, and artists have returned to the painted surfaces of ancient images. Like the Greek,

6-33 *C-8.* Originally a painter, Kimiyo Mishima, Japan, created collages and silkscreens of printed materials. Transferring her interest in the printed word and silkscreen to ceramics, she creates packaging of all types. She feels that *our daily life is flooded with a deluge of printed matters, of which the metamorphosis into ceramics and the creation of their static and condensed existence are the main characteristics of my work.* 9 × 11 × 6½″ (23 × 28 × 16 cm). *Courtesy of the artist.*

6-32 Aldo Rontini, Italy, *Endymion.* Rontini used terracotta and a crackled gold glaze to emphasize the contrast between the mortal shepherd, Endymion, and the moon goddess, Silene, with whom he fell in love. 1982. Height 3′ (0.9m). *Courtesy of the artist.*

Etruscan, Oriental, and Italian sculptors who painted directly on the terracotta, sculptors today may paint on the fired clay surface with nonceramic colors. Sometimes using their paint diluted to stain the clay with muted tones, sometimes applying it thickly, or at other times sawdust-firing the sculpture to soften the painted color, they are more interested in the image or in the effect created than in keeping within the confines of glazed ceramics. Whether applied as oil paint on china shards (Colorplate 14), as acrylic paint (9–12), or as enamel, nonceramic paints now are used both to create realistic images or to create illusionary effects on the three-dimensional forms of the sculpture (9–7).

Other sculptors may add glitter or flocking to glazed surfaces (6–34), or draw on the clay with a felt-tip pen, while still others may scatter sand on the clay surface, grow grass on it (1–8), or cover unfired clay with coats of used motor oil (11–5). This sense of exploration of materials brings clay into a wider context, unlimited by the ancient traditions of ceramics, and the new attitude is summed up in a comment by John Nelson (3–20): *If it works, I use it.*

6-34 Toby Buonagurio, U.S.A., *Tiger Cord.* With low-fire clay, Buonagurio cast and hand-built a Cord-that-never-was. Her ceramic version of the marvelous machine is glazed in brilliant colors and further customized with metallic luster, flocking and glitter. 29 × 11 × 29″ (74 × 28 × 74 cm). *Courtesy of the artist.*

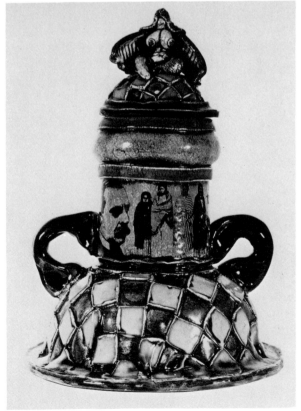

6-35 Erik Gronborg, U.S.A., *Container with Lid.* Gronborg has frequently used photo decals on his plates and containers, combining them with colorful low-fire glazes. Stoneware; low-fire glazes, photo decals. Height 14″ (36 cm). *Courtesy of the artist.*

IMAGES AND
IDEAS IN CLAY

Creative Responses to Clay
Among Artists of Many Eras

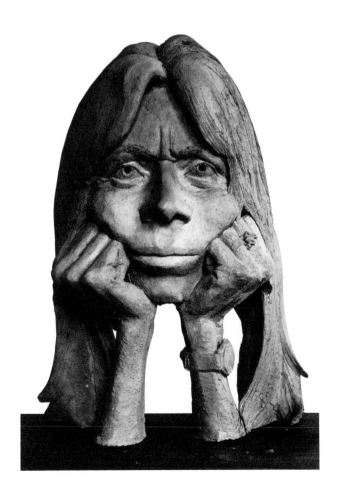

7-1 Penelope Jencks, U.S.A.,
Self-Portrait. Terracotta. Life-sized.
Courtesy of the artist.

Architectural Uses of Clay Sculpture

*The nature of the material and the combination of colors and forms
special to ceramic sculpture attribute to it a character very appropriate
to the architectonic environment.* —*Alain Tremblay, Canada*

Architecture and clay have had a long association, for clay is a natural building material. As early humans abandoned their nomadic lives to settle down to farming, they naturally turned to the plentiful earth material to construct their shelters. Shivering northerners daubed mud on frameworks of supple twigs or woven reeds, while in the hot, dry climate of Mesopotamia and other warm areas, builders used river mud to form bricks. Dried in the sun, these bricks were the construction units of all building projects—palace to potter's workshop, peasant hut to temple, city gate to ziggurat.

Clay in Early Architectural Decoration

Given such a widespread use of clay for construction, it is not surprising that it was also used for decoration. In Mesopotamia, some of the earliest architectural decorations were mosaics that were formed of red, black, and white cones of sun-baked clay imbedded in the mud walls. Later, when alkaline and lead glazes were developed in Egypt and Mesopotamia, they made it possible to bring brighter color and a certain degree of impermeability and weather resistance to fired bricks. These glazes were applied to fired bricks that were then used to face the sun-dried brick construction, protecting it from the weather (7–2). This early use of glazed ceramics in association with architecture spread with the Moslem conquests from Persia to Africa, to Spain, and on to Europe, eventually leading to the development of ceramic tiles as we now know them. In general, these glazed bricks and the facing tiles that developed from them were used flat, but in some instances they were modeled to form low-relief sculpture.

Throughout the Mediterranean, terracotta images of gods and goddesses, mythical heroes, and religious figures were often associated with architectural settings. Sometimes these images were integrated into the composition of a building (Color-

105

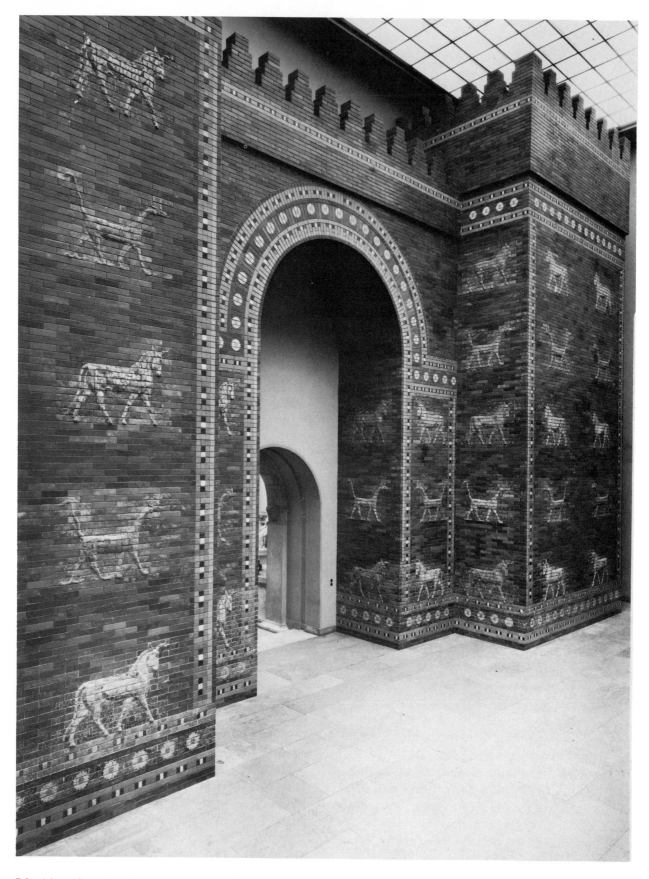

7-2 Ishtar Gate, Babylon. As part of the New Year celebration in the rich and flourishing city, images of the gods were carried from the main temple of Marduk through this gate to the Festival House outside the town. Built by Nebuchadnezzar II, the Ishtar Gate was decorated with brightly glazed tiles depicting animals in relief. 604–562 B.C. Height 47′ (14.3 m). As rebuilt in the Staatliche Museum, Berlin. *Photo: Abeitlung, courtesy of the museum.*

plate 1), sometimes they were freestanding statues that, although not integral, were an important element in both the architectural and religious concepts that governed the design of the building. Indeed, it is often difficult to draw a line between these two categories, for while enhancing the appearance of a building a sculpture may also communicate religious or political ideas. These concepts may be foreign to us now, and what we see as merely decorative or pleasing additions to a building undoubtedly had a totally different meaning to the people who looked at the building when it was new. For example, the Gorgon on an archaic Greek temple is more amusing than frightening to us, but to the Greek steeped in mythology, the snake-haired monster represented evil (7–3). In the same way, we may look at the figures on an Indian temple (7–8) as a charming decoration, while the person who came to worship at the temple would have seen them as exemplifying divinities who expressed the universal life principle, or as characters in an ancient myth.

7-3

7-4

7-3 An archaic Greek roof ornament (akroterion), found in Syracuse, Sicily, depicts the Gorgon Medusa, at the moment she was mortally wounded by Perseus. The winged horse Pegasus was born from her death wound, and is seen here under her arm. Brilliantly colored in red, purple-black, and yellow, the relief was attached to the temple gable with metal nails set in the holes. Sixth to seventh centuries B.C. Height 10 × 10½″ (26 × 27 cm). *Courtesy of the Soprintendenza Archeologica, Siracusa.*

7-4 *Apollo.* The terracotta figures that once were silhouetted against the sky on the roof of the Etruscan temple at Veii told the story of an angry confrontation between the god Apollo and the hero Hercules, whom Artemis, Apollo's sister, had accused of stealing her sacred deer. c. 500 B.C. Height 68⅞″ (175 cm). *Museo Nazionale della Villa Giulia, Rome. Alinari/Editorial Photocolor Archives, Inc. Photo: courtesy of the Art Reference Bureau.*

Mesopotamia

Low-relief sculptures formed of brick were a feature of important buildings in Mesopotamia. In Babylon, for example, the walls that lined the Processional Way leading up to the imposing Ishtar Gate (c. 580 B.C.) were covered with flat blue-glazed bricks into which modeled bricks were set, forming low-relief sculptures of lions, bulls, and fantastic animals. Glazed with turquoise, green, blue, yellow, and purplish-brown, the colors on these brick reliefs were kept from running into each other with raised outlines of trailed slip (7–2).

Greece

In ancient Greece, where the first sanctuaries were built of wood and sun-dried brick, the walls of the shrine holding the sacred terracotta image of a god

7-5 The Etruscans probably learned from the Greeks how to protect their wooden temples with terracotta. The protective devices soon became decorative, and the painted clay antefixes that covered the ends of the roof tiles became even more exaggerated on Etruscan temples. *Museo Nazionale di Villa Giulia, Rome. With permission from Soprintendenza Archeologica per L'Etruria Meriodionale.*

or goddess were protected with a roof that extended out beyond the walls to rest on wooden posts. As temples became larger and more elaborate, terracotta panels were attached to the ends of these roof beams to protect them from the weather, and were also applied to the areas between the beam ends. The roofs were tiled, and according to Pliny, the Roman writer, it was the potter-sculptor Butades of Corinth, about 700 B.C., who first placed masks on the ends of the tiles on the roofs of temples. These masks became the antefixes that decorated both Greek and Etruscan temples (7–5). Pliny also states: *It was from these that the pediments of temples originated.**

As time went on, these masklike antefixes and the low-relief sculptures of gods, goddesses, and mythological characters became more and more elaborate. Eventually they were sculpted in full relief, then finally in the round. The three-dimensional clay sculpture was also painted in bright colors, and even the marble figures that decorated the later Greek temples carried on the tradition of bright color derived from the polychrome terracotta sculpture.

The terracotta figures on early temples in Greece represent a transitional step between the stiff figures of the Archaic period and the graceful sculpture of the Classic period. These clay figures were obviously important religious images, whether they were cult statues within the temple or were architectural decorations on the exterior. Indeed, we know that these early images were venerated by following generations, for many of the oldest clay sculptures were kept in the sanctuaries of temples that had been rebuilt in stone. Finally, when they were replaced by marble images, the outmoded terracottas were buried under the floor of the new stone temple. In this way, the new place of worship rested on the old clay images of the god or goddess to whom it was dedicated, receiving added sanctity from their presence. (For a modern adaptation of Greek temple sculpture, see 7–12.)

Etruscan Architectural Sculpture

According to Pliny, that encyclopedic writer whose *Natural History* covers art as well as science, it was the Greek colonists in Italy who taught the Etruscans their skill with clay. Pliny reports that an exiled nobleman, who came from the

* Pliny the Elder, *Natural History,* XXXV, 151–52.

Greek city of Corinth in the seventh century B.C., brought with him three modelers in clay. It was through these men, Pliny says, that the art of modeling in clay came to Italy. Whether or not this is a simplification of history, it certainly is true that Greece exerted a strong influence on Etruscan and Roman clay sculpture. As in everything else, however, the Etruscans brought their own vitality to clay. They loved color and ornament, and even their earliest brick temples boasted painted terracotta decorations. As time passed and Etruscan technical knowledge improved, the antefixes grew larger, and their color became brighter, while the sculptures in the round were built and fired larger, until eventually the temple itself appeared to become almost less important than the sculptural decoration that was placed on its roof. These life-sized polychrome terracotta figures seen against the blue sky of Italy were characteristic of temple architecture at the height of the Etruscan period. Roman descriptions of the appearance of these temples and their decorations have come down to us, and parts of the group of Apollo, Hercules, and Artemis that once stood on the roof of the temple at Veii can now be seen in the Villa Guilia museum in Rome (7–4). There, their lively presence conveys much of the spirit of Etruscan art. They were discovered on May 19, 1919, when workmen excavating at the temple site unearthed the top of a terracotta head. As they dug around it and it became visible, the archeologist Giglioli was so moved by seeing the god Apollo's face reappearing from the earth after thousands of years that he fell on his knees and kissed it. Set up in the museum as they probably were on the roof, the two figures strain toward each other, their muscles tense, about to wrestle for a sacred deer that Artemis accused Hercules of stealing.

The creator of these sculptures—possibly Vulca of Veii, the only Etruscan sculptor whose name we know—communicates his delight in the material as well as his aesthetic response to the movements of the human body. Vulca was, in fact, so famous for his sculpture that Tarquinius, the Etruscan king of Rome, is said to have called him to Rome to execute the terracotta figure of Jupiter for the temple dedicated to that god on the Capitoline Hill. In his book *The Lives of the Noble Grecians and Romans,* the Greek writer Plutarch (c. A.D. 45–c.120) relates a story about some of the clay decorations sculpted for this temple. He says that when Tar-

quinius was still king, he commissioned the clay sculptors of Veii to create a clay chariot and horses (quadriga) to be set on the roof.

While the work was being completed, Tarquinius was driven from Rome. The sculptors finished modeling it and placed it in the kiln, whereupon, according to Plutarch, *the clay showed not those passive qualities which usually attend its nature, to subside and be condensed upon the evaporation of the moisture, but rose and swelled out to that bulk, that, when solid and firm, notwithstanding the removal of the roof and the opening of the walls of the furnace, it could not be taken out without much difficulty.* According to Plutarch, when the sculptors finally did get the quadriga out of the kiln, the local soothsayers decided that this unusual occurrence meant that success and power would come to those who possessed the quadriga. For this reason, the Etruscans decided not to deliver the sculpture to Rome, saying that it belonged to their exiled king. However, shortly after, during a chariot race at Veii, as the winner was driving his chariot out of the ring, his horses suddenly broke into a gallop and ran uncontrolled to the Capitoline Hill in Rome, where the driver was thrown out. This second wondrous occurrence convinced the Etruscans that they had better allow the clay chariot and horses to go to Rome to be installed on the temple on the Capitol. Similar quadrigas were used as decorations on other temples, and horses, winged or not, were popular in Greek terracotta sculpture.

So sacred were all these early sculptures that, even when the Etruscan kings were expelled from Rome and the Republic was founded, the terracotta images of the gods that the Etruscan artists had sculpted remained on numerous Roman temples for centuries. Vitruvius wrote of them, and Pliny mentions that even in his day some temples were still ornamented with terracotta figures, which he describes as *remarkable for their artistic merit and durability, more deserving of respect than gold, certainly more innocent.*

Rome

The Romans were brilliant engineers, but most of the art that decorated their buildings was either brought as loot from foreign conquest or was created by Etruscan or Greek artists. Skilled in the practical aspects of ceramics, and master builders, the Romans were famous for their bricks, but when it

came to sculpture, they called in foreign artists and commissioned them to create the type of architectural decorations that best suited Rome's secular and materialistic taste. Skillfully modeled, probably by Greek slaves, these decorative panels that often showed domestic scenes, or scenes from mythology, lacked the intensity of expression the Etruscans brought to their clay sculpture.

The Orient

The use of clay for building and for architectural sculpture was not confined to the Mediterranean world. In China, bricks were molded with reliefs, then painted with slip. Probably colored with pigments, these bricks were used on tombs or sanctuaries (7–6), while elaborate terracotta roof ornaments also decorated the gables of palaces, temples, and ceremonial gateways. In addition, although the freestanding ceramic sculptures of tomb guardians and meditating lohans were not actually part of the sculpture of buildings, they also formed an important element in their design (2–8).

7-6 This decorative brick once added vitality to the Hsiu-ting-ssu pagoda in Anyang, China. Made of gray clay coated with yellow slip, it depicts a dancing man in the characteristic costume of western Asia. T'ang dynasty, c. A.D. 625–650. *Courtesy of the Asian Museum of San Francisco, Avery Brundage Collection.*

India

During the Gupta period in India (fourth to sixth centuries A.D.), when so many temples were built, stone was the preferred material for architectural sculpture, but stucco and clay also were used (7–7). Modeled, molded, or carved, clay was formed into images of Buddhist deities who were portrayed as kings and princes surrounded by the trappings of court life. Ruled by crafts guilds, the sculptors had little creative freedom, for each gesture, every attribute, even the colors were prescribed by regulations formulated from scriptural references.

The tradition of building brick temples covered with clay images was especially strong in rural Bengal, where it persisted well into the nineteenth century (7–8, 7–9).

These decorated brick village temples were made by guilds of builders who traveled from place to place, erecting temples that were commissioned by people in all walks of life. Although alluvial clay was abundant, not all of it was suitable, and the guild members would search out the best local clay, usually mixing it with sand or rice husks, sometimes with mashed jute. Once the master builder had worked out his design and the workers had experimented with batches of local clay, the structural bricks and the sculptured plaques were

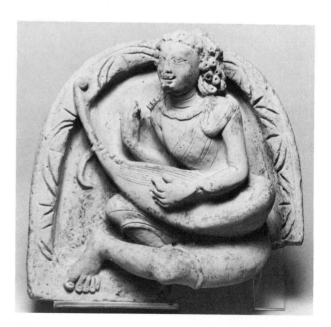

7-7 The figures sculptured on the walls of temples in the Gupta period in India appear to be members of the luxurious court, but in reality they often represented deities. Fifth century A.D. Central India. *Courtesy of The Trustees of the British Museum, London.*

7-8 Terracotta temple facade, Lakshmi-Janardana Temple, Surul, Bengal. The clay decorations that cover the facade depict scenes from the epic *Ramayana.* Mid-nineteenth century.

7-9 Royal ladies attending to their toilet. Typical of the terracotta sculpture are the swelling forms that seem almost to burst through clothing and skin, expressing spirituality through the curves of the body. Detail from left section of facade, Lakshmi-Janardana Temple, Surul. Mid-nineteenth century. *Photos: courtesy of Lalit Kalà Akademi, New Delhi.*

111

formed, the details were carved, and the reliefs were fired at the site in kilns built of clay.

The earliest of these temples which still exist date from the seventeenth century, although the tradition is obviously much older than that. The decorations usually show religious figures, and scenes from the epics and from daily life. In the village of Surul, for example, about a dozen clay temples were built about 1830, most of them covered with sculptures of goddesses and gods and mythological scenes.

Islamic Countries

In the Islamic countries, where making any three-dimensional image of animals or humans was considered an insult to Allah, the use of clay in architectural sculpture was generally restricted to flat glazed tiles, sometimes with a few low-relief embellishments or with quotations from the Koran molded in raised designs.

Europe

Although Islam made little direct contribution to clay sculpture, the glazes and lusters that the Islamic potters perfected and used to color the tiles on mosques and minarets were brought to Spain by the Moors and reached Italy about 1300. Potters in Italy soon learned to use these tin glazes to cover earthenware, and it was the same glazes that were further developed and refined by the Della Robbias in Florence. Working in secret, Luca (1399–1482), Andrea (1435–1525), Giovanni (1469–1529), and other family members covered Madonnas, saints, wreaths of fruit, and cherubs with soft, opaque colors—rich, creamy white, clear blue, yellow, and green (6–4).

At the same time that the Della Robbias were creating their glazed sculpture, anonymous clay workers were using unglazed clay to produce molded bricks with which to decorate the buildings of northern Italy. In Cremona, Pavia, Bologna, and other northern Italian towns, most of the windows, arches, and doorways were highlighted with these modular units stamped with twining foliage, dolphins, cherubs, or abstract patterns. In fact, one late-fifteenth-century Bolognese building has an entire facade of decorative bricks combined with terracotta sculpture. Where good low-fire clay was available, these decorative bricks were manufactured in quantity and their sizes were controlled and standardized; for example, the measures used

to make sure that the bricks were up to standard can still be seen on the facade of Bologna's fifteenth-century city hall.

Also working in northern Italy, an active group of sculptors chose the plentiful terracotta to create sculpture for architectural purposes. One of these was Niccolò dell' Arca (d. 1494), who executed many commissions for buildings and tombs, sculpting them in both marble and clay. Several such commissions given to Dell' Arca are mentioned in the ancient archives of Bologna, and his terracotta Madonna still gazes down on the main piazza of that city (7–10). (See also 8–11, 8–12.)

In England, where Italian sculptors were invited by the Tudor kings, they, along with Italian-influenced English sculptors, not only modeled portrait busts in clay (6–3) but also created terracotta figures that were incorporated into the elaborate late-Gothic and early-Renaissance tombs that memorialized kings, nobles, and bishops in English churches.

In the centuries following the Renaissance, in other parts of Europe, especially in the Low Countries, homes, shops, churches, and barns were largely built of bricks, but little sculpture was commissioned to decorate them. When porcelain became fashionable due to Chinese influences, a few monarchs—Queen Maria Amalia of Naples, for example—called on the modelers at the royal porcelain factories to panel whole rooms with Rococo fantasies in ceramic relief, while J.J. Kändler at the Meissen factory in Germany was commissioned to create a large porcelain altar and to decorate a royal palace in Japanese style.

While such extravaganzas were being constructed in Europe, traditional village builders in parts of Africa were continuing to use mud and clay for building. With it they decorated the interiors of mosques with low-relief patterns, and later, in the nineteenth century, they modeled images on the exterior walls of their mosques and houses. One could also say that in Africa the use of clay as a sculptural medium extended to the forms of the buildings themselves, for the mud houses of the Dogon and the granaries in the Nok areas were themselves shaped like large sculptural pots.

In the nineteenth century, in the United States as well as in Europe, the revival of various historical building styles—especially the Gothic Revival—encouraged the use of ceramics, both glazed and unglazed, for architectural decoration. To

meet the needs of builders, the English family who owned the Coade clay works developed a clay body that fired to a dense, durable material. Naming it Coade Stone, they used it for architectural decorations as well as for freestanding sculptures (10–11).

One architect in England, Alfred Waterhouse (1830–1905), recognizing the potential of clay as a functional and decorative material, chose terracotta to create a repository for the collections of the National History Museum in London. Concerned about the possible effect on the exteriors of buildings of London's sooty and acid-laden air, he decided that a dense, fine terracotta would best withstand its pollution and could be easily cleaned. Employing this material both inside and out in two colors—a warm tan and soft gray—he designed a veritable jungle of foliage in which birds, beasts, and fish crawl, fly, and climb over the building's arches, columns, and windows (7–11, 10–13). Unlike the Romanesque style of the building itself, the sculptural details that Waterhouse designed were totally original, based on a study of actual zoological and botanical specimens. Waterhouse's imaginative use of clay was exceptional, however, and on the whole the ceramic detailing on city buildings at this time was copied from earlier periods (7–13).

U.S.A.

In the United States, another museum used a historical style—the Classic Greek—to house its treasures. The Philadelphia Museum of Art, apparently conceived as a temple of culture, was decorated with large terracotta sculptures in its pediment (7–12). Painted in the brilliant colors typical of Greek temple decorations, they give us a good idea

7-10 *The Madonna of the Piazza,* by Niccolò dell'Arca, has been gazing down on the citizens of Bologna since 1478. The artist signed his name at the base. Terracotta, late fifteenth century.

7-11 The entire building—inside and out—of the Natural History Museum, London, is decorated with terracotta birds, animals and flora. Architect Alfred Waterhouse (1830–1905) employed a dense terracotta to resist the pollution of Victorian London. The building, completed in 1880, has been cleaned recently, and the gray and blue tones are still bright and the details sharp. (See also 10-13.)

of what those decorations probably looked like in the bright sunshine of Greece.

This love of eclecticism in architecture and of ceramics as a decorative material seemed to go hand in hand. Colorful tiles or monochromatic terracotta were used to create every conceivable style of decoration on the facades of commercial buildings, warehouses, and, later, movie palaces, in a mass borrowing from the past that put decorative motifs designed by former cultures onto nineteenth- and twentieth-century buildings (7–13).

In the late 1930s and 1940s in the United States,

7-12 Terracotta decorations were popular in the United States as well. In Philadelphia, the Greek Revival Museum of Art was designed with polychrome terracotta figures in the pediment. This detail, depicting gods, goddesses, and heroes, dispels any ideas we may have about pure white marble temples in Greece. All the figures are brightly colored. The sculptor was Paul Jennewein. *Courtesy of the Philadelphia Museum of Art.*

7-13 Terracotta facade of the Maskey Building in San Francisco was recently the subject of controversy: denied landmark status by board of supervisors, it is to be torn down to make way for a savings and loan association. 1982.

some clay sculptors were commissioned to execute sculpture for integration with architecture. Weylande Gregory (8–4), for example, modeled a large fountain for the 1939 World's Fair, and Lily Saarinen created reliefs and freestanding sculptures of animals for schools (10–14). After World War II, when factories in Europe set up experimental studios, potters and sculptors who designed production pottery also began to create large architectural works, and ceramics again began to be used on buildings in a way that was at the same time traditional in application and contemporary in design.

VIKTOR SCHRECKENGOST, U.S.A.

One American artist, a descendant of several generations of potters, moved from pottery to clay sculpture, and also became an influential industrial designer, teacher, and painter as well. Viktor Schreckengost's sculpture has frequently been humorous, and has always had a quality of warmth and earthiness. Called on to execute terracotta decorations for the Cleveland Zoo, he created reliefs of birds for the aviary as well as a large relief of mammoths for the Pachyderm Building (7–14).

Schreckengost used press molds to form the sections of his *Mammoth* relief, creating a sculpture that became part of the bearing wall. To begin with, however, he made a quarter-size model from his original sketches, casting it in plaster for reference. Next, a huge armature was built, and a full-sized clay model was made on it, including about 10 percent enlargement to allow for shrinkage. Schreckengost says, *The reason for not firing the original large clay model was to insure that we*

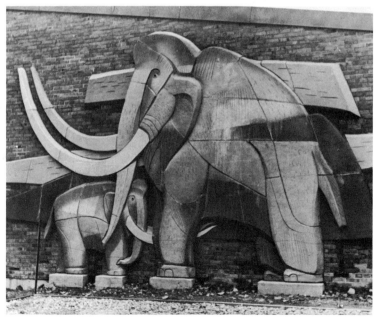

7-14 In the 1950s, Viktor Schreckengost, U.S.A., was commissioned to execute a terracotta mural for the elephant house at the Cleveland Zoo—a mammoth mural of a mammoth. Above: Schreckengost working on the full-size model from which plaster press molds were made. Below: The completed relief is built into the bearing wall of the pachyderm house. Terracotta with vitrified engobes. 1956. 13'6" × 25' × 8" (4.1 m × 7.5 m × 20 cm). *Courtesy of the Cleveland Metroparks Zoo.*

could replace any parts which did not come through the firing in good condition.... As I remember, it was only necessary to remake two pieces.

This full-sized model was cut into fifty pieces, and plaster molds were made of each piece. Terracotta clay was then pressed into these molds, and about eight inches of clay were added to the back of each piece to enable it to be built into the bearing wall. The largest of these pieces weighed about six hundred pounds, and the final fired relief was twenty-five feet long. Schreckengost recalls that *a vitrified engobe was applied to the surface in a range of earth colors; burnt sienna, ochre, sepia, browns and grays.... Caulking was stained to match the surface colors. During the past twenty-seven years it has been recaulked, but there have been no cracks or changes of color even though they have been through a few very rough winters.*

In the 1950s, such a large clay sculptural commission was rare in the United States. Today, however, in the United States as well as in Europe and

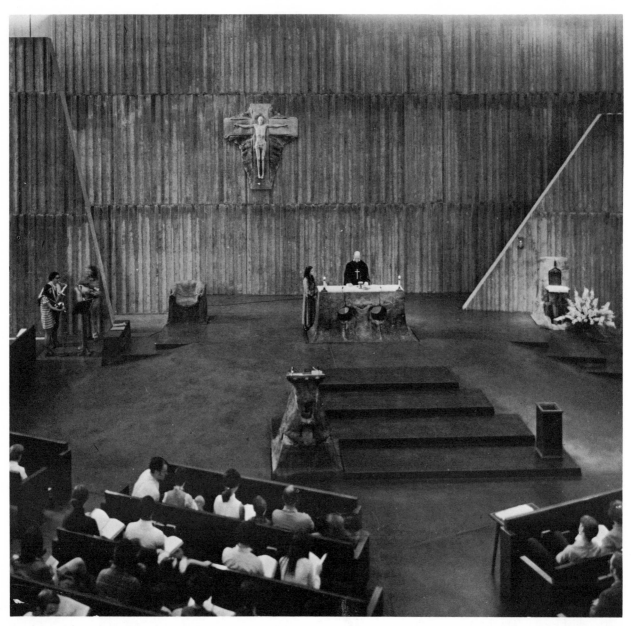

7-15 In the sanctuary of the Holy Spirit Chapel at the Newman Center, University of California, Berkeley, Stephen De Staebler, U.S.A., carried his concern with landscape forms into architecture. Mounding the sanctuary floor, he designed the altar, lectern, tabernacle and chair to relate to its earth form, completing the composition by placing the crucifix on a landscape background. 1967–68. Stoneware and bronze. *Courtesy of the artist. Photo: Karl H. Riek.*

Japan, sculptural ceramic works of many types are commissioned for schools, hospitals, banks, subway stations, and homes. They range from monolithic columns (7–16) to murals in zoos (7–14), from fountains (7–27, 7–28) to chapel interiors (7–15) and memorial arches (2–28). In these large works the clay has been used creatively, with meaning for today, no longer as Classic or Renaissance ornament applied to contemporary buildings (Colorplate 13).

Architectural commissions like these are created under various working conditions. A good number of the artists produce architectural sculpture in their own studios, ingeniously working out ways to fire huge monoliths or tall murals in their studio kilns—building, glazing, and firing them themselves, perhaps with the help of one or two others (7–16). Others may work in a team situation in a factory, while some may turn part of the construction work over to a well-equipped workshop that

will build, glaze, and fire the components to the artist's specifications (7–33).

Whatever method is adopted, there are certain considerations the artist must take into account when planning large-scale architectural work. Aside from the aesthetic aspects, there is the matter of viewing angle, scale, the relationship of the work to the setting, and, of course, technical considerations that may influence the design. For example, in a work that is to fit into a specified area, shrinking and warpage are critical considerations, and measurements must make allowances for them. Often engineers must be consulted, and the sculptor may have to deal with special mortars, resin cements, or steel supports (7–18, 7–23). If the work is to be installed outside, weather resistance, vandalism, and even earthquakes may pose special problems, and there are usually legal and contractual questions to be settled. Although the artist

7-16 Left: Stephen De Staebler working on the supporting framework of an architectural sculpture, *Canyon*. Right: The upper layer of slabs is in place, and the piece

has been sectioned for firing. De Staebler reaches inside to check the joining of the upper slab and interior supports. 1982. *Courtesy of the artist. Photo: Scott McCue.*

who is used to working alone in a studio may find working in collaboration with an architect, fabricator, engineer, construction crew, or landscape architect a new experience, such teamwork opens the door to a wider range of possible uses of clay, and can be a real challenge.

In the pages that follow, we can see how some sculptors, in a variety of working situations, create sculpture for architectural use, how they maintain their original concept through the months of work involved, and what procedures they follow to make the fabrication go as smoothly as possible. Each commission brings its own set of problems that each artist confronts and solves in his or her own manner. There are no set rules that can be followed, and every new project calls for discipline, hard work, and guts—plus a touch of luck.

STEPHEN DE STAEBLER, U.S.A.

Stephen De Staebler builds and fires his massive architectural sculpture (Colorplate 6) in a studio located in an industrial area beside San Francisco Bay. Freight trains occasionally rumble past outside while inside the activity of building and firing the massive sections of the sculpture is carried on.

Commissioned to create a sculpture for a bank plaza in southern California, De Staebler decided to build two tall columns of rough-textured clay that would swell and twist slightly as they rise up toward the sky. The walls of the sculpture, aptly entitled *Canyon,* shade from earth tones up to blue.

Building a towering sculpture is nothing new to De Staebler, who has executed numerous architectural commissions—one of them thirty-seven feet tall—but each new work brings its own set of challenges. This piece was built in a horizontal position on the studio floor, using the hand-formed slabs that the artist favors. Hand-formed is perhaps not the right word, because while making his slabs De Staebler will use his arms, feet, or entire body if necessary. He prefers to use as few mechanical aids as possible at all stages, since for him the total involvement of his body is an important part of the creative process. He says: *I am doubtful I can sacrifice that part of the physical involvement without sacrificing part of the psychic involvement.*

Once the first slabs of *Canyon* were laid down and had stiffened, he built up a structural network of walls on top, then waited for them to stiffen before covering their edges with a thick coating of slip in preparation for setting the final layer of slabs in place (7–18). When the hollow sculpture reached just the right degree of stiffness, De Staebler sliced through it with a wire to section it. The timing of the cutting is critical, for if the clay is too soft, the forms may be damaged, but if it is too hard, it may be impossible to pull the wire through.

Since his studio is only about four feet above the level of the Bay, it is inclined to be chilly and damp, so slow drying is no problem. De Staebler says that he discovered early on in his work with clay that *you don't try to do everything all at once. You have to wait for the clay.* In the case of *Canyon,* the waiting extended over four months while the thick slabs of the sculpture dried.

Once the sections were dry enough, they were fired a few at a time, a process that stretched out over several days for each load. The loading alone took hours of demanding work as De Staebler and his helper, John Toki, placed the sections in the kiln. Using a hoist to bring the sculpture into loading position in front of the kiln, they then carefully juggled each piece into place (7–17).

In the course of completing any clay sculpture, an artist usually lives through moments of crisis, and the building and firing of *Canyon* was no exception. Just at the end of the last loading, as the final piece was being positioned in the kiln, one of those unpredictable events that give artists nightmares occurred; the kiln shelf on which it was resting broke under it. Fortunately, the built-up fire bricks supported the section and kept it from falling on those below, but until extra props were arranged, its fate, and that of those under it, was uncertain. Once it was securely propped, De Staebler, realizing that he and Toki were both tired and that that is the time when the worst accidents occur, decided to leave it overnight. They returned the next morning to ease out the broken shelf, replace it, and turn on a heater to give the sculpture a final drying before bricking up the kiln and lighting the gas. In this case, the firing itself took five days for each load.

Canyon's rich color was achieved with dry coloring material applied to its surface, gradually shading up through beige tones to blue. When the sections were fired, some of them received a greater reduction and higher firing than others, darkening and muting the colors somewhat. Taking advantage of these variations, De Staebler worked out the placement of the sections in the kiln with great

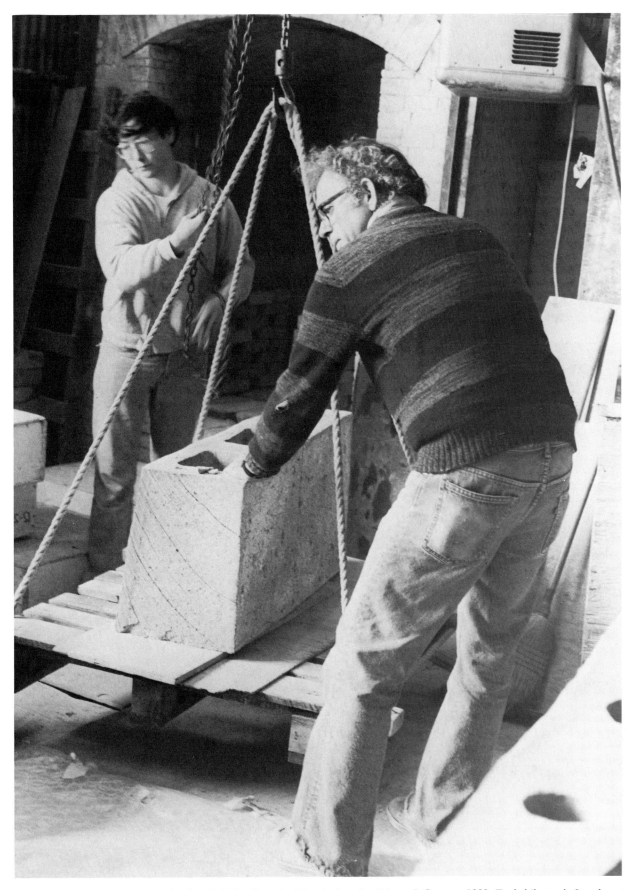

7-17 Stephen De Staebler and John Toki loading the kiln during the firing of *Canyon*, 1982. Each kiln took five days to fire. The sections were moved to the kiln with a hoist, but then it required careful juggling and muscle power to place them in the kiln. Stoneware with applied dry coloring materials.

care, creating an apparently random, but actually carefully planned, pattern.

With the piece completed and transported to the site, De Staebler, John Toki, and Tom Stamper worked along with the installation crew as they positioned it on its engineered steel framework (7–18).

Finally, months after its conception, the sculpture took on a new life as sunlight touched the tops of the installed columns. It was the culmination of a process that took a raw material from the earth and, using the creative imagination of the sculptor, the force of his body to form it, minerals to color it, and the heat of the fire to harden it, transformed the clay in a manner that echoes the action of the geological forces of heat and pressure that molded and shaped the earth.

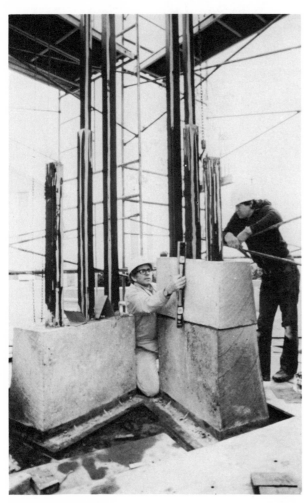

7-18 Installation shot of *Canyon* shows the engineered steel supports that hold it in place. De Staebler has the engineers work out the support system before he starts on a work of sculpture, so that he can build the accommodations for structural supports into the clay forms as he goes along. *Courtesy of the artist. Photo: Jerry Newton.*

PETRA WEISS, Switzerland

Petra Weiss is also inspired by nature, by the *contemplation of nature in all its forms, structures, movements, moments, changes, impulses, and rhythms.*

Petra Weiss lives and works in a hillside village on the border between Italy and Switzerland. Working with simple tools and a small kiln in what seem like very small quarters, she is nevertheless able to execute large architectural commissions by careful planning and ingenious methods. Her studio space consists of what were once the stables and outbuildings attached to a large house, and her pleasant living area above her kiln room is a remodeled hayloft. Each room is small, and it is only when the weather is good that she can lay an entire work out in the courtyard and see it as a whole. In order to build, fire, and glaze a mural that may be as much as thirteen meters long, Weiss uses modules that can be modeled and fired in sections (7–19 through 7–22).

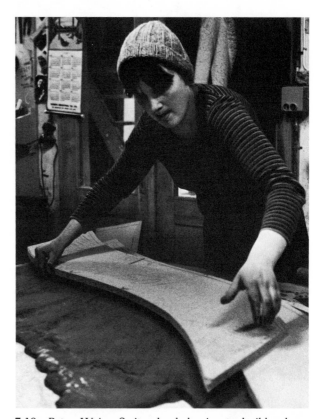

7-19 Petra Weiss, Switzerland, begins to build a large mural for a retirement home by laying out the wooden pattern on a handmade slab, then cutting around it. *I mix the clay myself from various clays. It is formulated according to the needs of the work.* This clay was stoneware. *Courtesy of the artist. All photos of Weiss: Bindella-Heitmann.*

Once the composition of a large sculptural commission is clear in her mind, Weiss draws a full-sized cartoon on paper, breaks the composition down into large elements, and draws these on chipboard panels. She also makes a scale model of the piece and executes several finished sections as samples to show the clients and to test the glaze. She then takes the chipboards to a local lumber shop, where they are cut to become templates that help her keep the overall rhythm intact as she works on the individual numbered sections.

Starting with a slab that she makes by hand, pounding and slapping it to about three-quarter-inch thickness, she cuts it to shape, using the wooden panels as guides (7–19). It is on these slabs that the relief is developed, sometimes with extruded tubes, sometimes with additional slabs that she shapes into undulating forms over wads of clay. Once the sections are built, she places each numbered section on slatted demountable shelves in her kiln room, where they dry before the bisque firing. It is only when they have all been bisqued that she brings the wooden templates out into the courtyard and assembles the work again for glazing (7–21). Weiss fires in an electric kiln, and one of her large works may take about ten bisque firings and up to twenty glaze firings.

From its conception, through the drawings, the

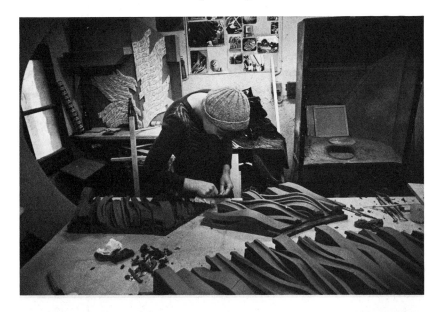

7-20 Weiss begins to assemble the extruded tubes and the slabs. Altering and twisting the forms, and sharpening the cuts with a wire, she builds the sections. The model shows how the mural will extend around a corner to cover two walls.

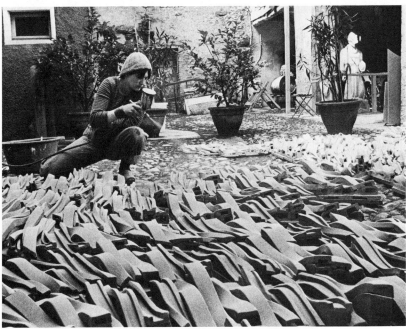

7-21 Weiss sees the piece in its entirety for the first time when she assembles it in the courtyard for glazing. She uses ash glazes which she formulates to produce dark browns, or browns that shade from a rich, warm medium brown to ocher. 1980.

model, and production to final installation, a wall commission may require about six months to complete. During these six months, Weiss will have carried each of the hundred-odd pieces from slab table to shelf, to kiln, from kiln to shelf, to courtyard and back again—about ten trips per slab. Realistic about the work involved, Weiss nevertheless still finds it a rewarding process and speaks of the *continually fascinating contact with the four elements—earth, water, air, and finally fire, which, brought together, give us ceramics as the end result.*

ALAIN TREMBLAY, Canada

Alain Tremblay feels that the most important factors that led to his involvement in what he calls environmental sculpture were: *Firstly, a certain love of challenge and secondly my fascination for the ancient civilizations where the works of art stand out proudly in public squares rather than locked up between four walls in a room. . . .* With this philosophy, he naturally was drawn to the idea of creating sculpture for exterior use, but he found that placing fired clay sculpture outside in a climate where winters are severe creates additional problems for its creator. In order to do this successfully (some of Tremblay's outdoor installations have withstood ten years of Canada's alternating freezing and thawing weather), Tremblay has worked out a careful process from mixing the clay to firing the sculpture, to installation (7–23, 7–24). Working in his studio on an island in the river near Quebec, he uses stoneware, firing it to 1,300°C to give his work maximum resistance and impermeability, following his own recommendations:

7-22 Left: Before transporting the mural to the site, Weiss or a helper have cemented two or three sections together, reinforcing them with steel rods. Pins were cemented into the back of sections and will be cemented into holes in the wall. After many trips up the scaffolding, car-

rying section after section, the artist has almost completed her work. Right: With the mural completed and the sun room in use, the artist's fatigue vanishes in the satisfaction of seeing an idea realized.

7-23 Alain Tremblay, Canada, *Autumn-Springtime*. Wheel-formed columns that seem to wave in the breeze bring animation to the facade of a government building. The stoneware forms have a magnesia glaze and are fired to 1300°C (2370°F) to ensure impermeability—an essential in Canadian weather. *Courtesy of the artist. Photo: Daniel Gagné.*

7-24 The columns are reinforced with rods and filled with concrete that is vibrated in place. Scaffolding holds the entire structure in place while the concrete dries for twenty-four hours.

- *If there is no danger of vandalism, it is safer to leave the hollow of the sculpture empty.*
- *The stoneware has to be completely vitrified with 0% absorption. Test the batch.*
- *Get an engineer's plan for installation. Make sure that soil water does not penetrate the sculpture by capillary action.*
- *Make certain that the joints between sections or any opening are waterproof.*
- *Place a temporary roof over it for the first winter, preferably with a heating element around it.*

To weatherproof and give stability to the bending columns of the sculpture that he installed outside a government building, Tremblay used steel rods with steel wire surrounding them, and filled the hollows with cement.

ULLA VIOTTI, Sweden

Ulla Viotti loves the water and the beaches along the shore of southern Sweden where she lives and works in a remodeled farmhouse. Even during a hard Scandinavian winter, she says, *when it is not too cold or stormy, I go down to the beach and find inspiration.* An active environmentalist, Viotti brings the inspiration that she gets from nature to sculpture that often expresses her love for beaches and water (7–26).

Viotti, who has an art school background, started working in clay as a potter, but in the last twelve years she has mostly been creating sculptural ceramics formed of modular units. She says her working method is to *roll out the clay and form it and press tools into it before I tear it apart into pieces and bend it and model it and press it together again.* Occasionally she uses press molds to create her modular units. With these units, she assembles permanent murals and movable wall panels, as well as what she calls water reliefs, in which she may combine ceramic forms, natural rocks, and running water to *recreate memories of the lovely summer beaches.* Viotti's sculptural reliefs are all once-fired stoneware, and she uses no glazes, achieving her colors with oxides. Her favorites are iron and cobalt, because with them she can recreate the browns and blues of the natural environment that inspires so much of her work.

7-25 Barbara Grygutis, U.S.A., installation in a private residence. Working in the American Southwest, Grygutis brings a sense of open space to her architectural work. She cuts out her slabs with paper patterns when the clay is leather hard, then puts the pieces together *like cardboard boxes.* Two of the forms are coated with oxide-colored slips; one is painted black. Earthenware. 8'4" and 5' × 15" (2.5 m and 1.5 m × 38 cm). *Courtesy of the artist. Photo: Timothy Fuller.*

Clay Sculpture and Water

Water, splashing in fountains or mirrorlike in reflecting pools, has been a feature of architecture for centuries, and ceramics have been linked with water use since the days when Greek fountains spouted spring water through terracotta lions' heads.

Since fired clay does not deteriorate in water, it has been used over the centuries in many ways in relation to water, and today, water cascades, drips, or sprays over ceramic forms in a variety of architectural settings and styles (7–26 through 7–30). Ulla

7-26 Ulla Viotti, Sweden, combined blue oxide-colored forms with natural rocks in a relief for a wading pool. Every ten minutes a spray of water plays over the wall. Stoneware; once-fired at 1280°C (2340°F) in an electric kiln; 8 × 27′ (2.5 × 8 m). *Courtesy of the artist. Photo: Bengt Goran Carlsson.*

7-27 Kimpei Nakamura, Japan, using blue-glazed stoneware components over which the water flows, created an animated contrast to a stark architectural background. 1974. Stoneware. 11 × 13′ (3.5 × 4 m). *Courtesy of the artist. Photo: Osamu Murai.*

7-28 Beate Kuhn, Germany, designed a fountain that was fabricated in a stoneware pipe factory for a park in Mannheim. Made in plaster molds of the same white clay as the pipes, it was raw-glazed with the artist's glazes, then fired to about 1280°C (2340°F) in the huge gas kilns at the factory in an oxidation firing. The vessel forms are mounted on steel rods. Approximately 6'10" (210 cm) each dimension. *Courtesy of the artist. Photo: Jochan Schade.*

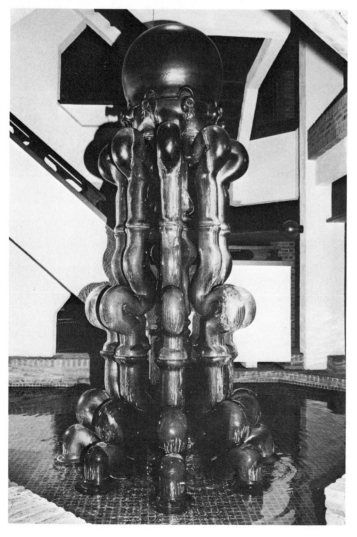

7-29 *Octopus,* a massive fountain by Huub Commans, Netherlands, stands in a shallow pool in the stairwell of the Provinciehuis in Utrecht. Commans says, *The glazes have an iron saturation which causes a dark earth color to appear that emphasizes the objects' heaviness.* The water that slowly slides over the brown-glazed surface seems to echo the deep colors of the water in Holland's slow-moving canals. Height 11.5' (3.5 m). Stoneware. *Courtesy of the artist.*

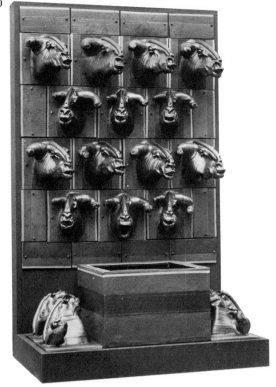

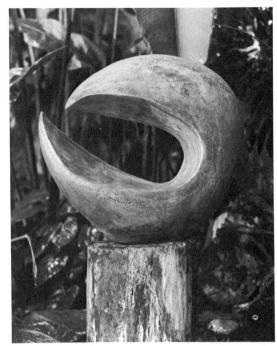

7-30 Marilyn MacKenzie, U.S.A., combines slabs and altered thrown forms to create her wall fountain. She has found that a single firing works best for her, so she sprays her glazes directly on the dry clay, skipping the bisque firing. Stoneware; 3′9″ × 2′4″ (114 × 70 cm). *Courtesy of the artist.*

7-31 Garden sculpture by Silvia Blanco, Puerto Rico. Blanco says: *My sculpture is mostly intended for gardens, and I strongly favor local reduction. I feel that art in the tropics must be colorful to capture interest and stand out among our vivid landscapes, lush vegetation, and bright weather.* 1981. Reduction firing. 20 × 26 × 10″ (51 × 66 × 25 cm).

7-32 *Kwel.* Dale Enochs, U.S.A., says, *My work is designed for outside placement in secluded settings. The interaction of sunlight and shadow and natural elements is an integral part of the pieces. Made of high-fire stoneware clay, stained with various oxides and minerals, they are impervious to the changes of northern weather.* Height 8′4″ (2.5 m). *Courtesy of the artist. Photo: Lee Edgrin.*

Viotti utilizes natural forms and colors for her water reliefs, while Marilyn MacKenzie replaces the traditional lion's mouth spout with a whole flock of sheep. Kimpei Nakamura designed a freestanding fountain in which he used glazed modules, creating a clifflike form over which a sparkling waterfall pours. Huub Gommans, on the other hand, builds massive fountains whose earthy brown glazes reflect the dark tones of Holland's slow-moving canals, while Beate Kuhn strung a series of glazed vessel forms on steel rods, creating an assemblage that suggests enormous drops of water.

Collaborative Fabrication

Although most of the work discussed so far in relation to architecture has been executed by sculptors working alone in a studio with the help of perhaps one or two others, some of it, like Beate Kuhn's fountain, was made in a factory situation. Since the days when J. J. Kändler decorated a Japanese palace, European ceramics factories have had a long tradition of maintaining staff sculptors or modelers to design and create prototypes, or original works, for fabrication at the plant. After World War II, several European factories set up experimental studios where artists not only created designs for functional ware but were also encouraged to explore

Clay sculpture that is intended for outdoor use may also be placed in garden or park settings, where the sculptural forms must carry against surroundings whose colors and complexity will both enhance and compete with the sculpture. Silvia Blanco, of Puerto Rico, for example, who makes most of her work for garden settings, finds that she has to take into account the tropical surroundings, where the forms are lush and the colors are brilliant (7–31), while Dale Enochs, U.S.A., feels that the play of light and shade adds vitality to his sculpture (7–32).

new avenues in their own work, and to learn skills that enabled them to execute large commissions. In the United States, England, and Japan, industrial producers of ceramics have also sponsored a variety of programs that have brought ceramists, painters, and sculptors into the factory to work on personal or collaborative projects in clay.

Another type of ceramics enterprise—halfway between a studio-workshop and a factory—was opened in 1968 in Holland when two young ceramists decided to combine their know-how and set up a situation where artists could come and work in a well-equipped studio, or have their creations exe-

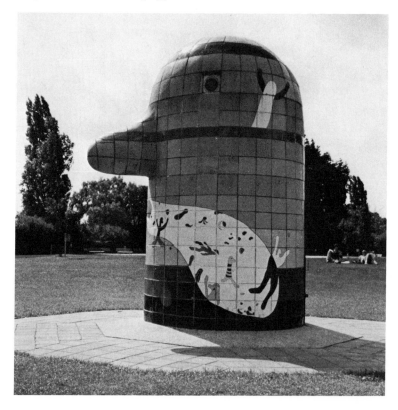

7-33 Jan Snoeck, Netherlands, likes his sculpture to be used, climbed on, sat upon and enjoyed, and their strong construction and weather-resistant glazes are well adapted to such uses. A trash eater in a park is both useful and decorative. *Courtesy of the artist and Struktuur 68.*

cuted for them by an experienced staff. Since then, Struktuur 68 has worked closely with artists who come from a variety of backgrounds, helping them to realize large projects in clay. One of the partners, Henck Trumpie, says: *I'd like to get art out of museums and onto walls and into public areas where it can be seen* (7–33).

JAN SNOECK, the Netherlands

Among the artists who have made use of the facilities at Struktuur 68 is Jan Snoeck, a sculptor whose training includes metal and stone. But, he points out, *the largest part of Holland is clay, formed out of slip; water/clay. When you are born here you must think in/about/with clay.*

A painter, sculptor, and writer, Snoeck has designed colorful sculpture for schools, shopping plazas, parks, electric power houses, and government buildings (7–33). Snoeck does not build his work himself, preferring to have it made for him by studios like Struktuur 68 and Porceleyne Fles, but he works in close collaboration with those who fabricate his sculpture, bringing the brilliant colors and organic forms of his fantasies to life.

Snoeck believes that there is room for joy and humor in architectural sculpture, and despite the continuing influence of De Stijl in contemporary Dutch architecture, architects and planners in Holland have given him ample opportunities to indulge in his sense of fun. His work includes colorful "worms" that crawl over walls and courtyards of schools and universities, cheerful sculptures of hospital beds (Colorplate 13), and a functional trash eater at a public swimming pool (7–33).

Collaboration with Industry

Mass-produced clay modules, such as glazed bricks formed in a wooden mold in ancient Mesopotamia (7–2), decorative elements produced in quantity in Renaissance Italy, or cast elements decorating a nineteenth-century museum (7–11), have been associated with architecture for almost as long as the art of constructing large buildings has existed. Adapting the mass-production of modules to contemporary taste and industrial methods, Italian sculptor and designer Nino Caruso feels that a relationship between the creativity of the artist and the technical knowledge of industry can be fruitful (7–35, 7–36).

As so often happens, Caruso developed his idea for a modular system as a result of a chance occurrence. Wondering what to do with the leftover wooden scraps from a large wall relief he had finished, he began to press clay into them. Then, joining the simple, geometric shapes that emerged from these press molds, he created some vases. When he casually stacked some of the vases together, he realized that they were like hollow building blocks that could be combined and recombined in almost endless variations.

Working out a method of cutting Styrofoam blocks to create related negative and positive forms, he made molds from them in which to cast new forms. Deciding that industrial materials would be better than any he could handle in his studio, and that a factory could cast the blocks faster and more economically than he could, Caruso collaborated with a company that mass-produces his modules. The modules can be used for bearing walls, as surfacing materials on a wall, or as units that can be stacked into freestanding sculptures (7–35, 7–36). In this collaboration, however, and in any project that might use his modules, Caruso insists that their placement and arrangement must follow his design.

In his book *Manual of Architectural Ceramics,*

7-34 At Struktuur 68 in Holland, sculpture is always built solid, then cut apart and hollowed when the clay is stiff. Glazed and fired, these sculptured components are then assembled and installed according to the artist's design. 1981.

7-35 With the positive and negative forms that emerge from a block of Styrofoam, Nino Caruso, Italy, makes molds from which modular units will be cast. Caruso points out that *with just four complementary pieces I have the possibility of enormous variation. It's a flexible sculpture, and it can grow according to one's needs—in both length and height. That's what interests me most—you can make freestanding sculpture, walls, garden walls, benches.* Pushing and guiding a Styrofoam block against an electrically heated wire, he cuts it into positive and negative forms from which he will make molds.

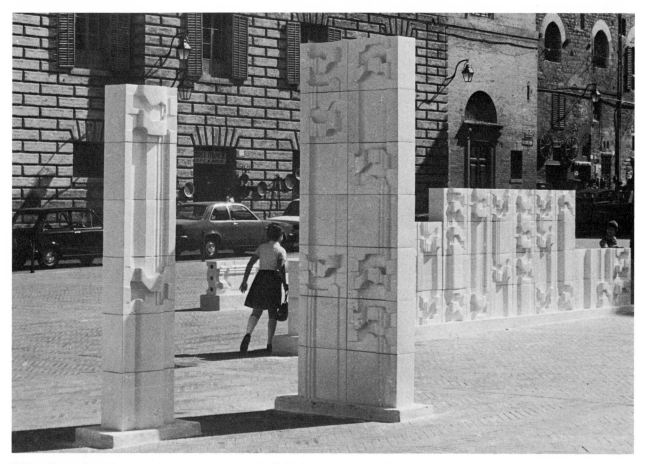

7-36 Above: Modules spread out on the piazza in Gubbio are waiting to be stacked onto freestanding walls and columns. Below: Echoing the horizontals of the ashlar facade and the verticals of the pillars, Caruso's walls and steles show the variations possible with a few modular units. Caruso refers to these variations in musical terms—pointing out their rhythms, rests, and pauses. 1981. *Courtesy of the artist.*

David Hamilton points out that he does not distinguish between studio and factory production in discussing the techniques of making bricks, tiles, and large-scale sculpture. He ends his introduction by suggesting closer collaboration between architects and ceramic artists:

> *Some of the heroic work of the past may serve as a beacon to those who recognize that decoration is not synonymous with depravity or decadence but is a striving for the humanity in architecture which should be the motivating force in any building design.**

As our urban surroundings become more and more dehumanized, it seems especially appropriate that architects should recognize and make use of clay sculpture to bring human values as well as visual and tactile enrichment to architecture.

*David Hamilton, *Manual of Architectural Ceramics* (New York: Thames and Hudson), 1978.

7-37 Elizabeth Langsch, Switzerland, called on to create a mural for a music room, captured the feeling of musical themes in clay. She built the mural in sections in her Zurich studio and glazed it with warm, light tones. 1980. Stoneware. 23 × 11′ (7 × 3.3 m). *At Seminar Pfäffikon, Zurich. Courtesy of the artist.*

Faces and Figures
Emerge from the Clay

*I will not be afflicted at men's not knowing me—I will be afflicted that I
do not know men.* —*Confucius (551–474* B.C.*)**

The motives that lead an artist to sculpt the human figure might be a desire to discover himself, or a desire to find identification with "the other." In this search, the visual, tactile person may find that modeling in clay offers the same means of discovery and expression that words offer the poet. At any rate, for whatever compelling reason or motives, clay artists throughout history have studied the human body and face, searching for the gesture, the expression that best interprets their own humanity or that of those around them.

At some time and in some place, almost every conceivable human type has been depicted in clay, as well as almost every deity that humans have imagined in their own shape. Kings, warriors, saints, lovers, children, athletes, actors, priests, bakers— standing, sitting, dancing, worshipping, making love, fighting—it would seem that the entire story of humanity, its everyday activities and its aspirations, has been created in this common material.

**Thanks to Margaret Keelan (8–18) who gave me this quotation.*

Clay is such a responsive material that it allows the sculptor to give direct, spontaneous expression to the emotions that move and motivate all humans, and through looking at clay sculpture we can learn a good deal about our early ancestors. Although we may find it difficult to understand or relate to the jaguar paw vessel or the trophy head necklace of a Zapotec priest (8–9), we *can* understand the awe of natural forces and the fear of crop failure that motivated the ritual he is performing. Indeed, without the records of humanity made permanent in clay, archeologists, anthropologists, and historians would be hard pressed to interpret entire civilizations of the past.

The use of clay for figurative sculpture has been so widespread that any attempt to trace its complete development would require a survey of world history. In this chapter and throughout the book, we can illustrate only a selection of figurative sculpture that shows how the human figure was modeled in clay as well as some themes that have been especially popular with figurative sculptors.

Mothers and Children

As we saw earlier, one of the most ancient sculptural themes was the female figure as a fertility symbol—sometimes alone, sometimes with a child. That image of maternity has persisted in clay sculpture throughout history, and mothers and children may well have been modeled, molded, carved, or cast in clay a greater number of times than any one other theme. A comparison of how the maternal image has been seen and handled by artists who lived in quite diverse cultures provides us with a glimpse into the life of people everywhere (8-1, 8-2; 8-4 through 8-7).

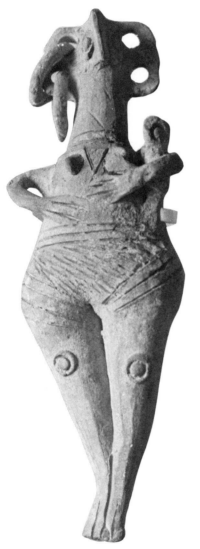

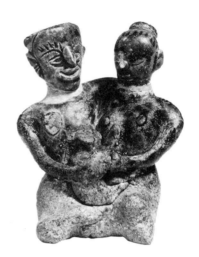

8-1 Maternity figures were among the first images created in clay, and have continued to be popular throughout history, varying from place to place and from culture to culture. Left: *Mother and Child* found on the island of Cyprus. Late Bronze Age, 1400–1050 B.C. *With permission, Soprintendenza Archeologica per la Toscana.* Right: A family group from Thailand. Sawankhalok, Thailand. Brown glaze. *Courtesy of the Brooklyn Museum.*

The Human Body

The human body, as we all know, is extremely expressive, with a capacity for gesture and movement that can convey joy, sadness, threat, exultation—the myriad emotions of humanity. Combined with the mobility of the human face, it represents an instrument of expression of great subtlety and force. In order to use it to its greatest potential, the sculptor must study how the body is constructed, what poses its bones, joints, and sinews allow it to take, what curves, knots, or hollows its muscles produce, how they contract or relax, and what their movements do to the expression of a face or the swing of a hip. Certainly a figure sculpture need not portray every wart or wrinkle, but whether it is representational, abstract, simplified, decorative, intense, or cool, it must relate in some

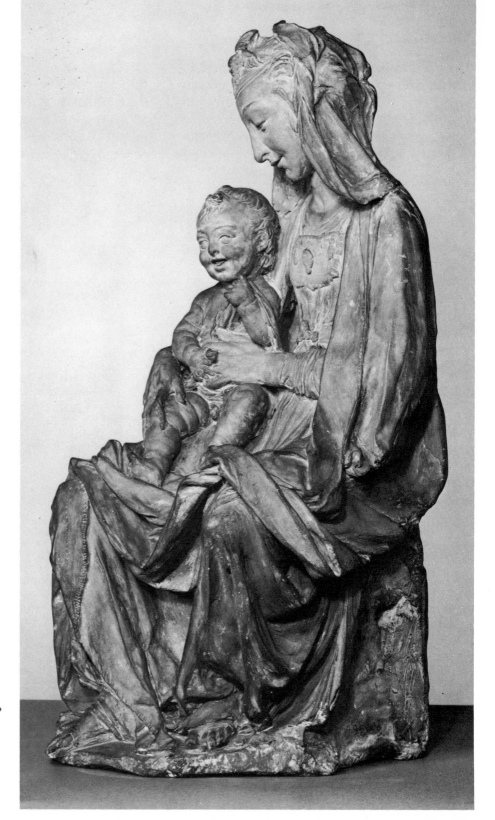

8-2 *The Virgin and Laughing Child* has been attributed to various artists, among them Leonardo da Vinci, but is now believed to have been modeled by Antonio Rossellino (1427–1479). It is possible that it was created as a model for a larger stone sculpture. Left: The hollow back shows the prints of the artist's fingers, and the folds of the cloak preserve the sweeping mark of his tool. Italy, fifteenth century. Terracotta. Height 19″ (48 cm). *Courtesy of the Victoria and Albert Museum, London. Crown copyright.*

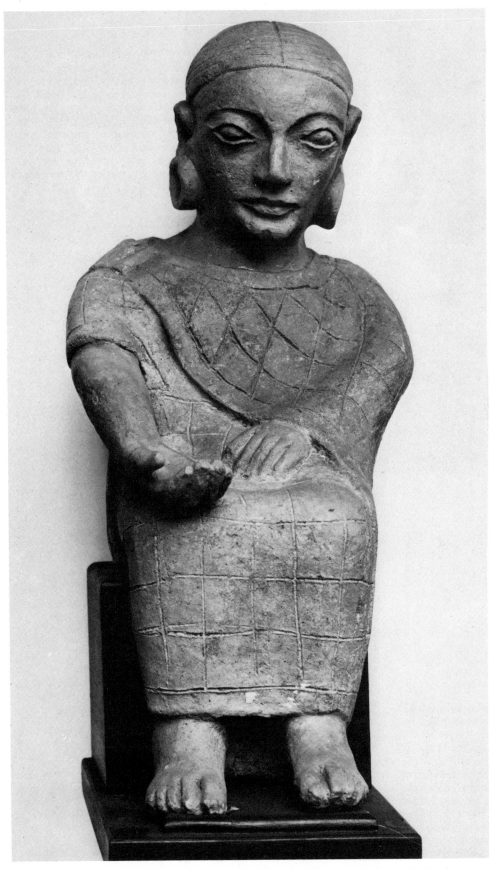

8-3 An early Etruscan figure, possibly representing a member of the deceased's family, it was part of the furnishings of a tomb. It shows the Etruscan interest in portraiture even at an early date. Seventh century B.C. Painted terracotta. *Courtesy of the Trustees of the British Museum, London.*

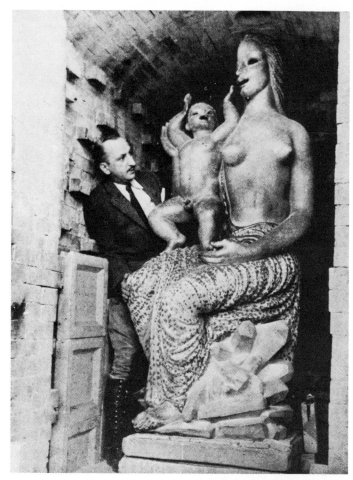

8-4 Weylande Gregory, U.S.A., *Mother and Child*. Gregory modeled this large image at a time when few sculptors were working in fired clay, and even fewer at this scale. Here the artist examines the fired sculpture in his kiln. Speaking of firing, Gregory has said, *the artist's work is now in the volcanic womb of nature and as the heat of the kiln is increased "aeons" and "aeons" of artificial time are projected upon the raw material of the ceramic sculpture.* (As quoted in *American Artist,* September 1944.)

8-5 Weylande Gregory's structural method was inspired by forms in nature: *If one has observed the crayfish build up the protective embankment at the entrance of his home in the earth or has seen the wasp build up the nest of mud something of the method of building up a ceramic sculpture is revealed. (American Artist,* September 1944.) Right and far right: Photographs show how Gregory built the structure, gradually filling in between the ribs. c. 1944. *Photographs from* American Artist, *September 1944.*

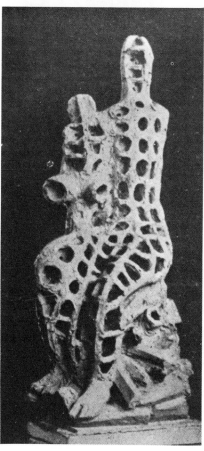

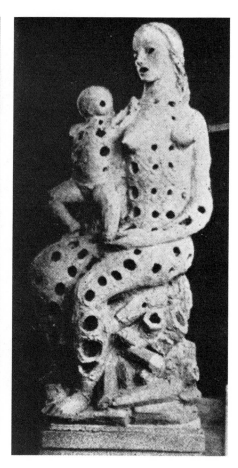

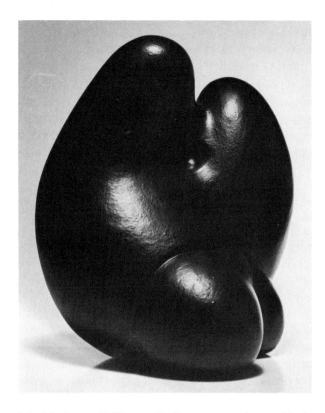

8-6 Norberto di Giorno, Spain, captures the symbiotic relationship between a mother and child by simplifying their figures. 1981. Stoneware. Black glaze. 15¾ × 11¾″ (40 × 30 cm). *Courtesy of the artist.*

way to the actuality of flesh, bone, muscle, and gesture. Even a fantasy figure depends for its impact on how it contrasts with reality.

From the rather self-satisfied figure of Zeus abducting Ganymede (Colorplate 1) to the dramatic expression of grief in a Pietà (8–11), from the joyous laugh of a child in Veracruz (8–9) to the sadness of *Charlie* (6–30), faces and figures made of clay continue to express universal human emotions.

Although today artists are not as concerned with the rules of proportion or with the wonders of human anatomy as were their artistic predecessors in the Renaissance and post-Renaissance years, one consideration that has preoccupied figurative sculptors from the time they first started to model or carve is the question of how to depict the figure's three-dimensional form in space, and how the forms relate to each other and to the viewer. Of course this applies to all types of sculpture, but because the figure is so complex and because it can only be distorted just so far, the sculptor who works with it in the round faces particular obstacles.

Benvenuto Cellini (1500–1571) wrote about one problem faced by the figurative sculptor. Describing an artist working in clay or wax, Cellini says that as he begins to model the figure, *he often*

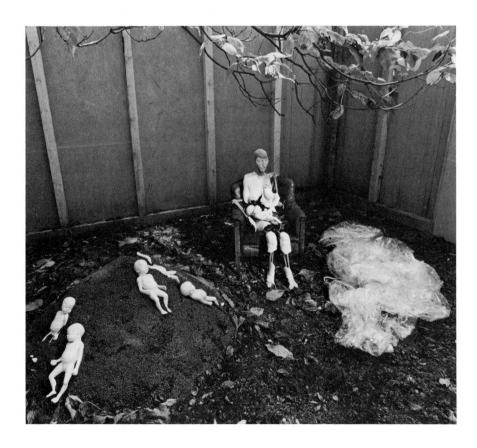

8-7 Klaus Ziegler, Austria, *Trivialities.* A half-skeleton, half-woman, and child sit next to a heap of basalt pebbles strewn with newborn babies. Installation in a park, Graz. 1979. *Courtesy of the artist.*

*raises, lowers, pulls forwards and backwards, bends and straightens every limb of the said figure. And once he is satisfied with the front view, he will turn his figure sideways . . . and more often than not he will find that his figure looks far less graceful, so that he will be forced to undo that first fine aspect he had decided upon, in order to make it agree with this new aspect.** This will have a familiar

Figures in Groups

Humans are social beings, and people in groups, related formally or narratively, have always fascinated sculptors. Conflicting or relating, attracting or repelling, even the most disparate group of figures is, by the common humanity of its components, related in some way. In the past, groups of figures like those on the roof of an Etruscan temple (7–4), the figures on an Indian temple (7–8), or those in a chapel niche (8–12) were often composed for a specific architectural location that dictated a particular composition. Today, when there is little call for figurative architectural sculpture, gallery installations in which the figures are placed in a particular scene or narrative are increasingly common, perhaps representing our mobile society's equivalent of the sculptures that used to tell a story or set a mood on temple or shrine (8–22, 8–24). In these installations the formal relationships between the figures as well as the composition of the space between them plays a part in developing the expressiveness of the whole group.

Faces

The human face, seen in all its changing moods, is mobile and spontaneous, recording the marks of life on its surface. Clay, so pliable, so varied in texture, so capable of imitating any color or surface, is an ideal material with which to capture the traces left by time and life. Idealized or realistic, distorted or sentimentalized, clay faces stare at us from times past with vitality and intensity (8–26 through 8–31; Colorplate 3 and 4).

Although almost all cultures depicted the human face, the attitude toward portraiture has varied from culture to culture, and the choices the artist makes about what aspects of an individual to

*Benvenuto Cellini, "I trattati dell'oreficieria e della scultura" in *Artists on Art*. Robert Goldwater and Marco Treves, trans. (New York: Pantheon Books), 1945.

ring to anyone who has worked in life class with clay, moving from one aspect of the figure to another, frequently feeling a great sense of frustration as a pose or a gesture that is expressive from one angle simply does not work from another one. And when there is more than one figure involved, the problems are compounded because of the added complexity.

In addition to the relationships between forms, there is the negative space to take into consideration. Even if we are not as concerned with "balance," "proportion," or "harmony" as Renaissance sculptors were, the space between objects affects our perceptions of the objects themselves, and can change the emotional impact of a work. Therefore, when a group of figures is created, the composition of the negative space as well as the positive form becomes an important factor (8–16). Of course, many gallery groupings of figures on exhibit are beyond the control of the artist, but the placement of even nonrelated pieces shown together has a decided impact on their appearance (8–22).

If you add the many variables of the human face to all these considerations, it is no wonder that the depiction of people has held such satisfaction and such frustration for sculptors ever since some Ice Age artist first formed and fired clay female figures (1–14).

emphasize not only tells us about the subject, but something about the artist and the culture as well. The Romans, for example, were realistic people, and any statue they commissioned, whether of general, emperor, merchant's wife, or young boy (8–8), had to be recognizable. Their interest in portraiture is discussed by Pliny, who contends that it was the Greeks who first invented portraits. This is unlikely, because the Classic Greeks not only idealized their images of gods, but they did the same with their heroes and victorious athletes, and it was not until the Hellenistic period that Greek society and Greek art became concerned with the individual and with portraiture. However, Pliny tells a story to explain how portraiture was invented: *The modeling of portraits from clay was first invented*

*at Corinth by Butades, a potter from Sikyon; it was really the achievement of his daughter, who was in love with a young man, and when that young man was leaving for a trip abroad, drew an outline of the shadow of his face which was cast from a lamp onto the wall.** The girl's father, Pliny continues, made a relief portrait of the young man's profile by pressing clay onto the outline of the face his daughter had drawn on the wall. Then when it dried, he fired it. Thus, says Pliny, was portraiture born.

At any rate, whether they were originally created as quick studies for works in marble or bronze (8–29) or as fired works (8–28), the faces of humans in clay present a gallery of races and nationalities in which we can see how our similarities as human beings outweigh any superficial difference in the shape of eyes, lips, or noses. When an artist in Ife (8–27) modeled the face of an important man, when John Dwight depicted King Charles II (8–28), or when Rodin sculpted a writer's face (8–29), they were not only creating portraits of the sitter, but were also dealing with the expression of feelings that are common to us all.

The past can teach us a good deal about figurative sculpture, because until the concerns of nonobjective art became uppermost in many an artist's mind, the depiction of the human body was the prime concern of sculptors in all media; looking at an Etruscan grave figure (8–3), a Nok portrait (2–3), or a Peruvian portrait vessel (6–7), a contemporary figurative sculptor can feel a real sense of continuity with the earlier artists who used clay to create images of gods and mortals.

We do not know much about the lives of many of the sculptors who created these images, but we do have enough information about one clay sculptor in fifteenth-century Italy to be able to visualize him at work.

* Pliny the Elder, *Natural History.*

8-8 The life-sized figure of a youth is representative of clay portrait sculpture created in the Greek colonies in southern Italy. These sculptures, with their individualized faces, are precursors of later Roman portraits. Third century B.C. Height 71⅝" (182 cm). *Courtesy of the Ny Carlsberg Glyptotek, Copenhagen.*

NICCOLÒ DELL' ARCA, Italy (d. 1494)

Niccolò dell' Arca, one of the best known of the northern Italian creators of terracotta religious groups, comes alive to us through the records that are still kept in Bologna's city archives. For example, it is recorded that on the twenty-third of September, 1463, he rented a studio from the builders

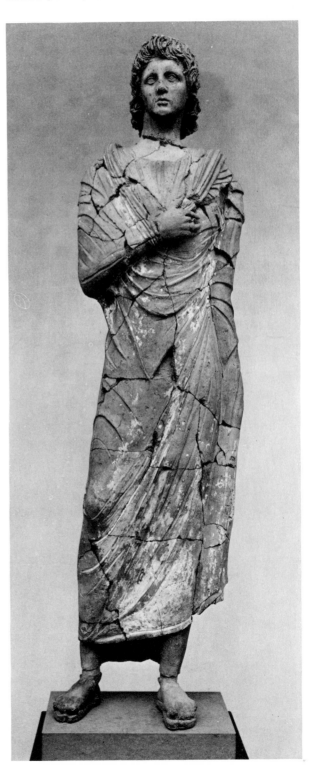

who were completing the cathedral in Bologna's main square. Since most of the buildings that surrounded the piazza then are still standing, it is easy to imagine Dell' Arca working there, modeling his figures, firing his kiln, and perhaps yelling at his apprentices for some lapse of craftsmanship—Nicolò was known as "Barbarus moribus" for his difficult personality, but he was also known as "Egregius magister" for his mastery of both clay and marble, and was highly honored by his adopted city, Bologna.

We are not sure where Niccolò came from, nor do we know his full name. His nickname, Dell' Arca, comes from his work on the marble arca (tomb) of Saint Dominic, a tomb on which the young Michelangelo (1475–1564) also worked. Dell' Arca is believed to have worked in Naples, where he would have been exposed to Burgundian

influences, and he was also influenced by the Sienese sculptor Jacopo della Quercia (1374–1438), who sculpted the marble *Madonna* on the cathedral portal in Bologna. Thus Dell' Arca's work was important in the interchange between north and south.

We may even know what the artist looked like, for tradition has it that the figure of Nicodemus in the *Pietà* is a self-portrait (8–30). The *Pietà*, a group of figures mourning over the dead Christ, was one

8-9

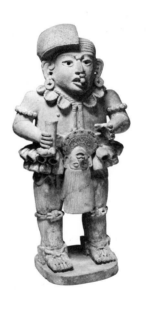
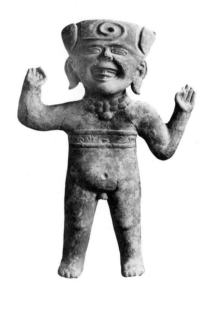

8-9 Two figures from different cultures in what is now Mexico provide a contrast between the formal pose of the adult and the laughing abandon of the child. Left: Probably a priest, with trophy head around his neck, a belt of shells, and a paw-shaped cup in his hand. Zapotec. Mitla, Mexico. Height 28″ (71 cm). *Courtesy of The Museum of the American Indian, Heye Foundation, New York City.* Far left: Smiling child, typical of many found near Remojadas, Veracruz. A.D. 250–600 Height 17½″ (44 cm). *Courtesy of the William Rockhill Nelson Gallery of Art,* Atkins Museum of Fine Arts, Kansas City. *Gift of Mr. Illus W. Davis.*

8-10

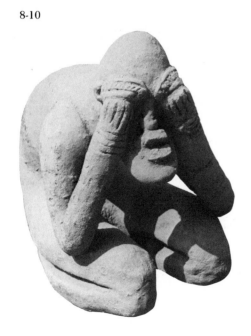
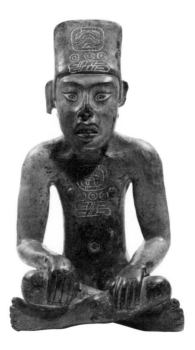

8-10 Seated figures from two cultures. Left: Formed of coarse, heavily tempered clay, this kneeling figure from Djenne was fired to a higher temperature than most African sculpture. *Courtesy of Simon du Chastel, Belgium.* Right: A seated figure found at Monte Albán, the sacred city in central Oaxaca, was inscribed with a date symbol on his forehead and chest. Monte Albán II. Early Zapotec culture. Earthenware. Height 12⅝″ (32 cm). *Courtesy of The Cleveland Museum of Art. Gift of the Hanna Fund.*

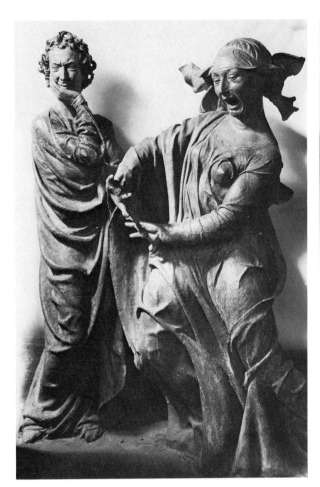
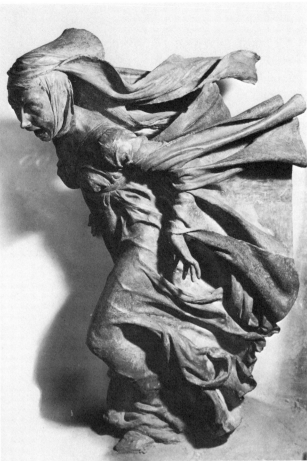

8-11 Niccolò dell' Arca, Italy, figures from the *Pietá*. Italian, fifteenth century. Almost life-sized. These painted terracotta figures are among the most dramatic of the religious figures sculpted of clay in northern Italy. Left: Mourners. Right: Mary Magdalen. *Photo: Villani, Bologna.*

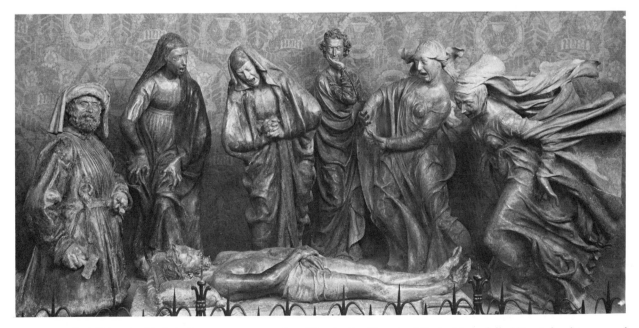

8-12 Nicolò dell'Arca's *Pietà,* in its present cramped position in the Church of Santa Maria della Vita, is hard to see and harder to photograph. Originally created for a hospital, it has been moved at least twice, and one figure is missing, but despite the surroundings and awkward grouping, its impact is unforgettable. *Photo: Villani, Bologna.*

of his most important clay commissions (8–12). Moved several times before it was placed in a cramped corner of the church of Santa Maria della Vita, one of its figures is believed to be missing, and the figures were probably arranged differently, but despite these depredations, the group is overpowering in its emotional impact, and impressive in its clay technique (8–11). Along with Dell' Arca, other sculptors in northern Italy created similar groups of religious figures in terracotta and painted them with realistic colors. Seeking added realism, they would often make molds from living hands, feet, arms, and even faces, from which they made clay casts. It is difficult to imagine how Dell' Arca could have taken molds from faces that were as contorted as those in the *Pietà*, so presumably these were molded from life rather than cast, but

the face of Saint Dominic (6–5) may have been cast by the artist from a contemporary model.

In the main piazza of Bologna, where today elderly men argue politics, children chase pigeons, and students toss Frisbees, another major commission of Dell' Arca's has looked down on the citizens of Bologna for centuries; his beloved *Madon-*

8-14 Isamu Noguchi, U.S.A., *The Queen.* Noguchi simplified the figure to a series of cylinders, reminiscent of the tomb figures of ancient Japan, yet contemporary in feeling. 1931. Height 45½″ × 16″ × 14″ (116 × 41 × 36 cm). *Courtesy of the Collection of The Whitney Museum of American Art, New York City. Gift of the artist. Photo: Geoffrey Clements.*

8-13 Giovanni Lorenzo Bernini (1598-1680), *Kneeling Angel.* To the contemporary eye, the spontaneous clay sketches by Renaissance and Baroque artists are often more appealing than the carefully finished marble sculpture for which they were models. Height 11¼″ (26 cm). *Courtesy of the Fogg Art Museum, Harvard University, Cambridge, Massachusetts. Gift of Friends of the Fogg Museum; Alpheus Hyatt Purchase Fund.*

8-15 Giacomo Manzù, Italy, *Death by Violence*. The clay original of one of the panels for the *Portal of Death* on the Basilica of St. Peter, the Vatican. Manzù sculpted all of the reliefs for the great bronze doors in clay, then cast them in bronze. 1963. *Courtesy of the artist. Photos: A. Cartoni.*

143

na of the Piazza on the Palazzo del Commune has been a guardian of the city's life since 1478 (7–10).

One sculptor who pioneered the building of large sculptures in twentieth-century America, Weylande Gregory, was less lucky than Dell'Arca in that the location of his largest work, the *Fountain of Atoms*, created for the 1939 World's Fair, is now unknown.*

WEYLANDE GREGORY, U.S.A. (1905–1971)

Weylande Gregory not only sculpted figures in terracotta at a time when few others were using the material for serious sculpture, but he created large-sized figure sculpture when even fewer people were working in that scale in clay. His fountain for

* Garth Clark and Margie Hughto, *A Century of Ceramics in the United States* (New York: E.P. Dutton), 1979.

the 1939 World's Fair weighed tons, and his monumental *Mother and Child* was built and fired in one piece (8-4, 8-5).

Gregory first began to model in the clay he found on the banks of a Kansas swimming hole; then he discovered in grade school that clay could be fired in the kiln. From then on, he said: *The very earth was pregnant with anxious plasticity, ready to speak with all the surge of elemental force and meaning. Earth, water, air and fire awaited my bidding.* To create his large figures, he devised a method of building up the clay using a self-supporting structure, saying: *It is fundamental to any real understanding of ceramic sculpture that the nature of the material and the construction of the hollow-in-and-outness is fully comprehended. . . . And this hollowness and openness can be a means of great expression, for it allows a sculpture to have an inner*

8-16 During the 1940s, Louise Nevelson, U.S.A., created several works in clay, among them *Moving-Static-Moving Figures,* made up of fragments of human forms assembled on metal rods. 1945. Terracotta. *Courtesy of the Collection of The Whitney Museum of American Art, New York City. Photo: Geoffrey Clements.*

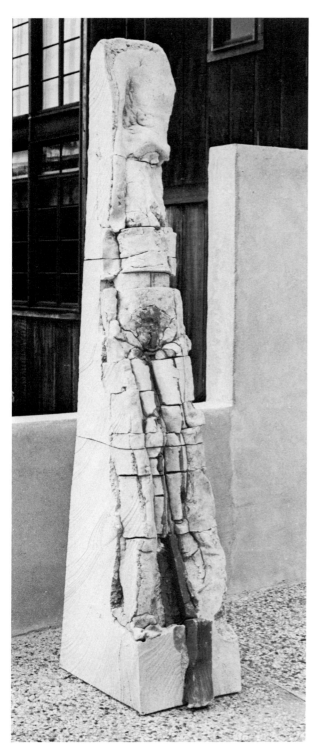

8-17 Stephen De Staebler, U.S.A., *Standing Man with Navel Slit*. Of his struggle to construct large standing figures, De Staebler comments, *Something I have discovered about clay is that you don't try to do everything all at once. That is a typical Western attitude towards a task: you set the problem, you attack it, you solve it, and you go on to something else. Well, clay on a large scale doesn't lend itself to that because you have to wait for it—you have to be in touch with natural rhythms.* 1978. Low-fire clay, stoneware, porcelain, fired to cone 6. 92 × 18 × 25″ (234 × 46 × 64 cm).

*modeling and in some cases to be seen into and seen through.** The writer of the article, wondering why more sculptures like Gregory's cannot be seen in our parks and gardens, answers the question by saying: *It is partly, of course, because there are not enough Weylande Gregorys.* That was in 1944.

Contemporary Figurative Sculpture

Moving up to the more recent past and the present, it is clear that the approach to the figure in contemporary clay sculpture encompasses all types and tastes, ranging from Michael Lucero's dangling, dancing constructions (Colorplate 12) through Viola Frey's brilliantly glazed women (Colorplate 15) to Penelope Jencks's restrained groups and to Stephen De Staebler's fragmented figures.

Despite obvious differences between the work of Weylande Gregory, Stephen De Staebler, and that of Auguste Rodin, they all share a common concern that the surface of their sculpture should express the inner structure of the body. Rodin once wrote about his work: *Each profile is actually the outer evidence of the interior mass; each is the perceptible surface of a deep section, like the slices of a melon, so that if one is faithful to the accuracy of these profiles, the reality of the model, instead of being a superficial reproduction, seems to emanate from within.* †

A big difference, however, is that while Rodin built clay up solid on an armature, Gregory and De Staebler have worked from the inside of the hollow figures. Clay, De Staebler says, is the only sculptural material in which you can actually make the forms grow from the inside out. *It became crucial to my sense of form to be able to get the swelling from the inside out. Sculpture formed of solid materials can only simulate it, but clay sculpture can actually do it.*

De Staebler struggled for some time with the problem of getting the figure to stand up without overworking the surface and killing its vitality, gradually developing his own method of working from the inside out. He found a way to reach underneath. *I could cut portholes and reach in, then when the clay was still quite soft, I would cut it into*

* "Weylande Gregory's Ceramic Art," by E.W. Watson, *American Artist*, September 1944.
† From a letter. Quoted in Robert Goldwater and Marco Treves, eds., *Artists on Art* (New York: Pantheon Books, a Division of Random House, Inc.), 1945.

sections and lift it onto the wedge forms. In this way he was able to keep the surface fresh.

Although his figurative sculpture is fragmented in image, De Staebler sees it not as an expression of death but rather as metamorphosis, of decomposing and knitting the body back together again, just as, with clay itself, forms can decompose and be reunited. He also responds to the kind of unplanned connections that can occur in clay. *There is something about random connections,* he says, *which we take for granted in everyday life because they are all around us. Then when we get serious about being an artist we often forget that that randomness is one of the key connections we have with life.* The viewer becomes especially aware of

random connections while watching living bodies move among De Staebler's figure sculpture. As living and sculptured forms interact, a convex curve in living flesh may be countered in the concave form of a clay figure, or the tension in a living muscle will be contrasted with the fluidity of the clay surface. Seen together, the real and the sculptured become one, and the viewer becomes increasingly aware of connections—not only between the sculptures and the living bodies, but among human beings as well.

MARGARET KEELAN, U.S.A.

Margaret Keelan is one sculptor who is especially interested in portraying the total personality and who integrates the face into the whole image. She says: *I feel my work reflects a process I have long been concerned with—that of finding in others and*

8-18 Margaret Keelan, U.S.A., says of her figures: *I use porcelain because through it I feel I can produce the effects I need.... This particular type of clay can suggest the cool, smooth quality of flesh or marble, or the grainy, rough whiteness of fossilized bone.* 1982. Porcelain, acrylic paint. Height 24 × 12″ (61 × 30.5 cm). *Courtesy of the artist, Anna Gardner, and The Elements Gallery, New York City.*

8-19 Guido Mariani, Italy, *Alla Palmetta Persiana.* Sculpted with grogged clay and colored with oxides, the figure sits on a ceramic bench decorated with the typical designs of Faenza's traditional majolica—Faenza is the artist's hometown. 1981. Figure fired at 1080°C (1980°F). Bench fired at 950°C (1740°F). Height 49 × 41″ (125 × 105 cm). *Courtesy of the artist.*

expressing from within myself the essence of human personality.... There must be a common sympathy or understanding established between the sitter and the artist, for it is not, as is often believed, *only three dimensions that are demanded of a portrait, but four, and this fourth one is the psychological atmosphere of the personality, which must add expression and character and the endless variations of mood.*

PENELOPE JENCKS, U.S.A.

Penelope Jencks, who always works from life, often exhibits her work as installations of several figures. Although she does not plan them as groups, after the work on a series of figures is finished, she says, they appear to fall naturally into a relationship. Even seen jammed together in a crowded store-room, her figures seem to be holding a dialogue with each other—an angry old lady confronts the rigid back of an ignoring young woman, while another figure stands watching the two with a pensive expression. Speaking of how her figures often appear interrelated, Jencks says, *Making them, I'm really very much concerned with making a specific person. The relationship of the models to the artist*

8-20 Lenny Dowhie, U.S.A., *She Spilled Her Cup in Nervous Anticipation.* Dowhie combines figurative elements and symbols of daily activities, saying, *The importance of situational responses, conditioned through years of reinforcement by social mores, is at the core of all the images.* 1982. Height 54 × 26 × 10″ (137 × 66 × 25 cm). *Courtesy of the artist.*

8-21 Penelope Jencks, U.S.A., usually builds her figures over a structure of clay. Sometimes she also uses dowels and pipes as well as wads of clay to prop the figure up until it is stiff.

is something that has always interested me, and I find that having some kind of a relationship with the model means that when I put two of them together, they have a relationship to each other, rather than to me (8–22).

Whether sitting, standing, reclining, facing each other, or pointedly turning their backs on each other, Penelope Jencks's people rarely indulge in dramatic gesture, but one senses strong emotions, tightly controlled. Despite the fact that their restrained manner is far removed from the dramatic expression of Dell'Arca's mourners (8–11), Jencks's figures bring those earlier sculptures to mind. Perhaps this is because no matter how much they dif-

fer in style, or how differently their subjects handle their emotions, in both artists' works the clay is modeled with strength, and both have created portraits of great psychological penetration.

Jencks has worked for several years in an airy, but sometimes chilly, studio, several flights up in an old brick warehouse close to Boston's historic harbor. Clay figures sit and stand around the room, a commission for a bronze memorial is in progress, and at one end a sectional electric kiln stands ready for firing (2–33). Now that she has this sectional kiln, Jencks builds her standing figures in one piece, lowering the kiln down over them, while her seated and reclining figures must be fired in sections.

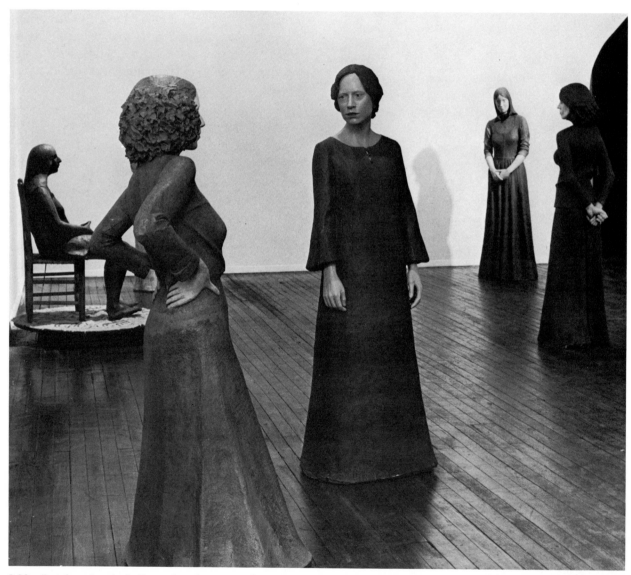

8-22 Penelope Jencks believes that the reason the individual figures in her installations seem to interrelate is because she tries to get the model to take a pose that has some relation to her. Terracotta, some areas painted. Life-sized. *Courtesy of the artist and Landmark Gallery, New York City.*

MARILYN LYSOHIR, U.S.A.

Marilyn Lysohir is an artist whose figures, unlike those of Jencks, are specifically planned as related compositions.

Lysohir says that even her earliest sculpture was figurative and situational: *The initial impetus for my work always comes out of personal experience and feelings. The end result, however, is an accumulation of fact and fancy and form and function, never a simple historical account (6–27, 8–23).*

Lysohir creates groups of women who, at first glance, appear alike, but on closer examination are not identical. Of her use of the female figure and the situations in which she places them she says, *I don't want to be classed as a feminist artist or to have the meaning of my work limited to just that. But I use the female figure because I'm comfortable with it. One way or another all the works look a bit like me!**

The creative process, says Lysohir, is difficult to explain: *It's easier to explain the technical considerations of each piece, such as figure scale, types of materials used, and firing temperatures. . . . Since I fire the clay to cone 06–04, I either use a terracotta body or a body high in talc, both of which contain*

**Quoted from an interview by Patricia Grieve Watkinson, Curator, Washington State University Museum of Art, 1982.*

one half to one percent nylon fiber along with pearlite or vermiculite. Each piece, because of size, must be made in numerous sections for portability, and must also be structurally supported on the inside for strength. In recent pieces, Lysohir has used other materials along with clay, and finds such a combination useful in developing her images (6–27).

KLAUS ZIEGLER, Austria

Born in West Germany, Ziegler settled in Austria in 1966. Since then, he and his wife have supported themselves producing utilitarian pottery, while Ziegler works on his sculpture. His works include cast and modeled ceramics, which he installs along with earth, and with video screens. Combined with performances related to clay, these have been presented in locations that range from an empty field to a shelter in a city park (8–7). Speaking of his use of a combination of media, which include performance, Ziegler says, *I evaluate this work with video sketches as a ceramic work which stands by itself. Ceramic is a formulated relatedness to the earth. So-called primitive people use clay to cast spells, they paint their bodies with it; ceramic becomes a body experience.* This body involvement with clay appears in his video and stage performances as well as in the narrative aspects of his work.

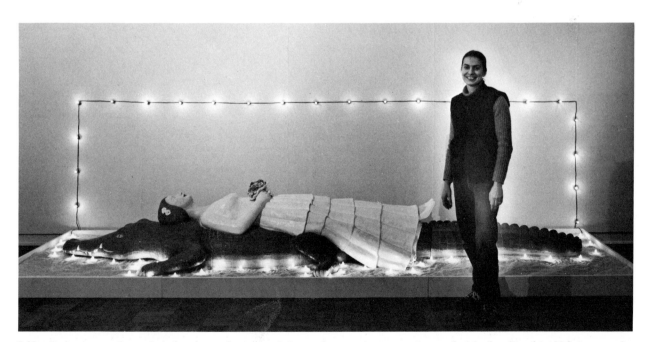

8-23 Referring to the artist's freedom when conceiving and executing a creative work, Marilyn Lysohir, U.S.A., says she feels the viewer deserves the same freedom to interpret the work. *The Alligator's Wife.* 1981–82. Low-fire clay, rice, lights, terra sigillata. 15 × 4 × 4' (4.6 × 1.2 × 1.2 m). *Courtesy of the artist and the Foster White Gallery, Seattle. Photo: Mike Short.*

Ziegler is now working on an ongoing sculpture entitled *The Passions of Dr. L.,* in which his objective is *to portray a fictitious person, Dr. L., with all the advantages and disadvantages of the sensitive and suffering human. This work will surely require ten to twenty years until all facets of this human become visible.* In the meantime, Ziegler is exhibiting portions of the story of Dr. L.'s life, including his infancy.

MICHAEL LUCERO, U.S.A.

Michael Lucero's figures are not composed in related groups, but a room full of their imposing presences, so varied in pose and persona, nevertheless has a common spirit that makes them appear like some gathering of celebrants in a shared celebration.

Swelling vessels represent the heads on Lucero's larger-than-life-sized figures, in a poetic metaphor for the human spirit. The vessels in these beings surely hold the mystery of their consciousness, for on their surfaces are engraved, painted, or modeled cloudlike forms, mountain landscapes, or symbols that seem to express their inner fantasies (Colorplate 12).

Enigmatic, like the stick figures painted or carved on cliffs by early cultures, Lucero's figures are full of vitality and seem to dance as they dan-

gle. They are made of collections of shards strung together with telephone wire, and the wires that connect them bristle like sensitive nerve endings, acting on several levels—functional, decorative, and, perhaps, symbolic, suggesting the artificial lines of communication we rely on in our urban lives.

JOD LOURIE, U.S.A.

In her figurative installations, Jod Lourie uses form *to catch a suggestion, a memory, an emotion.*

Although Lourie's main concern is with the content of the groups and with their form rather than with technique, she says, *I often work with metal workers and carpenters to figure out complicated armatures and ways of presenting elements into the piece in an effortless way.... As the concepts in my pieces move and change, I am constantly challenged technically, which provides a continual opportunity to amaze myself* (8–24).

Lourie uses a petroleum additive mixed in with her clay. She finds that three ounces of this, added to every one hundred pounds of clay, tremendously increases the clay's plasticity and resistance to cracking. She also adds nylon fibers to the clay, and rolls it out into thin slabs which she then forms by pressing over living models or by direct manipulation. She fires her work in sections in an electric

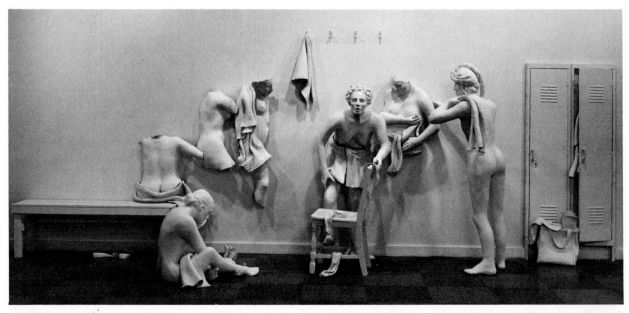

8-24 Jod Lourie, U.S.A., *Woman's Locker Room, West End House, Brighton.* Lourie says she works from memories, especially recollections of situations in which people are vulnerable. She uses porcelain for her situational sculptures because, she says, *I feel most at ease in the medium, and it allows me to deal with form as a fragile solid, as an emotion is a fragile solid....* 1981. Porcelain, plaster, wood, and metal. 6½ × 15 × 5′ (2.0 × 4.6 × 1.5 m). *Courtesy of the artist. Photo: Linda Payne.*

kiln, using an intricate bracing system. Once the sections are fired, she assembles them with a marine epoxy putty which she has found has unique bonding qualities with porcelain. She fills the joints with plaster, sands them, then paints the entire piece with latex paint, and sprays it with a fixative.

Miniature Groups

Groupings of figures need not be life-sized, of course. The Egyptians modeled miniature scenes of daily life—workers brewing beer, making bread, or farming—to be placed in the tombs of kings, assuring them the necessities of life after death. The Chinese and many other cultures did the same, perhaps depicting a troupe of acrobats performing at a fair, or a group of court ladies playing polo (10–6).

The twentieth-century sculptor Patti Warashina, U.S.A., who also assembles figures into min-iature tableaux, may not be concerned with the afterlife, but her women have the same kind of vitality as do the T'ang ladies on their ponies (10–6).

Louise McGinley, U.S.A., uses a stage setting for many of her pieces, placing the actors on theatrically lighted stages, where they are often unknowingly menaced by some threat (2–10). She uses light dramatically, sometimes placing its source behind sparkling glass windows that she makes from broken bottle scraps melted together,

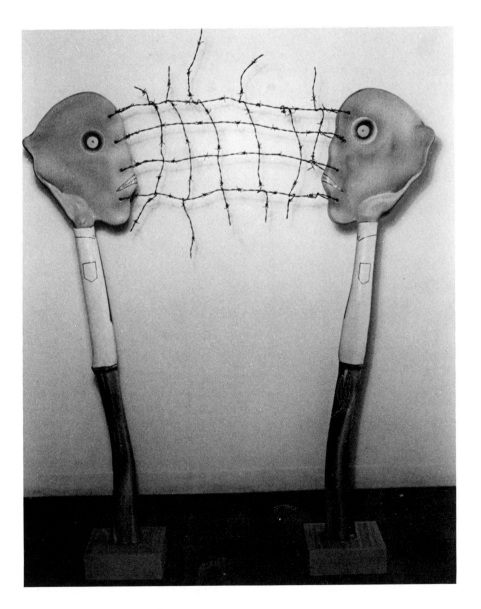

8-25 Robert J. Schumacher, U.S.A., says that in *Human Ties* the figures are *on one side of the face, soft and docile, and on the other hard and aggressive.* Barbed wire both divides and ties them together, while their awkward stance emphasizes their insecurity. Low-fire white clay, refractory stains airbrushed on; barbed wire, wood. 54 × 4 × 50″ (137 × 10 × 127 cm). 1982. *Courtesy of the artist.*

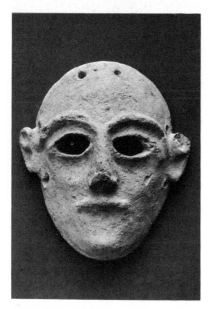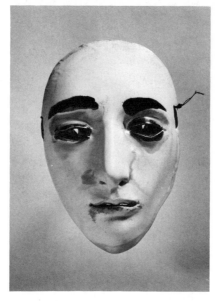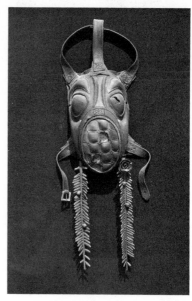

8-26 The face of humanity has not changed much over the years, but will it be changed by events in the future? Left: *Mask* found next to a potter's wheel. Hazor. 1550–1250 B.C. *Courtesy of Israel Department of Antiquities and Museum. Photo: David Harris.* Center: *Mask* by Letitia Eldredge, U.S.A., which was used by her in a dance performance. 1973. *Courtesy of The Fort Worth Art Museum.* Right: Richard Lipscher, U.S.A., *Contemporary Ceremonial Warfare Mask # 6.* Raku body, acrylic paint. 1981. Height 22″ (56 cm). *Courtesy of the artist.*

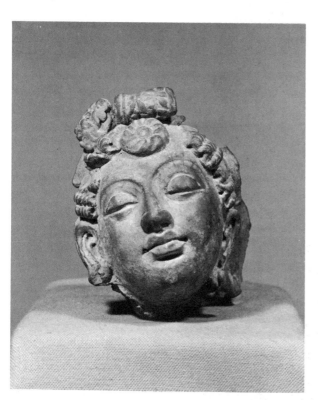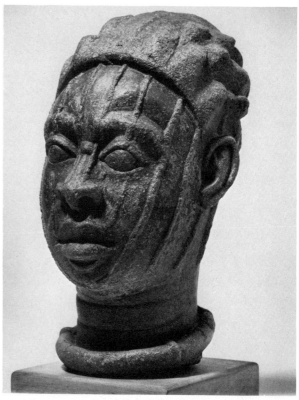

8-27 Faces made of clay have mirrored humanity throughout history. Left: The faces of guardian gods and attendant nymphs and dancing girls sculptured on Indian temples and monasteries often were ecstatic in expression. Aknar, eighth century. Right: The terracotta heads from Ife, more naturalistic than the earlier Nok sculpture (2-3), still display an idealization that lends them great dignity. *Courtesy of National Museum of African Art, Smithsonian Institution, Eliot Elisofon Archives. Photo: Eliot Elisofon.*

8-28 Left: John Dwight, the sculptor of this bust of King Charles II, was the founder of the Fulham Pottery in London, where he introduced stoneware into England c. 1675. *Courtesy of The Victoria and Albert Museum, London. Crown copyright.* Right: *Jonathan Tyers.* Louis François Roubilliac (1702–1762), a French sculptor who lived in England, used clay to make sketches for marble portraits. *Courtesy of The Victoria and Albert Museum, London. Crown copyright.*

giving an added quality of unreality to the scene.

Whether sculptured as miniatures, as life-sized figures, as portraits, or as narrative installations, figurative works express varying aspects of life as we know it today. At the same time, we can thank the artists of the past who have sculpted the human figure and face in clay for much of the knowledge we have of how earlier peoples lived and acted. It gives one pause to think that future generations may base their knowledge of *our* lives, *our* activities, and *our* aspirations on the images in clay that we leave behind us.

8-29 *Study for Head of Balzac.* Although Auguste Rodin (1840–1917) did not often fire his clay sculpture, he was a master in the medium, using it to model the originals for his bronzes, as well as to make portrait studies like this, which was fired. c. 1891. Terracotta. *Courtesy of The Metropolitan Museum of Art, New York City. Rogers Fund, 1910. All rights reserved, The Metropolitan Museum of Art.*

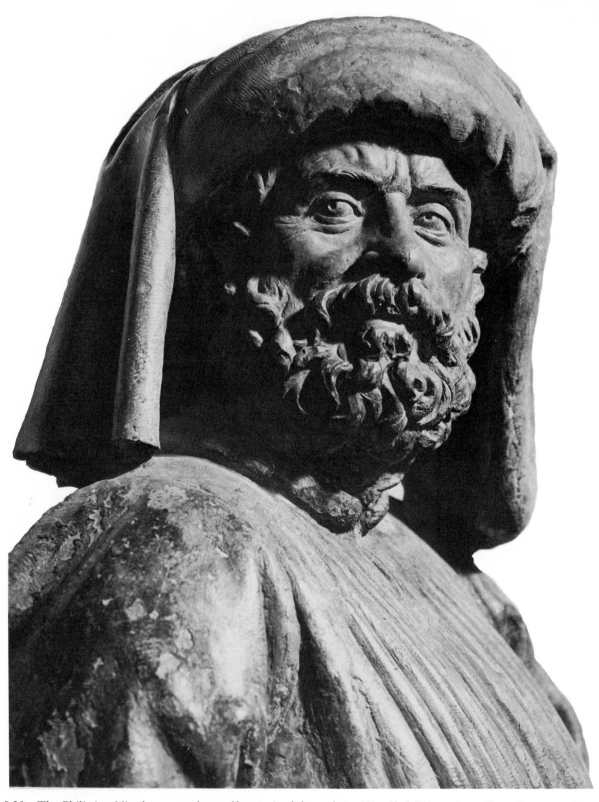

8-30 The Philistine *Nicodemus* may be a self-portrait of the sculptor Niccolò dell'Arca. Late fifteenth century. From the *Pietà* in Santa Maria della Vita, Bologna. *Photo: Villani.*

8-31 *Bust of Lefebvre.* Honoré Daumier, France (1808–79), probably modeled his unfired, painted busts as studies for lithographic portraits. *Courtesy of Documentation photographique de la Réunion des Musées Nationaux.*

8-32 Contemporary images of the human face in clay evoke an infinite range of human expressions. Right: *Five Splat*, detail, by Robert Arneson, U.S.A. Earthenware and slip. 1976. Head approximately 15 × 11½″ (38 × 29 cm). *Courtesy of the Everson Museum of Art, Syracuse.* Left: Peter Vandenberge, U.S.A., *Woman with Bowler Hat.* 1979. Height 19″ (48 cm). *Courtesy of the Quay Gallery, San Francisco. Photo: Philip Galgiani.*

8-33 Parts of a body may evoke a presence as vividly as the entire figure. Above: Keiji Ito, Japan, *Buddha's Foot*. Fired for six days in a wood kiln. 6 × 18 × 14″ (15 × 45 × 35 cm). Right: Eric Gronberg, U.S.A., *Dwelling Series: Tenement*. Gronberg uses parts of the body in repetition, suggesting the inhumanity of contemporary urban environments. 20 × 22″ (51 × 56 cm). 1979. Wood and clay. *Courtesy of the artist.*

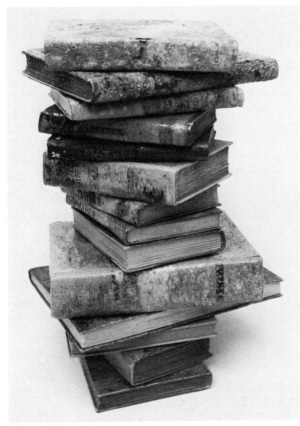

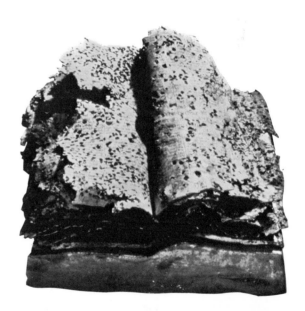

8-34 Books that may contain the history, poetry, philosophy, mythology, religious writings, and scientific theories of humanity. Left: Warren Mather, U.S.A., *Reading Matter.* 1981. Stoneware; sodium vapor glaze, oxides. *Courtesy of the artist.* Photo: Pat Terry. Center: Takako Araki, Japan. *Bible of Decadence.* Porcelain; silkscreen. *Courtesy of the artist.* Right: *Book Jar with Ashtray.* Richard Shaw, U.S.A. Shaw created containers from piles of books. To make them, he builds prototypes from which he makes plaster molds. Porcelain with decal overglaze. 1981. 4½ × 9¼ × 7½″ (11 × 24 × 19 cm). *Courtesy of the Braunstein Gallery, San Francisco. Photo: Schopplein Studio.*

Time, Place, Fantasy, and the Creative Imagination

The world of reality has its limits; the world of imagination is boundless.
—Jean Jacques Rousseau, 1712–1778

This chapter concerns the workings of the creative imagination, how it responds to perceptions from the external world, and how the developed skills of the artist transform those responses into new images that are once more returned to the external world as objects that we can perceive.

External stimuli may be experienced by everyone, but each one of us brings an individual set of references to those experiences. We look at a place, at a face, or at a house with virtually the same physical eyes, but our inner eye is influenced by a lifetime of memories, dreams, and fantasies. How each person's background, surroundings, memories, mental associations, and dreams influence the creative process is dramatically illustrated in the varying ways that different artists treat similar subjects. For example, images of a skull or of bones that connote death to one person may, to another, suggest life (9–13, 9–17).

One theme that has interested some sculptors is the effect of time on the material itself, often symbolic of our vulnerability to time.

Time and Transformation

The transformation of clay over a period of time as it is acted on by some of the most elemental forces—water, air, and fire—is central to the ceramic process. From crushed dry clay to slip, from slip to plastic state, from leather hard to greenware, through the fire to permanence, and, finally, from fired clay to a broken handful of shards, each particular state of clay has its own degree of vulnerability to one or the other of these forces. Intrigued with the traces left by the passage of time and the action of natural forces on clay, several sculptors have created works whose central theme is the vulnerability and/or durability of clay. One might call the theme disintegration, but since whatever disintegrates becomes something else, it is also transformation.

PAUL ASTBURY, England

Paul Astbury has moved from creating images to dealing with the concept of time in relation to clay and man-made materials. Astbury says: *I became aware of the life of these modern materials next to clay—clay is a very long-lived material. You can never destroy it completely, you can only break it up.*

In his recent work, Astbury has been using fired clay in conjunction with man-made materials of varying known or unknown durability—paper, cardboard, metal, felt-tip pen markings, and various synthetic resins (9–1, 11–6). Painting on the paper and cardboard with synthetic coatings, he gives the paper a degree of protection, seeing this as part of the process we are all involved in throughout our lives. *Reality,* he says, *is all about that, about boarding things up, about painting things, and renovating houses. It's action against the reality we know exists that destroys everything.*

Astbury lives and works in a house he has been remodeling on a tree-shaded street in London. His workroom is small; at the back of the house, it opens through a glass door into a garden where he can work—if the weather allows it. Walking to Astbury's house along the main commercial street in Shepherd's Bush, one passes shops that sell useful items of every description—auto parts, plumbing supplies, paint products, and building materials. When I arrived, and remarked that this made it a wonderful neighborhood for an artist to live in, Astbury agreed. *Yes, there is a shop that just sells nuts and bolts; another sells metal rods. I love to go into the shops and just look around.*

Astbury says he wanders around looking at these materials as one would shop for the more conventional art materials—bronze, oil paint, or glazes. Since he moved to the city, industrial materials have, in fact, become an important factor in his sculpture, influencing it both materially and philosophically.

For some time after he moved to London, Astbury's work dealt with fragmentation, depicting robots transformed into fossils—technological fossils—a robot eating another robot, animal machines in a state of disintegration. Many of these earlier works are covered with ink markings on their smooth, press-molded surfaces. When some of them were returned from an exhibit, Astbury thought, *Well, there's got to be a kind of extra life*

9-1 Paul Astbury, England, *Observed Arrangements.* Astbury says, *my work is one continual experiment creating new combinations and arrangements with the materials. It is a matter of trying to establish new meeting points, allowing each material to emerge with new values.* Astbury likes to combine insecure materials with fired clay, a material that can never be destroyed completely. 1981. Clay, cardboard, and paper, screwed and bolted to wood; epoxy resin. *Courtesy of the artist. Photo: Ian Dobbie.*

to these things, there's got to be something going beyond that. So then I started smashing them up and reassembling them.

After he had used up his broken press-molded images, the next step *became somehow a natural reflex to treat clay in an absurdly simple way so as not to transfer its material qualities through the distraction of being an image.* Astbury simply began to roll out the clay into slabs and cut it into rectangular shapes, punching holes in them so that when fired they could be bolted to whatever material he chose. In this new work, the adhesives, resin, and fillers he uses became more than substances that stick one piece of fired clay to another. *I now allow them to become qualities in their own right— something to smear over a surface of clay or cardboard, then maybe burn with a match, or rub some dirty oil into.*

Extending his use of clay, pushing his concept of vulnerability further, and becoming ever more aware of the effects of time with each step he took, Astbury came to realize that: *The thing I sense most about materials of all kinds is their own individual contract with time. This is emphasized through the vulnerability inherent in each material, depending on the environment it exists in, the arrangement of the material within that environment, and the probable dependence and security of one material upon the survival of another (9–1).*

Unlike Paul Astbury, who works with fired clay in relation to man-made materials, other sculptors have created works that deal with varying aspects of the vulnerability of unfired clay to different environments and to the action of time, water, and fire.

GEORGE GEYER and TOM McMILLIN, U.S.A.

Among other works, George Geyer has placed extruded ropes of clay in water, allowing them to disintegrate slowly throughout an exhibit period, and Tom McMillin once fired a large mound of earth on a hillside above a Los Angeles freeway by surrounding it with an open kiln. It is not surprising, then, that these two southern California sculptors, who individually have been concerned with the response of clay to transforming processes, and who share a lifelong love of the sea, should choose to work together on a project to expose unfired clay to the force of the ocean.

McMillin and Geyer chose a cove on the coast of California as the site for *Surfline Erosion,* and along with friends and students they erected a row

of clay slabs on frameworks at the edge of the ocean (9–2, 9–3). Before the work could be placed on the beach, however, weeks of preparatory work went into the project, and in order to bury the supports deeply in the sand, the workers had to learn to respect the ocean's cycles, working when the tide was out. In the meantime, the slabs were formed of clay (mixed with sand and clay stabilizers) that was tamped into molds. Once the supports were firmly in place, the clay slabs were bolted on and were installed at the water's edge. These wood, metal, and clay structures then faced the waves, the tides, and their eventual destruction with an almost-human stance of defiance (9–3).

As the tide ebbed and flowed, the water began to do its work, eating away at the clay, undermining the supports little by little until eventually all that was left on the beach were a few bits of debris, like the flotsam from some wrecked ship.

Sand, clay, and water have interacted for millennia, but in *Surfline Erosion* this interaction was dra-

9-2 *Surfline Erosion.* George Geyer and Tom McMillin, U.S.A., made slabs of unfired clay that was mixed with stabilizers, then pressed the slabs into metal-reinforced molds and positioned them to await the arrival of the encroaching water. The artists and their helpers at work, constructing the framework that will eventually support a clay slab. 1981. Earth, steel, wood, sand, and water. 7' × 10' × 75" (2.1 × 3.0 × 1.9 m). *Courtesy of the artists and Neil G. Ousey Gallery, Los Angeles. Photo: Libby Jennings.*

matized by being concentrated into a few weeks, and the only records of its existence are photos and a videotape that documented the work. Part of the exhibit *California Landscape: State of the Art,* held at the Newport Harbor Art Museum in 1981, it represents a contrast to the role usually played by a museum—the preservation of works of art in a controlled, interior environment.

WILLIAM MAXWELL, U.S.A.

Time and change are central to William Maxwell's excavation pieces, which are designed so that the elements will interact with them over a prolonged period, the rain filling them with water, grass sprouting on them, and humans possibly leaving

their mark as well. *My concept,* Maxwell says, *was to do a piece that would be left for people to discover.... The impression I tried to leave with the piece was that it was very old and of some symbolic or ritualistic nature.* Intrigued with the idea of having a nonartist audience, Maxwell discovered that it can bring complications. He placed one piece, *Partial Excavation,* in an intimate setting in a wooded area, and when people did discover it, some of them were convinced that satanic rites had taken place there. Believing that bodies were buried at the site, they reported it to the police, and Maxwell had to intervene before the authorities destroyed his work by looking for buried bodies under it.

A Sense of Place

A dictionary defines "place" as "an area occupied or set aside for someone or something." For our purposes we'll define it a little less broadly, as an area that has some special meaning to a human. Perhaps it is a mundane, everyday place where one feels especially secure, or an imagined wonderworld into which one can retreat; maybe a lost

place, or a yet-to-be-discovered place, a religious place, or a place remembered in every detail from childhood. Wherever it is, or whatever its quality, real or imagined, places are of such importance to humans that many of us seem to feel a need to respond to their impact creatively. Novelists describe them, painters represent them, poets con-

9-3 *Surfline Erosion,* by George Geyer and Tom McMillin, U.S.A. As the water starts its action, one panel succumbs to the force of the waves. *Courtesy of the artists. Photo: Libby Jennings.*

dense their essence into few words, photographers record them, and sculptors create the spatial, visual, and tactile characteristics of real or imagined places.

Places, actually seen, moved through, touched, and smelled or merely imagined, have inspired artists to capture their essential aspects in clay, recording their physical qualities and the human emotions surrounding them, expressing the spiritual qualities seen in them or projected onto them. Among many others, Paula Winokur's bird's-eye views of mysterious places (9–5), Pierre Baey's visions of deserted cities (9–4), Mutsuo Yanagihara's memories of the sky (9–11), or Jod Lourie's recreations of remembered places (8–24) are experiences of places transformed by the creative imagination.

PIERRE BAEY, France

Pierre Baey's parental background was in craft—his family worked with wood, hewing it and forming it into wooden shoes. But since he discovered clay, Baey has worked primarily with that material, especially stoneware. After several years of study and apprenticeship, he established himself and his kiln on a small farm in the French countryside. Baey lives in the country not, he says, because he dislikes contact with people, but in order to work tranquilly. Two or three visits to the city a year give him ample opportunity to see how people live in the urban environment, to know how they move through it, and to imagine how cities might be different.

His work includes a wide variety of images, among them an evocation of urban place and space. A ruined port, unknown cities, a tiny theater setting—all these appear in his work. Of the cities he encloses in spheres and cylinders, Baey says: *In my pieces there are circulations that correspond to my personal circulations at the moment that I make them. I imagine that I pass through this door, that I take this winding staircase. . . . I will wander here and there. But it is not ordered that another must do the same. I leave to him the possibility of looking and acting in his own way. ***

* L'Atelier des métiers d'Art (Paris), April 1980.

9-4

9-5

9-4 Pierre Baey, France. The interiors of Baey's deserted and crumbling cities invite exploration, luring us to wander through them or to people them with imaginary inhabitants. 1980. Stoneware. *Courtesy of the artist.*

9-5 Paula Winokur, U.S.A., says that *the* Small Resting Place *represents a newer direction for me—that is, leaving the container behind and focusing totally on the content.* She says, however, that she thinks of the earth as *containing all sorts of mysteries,* so there is a relationship with her vessels. 1981. Porcelain; metallic sulphates and lusters, feldspathic clear glaze; reduction fired. 6 × 6″ (15 × 15 cm). *Courtesy of the artist and The Elements Gallery, New York City.*

CHARLES SIMONDS, U.S.A.

*There are a thousand ways to touch clay, a million.
They're all expressions of love or intention.**

After a traditional training in sculpture, and experience creating clay originals for cast bronzes, Charles Simonds began to move his sculptural activities into city streets. He has been seen in New York's Lower East Side, in Europe, and in China carrying a bag of clay and enough preformed miniature bricks to build one of his *Dwellings*, searching out a spot that he feels might appeal to his im-

aginary Little People. As he builds these deserted environments in the streets, in empty lots, or on building ledges, Simonds, in addition to expressing his own sculptural concepts, is reacting to the imagined lives of the Little People as well as to the actual lives of the neighborhood residents who gather around to watch him work. *My work,* he says, *is not generated by art. When I'm thinking about things, I'm not thinking about art. Which is to say I think about life.*

Simonds feels close to his Little People, and likes to consider how they would choose to live in their *Dwellings* (9-6), but at the same time, he says, *I think about me in there. It's a mental positioning*

** All quotations by Simonds are from "Charles Simonds: The New Adam" by Ted Castle, in *Art in America*, February 1983.*

9-6 Above: *Dwelling.* Charles Simonds, U.S.A., working on one of his sculptures in the Passage St. Julien La Croix, in Paris. These miniature environments, now deserted, were once inhabited by the artist's imaginary race of Little People. They are built of tiny bricks of unfired clay, held together by white glue, and are tucked into windowsills, under piles of rubbish, or in gutters in cities around the world and are left to be affected by the destructive action of weather, people, or traffic. 1978. *Photo: Jacques Faujour.* Right: *Ritual Tower.* Simonds is also creating a series of objects that follow the changing history—both geological and mythical—of one small area of Earth. On plywood panels, he builds organic forms or archeological remains of former civilizations. 1978. Unfired clay, plywood. Approximately 30″ square (76 cm square). Private collection, Paris. *Courtesy of the artist.*

inside. But I also think about them—they're incorporeal, but they are quite alive. It's tricky because since I'm not crazy I don't live like they live: they do things I wouldn't do. They drag me into different situations. They also take me all around the world.

A sense of life, both biological and mythical, infuses all of Simonds' work, but the sculptures are physically extremely vulnerable, and as they are left to crumble, to rot, or to be stamped on, they seem symbolic of our fragile twentieth-century urban lives.

Most of the *Dwellings,* sited in spots to which he feels the Little People would be drawn, are rapidly destroyed. Only those that have been built in protected environments, such as New York's Guggenheim and Whitney museums, Chicago's Museum of Contemporary Art, Zurich's Kunsthaus, or private collections, have endured. Even in these sheltered places, the unfired clay cracks as it dries, but Simonds makes use of some of these cracks, or fills and patches those he does not want to leave as part of the work.

Simonds is also working on two ongoing series of objects—*Circles and Towers Growing* and *House Plants.* The *Circles and Towers* record in material form the history of a selected area of earth. Sometimes it is sear and dry, sometimes it shows signs of stirring life beneath, while at other times it may carry physical remains of the Little People—*Ritual Tower* (9–6) or *Ritual Furnace.* Far from seeing these as exercises in fantasy archaeology, Simonds says, *I am very interested in how we live, or how one lives, which is to say the relationship between your dwelling, through time, relative to your life.*

ELISA D'ARRIGO, U.S.A.

Elisa D'Arrigo says that the sources of her work go back to a childhood spent in the Bronx, which she remembers as a very gray world without much visual stimulus, so that she had to create her own. *My work,* she says, *begins with mental images which I envision as emerging and returning from a deep pool containing a dark liquid. The exact recipe of this liquid is unknown to me, but the ingredients probably include dreams, thoughts from when I was very young and made up my own myths out of not-knowing, travels to exotic places, growing up in New York City, etc., etc. All of these sources have fused and meshed with my imagination.*

When D'Arrigo was eleven, she went with her parents to Sicily and saw the life of a Mediterranean town where life goes on in courtyards, in the street, in the fields, and on the beaches as well as in the houses. After the clearly defined living spaces she had known as a child, the undefined quality of Sicilian houses made a great impression on her, and she retained strong memories of what it is like to *enter the pale stucco facade of the house and walk through a dark corridor which leads you outside again to a courtyard. Past that was a lemon grove, and beyond that, a wall with a gate which opened onto a beach. There were hallways without roofs and the door to the bedroom led outside. Another*

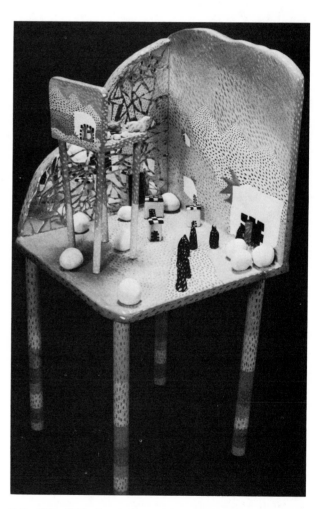

9-7 Elisa D'Arrigo, U.S.A., *Mesa Table.* The ambiguity of interior-exterior spaces in Mediterranean and Pueblo architecture fascinates D'Arrigo. *My hope,* she says, *is that these works will trigger various associations in the viewer; and I always encourage many different interpretations because they never represent just one thing to me either.* Wood and ceramic, painted. 1979. 39 × 18 × 18″ (99 × 46 × 46 cm). *Courtesy of the artist.*

house had an underground passage that led beneath the street to the beach. *

Later, D'Arrigo found that here in the U.S.A., Pueblo architecture has some of the same ambiguity, and she draws inspiration from it as well. Of her need to externalize her inner fantasies, D'Arrigo says, *I am sometimes compelled to translate one of these images into an object, thereby giving it a physical existence so that I can actually see it and learn from it (9–7).*

Over the ages people have marked special places with some kind of distinguishing sign—a mound, a standing stone, a cairn. Sometimes these places are merely suggested by ambiguous maplike forms, which might represent places either in the internal

*Quotation with permission of Akiko Busch, from his article, "Artists Who Make Architecture," *Metropolis*, Bellerophon Publications, August/September 1981.

or in the external world (9–12), while at other times they are based on memories of specific places.

ANN MORTIMER, Canada

Ann Mortimer creates works that contain references to transformation, to time, and to places that appear to have a special aura, or a sacred meaning. Peering through the doorways and shattered windows of her sculptures, we look into a mysterious space where we see faces existing in an atmosphere that is not of our world. Although Mortimer prefers to let her work stand on its own without verbal explanation, her titles alone suggest certain imagery, and her techniques emphasize those images. This transcendental atmosphere is heightened by the firing techniques she uses—the raku, pit firing, and residual salt firings produce surfaces and textures that evoke ancient buildings and artifacts.

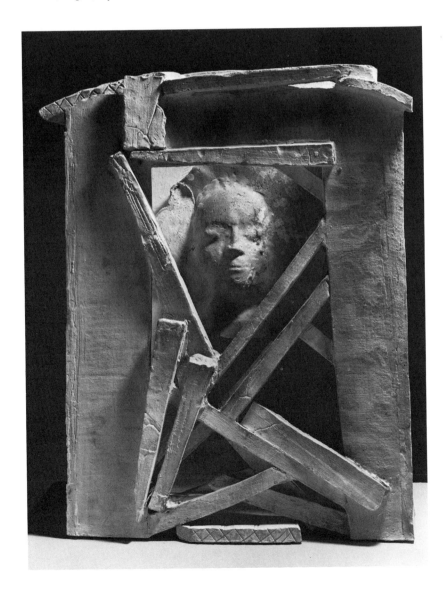

9-8 Ann Mortimer, Canada, *I Am No Longer That Which I Have Been.* Mortimer uses a combination of sculpture bodies, slips, and residual salt firing to create the texture and color of ancient structures. Inside them, disembodied faces appear to await transformation. 1981. 29 × 23 × 10″ (74 × 58 × 25 cm). *Courtesy of the artist and Everson Museum of Art, Syracuse. Photo: Courtney Frisse.*

Fantasy, Dreams, and the Unconscious as Creative Sources

It is the divine attribute of the imagination, that when the real world is shut out it can create a world for itself. . . .
—*Washington Irving, 1783–1859*

Carl Jung, speaking of how in general modern man lives split off from the rich material that exists in his unconscious, said that many people still assume that "consciousness is sense and the unconscious is nonsense."* The artist, however, is more aware of the value of the unconscious, for he knows that to limit art to the re-creation of the "real" world would be merely to record a perception. Jung also

* Carl G. Jung, *Man and His Symbols* (Garden City, N.Y.: Doubleday and Company), 1964.

9-9

9-9 John Chalke, Canada, *Early Violation of Alberta Air Space.* Chalke says, *My ceramic pieces are at once paintings, drawings, graphics and clay manipulations. . . . Above all, they are kiln experiences.* Often they evoke places—ancient places, imagined places, or places where the artist has lived. 1982. Cone 6. 19 × 17½ × 2″ (48 × 45 × 5 cm). *Courtesy of the artist. Photo: Rhea Skocylos.*

9-11

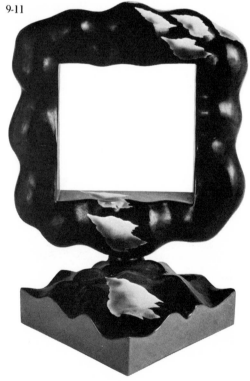

9-10

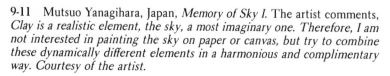

9-10 Chris Untersher, U.S.A., *Delivery for the Wheatena Plant, Rahway, New Jersey.* Untersher creates three-dimensional miniatures of the American scene, ranging in subject from geysers to factories. This *postcard series is exactly that—subject matter abstracted from postcards, but simplified in order to let the qualities of color and formal relationships have more prominence than in the source postcard.* 1979. Porcelain. 8 × 5 × 1½″ (20 × 13 × 4 cm). *Courtesy of the Quay Gallery, San Francisco. Photo: Philip Galgiani.*

9-11 Mutsuo Yanagihara, Japan, *Memory of Sky I.* The artist comments, *Clay is a realistic element, the sky, a most imaginary one. Therefore, I am not interested in painting the sky on paper or canvas, but try to combine these dynamically different elements in a harmonious and complimentary way. Courtesy of the artist.*

points out that the images produced in dreams are more vivid than waking images. This is nothing new to the artist, who has long known the strength of images that come through fantasies, dreams, or visions. These fantasies, dreams, and unconscious images are clearly not totally new material that comes from some strange unknown source; rather they are the accumulation of perceived stimuli and memories, formed and transformed, combined and recombined, until they may reappear years later. Made conscious, these images are a rich source from which all artists draw, and creative people—painters, sculptors, writers—deliberately keep the line to the unconscious open, for it is there they find so-called "inspiration." Each artist develops a personal technique that makes it easier for these thoughts, images, and fantasies to come to the surface.

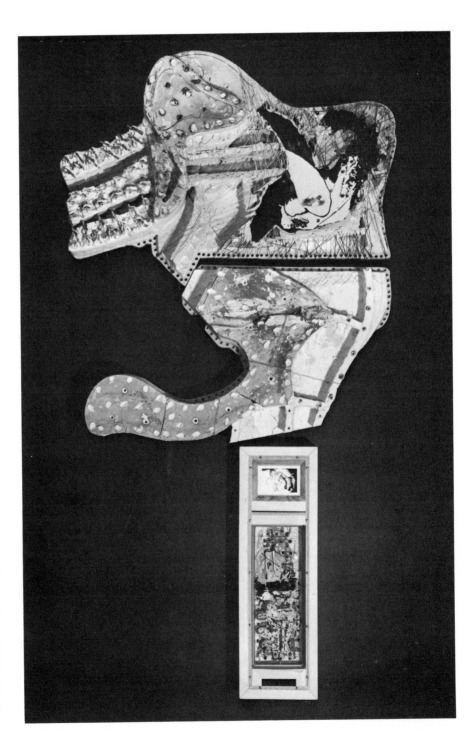

9-12 Mike Moseley, U.S.A., *Fishing.* Moseley creates a mixed-media wall relief that may suggest landscape, visceral, sexual, fetishistic, or fossil forms—since the artist suggests rather than depicts, viewers may find their own references. The work has a painterly surface largely achieved with non-ceramic pigments on earthenware as well as casting resin and wood. Commercial stains and acrylic lacquers and enamels. 1982. 98 × 50 × 16" (2.49 × 1.27 × 0.41 m). *Courtesy of the artist. Photo: Vaughn Wascovich.*

9-13 Deborah Horrell, U.S.A., *Transition,* installation. Horrell combined slip-cast bones with life-sized drawing to create a symbolic installation within a triangular space. Horrell says that since her father's death she has reevaluated her choice of bones *as symbolic images. [I] understand its multiple levels. I now recognize the importance of the idea of human transition.* 1982. Porcelain, graphite drawing, acrylic paint. 24 × 16 × 9′ (7.3 × 4.9 × 2.7 m). Installed at Alfred University. *Courtesy of the artist and The Elements Gallery, New York City. Photo: Karl Wilkens.*

9-14 Rinda Metz, U.S.A., *Picou's Landing*. Intrigued with the vulnerability of rickety structures lifted off the earth on pilings, Metz recreates them in an even more vulnerable material—clay. Hand-rolled coils joined with slip precariously hold up a walkway of slabs formed in slings. Terracotta. Length 15′ (4.6 m). House, fiberfax; roof painted with slip and fired. *Courtesy of the artist. Photo: Mark Wolfe.*

9-15 Raymon Elozua, U.S.A., *Fictif #16*. This structure is derelict, deserted, and disintegrating—its enigma creates its fascination. Clay and acrylic. 24½ × 11″ (62 × 28 cm). *Courtesy of O.K. Harris Works of Art, New York City.*

Symbols

In a homogeneous society in which people have a strong shared mythology, certain symbols are recognizable to everyone. In our more fragmented society, there are fewer common symbols, and when an artist uses symbols that are exclusively his or her own personal ones, the viewer may complain that the result is too personal. It is true that our culture is less concerned with universality than others have been in the past, and this means that the artist working today must decide just how clear to the viewer he or she wants to make the symbols.

DEBORAH HORRELL, U.S.A.

Speaking of her work, in which bones have become an important symbol, Deborah Horrell says that, to her, *bones are defined not as death symbols but as elements of support and structure, the essential element of life. The nest, constructed of human bones, consequently is a symbol of germination, change or growth.* She feels that her sculpture of a full-sized nest of human bones is given an aura of transcendence, of rebirth, through the winged figure and the winged legs (9–13).

Horrell says that her work is in a constant state of flux: . . . *what was created two years ago within a particular frame of mind and understanding is now reinterpretable. This transition in comprehension is a result of distance, growth, and consequent clarification. My work takes a form similar to dream analysis and becomes an expression of the unconscious.*

For her earlier work, which contained small nests, Horrell slip-cast from real bird bones, but for an installation to be built in life-sized scale, she cast the bones from a plastic replica of a human skeleton. Instead of glazing the bones together, she stacked them carefully into a structure that could be dismantled and reconstructed, and says that she experienced a sensation of the nest emanating a power, due to this new size relationship and scale.

Horrell sees this installation as concerned with the concept of transition—the human desire to escape the finite qualities of life—and with the artist's control of the viewer's perceptions of the work. *The porcelain nest, the winged skeletal feet, and the drawing were viewed through a small two-inch by two-inch window—photographs cannot, consequently, adequately document the experience of seeing the installation.* Horrell hopes to explore further this idea of forcing the viewer to see an installation in a certain way through the control of the window, and she also hopes to be able to continue to work on a large scale.

JUGO DE VEGETALES, U.S.A.

Many of Jugo de Vegetales's sculptures depict humans and animals communing with the spirits of plants, rocks, or water. Although these are influenced by Native American mythology, Jugo says his own philosophy developed out of identifying with the surrealists. *I believe,* he says, *that the unconscious mind, as a representative, as an extension of the collective unconscious, is the only source of truth. So my "method" is to explore my own unconscious by whatever means I can, in the hope that I will stumble on something of universal significance. I work from drawings most often, but the best work comes from spontaneous collisions of forms.* His models are the things he sees around him—his dog, wild animals in the natural history museum, his wife, his mythology books—all these he combines with inner source material. His works, he says, *are based on real life experiences and things which have endured through my past. The images I remember combine subconsciously from various references, such as: Sunday school Bible stories, Japanese monster movies, classical myths and nature symbols which are more or less universally revered.*

To create his life-sized figures, De Vegetales makes body casts from willing subjects. These casts are made with plaster-impregnated gauze that produces a crude two-piece mold. Refinements and details are added later, while the sculpture is damp. (See also Chapter 5.) De Vegetales says: *I cast up a lot of stuff I know I want to use (from drawings), then I start to make a few, do more drawings to figure out possibilities, and usually I'll have to make a few new molds for ideas I get halfway through a piece.*

9-16 Jugo de Vegetales, U.S.A., *Cynara.* The artist believes that *the unconscious mind, as a representative, as an extension of the collective unconscious, is the only source of truth.* His work develops from his unconscious, through drawings, which he translates into life-sized figures through the use of body casts. (See also 5-18.) 1981. Painted ceramic. Life-size. *Courtesy of the artist.*

RICHARD NOTKIN, U.S.A.

*When it comes right down to it the only thing I am sure of is I like to make things. There are two poles to man's abilities; creation and destruction. I like to stay on the creation end.**

Richard Notkin's commitment to the creation end, and his love of making things, have led him to carve miniature animal skulls, then to balance them precariously in unexpected settings (9–16). He also turns human skulls into pyramids, opens their tops, and allows their brains to grow out like a garden of cactuses (9–17). He turns another pyramid skull into a teapot, or an ashcan into a cup.

Notkin's animal skulls, so tiny they can be held in a palm, are anatomically perfect in every detail. However, Notkin says, *I always change the scale. I never work one to one in size. If I did that then I might as well use a mold, and that's not what it's about for me. I take joy in carving the animal skulls, but it also wipes me out—I spent over 60 hours on the last one.* He does not see animal skulls as a symbol of death, rather as indicative of life. Notkin realizes, however, that it is difficult to dissociate the human skulls from the connotation of death, but he sees them as symbols of spiritual and moral death as well as physical.

The pyramid is, Notkin believes, *a universal symbol of monuments. Of everything man has built, the pyramids are definitely the most permanent, yet they are impermanent on a cosmic scale.* He does not like monuments, believing that a society that is good enough does not need such constructions to prove that it is good. At least one of his skull-pyramid works, *Demons of the Intellect* (9–18), could be categorized as social commentary, but it is also one of his most "unreal" images. In this row of grinning death's heads, the brain can no longer be contained inside the skull, so it escapes in weird configurations that suggest mutations of human intelligence. To Notkin, the pointed heads are equated with overdevelopment of the intellect and consequent spiritual death.

Notkin's images are, at least in the pyramids and skulls, universal, but in the manner in which he combines them he draws on his own experience and on his own inner fantasies, in order to comment on humanity's condition.

Realistic down to the last miniature detail, these works pose a question: Are they fantasy or are they realistic art? Or are they social commentary? And more important, does it really matter if they are placed in a category?

* All Notkin quotations from Louise Klemperer, "Notkin, Clay as Chameleon" in *Fresh Weekly* (Portland, Ore.: Willamette Weekly), April 1, 1980.

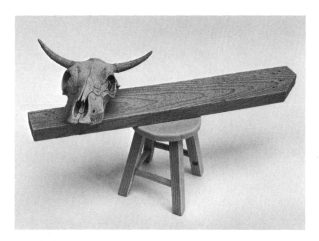

9-17 Richard Notkin, U.S.A., *Endangered Species #3.* Notkin has always collected and drawn animal skulls. Combining unusual scale, visually disturbing placement, perfectionist craft, symbolic imagery, and a verbal cue, Notkin creates a work to which we can respond on several levels. 1979. Porcelain; underglaze. 6 × 12 × 5″ (15 × 30 × 13 cm).

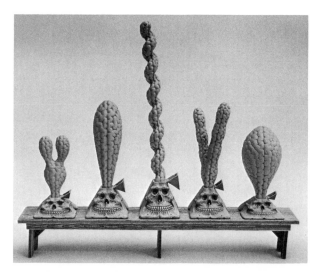

9-18 *Demons of the Intellect (Professing to Be Wise They Became Fools).* Richard Notkin sees this as the ultimate evolution of the human brain if we continue to sacrifice spiritual life to the intellect. Porcelain, underglaze. 9½ × 11½ × 2″ (24 × 29 × 5 cm). *Courtesy of the artist.*

DAVID GILHOOLY, U.S.A.

David Gilhooly has invented an imaginary Frog World where souls have taken frog bodies instead of human ones. In this world, the frogs can take nourishment from organisms in the air, so they eat for pleasure; the sun they bask in is more intense than in our world, but in many ways, they live lives similar to our own. For example, they have pets—pigeons, and sometimes fish (9–19). Gilhooly's brightly glazed animal and frog sculptures were influential in the development of polychrome clay sculpture in the 1970s.

Like David Gilhooly, Jens Morrison has created an entire culture of his own, based on an imagined group of piglike creatures who emigrated across the "Boaring Straits" to Iowa, where they set up tem-

ples to the gods "Bacornius" and "Trickinosos." Starting out in the 1970s with detailed drawings and carvings showing all aspects of the culture, Morrison's work has recently become less concerned with the Farmounian myths and increasingly involved with surface, form, and color (6–16).

It is clear from looking at these works that the line between "fantasy" and "reality" is a difficult one to draw, and that it is at the point where the two meet that some of the most fascinating art occurs. It is also patently absurd, in a book dealing with an artistic activity such as clay sculpture, to suggest that just one chapter can deal with the creative imagination. It is obvious that every work illustrated in the book draws, to a greater or lesser degree, on the dreams, fantasies, and the unconscious associations of the artist.

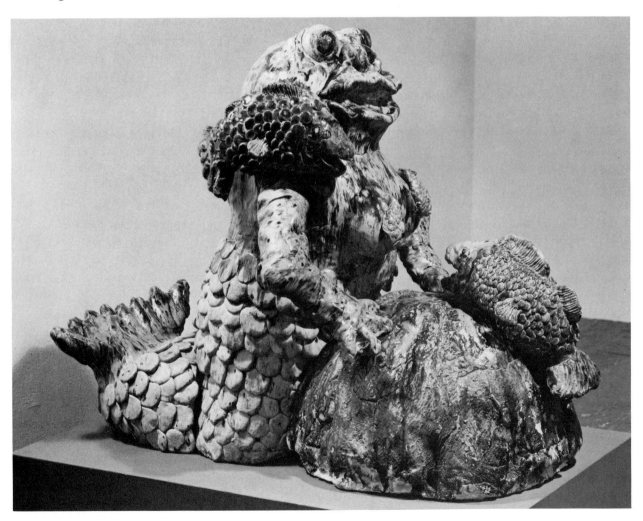

9-19 David Gilhooly, U.S.A., *Merfrog and Her Pet Fish.* Gilhooly has created a mythological Frog World, made of brightly glazed earthenware. Gilhooly's animal sculptures were representative of the growing interest in polychrome sculpture that evolved in northern California in the 1960s. 1976. 42 × 29″ (107 × 74 cm). *Courtesy of the Whitney Museum of American Art, New York City. Gift of Mr. and Mrs. William A. Marsteller, The John I. H. Baur Purchase Fund. Photo: Jerry L. Thompson.*

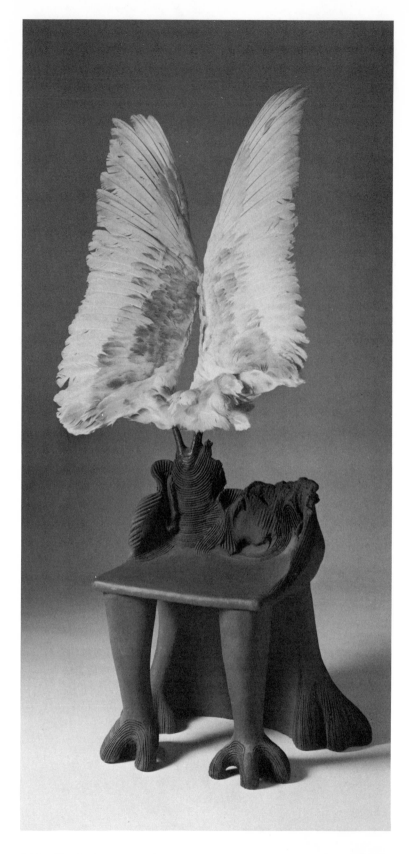

9-20 Ann Roberts, Canada, *Divine Buzzard*. With mythic overtones, the buzzard stands like a guardian of some sacred place. The series now numbers four, and Roberts intends to continue working on it, exploring the theme further. 1981-82. White earthenware; underglaze stains, glazes, and lusters. 42 × 67″ (106 × 170 cm). *Courtesy of the artist.*

9-21 Elizabeth Langsch, Switzerland, *Chair.* Langsch's studio contains a treasure trove of natural materials—wings of birds, dried grasses and pods. In Langsch's murals (7-34), she uses only glazed clay, but on her fantasy chairs she lets her imagination have free range and combines many materials, creating thrones worthy of magical beings. 1976. 51 × 24″ (130 × 60 cm). *Courtesy of the artist and Museum für Angewandte Kunst, Vienna.*

9-22 Dzintars Mezulis, Canada, *Vanity*. Mezulis says he is influenced by Bosch, Dürer, and Dali, book illustrations, and animated films. He remembers details of hands, faces, and gestures seen in buses or crowds, and brings to his sculpture a lifetime of working with his hands. Stoneware, brass, cloth. Height 20″ (51 cm). *Photo by the artist.*

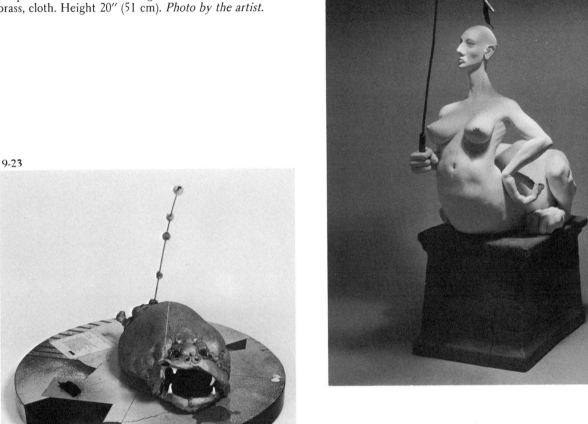

9-23

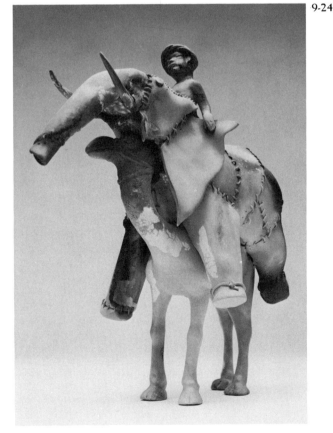

9-23 Steve Reynolds, U.S.A., *Texas Orobouros.* Reynolds says, *All my recent work has been a conscious attempt to integrate what I know about art (including art's relationship to mythology, literature, history and psychology) with the experiential, sensory side of my personality. In an age of extreme aesthetic self-consciousness, this is a provocative challenge to me.* White earthenware, transparent glaze, acrylic, and flocking. 16 × 28″ (41 × 71 cm). *Courtesy of the artist.*

9-24

9-24 Ronna Neuenschwander, U.S.A., *Queen Semiramis, War Elephant #2.* The artist based her series of camels disguised as war elephants on the legend of Queen Semiramis, engineer, general, diplomat, and founder of Babylon. The queen is said to have equipped her armies with camels disguised as elephants in order to frighten her enemies. 1981. Earthenware, sawdust fired, acrylic paint. 14 × 10 × 7″ (36 × 25 × 18 cm). *Courtesy of the artist. Photo: Jerome Hart.*

10

The Animal Kingdom

A winged steed, unwearying of flight,
*Sweeping through air swift as a gale of wind.**
—Pindar

Many authorities believe that the motive for much early art was a desire to gain magical control over the animals that were the main source of food for early hunting peoples. Certainly the art of the caves reflected the intimate knowledge of animals gained in the hunt (1–2). Later, when animals were domesticated and man's dependence on them and control of them increased, the artist could also draw on knowledge that was gained from a lifetime of observation in everyday life (10–2, 10–15, 10–16).

Animals, or the lack of animals, have profoundly affected human history; the departure of herds of wild game when drought dried up African grasslands, the disappearance of certain fish from coastal waters, a disease that decimates domestic flocks can cause humans to change their habitat or habits drastically. Animals have also changed the course of history in other ways: the hordes of Ghengis Khan swept across the steppes on swift horses that terrified all who opposed them, the Romans were routed by Hannibal because he crossed the Alps on elephants, and legend tells us that Assyrian Queen

Semiramis frightened her enemies with fake elephants (9–24).

In the last hundred years or so, we humans have lost the symbiotic relationship that we once had with animals. No longer are horses the main form of transport, nor do oxen pull the plough. If we are lucky, we may visit a farm occasionally, but since most of our day-to-day contact with animals is limited to dogs, cats, and hamsters, we no longer have our ancestors' built-in knowledge of the forms and movements of wild animals.

One animal that has been a constant companion and helper to mankind is the horse, and the relationship between humans and horses has often been a very personal one, in which horses and humans have lived, worked, and fought together. Acknowledging their special qualities, men have made horses into symbols of power, life, and fertility, and probably no other animal has so completely captured the imagination of artists or has so often been described in literature or depicted in art.

In order to see how one animal has been depicted in different parts of the world, here we illustrate horses from Japanese tomb mounds (10–1), from Chinese graves (10–2, 10–4), and from India (10–5), as well as contemporary horses (Colorplate 9).

*From a description of Pegasus, the winged horse of Greek mythology, in the *Odes;* as translated in Edith Hamilton, *Mythology* (New York: Mentor Books).

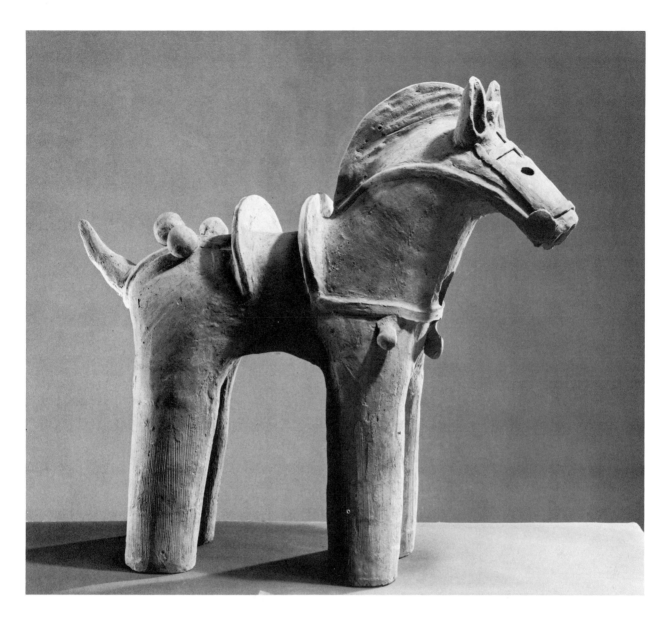

10-1 Two Japanese sculptors, 500 years apart, have found the horse a compelling image. Above: Haniwa horses like this were placed in rows around the tomb mounds of important persons. Coil-built of terracotta, they evolved from simple cylinders, and stood with legs partially buried in the ground. *Courtesy of The Cleveland Museum of Art. Gift of Mrs. R. Henry Norweb.* Right: Japanese sculptor Osamu Suzuki, Kyoto, working on one of his sculptured horses. 1981. *Courtesy of the artist.*

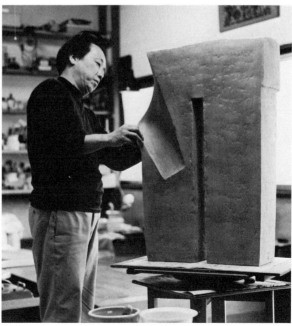

The Horse in Mythology and Art

A glance at the images in clay of horses as sculpted in various periods and cultures will testify to its appeal to artists, and in any book on mythology the references to horses are numerous. For instance, in India a horse guarded the villagers' lands (10–7), in Indo-European legends from Greece to Scandinavia the horse was believed to pull the chariot of the sun, and Pegasus brought the thunder and lighting to Zeus on Olympus (7-2).

The clay horses that were placed, along with figures of humans, around the earthen mound that covered tombs in Japan gave rise to a legend about a beautiful red horse and a man named Hyakuson. Riding home by moonlight one night, he passed

the tomb of the Emperor Ojin, and beside the haniwa figures at the tomb he saw a living horseman mounted on a spirited red horse. As he approached, the horse and rider dashed away along the moonlit road, and Hyakuson followed them on his piebald pony, trying to catch them and capture the red horse for his own use. He was unable to gallop as fast as they did, but to his surprise the horseman stopped suddenly, waited for him, and offered to exchange horses. Hyakuson agreed, took the horse home, stabled it, and went to bed. In the morning, much to his surprise, when he went to the stable there was no beautiful fettlesome red steed waiting there, but only a clay horse. Hurried-

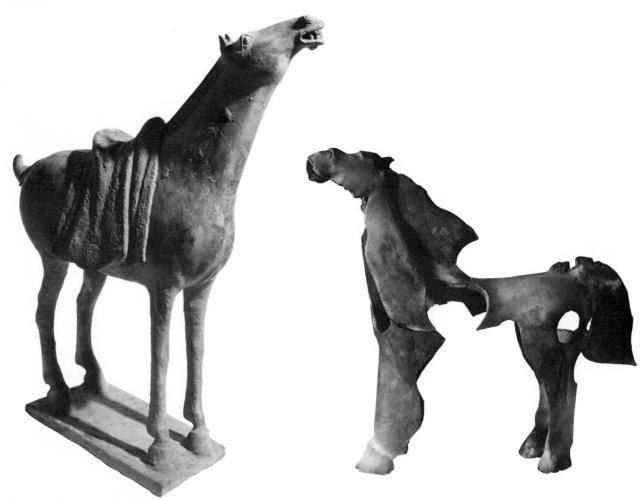

10-2 When the Chinese traded with western nomads for fleet-footed steppe ponies, they saw horses as possessing almost divine power. Later, when horses became more common, the personal favorites of emperors and courtiers were often depicted in art. Covered with white slip, painted after firing; height 24″ (61 cm). Three Kingdoms period (A.D. 220–589). *Courtesy of The Victoria and Albert Museum, London. Crown copyright.*

10-3 John Balossi, Puerto Rico, used terracotta and slab construction to build *Flame Horse,* then fired it in partial reduction to achieve fire coloring on the clay. 1978. Height 12″ (30 cm). *Courtesy of the artist. Photo: Pedro Martinez.*

ly he returned to the tomb, where he found his own piebald pony standing among the clay horses, so he gratefully took it back and left the clay horse in exchange. Today, in Japan, a contemporary sculptor creates horses from clay, sometimes glaz- ing them red, and his simplified horses recall the tomb figures and also the legend of Hyakuson (10–1).

Horses came to Japan from China, which in turn had traded for them with the nomad tribes that

10-4 One of nearly one thousand terracotta horses buried with the Emperor Qin, this horse was made with solid legs supporting a hollow body. A vent hole that was left in its side to allow vapors to escape was later filled in with a clay plug. The saddles were molded with the bodies, but the clay horses wore real bridles. *Courtesy of* The Great Bronze Age of China: An Exhibition from the People's Republic of China *and the Kimball Art Museum, Fort Worth. Photo: Seth Joel.*

10-5 Horse-shaped vessel from a Bhil graveyard, India. Although the Bhil neither raise nor use horses, the horse has an important place in their art and religion. Clay votive offerings to deities or heroes are often made in the shape of horses, to give thanks, to ensure success, or to aid the birth of a child. Twentieth century, from Chhota Vdaipur graveyard. *Courtesy of The Victoria and Albert Museum, London. Crown copyright.*

roamed the steppes of Asia and harassed the northern frontier of China. Eventually, the Chinese learned to use the horses as effectively as had the nomads. They exchanged war chariots for saddles, traded their long robes for trousers, and learned to shoot their bows from galloping horses. By the time of the Emperor Qin, cavalry was an important part of the army (10–4), and by the time of the Han and T'ang dynasties, the horse had become a part of the life of the court (10–6).

Other areas also had legends about horses. In India, the mythological symbolism of the horse varied, depending upon the locality and the religious background of the inhabitants, but it generally represented power or fertility and was often associated with guardian spirits of the land, or with the journey of the souls of the dead.

The Bhil tribes of India picture a horse and rider—the Spirit Rider—who helps the soul in its journey from earth to heaven. Clay votive figures in the shape of horses are still made there by potters, to be offered to the deities to ensure good health, children, or success in some endeavor. In Hindu mythology, Surya, the sun god, rode in a chariot pulled by horses, and in the Tamil beliefs, the deity Aiyanar watches over the villages and the fields,

riding at night at the head of a mounted entourage of heroes and demons. The villagers in this area of India offer Aiyanar huge clay horses so that he will not lack a steed to ride around the village and guard it (10–7, 10–8). Traditionally, at least two such horses were offered to him each year—sometimes by the village as a whole, sometimes by an individual. The village sanctuaries, located near the pond or stream that watered the fields, contained numbers of these clay horses—some as old as 100 to 200 years. In earlier days, they were left to break down and return to the earth, but today they are made of concrete, and the knowledge of how to construct them in clay is dying out. An American ceramist, Ron duBois, arranged for village potters to build a horse so that he could film and photograph the process before it is forgotten.*

In Greece the mythological half-men, half-horses—the centaurs—may have been inspired by the mounted horsemen who came out of western Asia, riding so well that the horse and man seemed one. Apollo, the sun god, was believed to drive a

* Ron duBois, *The Working Processes of the Potters of India: Massive Terracotta Horse Construction of South India* (film), 1982.

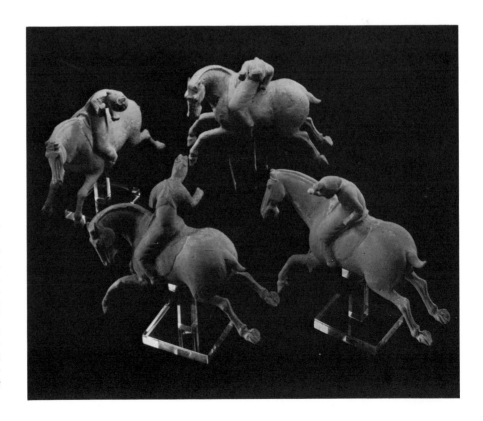

10-6 By the T'ang dynasty in China, the horse was used for recreation. Court ladies rode with the men and played polo, sitting astride their horses in flowing trousers. Red pottery, originally polychromed; traces of pigment. 10 × 5½ × 12⅞" (25 × 14 × 33 cm). Seventh to early eighth century A.D. *Courtesy of William Rockhill Nelson Gallery, Atkins Museum, Kansas City, Missouri. Gift of Miss Katherine Harvey.*

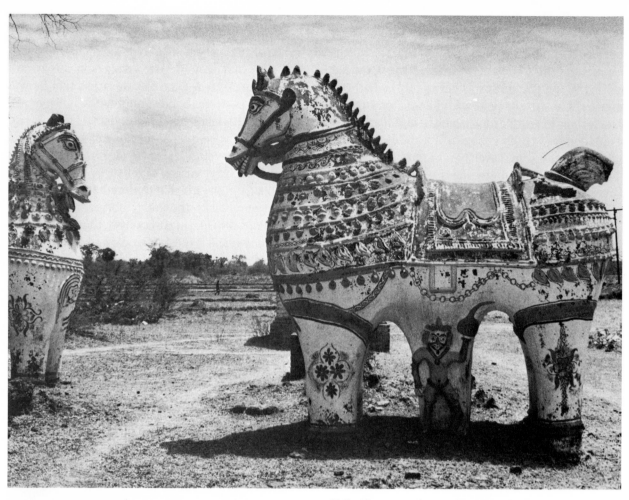

10-7 Terracotta horses, Tamil Nadu, India. Given by villagers as offerings to Aiynar, the deity who guards the villagers' lands, these huge clay horses were built and fired in place. These are about twenty-five years old, and the oxides that once decorated them have weathered. Heights range from 9 to 15 feet (2.7 to 4.6 m). *Photo: Ron duBois.*

10-8 On the third day of construction, coil-built legs and central support have been filled with clay. Right: As the four-inch-thick walls are built up and begin to stiffen, they become strong enough for a potter to climb inside to smooth the clay. The clay is heavily tempered with rice hulls and straw, and is built up over a wooden frame that will remain in place during firing. (See also 2-29.) This horse was built especially for filming and photography, but even so, the ancient rituals were followed. *Photo: Ron duBois.*

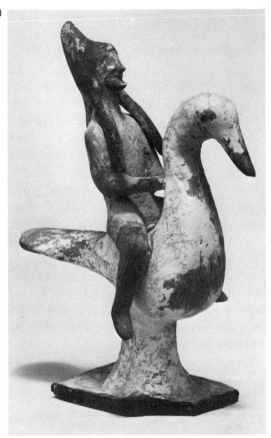

10-9 The possible blasphemy of trying to rival Allah's creative powers led to the neglect of full-round sculpture in Islam, so it is rare to find a realistically sculpted animal. This one's use is unknown—it may have represented an astrological sign. Syria, thirteenth century A.D. Lustrous beige glaze. *Courtesy of The Victoria and Albert Museum, London. Crown copyright.*

10-10 *Man on a Goose.* This terracotta figure, made in Greece about 500 B.C., still retains much of its original paint. The man's hat is red, his shirt blue, and he rides a white goose. Made in Beoetia, from Tanagra. *Courtesy of The Trustees of the British Museum, London.*

10-11 A king of beasts, saved by a king's intervention. When the Lion brewery on which this lion once stood was torn down, King George VI saved the sculpture from destruction and had it placed on a pedestal beside the Thames, where it now surveys the river with Big Ben in the background. Made of Coade Stone, a high-grade terracotta formulated by the Coade family of Dorset, it was once painted red; now it is a dignified beige. 1837.

horse-drawn chariot across the sky, and in Rhodes a chariot and four horses were flung into the sea every year as a sacrifice to the sun. Archaic Greek temples depicted horses in terracotta in relief, and as the skill of the sculptors in clay improved, the Greeks, and the Etruscans who learned from them, mounted in-the-round sculptures of horses on their temples. By Classic times, the horse had become an important image in Greek art (4–1).

When the image of the horse came to Rome from Greece, the horse and rider was transformed into a symbol of temporal power, and the massive bronze horses that carried Roman generals, and, later, Renaissance princes and condottieri, were originally modeled in clay. Even today, when the horse is no longer part of our daily lives, its dignity, its grace, and its power inspire sculptors to re-create its image in clay.

Other animals besides the horse have been de-picted in clay for their symbolic importance—the haughty eagle suggesting imperial power, the lion symbolizing dignity and royalty (10–11). In ancient Mexico, the feathered serpent was the symbol of the god Quetzalcoatl (5–5), while the jaguar partici-pated in the creation of the world, offering sacri-fices so that the sun could move. Several contem-porary sculptors have used animal images to symbolize their own fantasies or to construct their own mythologies (6–16, 9–17, 9–19).

Throughout history, almost every kind of animal has been modeled, cast, carved, and built out of clay, from a bull that may have been used in astrolo-gy to an opossum vessel, from a man riding a goose to a happy hog. Today, when animals are not our constant companions as they once were, fewer are the subject of sculpture. But for those artists who do sculpt them, their power over the imagination is as strong as it was twenty-five thousand years ago.

10-12

10-12 Zoomorphic vessel, representing an opossum, with a long spout for pouring. A.D. 1200–1600. From Temple Mound II, Cross Country, Arkansas. 8¼ × 9″ (21 × 23 cm). *Courtesy of the Museum of the American Indian, Heye Foundation, New York City.*

10-13

10-13 In London's Natural History Museum, the evolu-tion of the primates is symbolized by monkeys climbing up a vertebrate ladder. Conceived by architect Alfred Water-house, the entire museum is decorated with sculptured ani-mals, birds, and plants, both living and extinct.

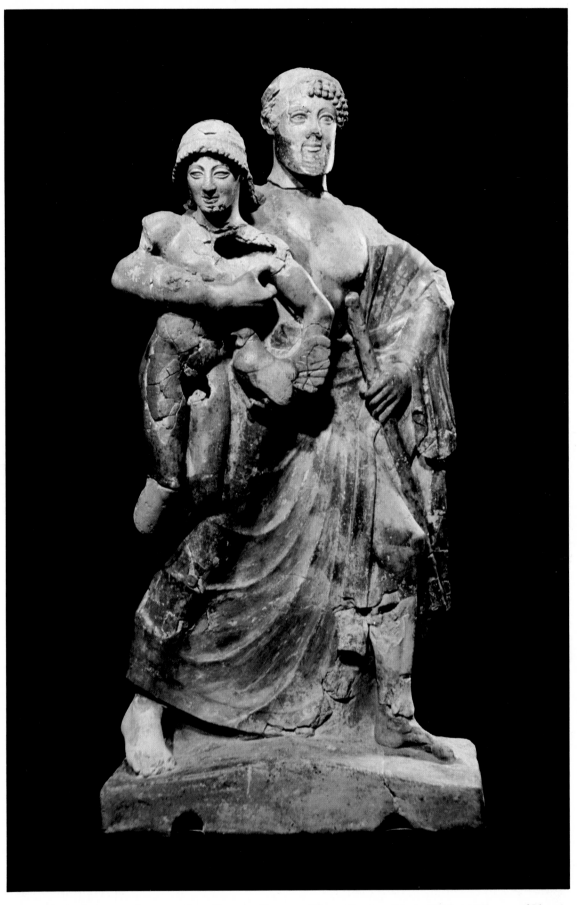

1. *Zeus and Ganymede,* painted terracotta from Olympia, Greece, c. 470 B.C. *Courtesy of the Archaeological Museum of Olympia.*

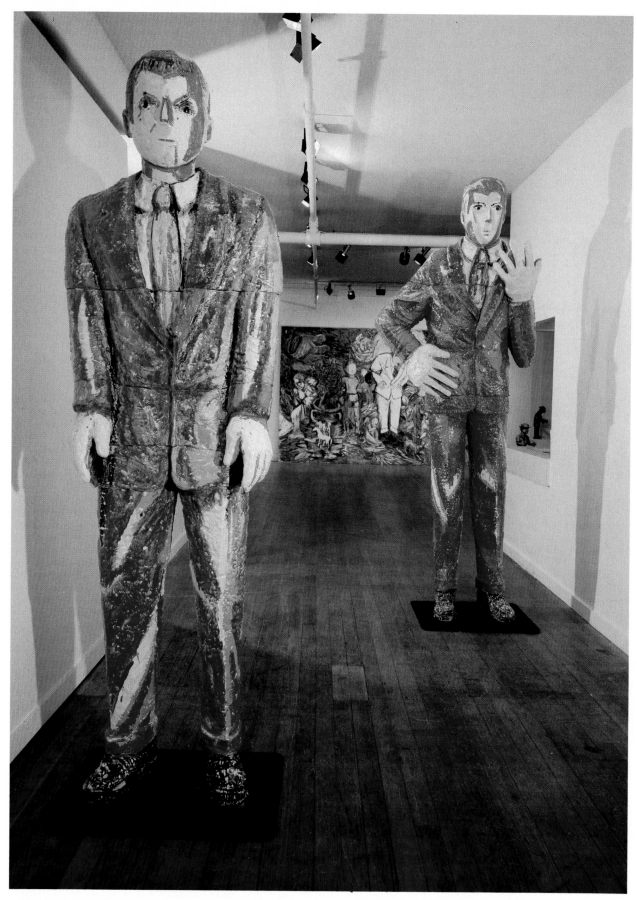

15. Viola Frey, U.S.A., installation in Quay Gallery, April 1983. Left: *Fire Suit*, 98 x 32 x 23" (249 x 81 x 58 cm), 1983. Right: *Fire Suit with Large Yellow Hands*, 109 x 43 x 23" (277 x 109 x 58 cm), 1983. *Courtesy of the Quay Gallery. Photo: M. Lee Fatherree.*

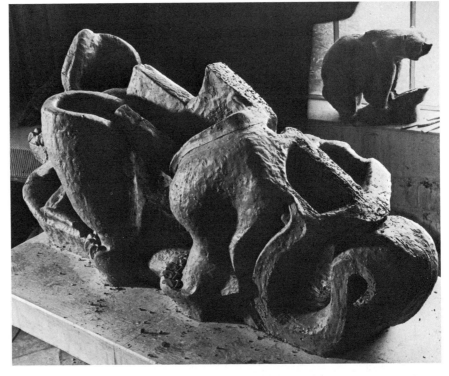

10-14 Lily Swan Saarinen, U.S.A., sculpted animals for use on school buildings at a time when little architectural sculpture was being created. Right: Progress photograph shows how she built up supports inside *Tiger*. Below: The tiger and cub, once completed, were cut into two sections and are shown awaiting firing in the studio of Majia Grotell at Cranbrook Academy of Art. Kiln openings were exciting, as few attempted such large pieces of sculpture at that time. 1942. *Courtesy of Cranbrook Archives.*

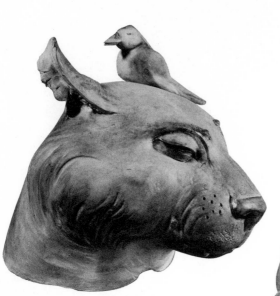

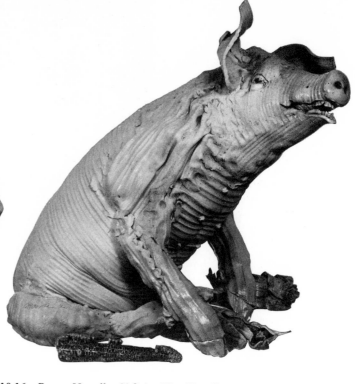

10-15 Joe Bova, U.S.A., Patience. Bova was strongly influenced by Mochican pottery of Peru, and although his images of animals and people with animals are contemporary, they still have some of the mythic power of those vessels. *I believe my images, animals, and people are wed symbolically to the root of pottery as a projection of living forms; e.g., cupped hands = drinking vessel. I do not deal with containerism directly, however; the essential form and idea of my pieces are derived from pure forms of pottery and the idea of a closed space.* 1981. China paint on unglazed surface. Height 10½″ (27 cm). *Courtesy of the artist.*

10-16 Bruce Howdle, U.S.A., Pig. Howdle, son of a hog farmer, uses the wheel to form his corn-fed pigs. Once assembled they are colored with stains to resemble Cheshire, Hampshire, and Yorkshire hogs, then are fired in a salt kiln at cone 9. 1982. The average size is 2½′ (76 cm). *Photo: Michael A. Oestreicher.*

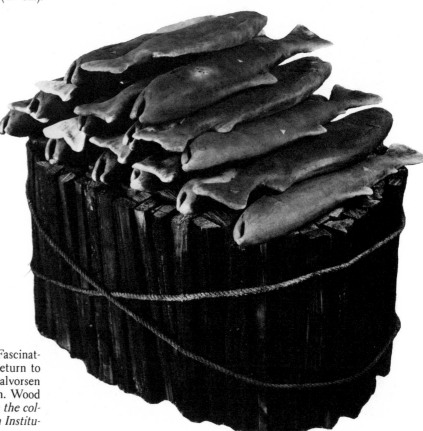

10-17 Lisa Halvorsen, U.S.A., *Fish Pyre*. Fascinated with the migration of the salmon who return to the rivers of their birth to spawn and die, Halvorsen casts her fish in molds taken from actual fish. Wood and clay, life-sized. *Courtesy of the artist. In the collection of the Renwick Gallery, Smithsonian Institution.*

New Ways with Clay, the Vessel as Sculpture, and a Look Ahead

I am one of those sculptors who uses a number of different media, one of which happens to be clay; the fact that most of my three-dimensional work contains at least some clay speaks highly to me of its versatility.
—Percy Peacock, England

The potter-sculptors who decorated a libation receptacle with feathers (11–1), made a tripod urn into a rattle by placing pebbles inside its legs (11–2), or placed a bronze crown on the headdress of a clay image of a goddess were not concerned with categorizing the work as sculpture, pottery, or mixed media. They just used what was at hand to create the effects they wanted. People working with clay have probably been combining it with

other materials for a long time—damp clay is such an easy material to poke holes into and fired clay is easy to attach things onto. Traces of decoration, or the holes for attaching it, still remain on some older objects, and African vessels dating from the late nineteenth and early twentieth centuries still retain bits of feathers, straw, and human or animal hair, predating twentieth-century mixed media constructions.

Mixed Media

Contemporary usage of mixed media in art dates from the early twentieth century, when the Dada artists made assemblages of found objects and the Cubists glued bits of newspaper or theater tickets onto their collages. The discovery that clay combines easily with other materials, along with the fact that clay offers qualities that no other material can offer, is one factor in clay's new popularity as a sculptural medium.

Increasingly, clay is being treated as just one of

many media from which a sculptor may choose. English sculptor Percy Peacock says: *My work is highly narrative in nature, often installation in scale, and so I only use clay where it is relevant to the idea, employing other materials as required* (11–3). American sculptor Clare Harris, who combines clay with welded metal, wood, and cloth, says: *I use any material necessary to express the feeling I try to get in and through my work* (11–15).

It is true, however, that technical considerations

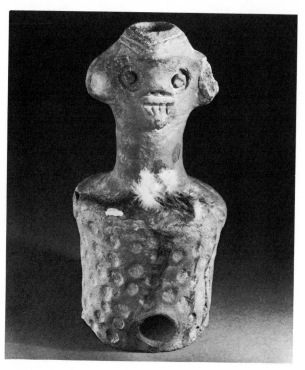

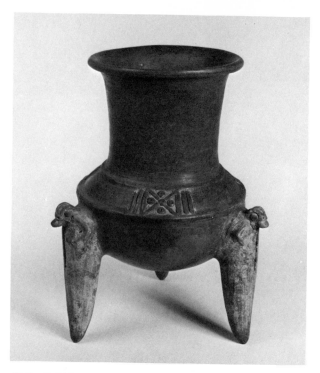

11-1 The feathers, the triangular head acting as a handle, and the openings in the handle and the base suggest that this figure was used as a libation receptacle. Cameroon. Height 9½", diameter 4" (24 cm; 10 cm). *Courtesy of The Portland Art Museum, The Paul and Clara Gebaur Collection of Cameroon Art. Photo: Bill Grand.*

11-2 Pebbles were fired into the slit legs of this tripod urn, forming a rattle. Costa Rica. A.D. 1000–1500. Redware. Height 16½" (42 cm). *Courtesy of the Museum of The American Indian, Heye Foundation, New York City. Photo: Carmelo Guardagno.*

11-3 Percy Peacock, England, progress photograph of *In the Bedroom.* Peacock speaks of his *present fascination with domestic environments/situations. . . . Figures in bedrooms, in the back garden of houses.* Peacock points out that *the fragile nature of these recent works is a crucial part of the whole. They are not monolithic structures, rather they are fragments of memory, or moments in time, an attempt to focus on something which constantly changes.* Fired clay with underglaze colors, paint, wood, steel, and color photocopies. 15 × 20' (4.6 × 6.1 m). *Courtesy of the artist.*

188

can make it difficult for sculptors with no background in clay to use it in their work; someone with limited knowledge of the ceramic process cannot always just go buy a bag of clay, model a form with it, then glaze and fire it successfully, while a painter who might be drawn to the color one can achieve with glaze on three-dimensional forms would soon discover that painting with glazes that look pale and chalky before the fire brings out their color is a quite different matter from painting directly on canvas. Or a sculptor who has worked primarily in plastics would discover that casting a form in slip and firing it successfully is not as simple as laying up fiber glass and epoxy in a mold—though a great deal pleasanter. Some nonceramic artists have handled the problems involved in working in what is to them a new material by finding knowledgeable people who help them solve the structural, glazing, and firing problems. Picasso and Miró, for example, executed their sculpture with the close collaboration of devoted colleagues who had spent a lifetime in ceramics: Picasso at Vallauris with Georges Ramié, and Miró near Barcelona, firing at the kilns of Josep Llorens Artigas (Colorplate 5). David Best collaborates with Mike Leach, who throws the pots, jars, and plates on which Best places sculptural forms (11–25).

Largely because of the technical knowledge needed to work freely and creatively with clay, the original impetus toward combining clay with other sculptural materials tended to come from potters who, with a background in clay, have moved into sculpture. Originally, a purist attitude that prevailed among many ceramists often discouraged those from other areas of art who wanted to experiment with clay, but that is no longer so true, and the movement now goes both ways as more and more sculptors use clay in combination with other materials. Percy Peacock, who found the lines between sculpture and ceramic classes firmly drawn in his student days in England, is one of that growing group of artists.

PERCY PEACOCK, England

Percy Peacock says that in his earlier sculpture, the materials he used, the way the pieces were controductions, and how he displayed his work were influenced by visits to museums. He hoped, in these works, to suggest that they were built for a specific function or for some sort of ritual involving humans, the nature of which was not made clear. Using a variety of media—clay, wax, wood, plaster—he presented the sculpture along with visual clues that contained associative material—a pair of

11-4 Rinda Metz, U.S.A., wove rolls of colored clay into a tapestry that shades from beige to pink to salmon to dark reddish brown. She suspended *Proliferation* from the ceiling so that it can be seen from both sides. *Its reference to*

yet another craft—weaving—and so much to painting and color theory make it rich, and the fact that it is so fragile is an expression of life itself, as well as its genesis. 1982. Clay, wire netting. 3′ × 4′ (91 × 122 cm). Courtesy of the artist.

surgical gloves, a photocopied image, an incomplete sentence.

More recently, Peacock's work has become more narrative, dealing with relatively specific subject matter. For instance, he set up one installation that dealt with the embarrassment of formal introductions, and another, an outdoor piece, that was concerned with the fragility of man-made environments in relation to the passage of time. He points out that these installations, *whilst being figurative for the first time, also have an air of theatricality about them, almost like props in a stage set. Each work consists of a number of elements which, when positioned near enough to each other in the correct relation, produce a complete, unified image which is intended to change—to impart different visual information as the viewer moves around the work* (11–3).

RINDA METZ, U.S.A.

Rinda Metz finds it fascinating to try to push a material beyond its limits, and she has done this in her handling of the clay in *Proliferation* (11–4). An ardent canoeist, birdwatcher, and lover of the natural world, Metz delighted in the organic way her "clay tapestries" seemed to multiply like living matter. Like Weylande Gregory (8–4, 8–5), Metz appreciates the engineering ability of certain creatures—both artists were struck by the way in which a crayfish constructs its mud dwelling, and Metz

once exhibited an installation consisting of these crayfish "houses." She recognizes, however, that in art this life energy must be contained. Seeing a need for geometry and abstraction as well, she imposed a rectangular shape onto the seething mass of clay "worms" in her tapestries.

She says that these pieces grew out of a time when she was fed up with the fragility of clay and was almost ready to quit using it. Instead, she decided to make an extremely fragile sculpture from clay, and in *Proliferation* she succeeded. Its hand-rolled coils are merely interwoven with the chicken wire and each other, so that when the time came to move the tapestries for exhibit, the problems of how to move such a fragile work became a part of the sculpture experience.

Numerous artists use clay in combination with other materials, and illustrations of their work are scattered throughout the book. Ken Little, for example (Colorplate 14), describes his portraits: *Physically they are life-sized structures built from old shoes, bed covers, tin cans, rocks, antlers, mannequins, tree bark, blown-out tires, barbed wire, extension cords, pine cones, cheap western paneling, oil paint, clay, plaster, fiber glass, etc.* David Vaughan, England, says that he enjoys using clay in combination with wood, plastics, and metal because *this tends to reinforce the vulnerability of the material, which in itself is capable of resembling so many others with such different characteristics.*

11-5 Joyce Kohl, U.S.A., leaves her large clay forms unfired; thus she can pinch and wad them with thick walls, without worrying about what might happen in the kiln. She uses a clay body containing asphalt to stabilize it, and paddles the clay to meld it as well as to create the forms. Built with an interior support network, they are strong enough to be moved safely. Their surfaces are saturated with several coats of used motor oil. 1981. Approximately 4 × 4 × 4' (1.2 × 1.2 × 1.2 m). *Courtesy of the artist.*

The use of other materials can also extend the possibilities of clay forms. Vaughan says that his use of other materials along with clay has led to his *exploiting the interaction and implications of the "wrong" and "right" material in association with defined, but often distorted and disjointed, everyday functional forms* (5–16).

To Robert Milnes, who combines copper with fired white clay, the copper is a functional as well as a visual element in the work, forming a grid that both supports the ceramic elements and defines and controls the space (11–14). Frank Steyaert, Belgium, on the other hand, combines clay, slip, wood, and glass in some of his works, whereas in others he creates what at first glance appears to be a mixed media sculpture but that turns out on close examination to have imitated each material in clay (11–10).

Sculptors working with clay along with other media may well find that the clay becomes the controlling factor, dictating the manner in which the rest of the work develops. One artist who found this out is Paul Astbury, who has been combining aluminum and clay forms in an effort to isolate the clay, to get it off the ground or the table top. Inspired by an article he read about waves and the scientific explanation of their formation and progression, he began to develop the piece that became *Predictions* (11–6). Starting out with the clay form, he decided to suspend it, and thought that using aluminum rods would be the best way to do it. Originally, Astbury says, he was very naïve about constructing in metal, thinking he'd just put a rod here and another there to support the clay. But it became more complex than that, as the aluminum sagged under the weight of the clay, and the arc sprang apart from the tension. Then, as he added wire to hold it together and twisted the aluminum to keep it from bowing, he discovered that each change predicted another, just as one wave follows another in a predictable pattern.

JACQUELINE GUILLERMAIN, France

Jacqueline Guillermain works with modular clay units that she combines with cords or rope into what she refers to as "collections." Sometimes these collections of objects are boxes, sometimes they are books or dossiers, and at other times they are bundles of rolled clay that she has bound together into *Ladders* (11–7). *Yes,* Ladders, *it is true, are also collections—of bars. It seems that gives them the appearance of a ladder, but rather like Jacob's ladder, they don't have a beginning or an end.* Guillermain sees many possible interpretations of her *Ladders,* leaving it to the viewer to read his or her own meaning into them, but she comments that: *Everything really only holds together by a thread, everything ties and unties itself, but always between fragments of that imperishable material—clay.*

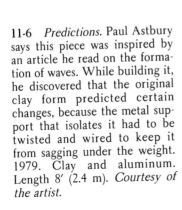

11-6 *Predictions.* Paul Astbury says this piece was inspired by an article he read on the formation of waves. While building it, he discovered that the original clay form predicted certain changes, because the metal support that isolates it had to be twisted and wired to keep it from sagging under the weight. 1979. Clay and aluminum. Length 8′ (2.4 m). *Courtesy of the artist.*

the viewer sees them, while in others the viewer may have a choice of angles and viewpoints.

Installations and mixed media works may also involve collaboration between people with widely differing skills—from the construction knowledge of engineers who help on the installation of large architectural sculpture (7–18) to the musical knowledge of those involved in a performance or ritual (11–20, 11–16). The tradition of using clay objects and images in ritual is a long one, ranging from the masks used in ancient Hazor (8–26) to the massive horses at a sanctuary in India (10–7), the offerings made at a shrine in prehistoric Crete (11–22), or the performance of dance and music taking place in and around Marion Held's monolithic clay pieces (11–16).

11-7 Jacqueline Guillermain, France, says she makes collections: *I am not sure exactly of what, but, for me, it is a notion that is very strong.* Music is also a strong influence in Guillermain's life, and she is intrigued with the musical staff and the support it gives to the notes. Many of her works, like *Ladders*, suggest the rhythms of music, the supporting structure of the staff. She feels also that the wool, rope, or cord that holds her fired-clay forms together represents the ties that bind people, things, or collections. 1980. *Courtesy of the artist.*

Hanging ladders of ropes and clay over the wall of an ancient church, as Guillermain did, might be said to turn her work into an "installation." That term, like "mixed media," is a convenient one that can be applied to work that does not quite fit any of the traditional definitions.

Either of these terms, or both, could be used to describe works like George Geyer's and Tom McMillin's construction of unfired clay, wood, and metal that they placed at the mercy of the waves (9–3), or Daniel Pontorau's pile of clay surrounding *A black hole. A void* (11–14). Some installations, like Deborah Horrell's (9–13) and Percy Peacock's (11–3), are constructed to control the way in which

11-8 John Spofforth, U.S.A., *Efficacy: Cross Cues.* Spofforth built a brick construction whose internal rhythms set up a counterpoint to the pseudo-Classic facade. 1981. *Courtesy of the artist. Photo: National Museum of American Art, Smithsonian Institution.*

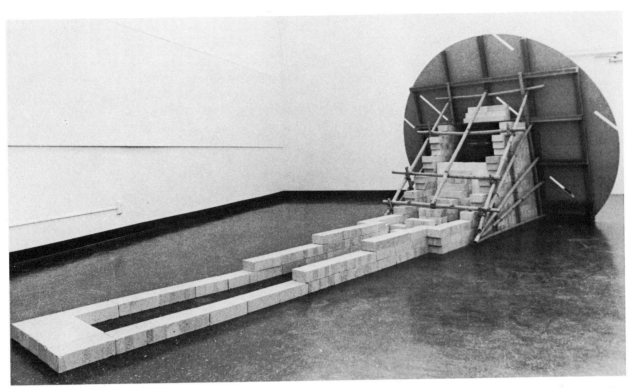

11-9 Jack Nielsen, U.S.A., *Installation.* Nielsen works with clay, firebrick, grog, bamboo, and wood to create indoor works, while his outdoor installations are executed in granite, and clay. 1981. *Courtesy of the artist.*

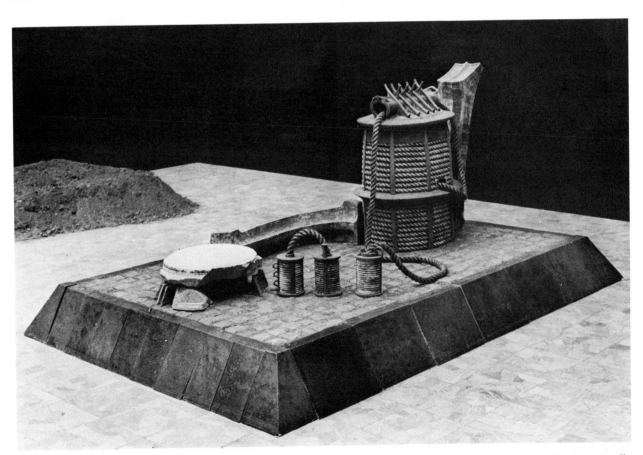

11-10 Frank Steyaert, Belgium, *Ceramic Landscape.* In this work Steyaert appears to be using mixed media, but actually the whole piece is composed of ceramic parts: the cord is made from a mold with an impressed pattern, the paving is of gray, blue, and brown tiles with a wood-ash glaze, and the surrounding wall is tenmoku-glazed stoneware. 1979. 4 × 39 × 10′ (1.25 × 12.0 × 3.0 m). *Courtesy of the artist.*

11-11 Angel Garraza, Spain, *Untitled.* Garraza combines stoneware clay with carefully crafted wooden forms. In his work, he treats clay as only one of his sculptural materials, using its rough texture to contrast with the polished wood. 1981. Stoneware, wood. *Courtesy of the artist.*

11-12 Robert Lyon, U.S.A., builds constructions that range from a few inches in height to hut size, using plywood that he covers with clay, glue, and paint mixture. When it dries, the surface becomes hard and permanent.

11-13 Annemarie Schmid-Esler, Canada, *Untitled.* The artist assembles cast objects, wood, wire, and found objects into brightly colored three-dimensional collages. *I try,* she says, *deliberately to push towards a freeing from rational concepts and try to trust chance and intuition without a calculated plan. One can lose control of a piece and occasionally lose it totally, but the risk is worth it.* 1981. Clay, wood frame; cone 05 glaze and acrylic paint. 31 × 23 × 21″ (79 × 58 × 53 cm). *Courtesy of the artist.*

194

11-14 Daniel Pontoreau, France, has made both outdoor and indoor installations using the elements of this piece, with unfired clay, or powdered clay mixed with cement, sand, and gravel. In the outdoor setup, the glass box is sunk over a hole. *There is nothing attached to the string. Only a black hole. A void. (Without bottom!)* In the indoor installation, the glass box was sunk in clay. At the bottom is a mirror under a construction of silk that is attached to cotton strings hanging down from the box. When one leans over the box, with a strong light shining into it, one sees lateral reflections. Box dimensions, each 27½″ (0.7 m). 1981. *Courtesy of the artist. Photo: Laurent Sully Jaulmes.*

11-15 Clare Harris, U.S.A., *Within Without.* The pyramids are made of local clays—white and red fireclay—scraped to reveal grog patterns, bisqued, then pit fired. The metal base was heated to allow color development and treated with gun bluing, while the grid was rusted by spraying with vinegar and water. 1981. Clay, welded sheet metal, tar, coal, and expanded metal. Pyramids, 7 × 11″ (18 × 28 cm), base 9 × 24 × 36″ (23 × 61 × 91 cm). *Courtesy of the artist. Photo: Mark La Moreaux.*

11-16 Marion Held, U.S.A., *Earth•Song*. Held says, *The use of monolithic figures and their organization in space is intended to function as do the mysterious standing stones of Stonehenge or the cromlechs of Scotland. They describe places of worship, they speak of cultures far removed from our own.* There are flutes built into the large monoliths which are played during performance, and floor pieces that act as percussion instruments. Instruments and music by Norman Lowrey. 60 × 23 × 14″ (152 × 58 × 36 cm). *Courtesy of the artist. Owned by New Jersey State Museum.*

196

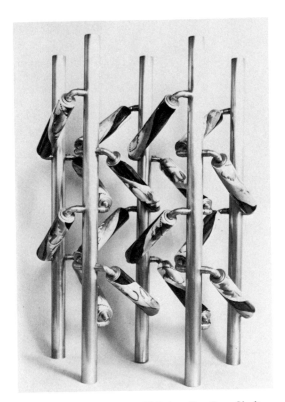

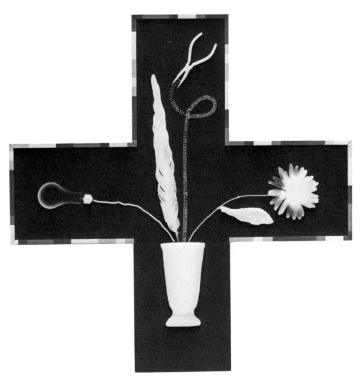

11-17 Robert Milnes, U.S.A., *Smelter Shelter.* Milnes combines copper and whiteware, using each material for a specific purpose—the copper is functional as well as visual, while the glazed whiteware allows him to include color and repeat patterns. 34 × 34 × 11″ (86 × 86 × 28 cm). *Courtesy of the Theo Portnoy Gallery, New York City.*

11-18 Martha Holt, U.S.A., *Sum of Man.* Intrigued with the relationship between structure and meaning, Holt combines objects into compositions in which the interplay between actual three-dimensional objects and their photographic representations force us to re-evaluate our perceptions. 1980. Fired, glazed clay; photogram. 39 × 39 × 3″ (99 × 99 × 8 cm). *Courtesy of the Theo Portnoy Gallery, New York City.*

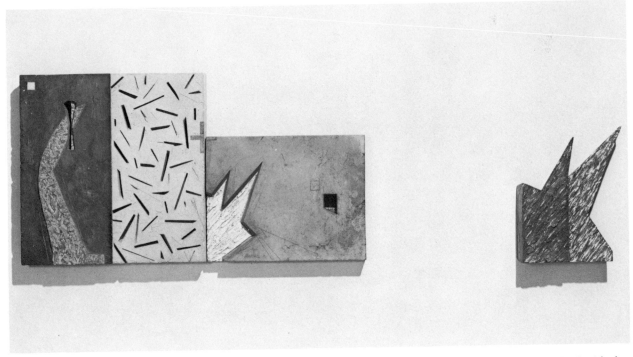

11-19 Nicholas Wood, U.S.A., *Study III (Stepp).* Wood says, *Over the past six years my work has been involved with the application of systems and structure which are manifested through the use of narrative, architectural, and encoded language reference....* 1981. Terracotta with terra sigillata and colored slips. 48 × 15 × 4″ (122 × 38 × 10 cm). *Courtesy of the artist and Delahunty Gallery, Dallas. Photo: Pelka/Noble.*

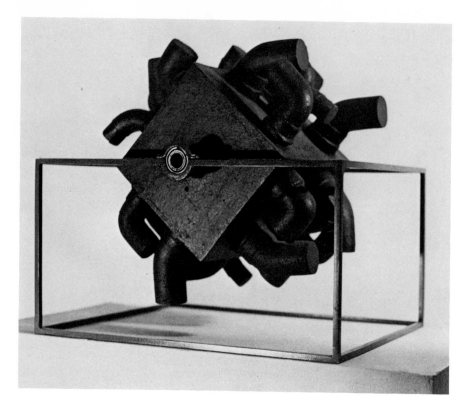

11-20 Lieve de Pelsmaeker, Belgium, *Sonomobil.* The artist creates what he calls *Sonomobils.* With them, he says, *I try to make a synthesis of sculpture, movement and sound. I want to engage the spectator to participate in the creation, and to abolish barriers between the spectator and art object.* Produced both manually and electronically, the sounds have been developed into musical compositions. Stoneware clay, red metal frame. *Courtesy of the artist.*

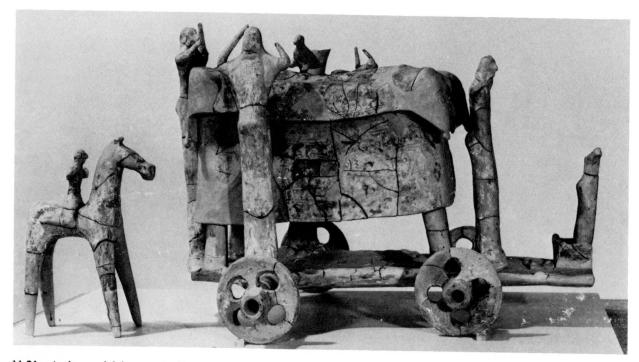

11-21 A clay model from early Greece represents a procession of mourners accompanying a body in a funeral cart, while the small figure on top of the cart represents the spirit of the deceased. The funerary rituals of early cultures frequently made use of clay models and vessels, and the potter-sculptor was important to the proper carrying out of these rites. From Necropolis of Anagyrous, Attica. c. 700 B.C. *Courtesy of the National Archeological Museum, Athens.*

The Vessel and Ritual

The vessel as the physical container of sacred material, or as a symbol of the spirit itself, has been linked with ritual for thousands of years (11–26), and an interest in the vessel in relation to ceremony is illustrated in a model of an ancient shrine, as well as in the work of some contemporary artists. Many of these, having come to sculpture from a pottery background, are concerned with exploring the concept of the container both as a sculptural form and in relation to its associations.

One of them, Jim Koudelka, U.S.A., has drawn on his background in making, using, and studying the vessel and on his experience as a waiter to create a series of pieces in which, he says, *the figures reach out and hold cup forms, offering service and nourishment to the viewer. These gestures are derived from personal experience as a waiter, and the environments represent shrines, altars, and intimate spaces.* Koudelka says he wishes to establish homage to the vessel through its placement and the associative qualities of the materials, the images, and the type of construction (11–29).

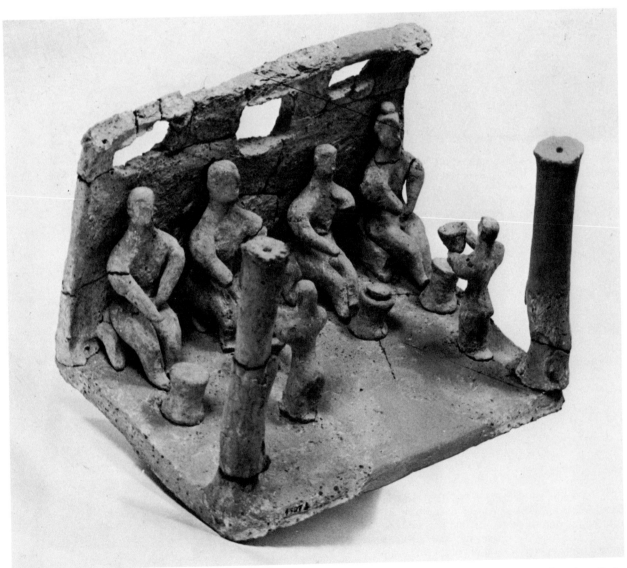

11-22 Terracotta model of a shrine on Crete shows figures holding vessels as offerings. The images seated at the offering tables are believed to represent the dead. Crete, 1400–1350 B.C. *Courtesy of the Archeological Museum, Heraklion.*

11-23 The Etruscan potter-sculptor who made this cinerary urn to hold ashes of the dead was not concerned with the question of what is a sculpture and what is a vessel. c. 700. B.C. *Courtesy of Soprintendenza alle Antichità, Florence.*

11-24 Sculptor Jeff Schlanger, U.S.A., *Jara el Salvador.* Schlanger worked cooperatively with Tomas Collins, who threw the jar, and Katsuyuki Sakazume, who fired the image, stopper, and lid, to create a contemporary fusion of pottery and sculpture. 1982. Stoneware, earthenware, and steel, wood-fired. Height 89″ (2.26 m). *Copyright the artist. Photo: John Begansky.*

200

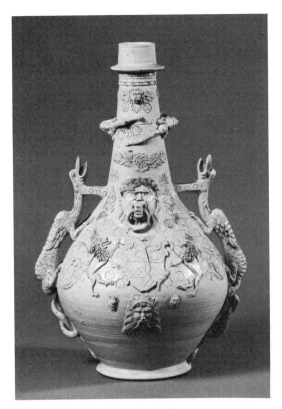

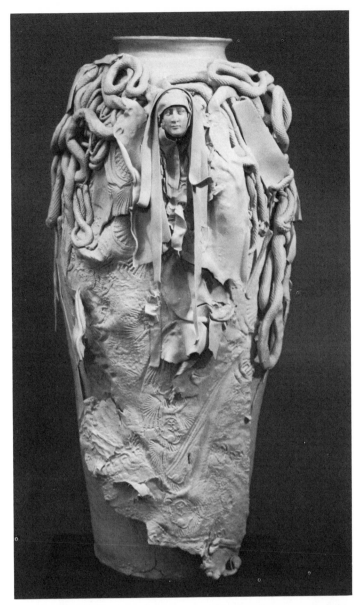

11-25 Above: A stoneware bottle, made in Germany in 1573, is decorated with stamped and mold-formed floral motifs, mythological animals, faces, and shields. Perhaps a presentation piece, it probably held wine, and unlike many of the Rhine valley jugs and bottles it was not salt-glazed. *Courtesy of The Hetjens-Museum, Düsseldorf.* Photo: Landesbildstelle Rheinland, Düsseldorf. Right: David Best, U.S.A., works with a colleague, Mike Leach, to create vessels that act, he says, like a vehicle. *I always use a vehicle for the information I want to put down, whether it be a spoon, a horse, a figure, or a jar.* Leach throws the pots after he and Best agree on the general form. Made in sections, the assembled vessel is placed in the kiln while it is still damp. Best, who says, *I like tightly crafted things, but I'm not patient,* works in the kiln, applying the molded and pressed porcelain forms to the damp vessel. The two clays are compatible and both fire to cone 10. 1982. Height 4′(1.2 m). *Courtesy of the artist. Photo: Carol Gold.*

11-26

11-26 View of David Best's studio, 1982.

Rick Hirsch, U.S.A., incorporated wood into his *Space Vessel #14*, much as earlier potter-sculptors used organic materials along with clay in their ritual vessels. 1981. Raku-fired; underglazes, cupric sulfate, ferric chloride. Height 36″ (91 cm). *Courtesy of the artist and Impressions Gallery, Boston. Photo: Robert M. Aude.*

11-29

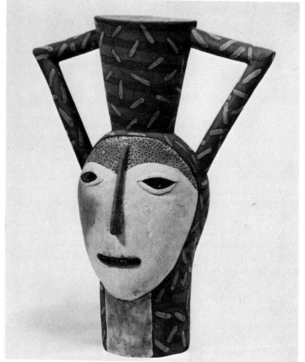

11-28

11-28 A large vessel by Paula Winokur, U.S.A. Recently, Winokur says, she has been *leaving the container behind and focusing on the content.* But even her newer work, which is landscape in image, she feels relates to the container because, she says, *I think of the earth as "containing" all sorts of mysteries.* 1980. Porcelain; sulfates and stain. Height 36″ (91 cm). *Courtesy of the artist and The Elements Gallery, New York City.*

11-29 Andrea Gill, U.S.A., *Spiral Headdress Jar.* Gill uses an altered vessel form as a three-dimensional painting ground, painting on the face with slips and low-fire glazes. *Courtesy of the artist and The Elements Gallery, New York City.*

John Goodheart, U.S.A., on the other hand, says: *My current work stems from an appreciation of pottery and my early training as a potter. In order to make what I do today, I had to stop making pottery and consider it strictly conceptually—its history, function, contribution, process, potential. This approach gave me the freedom to deal with the vessel as a sculptural form* (11–31).

Vessel or Sculpture?

The line between the vessel and sculpture was not a firm one in early cultures, where, as in the case of the potter whose shop was discovered near a shrine in ancient Hazor, the same person usually produced both the vessels and the images used in the temple. In the recent development of clay sculpture, however, the issue has caused considerable discussion and debate, posing questions such as: Does function as a container eliminate a vessel's validity as sculpture? If, one asks, a vessel *must* contain, does a sculpture *never* contain? Gauguin, for example, always referred to his ceramics as

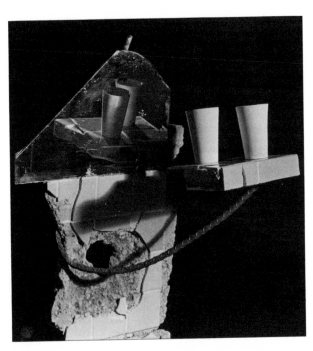

11-30 Jim Koudelka, U.S.A., in *Room Service*, has created a series in which, he says, *I have tried to blend fragmented, yet defined, architectural space with the human figure to emphasize a sense of service.... As the viewer confronts the pieces, the mirror reflects his face, which completes and personalizes the figure.* Cast clay, mirror, steel rod, pink and blue tile; cone 01. 6 × 3 × 3' (1.8 × 0.9 × 0.9 m). *Courtesy of the artist.*

11-31 John Goodheart, U.S.A., in *Post Painting*, creates precisely defined constructions of which he says, *My aesthetic concerns in clay involve the vessel as a sculptural form and as a conceptual and formal element in a broader aesthetic issue.* 1981. White earthenware; low-fire white slip; painted wood, wire, sand. Height 6' 5" (1.96 m). *Courtesy of the artist. Photo: Ken Strothman.*

sculpture rather than as pots. Richard Hirsch, whose tripod *Space Vessels* (11–27) are obviously created for purposes other than containment, feels that a line may be drawn between a vessel made primarily for function and one that is created primarily as a vehicle for concepts, sculptural ideas, or as a vehicle for painting or drawing. There are, of course, functions other than physical containment—the libation vessel in Africa served as both a physical vessel and as a spiritual one, and sculptural images that do not contain also have their function, although the use is a religious rather than a practical one. Some of Richard Shaw's books and other objects have lids that lift off, making them

containers. Are they then vessels, or are they sculpture? Need we draw the line? Marea Gazzard, Australia, says of her work: *I wouldn't call my work pottery. Pottery, I think, is defined by use. . . . But then, I don't think I'm making sculpture either. I'm just making objects* (11–34). Trained as a potter, Petra Weiss, Switzerland, now creates large sculptured murals. She says, however, *I love the wheel, and I would never want to give it up totally. After all, there is a distinct relationship between sculptural and vase forms.*

11-32 Jerry Rothman, U.S.A. Left: *Contemporary Attitude, Ritual Vessel.* Rothman has often moved from creating massive architectural sculpture to sculptural vessels and back again; he feels that the two are equally important. 1980. Porcelain; bisque, glaze firing, cone 06. Metal saturated luster; black glaze with grog on handles. Height 24″ (61 cm). *Courtesy of the artist and Garth Clark Gallery, Los Angeles.*

11-33 William Abright, U.S.A., says, *My work in clay is non-utilitarian. I retain the use of vessel forms, however, to explore sculptural concepts, and to play on the functional association that is historically Ceramics.* In his vessels, Abright uses the linear element of extruded clay sticks to accentuate the importance of the inside, carrying the eye in through holes cut in the walls. 1979. Hand-built, extruded sticks. Height 42″ (107 cm). *Courtesy of the artist and The Elements Gallery, New York City.*

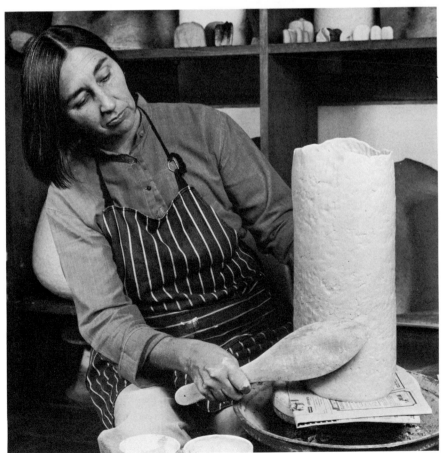

11-34 Above: Mingarri Group from *Uluru* series. Marea Gazzard, Australia. The *Uluru* series was based on the mythology of the Kunia tribe. Other influences that Gazzard recognizes are the rocks, the human body, and *something in the landscape* of her native Australia. Left: To build her coil-built pieces, Gazzard uses whatever clay works best for her— *I don't go digging for it. I just find a prepared clay that suits what I want to do.* 1979. Approximately 30 × 30″ (76 × 76 cm). *Courtesy of the artist.*

Tony Hepburn (1–7, Colorplate 7) discusses one factor he feels has a bearing on the issue, pointing out that today's ceramic sculpture *developed directly out of the making of pots. Someone at some point decided that any reference to function could be eliminated, and closed a pot over at the end of the throwing process. Another potter—probably Jim Melchert, decided that a pot need not take up a position at a right angle to the earth's surface, and laid it down, taking up more horizontal space than vertical. They were probably still fired and glazed and hence the term ceramic sculpture began developing. The appearance of those early departures bore such a close relationship to pots that the word sculpture needed to be qualified because it didn't fit that category historically, materially, or aesthetically.*

Since Tony Hepburn wrote those words, the question has been explored, debated, discussed, and written about at length by critics and art historians as well as by artists and craftspeople who have wished to analyze and discover their own place in the world of art/craft.

A related question is: What is the difference between craft and art? Is it the function of an object, or the material, that makes the difference? Or is it the expressive quality, concept, or lack of it, that draws the dividing line?

Craft is defined in one dictionary as:

Skill or ability in something, especially in handwork or the arts; proficiency; expertness.

In the same volume, art is defined as:

1. Human effort to imitate, supplement, alter, or counteract the work of nature. 2. The conscious production or arrangement of sounds, colors, forms, movements, or other elements in a manner that affects the sense of beauty; specifically, the production of the beautiful in a graphic or plastic medium. †

If one accepts these two definitions, it would appear that art and craft are not mutually exclusive, and that the post-Renaissance split that developed between art and craft is weakening.

Tony Hepburn also comments that one of the claims that ceramic sculptors have made is that there has been a prejudice against the material itself that has kept galleries from exhibiting it, because they have identified it with the craft rather than the art tradition. That situation is certainly changing as more and more galleries regularly include clay artists in their exhibit schedules, and Hepburn feels that artists who work in clay no longer have a right to make that excuse. *Clay sculpture,* he says, *must be measured against art as must painting or sculpture in general. Clay sculpture measured only against clay sculpture is too limited a measuring stick.*

This statement is well worth pondering, underlining as it does the responsibility of artists to apply tough standards to their own work. At the same time, it advises students of the standards they can expect to be applied to their work when they enter the world of galleries and sales.

The revival of interest in clay as a sculptural medium has changed the look of the ceramic studios in schools and colleges, and the same questions that have to be faced by the artist working in clay in relation to art, craft, and the vessel, have had to be faced by instructors in those fields. This new interest in clay has also led to the inclusion of clay in art classes, where at one time a strongly defined line had cut off all interchange between sculpture and ceramics. Percy Peacock (11–3) comments that in England, where education has been highly departmentalized, it was difficult for him while he was a student to find a place for himself, because of the educational system in which ceramics instructors could not deal with sculptural questions any more than the sculpture instructors could deal with ceramics. *I felt,* he says, *that there was something fundamentally wrong with a system which imposed at such an early stage in an artist's career the area of work he should be involved in. . . . More recently, some colleges have become more integrated, under the general banner of fine art, but there is still a strong tendency for different disciplines to work independently.* This strict categorization is less imbedded in the American educational system, where the relationship between different departments has been less rigid, allowing students to move more freely between them.

One comment that has been made about clay sculpture is that it is usually a step or two behind the general trend of art movements, that sculptors working in clay are inclined to deal with issues that have been raised in avant-garde art circles some time before. This may be the case, despite the fact

* *Clay* magazine, England. Copyright, Tony Hepburn.
† *The American Heritage Dictionary of the English Language* (Boston: Houghton Mifflin Company), 1978.

that the possibilities inherent in the ceramic material—especially low-fire glazes and china paint—gave considerable impetus to at least one twentieth-century development in art—the use of color in sculpture.

On the other hand, artists as well as critics have criticized ceramic sculpture as being more concerned with technique, process, and surface than with the formal aspects of sculpture. Comments like this led one artist, William Wyman (3–3), to state, *I have always been concerned with making expression transcend technique. I have been working with the conviction that clay and glaze are a legitimate media for aesthetic expression.*

Most sculptors who work with clay today, however, are above all concerned with the conceptual and formal areas of their work, and prefer to be judged as sculptors rather than to be categorized only as clay sculptors. Viola Frey (Colorplate 15), for instance, considers her work to come from the background of figurative sculpture, not from the craft tradition of ceramics, and says that she chose to work in clay because she could not decide between working in sculpture or painting. Responding to a comment that when a piece is not successful as ceramic sculpture it is sometimes because the surface has taken over, Stephen De Staebler agreed: *Yes, that's one of the biggest pitfalls with ceramics. I feel that sculptures should go beyond technical experiments. You've got to think of ideas and forms. I think that one of the biggest reasons why you get very bad ceramic sculpture is that people can become totally involved with the process. It's a very seductive process, ceramics.*

Perhaps partly because of such lively discussion of these subjects, the acceptance of clay as an important art material is now considerably wider than it was even five years ago. It is true that a general euphoria and sense of excitement reigned throughout the clay community as the old traditions broke down, and for a time, anything was acceptable. The pages of this book demonstrate that there is still excitement and ferment in the field, but it is already clear that increasingly higher standards are now applied to clay sculpture, and that as the material takes its place as one art material among many, it will no longer be able to depend on newness or on shock value to attract attention.

So, clay sculpture in the last part of the twentieth century is moving into a period quite different

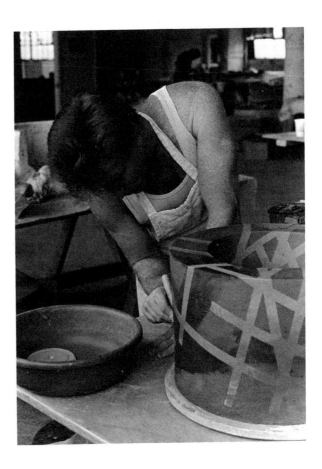

11-35 Left: Nick Starr, U.S.A., *Green Lattice Bowl.* Right: Starr creates his basic bowl forms in press molds, building their apparently massive walls hollow. Using wet strips of newspaper, he masks the first coat of colored slip, then paints freely with other slips made of the same clay body. Of his forms he says, *I do think of these bowls and column forms as being sculptural vessels: the size and surface separates them from a utilitarian purpose and to me suggests a ceremonial intent.* Raku body, colored slips; cone 05. *Courtesy of the artist. Photo: Courtney Frisse.*

from the 1950s and 1960s, when a few artists startled the clay world with iconoclastic attitudes toward ceramic sculpture. For the artist who uses clay, the future will no doubt pose new and different questions, questions that we cannot now foresee. Artists, however, are not only used to facing questions, but to posing them. Martha Holt expresses her awareness of this as she says, *I used to believe that artists, like scientists, were problem-solvers. The scientist looks for the cure to the common cold; the artist seeks to understand the rela-tionship between organic and geometric shapes. No longer. I have come to realize that for the artist there is no given. It is not a question of solving the problem but the realization that the artist must create the problem.*

What the problems of the future will be or what solutions will be created for them no one can say. But if the earth itself, its water, and the fuels needed for firing clay survive humanity's assaults, there will always be artists who will pose the questions and attempt to create some of the solutions.

11-36 Kris Cox, U.S.A., *Sanctum Vessel Series.* Cox constructs his large vessels and their attached "armatures" entirely of clay. The pegs can be removed and the superstructure disassembled. Their size, color, and surface markings create an imposing twentieth-century reinterpretation of ancient clay ritual vessels. Fired in open saggars made of steel drums cut in half. Cox says, *The use of saggars enables me to locate various materials against specific areas of each piece. These materials cause local changes in the coloration.* Height 4′ (1.2 m). *Courtesy of the artist and Green Gallery, Carmel.*

GLOSSARY

Akroteria Ornaments placed at the angles of the gable ends on Greek, Etruscan, and Roman temples.

Alkaline glazes Low-fire glazes, developed in the Near East, using alkalis as fluxes.

Alumina (Al_2O_3) One of the main materials in clay, also used in glazes. Heat resistant.

Armature A wooden or metal framework used to support clay as a sculpture is being built. Generally armatures are not fired, but some sculptors have used heat-resistant metal armatures.

Ash glaze Any glaze containing ashes. Since ashes are high in heat-resistant silica, they require high firing.

Bag wall Heat-resistant wall that separates the firing chamber of a kiln from the flames. It helps to direct the heat.

Bat Plaster slab on which wet clay is spread. It absorbs water, preparing the clay for handling consistency. Also, a plaster or wooden slab on which clay sculpture is built.

Bisque Unglazed clay, fired at a low temperature. Glazed sculpture is usually bisque-fired first, then refired with a glaze.

Bisque firing The process of firing unglazed clay to a low temperature to harden the clay and drive the physical water from it.

Bizen Wood-fired pottery, produced in Japan, with deliberately caused fire marks and ash glazes caused from the wood ashes in the kiln. The process is now sometimes adapted to sculpture.

Bone china Hard china, high-fired with clay containing bone ash, occasionally used for sculpture.

Bucchero A type of black pottery produced in the Etruscan period.

Burnishing A method of polishing the surface of stiff, but still-damp, clay by rubbing with a smooth tool.

Cartoon Full-size drawing. A sculptor may prepare a cartoon before starting to build a piece of sculpture.

China paint Low-fire overglazes, originally used to paint on glazed china, now often used to decorate sculpture.

Chokkomon A type of interlacing decoration, used during the Old Tomb period in Japan.

Cinerary urn Earthenware urn, used to hold human ashes for burial. During the Etruscan period, the urns were frequently sculpted.

Clay body Any clay used for sculpture or pottery. Clay bodies vary widely in consistency, plasticity, maturing temperature, color, and texture.

Coils Ropes of clay that are wound on top of each other to build up the walls of a clay sculpture.

Coloring oxide Any element chemically combined with oxygen that gives color in clay or glaze.

Cone (pyrometric) A small pyramid of ceramic material formulated to bend over when a certain point has been reached in the firing cycle. Affected by both temperature and duration, cones show when the kiln is reaching the maturing point of a clay body or glaze.

Crackle Small cracks that appear on a glaze when the clay body and glaze cool at different rates. Often deliberately induced for decoration, it can be emphasized by rubbing color into the cracks.

Crazing Unintentional cracks on the glaze surface.

Decals Design or image printed in overglaze paints on a specially coated paper that allows it to be transferred onto the sculpture before firing.

Deflocculant Usually sodium carbonate or sodium silicate, added to casting slip to keep the clay particles suspended in the water.

Drape mold Any mold or object over which clay can be draped to shape it as it stiffens.

Earthenware Iron-rich, low-fire clay that is porous and usually reddish or buff when fired. A common clay, most early sculpture was formed from it.

Engobe A mixture of clay and water, applied to the surface of sculpture to change the color or texture of the clay body.

Extruder Machine that pushes damp clay through a die to shape it. Originally used to make bricks and tiles, now it often is used to form hollow sculpture or sections of sculpture.

Faience Low-fire opaque-glazed pottery, developed in Renaissance Italy. Also a general term for any pottery of low-fire clay coated with an opaque glaze.

Feldspar One of a group of rock-forming minerals; a heat-resistant ingredient of stoneware and porcelain clay bodies. Also used in high-fire glazes.

Fire clay Heat-resistant clays used in sculpture bodies as well as in kiln bricks.

Firing chamber The area inside a kiln in which an object is placed to be fired.

Flash firing A quick firing in which smoke and flame are allowed to come in contact with the sculpture, creating color changes and markings. It often is achieved by a second firing with straw, leaves, or paper.

Flocking Not a ceramics term, this refers to short fibers scattered into a still-wet glued surface, giving the surface a plush, or pile, texture.

Flux Any material that lowers the melting point of the heat-resistant materials in clay or glaze.

Funerary urn An earthenware vessel used for burial. See also cinerary urn.

Glaze Glassy coating that has been melted onto the surface of the clay. Glazes can be low-fired, high-fired, glossy, or matt.

Grog Crushed, fired ceramic material that is added to a clay body to help reduce shrinkage and thermal shock.

Haniwa Cylindrical sculptures that were placed around grave mounds in Japan.

Hump mold Any crafted mold or found object that can be adapted to use as a mold, over which slabs of clay can be draped.

Kiln Furnace made of heat-resistant materials in which ceramics are fired.

Lead glaze Any glaze that contains lead as a flux. Because of health hazards, lead is now rarely used in the raw state, and lead glazes are not used on domestic ware.

Leather-hard The point at which much of the water has evaporated from moist clay. At this point, the clay has shrunk and become stiff, but not hard, and can be carved, burnished, or joined with slip.

Luster A coating of metallic salts mixed in a binding material, usually applied to glazed ceramics. When fired in a reduction atmosphere it produces a lustrous, metallic coating.

Luting The act of joining two pieces of leather-hard clay with slip.

Majolica Named for Majorca, the island from which it reached Italy; a type of pottery on which colored glazes

were painted on an unfired base glaze, so that when fired the color fuses with the base glaze.

Matt Any nonglossy finish.

Maturity The point during firing when a particular clay or glaze reaches its optimum state of density, vitrification, and hardness. Clay bodies and glazes mature at a wide range of temperatures.

Manganese (MnO_2) An oxide which gives brown, purple, and black colors in clay or glazes.

Molecular water The H_2O that is chemically combined with the silica and alumina in clay, the result of the natural processes which form clay. This chemical water starts to be expelled when clay is fired to about 350° to 400°F.

Open firing Firing in an open fire or pit, with no enclosed kiln.

Overglaze Enamels or china paints which are usually painted on an already fired, glazed surface, then fired at a low temperature.

Oxidation (oxidation atmosphere, oxidizing firing) The condition within an open fire or kiln in which oxygen is present, allowing the oxides in the clay or glaze to retain the oxygen in their chemical structure.

Oxide A compound that contains an element chemically combined with oxygen. In clays and glazes oxides serve several functions, from glass-forming, to fluxing, to coloring.

Paddling Beating the walls of a clay sculpture with a paddle, thereby driving the clay particles together, tightening the clay, and sometimes texturing the surface.

Pediment The triangular area at the ends of gabled roofs. On Greek, Etruscan, and Roman temples, it was often filled with sculptural decoration.

Pietà A representation of the Virgin Mary mourning over the dead body of Christ, often along with other religious figures.

Plaster of Paris A gypsum cement that forms a paste when mixed with water, quickly hardening into a solid; used for making molds.

Plasticity The property of moist clay that allows it to be modeled, pressed, or paddled to shape without cracking and to retain the form into which it has been shaped.

Platelets Microscopic particles making up the physical structure of clay. Thin, and elongated, when surrounded with water they cling together and slide, causing clay to be malleable, yet to retain its shape.

Porcelain A clay body that when fired at high temperature becomes nonporous, white, hard, and translucent.

Press mold Any fabricated mold, or concave object, into which clay can be pressed to form it as it stiffens.

Raku A method of firing, originally used for pottery in Japan, that has been adapted in the West. As now used for sculpture, the bisqued or glazed object is quickly fired in a red-hot kiln, and on removal is plunged into a container of reductive material that ignites from the heat of the sculpture.

Reduction The condition in a kiln when the oxygen is removed from the atmosphere by smothering, dampening down, or by burning materials that produce carbon. In reduction, the oxides in the clay or glaze lose their oxygen, causing color changes.

Reductive material Any material that is placed in a kiln or in a saggar to cause a reduction atmosphere.

Relief Sculpture in which the figures or forms protrude from a flat background. Relief can be low, high , or three-quarter round.

Saggar Container of fire clay in which sculpture or pot-

tery is placed in a kiln. Originally used to protect an object from the fire, it now often is filled with reductive material to cause local reduction.

Salt firing Firing in which salt is introduced into the kiln at high temperatures. The sodium vaporizes, combines with the silica in the clay, and forms a transparent glaze.

Sarcophagus Burial container that, in Etruscan times, was often made of terracotta and sculptured with a figure of the deceased.

Sgraffito Technique in which the clay surface is coated with colored slip and lines are scratched through the slip to reveal the clay color underneath.

Silk screen Method of printing, adapted to ceramics. Used to print overglaze colors on a glazed surface.

Sinter To fire any material to the point where it becomes a homogenous mass without melting.

Slab Clay that has been flattened with hand pressure or by rolling out with a pin or mechanical slab roller.

Slab roller Mechanical device for rolling out slabs.

Slip Mixture of water and clay, used for decorating, for casting sculpture in molds, or for joining leather-hard sections of sculpture.

Slip-cast Sculpture that has been cast by pouring slip into a mold and allowing the clay to stiffen. Slip for casting usually contains a deflocculant to help retain the clay particles in suspension.

Smoking Placing a piece of fired ceramics in a smoky atmosphere to change the surface coloration.

Soda ash Sodium carbonate (Na_2CO_3); used to increase plasticity in clay, and as a deflocculant in slip.

Sodium silicate Used as a deflocculant, it helps keep the clay particles suspended, thus requiring less water and lessening shrinkage.

Stoneware Clay that, when fired at high temperature, becomes dense, nonporous, and vitrified. Usually brownish in color.

Talc Used in clay bodies, it produces a white body that will mature at a low temperature.

Temper Any material, like sand or grog, that is mixed into a clay body to open the pores, making it less subject to shrinkage and thermal shock.

Terracotta Low-fire reddish clay body, usually containing temper. When fired, terracotta is porous. It has been used for sculpture since the earliest times.

Terra sigillata Fine slip, used by the Greeks and Romans to coat pottery; now sometimes used on sculpture to produce a smooth but nonglossy surface.

Thermal shock Produced when a clay object in the kiln is subjected to too sudden a rise or fall in temperature.

Tin glaze Low-fire lead glaze that is made opaque by the addition of tin. Used to coat the reddish earthenware clay of majolica pottery, it produced a white ground that allowed colored decoration.

Trompe l'oeil Any painted image that is so realistic that it gives the illusion of three dimensions—fooling the eye.

Undercut A cut that produces an overhanging form in a piece of sculpture. Undercuts make it impossible to release a one-part mold from the sculpture. Thus, sculpture with undercuts requires sectional molds.

Underglaze Colored decoration applied to bisqued clay, then coated with a clear glaze.

Updraft kiln Kiln in which the heat rises up through the firing chamber, leaving through a chimney or hole at the top. Early kilns were all updraft.

Vitreous Glassy. A clay body or glaze becomes vitreous when its glass-forming ingredients melt and fuse.

Wax-resist Decoration method in which wax is painted on areas of bisqued clay. When glaze is applied, the wax repels it so that those areas remain unglazed.

Wedging Kneading a moist clay body into a homogeneous mass and expelling air bubbles.

Whiteware Usually refers to white, low-fire clay which is fired at a somewhat higher temperature than earthenware.

FURTHER READING

General background, history, and individual sculptors listed by period or areas of interest.

Larousse Encyclopedia of Prehistoric and Ancient Art. René Huyghe, ed. New York: Prometheus Press, 1957.

Clay Figurines of Babylonia and Assyria. E. Douglas Van Buren. New York: AMS Press, reprint of 1930 edition.

5000 Years of the Art of Mesopotamia. Eva Strommenger. New York: Harry N. Abrams.

Greek Terracottas. R. A. Higgins. London: Methuen, 1976.

The Terracottas of the Tarantine Greeks. B. M. Kingsley. Malibu, Calif.: Getty Museum Publications, 1976.

Handbook of the Greek Collection, Metropolitan Museum of Art. Gisela M. A. Richter. Cambridge, Mass.: Harvard University Press, 1953.

The Elder Pliny's Chapters on the History of Art. K. Jex-Blake and Eugenie Sellers, transl. Chicago: Ares Publications, 1974.

The Art of Rome, Etruria and Magna Grecia. Germain Hofner. New York: Harry N. Abrams, 1969.

Etruscan and Roman Architecture. Axel Boethius and J. B. Ward-Perkins. Harmondsworth: Penguin, 1976.

Figurative Terracotta Revetments in Etruria and Latium. E. Van Buren. London: J. Murray, 1921.

Etruscan Sculpture. Ludwig Goldscheider. New York: Oxford University Press, 1941.

The Art of Etruria and Early Rome. G. A. Mansuelli. New

York: Crown Publishers, 1941.

Maids, Madonnas and Witches: Women in Sculpture from Prehistoric Times to Picasso. J. Bon. Photographs by Andreas Feininger. New York: Harry N. Abrams, 1961.

Haniwa: The Clay Sculpture of Proto-historic Japan. Miki Fumio. Tokyo, and Rutland, Vt.: C. E. Tuttle Co., 1960.

Ceramic Art of Japan. Seattle Art Museum, 1972.

The Art of Clay: Primitive Japanese Clay Figurines, Earthenware and the Haniwa. Seiroku Noma. Tokyo: Bijutzu Shuppau-sha, 1954.

Treasures from the Bronze Age of China: An Exhibition from the People's Republic of China. New York: The Metropolitan Museum of Art and Ballantine Books, 1980.

Chinese, Korean and Japanese Sculpture. Asian Art Museum of San Francisco, The Avery Brundage Collection. René d'Argencé, ed. Tokyo, New York: Kodansha International, 1974.

The First Emperor of China. Arthur Cotterell. London: Macmillan Ltd., 1981.

Art of Cameroon. Paul Gebauer. Portland, Oreg.: Portland Art Museum, 1979.

The Potter's Art in Africa. William Fagg and John Picton. London: British Museum Publications, 1970.

Ife in the History of West African Sculpture. Frank Willet. New York: McGraw-Hill, 1967.

African Art. Frank Willet. New York and Toronto: Oxford University Press, 1971.

Indian Terracotta Art. O. C. Gangoly. New York: G. Wittenborn, 1959.

Birbhum Terracottas. Mukul C. Dey. New Delhi: Lalit Kalā Akademi, 1959.

Unknown India, Ritual Art in Tribe and Village. Philadelphia Museum of Art, 1968.

From River Banks and Sacred Places: Ancient Indian Terracottas. Museum of Fine Arts. Boston: C. E. Tuttle Co., 1978.

The Ceramic Sculptures of Ancient Oaxaca. Frank H. Boos. New Brunswick, N.J.: A. S. Barnes, 1966.

Mayan Terracottas. Irmgard Groth-Kimball. New York: Praeger, 1961.

Pre-Columbian Miniatures. Anni and Josef Albers Collection. Anni Albers. New York: Praeger, 1970.

Moche Art and Iconography. Christopher B. Donnan. Los Angeles: University of California Latin American Center, 1976.

Maya Sculpture. Merle Greene, Robert L. Rands and John A. Graham. Berkeley, Calif.: Lederer, Street and Zeus, 1972.

Precolumbian Terracottas. Franco Monti. London: Hamlyn, 1966.

The Sculpture of Donatello. H. W. Janson. Princeton, N.J.: Princeton University Press, 1963.

Staffordshire Pottery Figures. John Bedford. New York: Walker and Co., 1964.

Gauguin's Ceramics. Merete Bodelsen. London: Faber and Faber, 1964.

Paul Gauguin. Letters to His Wife and Friends. Maurice Malingue, ed. London: Saturn Press, 1948.

Gauguin. John Rewald. New York: French and European Publications, 1938.

Dégas. John Rewald. New York: Pantheon Books, 1944.

The Ceramics and Sculpture of Chagall. Charles Sorlier. Monaco: Editions André Saurel, 1972.

Céramique de Picasso. Paris: Editions Cercle d'Art, 1974.

Sculptures de Miró, Céramique de Miró et Llorens Artigas. St. Paul de Vence: Fondation Maeght, 1973.

Meister der deutschen Keramik: Ceramic Sculpture in Germany 1900 to 1958. Cologne: Kunstgewerbemuseum der Stadt Köln, 1978.

Modern Italian Sculpture. Roberto Salvini. New York: Harry N. Abrams, 1962.

Giacomo Manzù. John Rewald. Greenwich, Conn.: New York Graphic Society, 1967.

Louise Nevelson. John Gordon. New York: Whitney Museum of Art, 1967.

The Sculpture of Isamu Noguchi. Nancy Grove. New York: Garland Publishers, 1980.

Peter Voulkos: A Dialogue with Clay. Rose Slivka. Boston: New York Graphic Society, 1978.

Low-fire Ceramics. Susan Wechsler. New York: Watson Guptill Publications, 1981.

American Porcelain. Lloyd E. Herman. The Renwick Gallery, Smithsonian Institution. Timber Cove Press, Oreg.: 1980.

TECHNIQUE

How-to books on ceramic sculpture that give additional information on certain techniques can be found in most libraries. Many of the following books are oriented toward pottery, but provide information on clay, glazes, and firing that is also applicable to sculpture.

Finding One's Way with Clay. Paulus Berensohn. New York: Simon and Schuster, 1972.

Claywork: Form and Idea in Ceramic Design. Leon I. Nigrosh. Worcester, Mass.: Davis Publications, 1975.

Hands in Clay. Charlotte F. Speight. Palo Alto, Calif.: Mayfield Publishing Co., 1979.

Ceramic Formulas: A Guide to Clay, Glaze, Enamels and Their Colors. John Conrad. New York: Macmillan Co., 1973.

The Potter's Complete Book of Clay and Glazes. James

Chappell. New York: Watson Guptill, 1977.

Ceramic Science for the Potter. W. G. Lawrence. Radnor, Pa.: Chilton Book Company, 1972.

Contemporary Ceramic Formulas. New York: Macmillan Co., 1980.

Clays and Glazes for the Potter. Daniel Rhodes. Radnor, Pa.: Chilton Book Company, 1968.

Ceramics, A Potter's Handbook. Glenn Nelson. New York: Holt, Rinehart, and Winston.

Manual of Pottery and Ceramics. David Hamilton. New York: Van Nostrand Reinhold Co., 1974.

Native Clays and Glazes for Ceramists in the Western States. Ralph Mason. Beaverton, Oreg.: International Scholarly Book Services.

The New Potter's Companion. Tony Birks. Englewood Cliffs, N.J.: Prentice-Hall, 1981.

Kilns. Daniel Rhodes. Radnor, Pa.: Chilton Book Co., 1973.

Electric Kiln Ceramics: A Potter's Guide to Clay and Glazes. Richard Zakin. Radnor, Pa.: Chilton Book Co., 1981.

The Book of Low-Fire Ceramics. Harvey Brody. New York: Holt, Rinehart, and Winston, 1980.

Electric Kiln Ceramics. Hal Riegger. New York: Van Nostrand Reinhold Co., 1978.

Raku: Art and Technique. Hal Riegger. New York: Van Nostrand Reinhold Co., 1970.

The Thames and Hudson Manual of Architectural Ceramics. David Hamilton. New York: Thames and Hudson, 1978.

MAGAZINES

American Ceramics, 15 W. 44th St., New York, N.Y. 10036.

American Craft, American Craft Council, Box 561, Martinsville, N.J. 08836.

Ceramic Review, 17A Newburgh St., London, W1V1LE, England.

Ceramics Monthly, Box 12448, Columbus, Ohio 43212.

Ceramica, Apartado 7008, Acacius, 9, Madrid 5, Spain.

Ceramique Moderne, 22, rue Le Brun, 75013 Paris, France.

L'Atelier d'Art et Métiers, 18, rue Wurtz, 75013 Paris, France.

The back issues of a variety of magazines such as *Craft Horizons, American Artist,* and *Smithsonian* offer a wide range of articles on clay sculpture of the past and present; they are too numerous to list here.

INDEX

Page numbers in *italics* refer to black-and-white illustrations.